Roman Art
in Context

An Anthology

EVE D'AMBRA

Vassar College

PRENTICE HALL
Englewood Cliffs, New Jersey 07632

Library of Congress Cataloging-in-Publication Data

Roman art in context : an anthology / [selected by] Eve D'Ambra.
 p. cm.
 Includes bibliographical references.
 ISBN 0-13-781808-4
 1. Art, Roman. 2. Art patronage—Rome. I. D'Ambra, Eve.
 N5760.R64 1993 92-27321
 CIP

For Franc

Editorial/production supervision and
 interior design: Patricia V. Amoroso
Cover design: Ray Lundgren Graphics, Ltd.
Acquisitions editor: Bud Therien
Prepress buyer: Herb Klein
Manufacturing buyer: Robert Anderson
Editorial assistant: Lee Mamunes
Copyeditor: Deidre Sadeh

 © 1993 by Prentice-Hall, Inc.
A Simon & Schuster Company
Englewood Cliffs, New Jersey 07632

Printed in the United States of America

10 9 8 7 6 5 4 3 2 1

ISBN 0-13-781808-4

PRENTICE-HALL INTERNATIONAL (UK) LIMITED, *London*
PRENTICE-HALL OF AUSTRALIA PTY. LIMITED, *Sydney*
PRENTICE-HALL CANADA INC., *Toronto*
PRENTICE-HALL HISPANOAMERICANA, S.A., *Mexico*
PRENTICE-HALL OF INDIA PRIVATE LIMITED, *New Delhi*
PRENTICE-HALL OF JAPAN, INC., *Tokyo*
SIMON & SCHUSTER ASIA PTE. LTD., *Singapore*
EDITORA PRENTICE-HALL DO BRASIL, LTDA., *Rio de Janeiro*

Contents

PREFACE AND ACKNOWLEDGMENTS *vi*

INTRODUCTION *1*

HOW TO READ A ROMAN PORTRAIT *10*

POSTSCRIPT *25*
 Sheldon Nodelman

THE GREAT FRIEZES OF THE ARA PACIS
AUGUSTAE. GREEK SOURCES, ROMAN
DERIVATIVES, AND AUGUSTAN SOCIAL
POLICY *27*
 Diana E.E. Kleiner

"PRINCES" AND BARBARIANS ON THE ARA
PACIS 53
 Charles Brian Rose

SCULPTURAL PROGRAMS AND PROPAGANDA
IN AUGUSTAN ROME: THE TEMPLE OF
APOLLO ON THE PALATINE 75
 Barbara Kellum

ALCESTIS ON ROMAN SARCOPHAGI 84
POSTSCRIPT 96
 Susan Wood

THE CULT OF VIRTUES AND THE FUNERARY
RELIEF OF ULPIA EPIGONE 104
 Eve D'Ambra

SOCIAL STATUS AND GENDER IN ROMAN
ART: THE CASE OF THE SALESWOMAN 115
 Natalie Boymel Kampen

PATRONS, PAINTERS, AND PATTERNS:
THE ANONYMITY OF ROMANO-CAMPANIAN
PAINTING AND THE TRANSITION FROM THE
SECOND TO THE THIRD STYLE 133
 Eleanor Winsor Leach

COPYING IN ROMAN SCULPTURE:
THE REPLICA SERIES 161
 Miranda Marvin

THE CITY GATE OF PLANCIA MAGNA
IN PERGE *189*
 Mary T. Boatwright

SOME THEORETICAL CONSIDERATIONS *208*
 Yvon Thébert

PRIVATE AND *PUBLIC* SPACES:
THE COMPONENTS OF THE DOMUS *213*
 Yvon Thébert

GLOSSARY *238*

SUGGESTIONS FOR FURTHER READING *246*

Preface

The idea for this anthology grew out of my experience teaching Roman art and architecture to undergraduates. I realized that I was not alone in relying on xeroxed articles to supplement textbooks and thought that it would be useful to gather them in a volume for the convenience of students and instructors alike. The contents of this volume were not selected to cover any single specific theme but rather to offer different approaches to various topics that are encountered in the study of Roman art: the forms and meanings of imperial propaganda, the role of art and architecture in conferring or enhancing status, the commemoration of ruler and citizen in portraiture and funerary art, the interpretation of mythological subjects, and the significance of sculptural displays in architectural settings. The objects of the studies are portraits, state reliefs, mythological statuary, sarcophagi, funerary reliefs, wall paintings, and examples of both domestic and civic architecture in the provinces.

It happens that the essays also focus on patronage. The study of patronage is useful because works of Roman art, whether the reliefs on the Column of Trajan or the wall paintings in a villa, were primarily determined by the institutions or persons who commissioned them. In the case of an emperor erecting a victory monument, the historical record is likely to be explicit about the commemoration of a military triumph, and the ceremonies of such celebrations are well known. For less illustrious patrons, the historical sources are silent and, frequently, all that is left is a name inscribed on a plaque on a tomb. The student must turn to the methods of social history, along with the analytic tools of sign theory and the perspec-

tives of feminist studies, to understand more fully the role of both private and imperial monuments in conveying power and social status. The study of Roman patrons indicates that individual tastes were dependent on historical forces and social attitudes.

Although all of the articles included in this anthology are not new (they range in date from the late 1970s to within the last several years), they address issues central to the field, and many of them deserve wider audiences than they have found in the scholarly journals in which they were originally published. Critics may charge that the collected essays concentrate narrowly on Augustan art and funerary monuments to the exclusion of other periods and works, but the articles cover topics from the first century B.C. to the fourth century A.C. and raise questions of interpretation that are pertinent to Roman art in general. Although this is most clearly demonstrated in the articles on portraiture, the Ara Pacis, and the Temple of Apollo on the Palatine, political or ideological motives also weigh heavily in the other essays, such as those on the City Gate of Plancia Magna in Turkey and the Roman house in north Africa, monuments in major and minor keys that balance a survey of Roman art with discussions of developments in the capital and in the provinces. An anthology by its very nature cannot be comprehensive, especially about such an untidy and complicated subject as Roman art. This collection aims to make the essays accessible to students and, perhaps, to provoke them to reconsider Roman art from different points of view. The selections strive for clarity and intelligibility for the beginning student who lacks a technical vocabulary, the knowledge of foreign and classical languages, or even a sufficient grasp of ancient history.

The essays are reprinted, for the most part, without any major revisions (except for reductions in the number of illustrations, particularly of monuments that are commonly published in textbooks or those that are discussed in more than one article). The citations of works published in foreign languages in the notes remain untranslated for the instructor's reference (common abbreviations of journals are found in the *American Journal of Archaeology* 95 (1991): 4–16). A glossary provides definitions of terms from Latin and art historical or architectural usage that may be unfamiliar to students, and there is also a brief bibliography for further reading suggestions in English.

I thank my editor at Prentice Hall, Norwell F. Therien, Jr., who first listened to the idea for this book over lunch one wintry day in Rhode Island and who was both supportive and patient in the process. The project has been improved by the comments and criticisms of the anonymous readers for Prentice Hall. Many others suggested essays to include (some of which could not be used for various reasons having to do with permissions and rights): Diana E.E. Kleiner, Natalie Boymel Kampen, Charles Brian Rose, Minott Kerr, Eleanor Winsor Leach, Barbara Kellum, Miranda Marvin, Elizabeth Bartman, Bettina Bergmann, and Ann Kuttner. The editorial decisions were my own, but my ability to make selections was sharpened by discussions with these colleagues and friends. I also learned much about the teaching of Roman art from these exchanges.

The contributors to this volume also aided me by providing offprints and photographs whenever possible. I am grateful to Susan Wood for writing a postscript to her essay that both updates it and integrates the wider issues of patronage, social status, and the meaning of mythological themes. Sheldon Nodelman also added a postscript on critical approaches to portraiture that offers additional bibliography. Mary T. Boatwright substantially rewrote her essay on the city Gate of Plancia Magna to be from an architectural point of view. I am indebted to her, especially in view of the difficulty of finding and acquiring essays on Roman architecture that would be appropriate for this volume.

Many of the photographs were supplied by the German Archaeological Institute in Rome, and Dr. Helmut Jung kindly allowed them to be published here. Karin Einaudi of the Fototeca Unione in Rome also furnished illustrations, and I thank her for her friendly assistance and interest in the work. My husband, Franc Palaia, shot photographs on site and in museums in Rome, and his work has enhanced the entire project from the beginning.

EVE D'AMBRA

Introduction

It is appropriate that textbooks on Roman art and architecture, as introductions to the subject, are concerned with matters of chronology and present the major monuments within the context of broad stylistic developments. It is also unavoidable that the contents of many textbooks lag behind the issues of current scholarship, which gradually reshape the contours of the field. This situation continuously improves with the publication of new texts on Roman art, sculpture, and painting, yet supplementary material is always needed for discussion sections and paper topics, particularly if there is interest in demonstrating art historical methods (which questions are posed, what evidence is cited, and how meaning is constructed) and in exploring such topics as private patronage or imperial propaganda and social policy that are only beginning to be mentioned in the texts.[1] The articles gathered in this volume can be used with any of the textbooks to expand a syllabus and provide more focused discussions on major monuments and the problems of interpretation.

The body of work that is known as Roman art has long been noted for its lack of unified or easily identifiable styles and content. Consequently, to define what is *Roman* about the art is to invite complications. The standard to which Roman art has been held is that of Greek art, with its more easily perceived stylistic coherence and its evolutionary scheme of development from the Archaic to the Hellenistic periods. In contrast, the art produced in any particular period in the Roman world varies widely in terms of its style, content, and craftsmanship: differences are apparent among state monuments in the capital that express divergent

messages from the same regime and among contemporary works from Rome and the provinces, as well as in works commissioned by patrons from the upper and lower social ranks. Even within the classicizing Augustan age, a period characterized by an obvious stylistic tendency, a range of Greek styles was evoked to express Augustus's mastery of the past and the present. What seems to define Roman art is a set of historical circumstances rooted in the experience of empire.[2]

The Romans' attitudes toward art are inextricably linked to the acquisition of empire, and I simply sketch a few of the distinguishing historical and political factors from Rome's legendary founding through the late Republic (from the eighth to the first centuries B.C.), the period that witnessed the growth of the city and expansion abroad. As Rome's hilltop settlements of shepherds and farmers gradually became urbanized in the eighth and seventh centuries B.C., the emerging city prospered because of its strategic location and the proximity of the Tiber river. Its position on the peninsula attracted interlopers such as the Etruscans, who took over the city in the late seventh century, ruled it for most of the sixth century, and transformed it with new buildings and religious institutions.[3] Technologically advanced and skilled at seafaring, the Etruscans traded bronze objects and utensils for painted pottery and other goods from the Greeks. Contact between Rome and Greece may have been accelerated through the intermediary of Etruscan trade, although Greek colonists were present in southern Italy and Sicily since the eighth century B.C. The influence of Greek art was strong but the Romans treated it as they did other foreign substances that they encountered: they absorbed it and made it serve their own interests.

According to tradition, the Romans reclaimed their city from Etruscan rule toward the end of the sixth century B.C. and established the Republic, which endured until the middle of the first century B.C. Power and wealth were concentrated at the top of society among the members of a narrow aristocracy. This group also formed the senate and the pool of candidates for the consulship, the office of annually elected coexecutives of the state, whose brief terms and joint appointments starkly contrasted those of Etruscan kings and Hellenistic monarchs (a situation that changed in the late Republic with Caesar and Pompey fighting for absolute control of Rome). Even as the cultural horizons of the senatorial elite broadened with increasing sophistication and cosmopolitanism (a byproduct of their urbanism and their contact with Greece), Romans clung to the myths of their rustic origins: the heroic tales of stern and pragmatic warriors who would lay down their arms after combat and simply return to their ploughs. Tradition shaped society and offered it stability: city-dwellers without titles or money flocked to the houses of great men for morning calls, the *salutatio,* in which they paid their respects and demonstrated their allegiances in return for gifts of money, invitations to dine, or other forms of assistance. These bonds between high and low, rich and poor, reinforced the status quo in a world that looked to the *mores maiorum,* the ways of the ancestors, for guidance.

Much of the Republic's resources were directed to military campaigns waged in order to conquer its neighbors, first on the Italian peninsula and then throughout the Mediterranean basin. Greek art flooded into Rome during the wars of

imperialist expansion, mainly in the second century B.C. and especially when Greece fell after the destruction of Corinth in 146 B.C. It was carted back to Rome as booty, and after arousing the crowd's curiosity when shown in triumphal processions, it was often displayed in temples and sequestered in the town houses or villas of the elite.

Roman acquisition of Greek art was a byproduct of conquest. The booty represented the power of the Romans as victors to take possession of the vanquished enemy's gods and wealth, in the form of votive statues and luxury goods. There were at least two reactions inspired by this counter-invasion of foreign art: on the one hand, the old guard condemned the fascination for things Greek as decadent displays of wealth and, on the other hand, the more progressive faction admired the achievements of the Greeks as the products of an older, superior culture. The archaeological record indicates that the latter position had popular appeal, and a flourishing art market that secured Greek originals for collectors and traded in copies implies that Greek art became a status symbol. By decorating a villa with Greek sculpture and artifacts, the owner could claim membership in an exclusive world of refinement, intellectual pursuits, and lofty aspirations. Competition among aristocrats for the possession of works of art fueled the process of Hellenization, and there was no denying the appeal of what Romans could now buy.[4] Yet, conservative attitudes toward the public utility of art and architecture as expressions of civic pride and achievement attempted to curb the permissive views that tolerated Greek imports, for example, the initially shocking nude portrait statues that honored Roman generals.[5]

These brief comments introduce the divisive character of the discourse on art and the extreme responses, either of suspicious scorn or acquisitive zeal, that were aroused by the arrival of gleaming bronze and marble figures on such a vast scale.[6] Later, during the Empire, the collector mentality dominated in the elite circles, yet it seems that it was possible for prosperous Romans of different ranks to commission art, if only in the form of a funerary plaque or portrait to commemorate the deceased. The diversity of Roman art is due, in part, to the prominence of the patron as an agent with his own cultural and political agenda. While the imperial court asserted political power with monumental art and architecture, the lower social strata also participated in the drive to display status, although in somewhat different directions.

A Roman's status was defined by a combination of factors: rank as determined by birth and wealth, the public perception of prestige through officeholding or other service to the state (or even through proximity to the powerful), and, finally, the absolute legal position as freeborn, freed (ex-slave), or enslaved. In such a society, the forum and other civic spaces in Rome provided backdrops for spectacles in which the elite made appearances and maintained the high visibility that designated privilege. Others—the citizens and masses at the bottom of the social hierarchy—took part in these events as spectators rather than players.

One group in particular, freedmen and freedwomen, participated fully in the drive to acquire status, as witnessed by the number of tombs and funerary sculpture commissioned for its members.[7] The ex-slaves manumitted to become Roman

citizens had ample reason to commemorate their status and, furthermore, the object of their ambitions would be their freeborn sons. In fact, it is these monuments that often provide the only record of individuals from the lower urban strata. Not content with an ostentatious tomb, the fictional Trimalchio, the proverbially successful freedman in Petronius's *Satyricon,* established that he *arrived* with ludicrous paintings in his house that documented his rise from slave (the slave market is complete with price tags and all) to estate steward, accompanied by Mercury, Minerva, and Fortuna (*Satyricon* 29). Trimalchio and his peers learned to manipulate the symbols and imagery that conferred status, even if their efforts occasionally achieved unintentional effects.

The differences attributed to the social status of the non-elite patron are only beginning to be considered in political and economic contexts. Without any significant interest in the private patron (as opposed to those with public or official roles, most importantly, the emperors), previous generations of scholars sought to explain the disparities of Roman art through its representation of space, its adoption of classical and non-classical standards, and its reliance on generic styles that characterize specific subjects (e.g., processions) or monument types (e.g., state reliefs).[8] Ranuccio Bianchi Bandinelli initiated the study of plebeian art by distinguishing formal elements such as a linear style of carving, a preference for frontality and hierarchic scale, and a symbolic representation of space.[9] While Bianchi Bandinelli and his students attempted to locate the origins of this style, others observed that elements of the style were ubiquitous: Lisa Vogel has proposed that many works of Roman art incorporate ''independent themes and systems,'' different generic styles or modes of representation from the polar extremes of the plebeian to the aristocratic styles, to convey meanings in counterpoint.[10] More recent studies have proven that Bianchi Bandinelli's definition was only preliminary, and that a range of styles was available to some patrons of the lower strata. In fact, it has become increasingly difficult to identify aristocratic or plebeian art on the basis of style alone (see the essays by Kleiner, Wood, D'Ambra, Kampen, and Leach in this volume). Studies of literature and epigraphy, demographics, popular religion and cults, family structure, and urban spatial patterns may provide the terms of discussion when the patron is unknown or absent from the historical record.

The question of gender deserves comment. The character of the patronage of Roman women tends to be more obscure because they usually depended on their fathers or husbands for their status and even for their identities. (For an account of a woman in public life whose civic accomplishments defied convention, see the essay by Boatwright.) Two works discussed in this volume (Figures 37 and 49; see the essays by D'Ambra and Kampen) that depict a woman in the guise of a goddess and another at work in her profession differ radically in subject and style, yet both works entail deeply ingrained social and moral imperatives that reveal the intersection of status and gender. While both reliefs adorned the facades of tombs, the former (Figure 37), from Rome in the late first or the early second century A.C. depicts the deceased, named Ulpia Epigone in the inscription, as Venus. The por-

trait head of Ulpia Epigone crowns a partially nude and physically resplendent figure reclining in a provocative pose. Its classicism reflects the court fashions through the portrait style and the modeling of the torso in depth. The latter work (Figure 49), from Ostia, the port of Rome, in the mid-second century A.C. depicts a midwife, probably the Scribonia Attice named in the inscription, actively engaged in her profession, attending a delivery. The scene on the terracotta relief shows a woman in labor, gripping the handles of the birthing chair, while an assistant steadies her from behind. The midwife, seated in front and reaching between the woman's legs, stares out at the viewer. The "simple and literal style" of the relief identifies the figures, whose forms are flattened in shape with rough features marked by deeply cut lines or gouges, by their actions (see Kampen's essay on style).

The midwife's relief gives the stark appearance of unmediated reality, that is, of a moment frozen in time, whereas the relief of Ulpia Epigone as Venus is one of studied elegance and aristocratic refinement. Yet, both Ulpia Epigone and Scribonia Attice were members of the lower urban strata who may have been freedwomen or descendants of them (the *cognomina* Epigone and Attice have Greek origins that are thought to connote a servile past although this is not definitive). In a world without the accolades of public office, titles, and fabled wealth, these women were not invisible: the midwife performed vital services for her community, and both the midwife and Ulpia Epigone's family accumulated enough resources to build tombs and commission art that perpetuated their memories. The epitaph on the midwife's tomb indicates that Scribonia Attice erected the tomb for herself, her physician husband (he is also commemorated with a relief depicting his profession), and her mother.[11]

Lacking the narrative detail and local color of the midwife's relief, the image of Ulpia Epigone seems rather formal, cold, and distant. It casts her as an exemplary woman through her possession of Venus's graceful body and the attributes of the faithful dog and the woolbasket at her feet. As a deity prominent in the imperial propaganda, Venus also offered venerable associations to those who were upwardly socially mobile. The costly marble, the craftsmanship, and the fashionable character of the mythological portrait of Ulpia Epigone suggest that her family was considerably well-off (probably more prosperous than the midwife) and, perhaps, all the more anxious to establish a secure social position. If Epigone or her relatives were in the service of the imperial court in Rome, then adopting the cultural language of aristocratic society was one way to assert that they *belonged*, to conceal their insecurities about their background or origins.

The works commissioned by non-elite patrons did not conform to any one standard, and gradations of status within the lower urban strata probably affected the selection of style and subject for the reliefs of the midwife and Ulpia Egione. Yet a question remains to be answered: what is the role of gender in these representations? In the mythological portrait Ulpia Epigone borrows Venus's charms to enhance her femininity: she is defined as bride, wife, a woman whose sexuality has ripened and whose body is fruitful.

Although the midwife clearly demonstrates pride in her profession through her straightforward and literal image, the relief differs from those that depict male physicians. Whereas male doctors are shown as divine healers, philosophers, or experts with the tools of the trade (see Kampen), the midwife's skills are portrayed through gesture to indicate that her ability to provide care and comfort to her patients defines her role. The intimate nature of the profession also gave rise to popular superstitions about the midwife's powers because her knowledge of family secrets and her supervision of an act fraught with anxiety and danger made others fear and distrust her. The relief depicts the midwife in a strategic position, literally and figuratively. The image, like that of Ulpia Epigone, is mediated by ideology, popular beliefs, and superstitions.[12]

The essays in this volume focus on patrons, both public and private, who commissioned works of art that enhanced or magnified their civic identities. In his groundbreaking article on portraiture, Sheldon Nodelman observes that the realistic representations of older men in the late Republic all look very much alike and are, in fact, a type. The standard features of the portraits of balding and wrinkled senators are ''a set of conventions dictated by ideological motives'' to express the traditional values of the conservative nobility at the end of the Republic. Nodelman also attributes the psychological depth and emotional presence of later portraits to the self-conscious attitude of the Roman subject—the portrait is aware of the viewer's gaze. A portrait is a political work that imposes the subject's identity and commanding sense of presence on the viewer (the tangible and familiar features of the face can also be seen as an abstract system of signs).

The next three articles cover major monuments of Augustan art. Both Diana E. E. Kleiner and Charles Brian Rose question the role of the children represented on the friezes of the Ara Pacis, while Barbara Kellum delineates the mythological themes represented in the sculpture of the Temple of Apollo on the Palatine. The notion of a thematic program is a concern shared by these authors. Although Kleiner and Rose agree that the depiction of children on the Ara Pacis is significant for imperial policy, they differ in emphasis: Kleiner concludes that the children are present to cast the imperial family as a model and to encourage the social reforms promoted by Augustus in his marriage legislation; Rose identifies the children and defines their role in dynastic politics and foreign policy.

Kellum considers how Greek myths can convey specific political meanings. The Temple of Apollo on the Palatine marked the victory of Augustus and the new era of peace and prosperity. A victory monument usually depicts battles and the defeated, or refers to them in mythological guise, but because the conflict between Augustus and Marc Antony was a civil war, it was better not to portray the blood and anguish of Romans fighting Romans, and difficult to find a suitable mythological analogue. The problem was resolved by an ingenious program from Greek mythology that appropriated significant motifs and styles to commemorate Apollo's role as defender of the Roman world and expiator of the crimes of conflict.

Susan Wood also discusses the depiction of a Greek myth but in the context of funerary art, specifically sarcophagi, commissioned by private citizens. The sarcophagus in question was commissioned by an official of the carpenters' guild

in Ostia for both himself and his wife. It depicts the myth of Alcestis, and Wood examines the meanings of the myth for evidence of the beliefs and aspirations of the married couple, who participated in the cult of Magna Mater. The symbolism of the mythological scene is drawn from Roman wedding ritual or the more abstract depictions of imperial virtues. Her postscript considers the social motivations of the patron, among other topics.

Both Natalie Boymel Kampen's and my own essay weigh the roles of the social status and gender of patrons who are commemorated by funerary reliefs placed on the facades of tombs (many of these are extant in Ostia as well as in the northern provinces). As mentioned above, I offer an interpretation of a relief depicting Ulpia Epigone, perhaps a freedwoman, who is represented as Venus. The mythological allusion is absent in the reliefs discussed by Kampen that represent the occupations of male and female vendors similarly, although in depictions of more highly respected professionals and artisans the classical elements are distributed unequally between men and women. Often women's participation in crafts or trades is veiled by idealizing allegorical depictions. On one hand, the relief of Ulpia Epigone in mythological disguise reveals a dependence on court models while, on the other hand, the reliefs of lowly salespeople appear to be of a world apart, where the deceased was unaffected by elite ideology and need not be ashamed of working for a living.

Eleanor Winsor Leach takes on the subject of wall painting from the point of view of patronage. In her opinion, the stylistic changes from the second to the third styles were promoted by competition among painting workshops for patrons, the owners of town houses and villas who sought ever more opulent and sumptuous decoration by imitating the architecture and painted interiors of the establishments of their social superiors. The rituals of dining and hospitality were staged amidst settings that were redolent of privilege and prestige.

Both Miranda Marvin and Mary T. Boatwright are interested in sculpture in architectural settings, although Marvin's emphasis is on the sculpture, while Boatwright concentrates on the architecture. Marvin analyzes the letters of Cicero instructing his agents to buy sculpture in Athens for the gymnasium of his villa. She concludes that the sculpture was selected according to its appropriateness to the location it would adorn and to evoke the atmosphere of the place. Marvin also points out that the sculpture's role in decorating architecture, usually public buildings that required great numbers of thematically consistent statues, encouraged the practice of making replicas of famous works.

Boatwright's essay investigates women's patronage of architecture in the eastern provinces with its study of the City Gate of Plancia Magna in Perge, located in Roman Turkey. The architectural form of the gate and courtyard has much in common with the other buildings erected in the Marble Style of the first and second centuries A.C., but the sculpture that accompanied it indicates the scope of Plancia Magna's ambitions in her dedications to the city's mythological founders and her family. Boatwright also considers the inscriptions found at the site to suggest the role that Plancia Magna played as a benefactress to her city.

Finally, Yvon Thébert's essay is an excerpt from a longer work that treats domestic architecture in Roman north Africa. Like Boatwright's study, it examines developments in the provinces. Thébert begins by citing Vitruvius's statement that there is a connection between the floor plan of a house and the social status of its owner. He defines what was considered *public* and *private* in the light of ancient social practices and draws on evidence from architecture in north Africa and Italy, contemporary literature, and mosaics. He guides us through an elaborate town house by describing the function of the spaces and indicating how these were enhanced by the room's decoration.

Although these essays differ substantially from each other in method and approach, they share an interest in the motivations of the patron, whether Augustus, Plancia Magna, or an anonymous shopkeeper. The works of art produced for them were shaped by their specific requirements, ranging in scope from recasting the events of history to perpetuating the memory of folk who lived simply and worked at a trade. It is remarkable that artists kept up with the demand and invented or appropriated a wealth of imagery to suit their clients. The Roman artist is less visible in this process than the patron, who fulfilled desires for monumental glorification or for representation that marked his or her participation, however modest, in a society driven by spectacular displays.[13]

NOTES

1. For example, Nancy H. Ramage and Andrew Ramage, *Roman Art: Romulus to Constantine* (Englewood Cliffs, N.J.: Prentice Hall, 1991), p. 94; Diana E.E. Kleiner, *Roman Sculpture* (New Haven and London: Yale University Press, 1992); Niels Hannestad, *Roman Art and Imperial Policy* (Jutland Archaeological Society Publications 19, Aarhus University Press, 1986). To a lesser extent, Roger Ling, *Roman Painting* (Cambridge and New York: Cambridge University Press, 1991). Although my *Private Lives, Imperial Virtues: The Frieze of the Forum Transitorium in Rome* (Princeton, N.J.: Princeton University Press, 1993) is not a textbook, it considers the representation of a myth—the punishment of Arachne flanked by scenes of women weaving—in the context of imperial policy.

2. Otto Brendel, *Prolegomena to the Study of Roman Art* (New Haven and London: Yale University Press, 1979), p. 129.

3. See Larissa Bonfante, "Recent Books from Italy on the Etruscans," *American Journal of Archaeology* 95 (1991): 157–64, for bibliography. David Ridgway and Francesca Ridgway, eds., *Italy Before the Romans: The Iron Age, Orientalizing and Etruscan Periods* (New York: Academic Press, 1979); and Ellen Macnamara, *The Etruscans* (Cambridge: Harvard University Press, 1991).

4. Bernard Andreae, *The Art of Rome*, trans. R.E. Wolf (New York: Harry N. Abrams, 1977), pp. 36–47, for a general account. Also, C.C. van Essen, "Literary Evidence for the Beginnings of Roman Art," *Journal of Roman Studies* 24 (1934): 154–62; G. Zinserling, "Studien zu den Historiendarstellungen der römischen Republik," *Wissenschaftliche Zeitschrift der Friedrich-Schiller-Universität* (Jena 1960): 403–48; T. Hölscher, "Geschichtsauffassung in römischer Repräsentationskunst," *Jahrbuch des Deutschen Archäologischen Instituts* 95 (1980): 265–321. Mary Beard and Michael Crawford, *Rome in the Late Republic* (Ithaca: Cornell University Press, 1985), p. 14.

5. Filippo Coarelli, "Classe dirigente romana e arti figurativi," *Dialoghi di Archeologia* 2–3 (1970–71): 241–65. J. D'Arms, *The Romans on the Bay of Naples: A Social and Cultural Study of the Villas and Their Owners from 150 B.C. to A.D. 400* (Cambridge: Harvard University Press, 1970).

P. Zanker, *The Power of Images in the Age of Augustus,* trans. A. Shapiro (Ann Arbor: The University of Michigan Press, 1988), pp. 11–31. H. Mielsch, *Die römische Villa: Architektur und Lebensform* (Munich 1987).

6. See Elaine K. Gazda, ed., *Roman Art in the Private Sphere: New Perspectives on the Architecture and Decor of the Domus, Villa, and Insula* (Ann Arbor: The University of Michigan Press, 1991). See Natalie Boymel Kampen's review in *Art Bulletin* 74 (1992): 327–29, and Eleanor Winsor Leach's "Reading Signs of Status: Recent Books on Roman Art in the Domestic Sphere," *American Journal of Archaeology* 96 (1992): 551–57.

7. Diana E.E. Kleiner, *Roman Group Portraiture: The Funerary Reliefs of the Late Republic and the Early Empire* (New York and London: Garland Publishing, 1977), pp. 13–19. Paul Zanker, "Grabreliefs römischer Freigelassener," *Jahrbuch des Deutschen Archäologishen Instituts* 90 (1975): 267–315.

8. See Brendel for summary and bibliography (supra n. 2), pp. 122–37.

9. Ranuccio Bianchi Bandinelli, "Arte plebea," *Dialoghi di archeologia* 1 (1967): 7–19.

10. Ranuccio Bianchi Bandinelli et al., *Sculture municipali dell'area sabellica tra l'età di Cesare e quello di Nerone, Studi miscellanei. Seminario di archeologia e storia dell'arte greca e romana dell'Università di Roma* 10 (1963–64). Bianca Maria Felletti Maj, *La tradizione italica nell'arte romana* (*Archaeologica* 3, Rome 1977). Lisa Vogel, "Flexibility versus Formalism," *Art Journal* 27 (1968): 271–78 (I thank Sheldon Nodelman for this reference).

11. H. Thylander, *Inscriptions du port d'Ostie* (Lund 1952), pp. 162–63. Guido Calza, *La necropoli del Porto di Roma nell'Isola Sacra* (Rome 1940), pp. 248–49. Natalie Kampen, *Image and Status: Roman Working Women in Ostia* (Berlin: Gebr. Mann Verlag, 1981), pp. 69–72, cat. no. 6.

12. Eve D'Ambra, "*Ars Plebis:* Popular Patronage in the Roman Empire," lecture given at the Annual Meeting of the College Art Association in New York City in 1990.

13. J.M.C. Toynbee, *Some Notes on Artists in the Roman World, Coll. Latomus,* vol. 6 (Brussels 1951). For literary sources, see J.J. Pollitt, *The Art of Rome c. 753 B.C.–A.D. 337: Sources and Documents* (Englewood Cliffs, N.J.: Prentice Hall, 1966; reissued by Cambridge University Press, 1983). Little is known about the imperial workshops.

How to Read a Roman Portrait

SHELDON NODELMAN

Like all works of art, the portrait is a system of signs; it is often an ideogram of "public" meanings condensed into the image of a human face. Roman portrait sculpture from the Republic through the late Empire—the second century B.C. to the sixth A.D.—constitutes what is surely the most remarkable body of portrait art ever created. Its shifting montage of abstractions from human appearance and character forms a language in which the history of a whole society can be read.

Beginning in the first century B.C., Roman artists invented a new kind of portraiture, as unlike that of the great tradition of Greek Hellenistic art (whence the Romans had ultimately derived the idea of portraiture itself and a highly developed vocabulary of formal devices for its realization) as it was unlike that of their own previous Italo-Hellenistic local tradition. This new conception, conferring upon the portrait an unprecedented capacity to articulate and project the interior processes of human experience, made possible the achievement in the ensuing six centuries of what is surely the most extraordinary body of portrait art ever created, and forms the indispensable basis for the whole of the later European portrait tradition, from its rebirth in the 13th and 14th centuries to its virtual extinction in the 20th. No clear account of the nature of this reformulation of the structure of representation or of its historical significance has so far been given.

Reprinted with permission from *Art in America* 63 (Jan/Feb 1975): 26–33.

That the portraiture which it engendered is strikingly "realistic" in the sense of evoking the presence of an astonishingly concrete and specific individuality, to a degree previously unknown and rarely equalled since, has been the universal experience of every observer. But this question-begging term (first used to characterize Roman portraiture, in opposition to the "idealism" imputed to the Greeks, three quarters of a century ago by Franz Wickhoff, at the inception of modern critical studies of Roman art and not yet effectively superseded in modern scholarship) tells us nothing of the specific nature of the innovations responsible for this effect. Indeed, aside from the inadequacy in principle of such a term as applied to works of art, it seems particularly inappropriate to a form of portraiture such as the Roman, in which, as can easily be shown, abstract and conventional elements play so large a part.

In some important respects Roman portraiture, like Roman art in general, can fairly be described as a system of signs. Both the idea of deliberate address to the spectator with the aim of arresting his attention, and the intent to convey a message, a meaning, are contained in the Latin word *signum,* one of the commonest terms used to designate an iconic statue. The will to reach out actively into the world of on-going life and to accomplish specific purposes within it through psychological modifications imposed upon the observer is the central organizational principle of Roman art, notable, for example, in the condensed and forceful propagandistic language of the imperial reliefs and in the elaborate manipulation of the spectator's movements through spatial pressures in architecture.

Since the dominant function of the monumental portrait in Roman antiquity was the public commemoration of civic distinction, it is natural to search the realm of contemporaneous political and social ideas for themes which may enter into the context of particular portrait modes. These are regularly to be found. In this regard it is instructive to consider the so-called "veristic" portraiture of the first century B.C., in which, in fact, the new portrait conception makes its premier appearance, and which is usually considered both quintessentially Roman as a social expression and as the example *par excellence* of Roman "realism." This class consists exclusively of portraits of men in later life, often balding and toothless, upon whose faces the creases, wrinkles and blemishes inflicted by life upon aging flesh are prominently and harshly displayed with a kind of clinical exactitude which has aptly been called "cartographic." The insistent presentation of unflattering physiognomic irregularities, apparently, from their diversity, highly individualized, extends also to the representation of emotional states: the expressions of these faces are without exception grim, haggard and ungenerous, twisted by fixed muscular contractions. The emphasis accorded these contingencies of physiognomy and the resolute refusal of any concession to our—or, so it would appear, antiquity's—ideas of desirable physical appearance lead one easily to the conclusion that these portraits are uncompromising attempts to transcribe into plastic form the reality of what is seen, innocent of any "idealization" or programmatic bias. These are the portraits of the conservative nobility (and of their middle-class emulators) during the death-agonies of the Roman republic. There is no need to

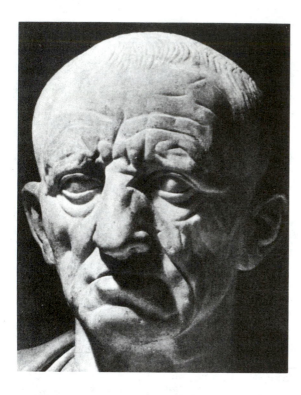

FIGURE 1 Unknown Republican (nose restored), First Century B.C., Marble *(Torlonia Museum, Rome)*

doubt that much of their character refers to quite real qualities of their subjects. These are men in later life because the carefully prescribed ladder of public office normally allowed those who followed it to attain only gradually and after many years to such eminence as would allow the signal honor of a public statue. One may well suppose that these hard-bitten and rather unimaginative faces closely reflect the prevailing temperament of the class and society to which they belong, and the twisted and pained expressions surely testify in similar fashion to the terrible emotional strains of a society torn apart in the chaos of civil war.

Nevertheless, a moment's reflection upon veristic portraits as a class reveals such an insistent pattern of recurrence in the selection and handling of particular physical and characterological traits that all these apparently so individualized portraits finally look very much alike, and it becomes clear that we are dealing with a conventional type, whose properties are dictated by ideological motives and—given the political function of the portrait statue—by the intent to convey a clearly drawn and forceful polemical content.

The nature of this content becomes clear as soon as the context of meanings available in the wider range of contemporary portraiture is examined. Through emphasis on the marks of age, these men call attention to their long service to the state and their faithfulness to constitutional procedures, in intended contrast to the meteoric careers and dubious methods of the individualistic faction-leaders—men

like Marius and Sulla, Pompey and Caesar, later Antony and Octavian—whose ambitions and rivalries in the quest for personal power were rending the fabric of the republic. The portraits of these *duces,* when we can identify them, betray rather different tendencies than do those of the veristic group, drawing heavily upon Hellenistic elements for the dramatization of their personalities and the suggestion of a godlike superiority to circumstance. The seeming frankness and air of indifference with which the subjects of the veristic portraiture acknowledge—or, rather, proclaim—their physical ugliness is surely a defiant and formalized response to the propagandistic glamorization of physiognomy and character in the portraits of the quarrelling war-lords whose aspiration toward personalized, tyrannical power and brutal disregard of traditional constraints were scandalous affronts to inherited values. Against the portraits of the *duces,* the verist portrait asserts a self-conscious pride in down-to-earth pragmatism, an absence of illusions, a contempt for vanity and pretense. The grim restraint which twists these features and the harsh suppression of feeling stand in programmatic contrast to the emotional pathos, the exaltation of spontaneity which had illuminated Hellenistic royal portraiture and which the *duces* had in modified form incorporated into their own images. It is not individuality, imagination and daring which are celebrated here but stern self-discipline, shrewd calculation, unbending resolution, unquestioning

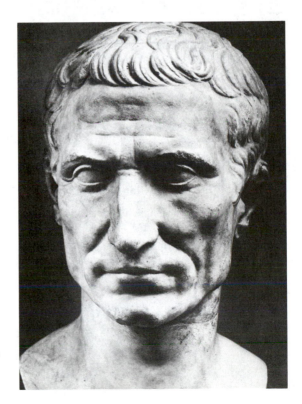

FIGURE 2 Julius Caesar, c. 40 B.C., Marble *(Vatican Museums, Rome: photo courtesy of German Archaeological Institute, Rome, neg. no. 34.108)*

acceptance of social bonds, painstaking conformity to those ancestrally sanctioned rules of conduct which the Romans called the *mos maiorum*.

The binding durability of this catalogue of old-Roman virtues of *gravitas, dignitas, fides,* which were the pride of the conservative aristocracy, may be read already, though without the defiant exaggeration of last-ditch resistance of a century later, in the stern features of one of the few surviving portraits of a Roman nobleman of an earlier age, the famed bronze of the second century B.C. known as the *Capitoline Brutus.* In the light of a work such as this, the "realism" of the veristic portrait is revealed for what it is: a set of conventions dictated by ideological motives—a highly selective assemblage of abstractions from suitable aspects of human appearance and character into an interpretative ideogram.

In the veristic portraiture of the first century B.C., the new image-structure which will determine the operations of the Roman portrait as a mode of communication and which will be immensely enriched and developed over several centuries, is clearly evident. Such an image is not an indissoluble nexus of mutually referential properties conceived on the model of a natural organism and presenting itself as a self-contained and self-justifying totality, as had been the images of the

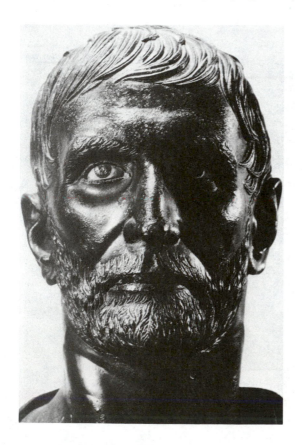

FIGURE 3 Capitoline Brutus, Second Century B.C., Bronze *(Palazzo dei Conservatori, Rome)*

Greeks. Rather it is a system of formalized conventional references whose specific content and polemical point are defined positively by the evocation of desired associations, and negatively by implied contrast with other images bearing an opposed content. Since the Roman viewer had necessarily, if perhaps only half-consciously, to recognize these references as such, their mutual independence as preconceived units of meaning had to be at least subliminally discernible within the overall context of the image, whose show of organic coherence after the Greek model could only be a superficial one and which effectively resembled more closely a collage, or better (in Eisenstein's sense) a montage.

Condensed into the image of a human face, these components are so fused as to be isolatable by the modern spectator only with a certain analytical effort. But an identical system of construction out of pre-existent and independently meaningful parts can be more easily seen in complete figures, such as the well-known statue of Augustus from Prima Porta. A body-type derived from the Doryphoros of Polykleitos and exploiting rhetorically the noble equilibration of its pose is juxtaposed to a right arm quite independently conceived, whose gesture of address, possessed of a well-established meaning in Roman society, is lent a compelling

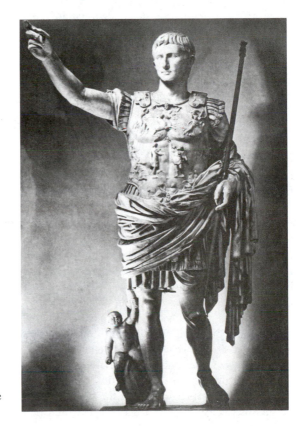

FIGURE 4 Augustus from Prima Porta, c. A.D. 14, Marble
(Vatican Museums, Rome)

emphasis through its abrupt breakage of the overall rhythm of the stance. The military costume, specifying the role of Augustus as *imperator* or commander and implicitly invoking the charisma of his martial successes as justification of his authority, is itself formalized into a separable unit of meaning rather than conceived as a simple fact, being, as it is, qualified or relativized by the noticeable omission of the boots which would normally complete it. The bare feet, forced to our attention by what would in a real-life context be their incongruity, are here a clear reference to the ideal nudity of heroic statues, and they inform us that the event represented takes place on a higher-than-mundane plane. The motives for this quasi-divinization are explained to us: first, in the reliefs which ornament the breastplate, illustrating against a cosmic panorama what Augustus sought to advertise as the crowning political success of his career, the return of the standards from Parthia (emblematically representing both a restoration of the natural order of things after the chaos of the civil wars and the elevation of Rome to a position of universal sovereignty); and second, by the little figure of a dolphin-riding Cupid, serving as a support beside the right leg, which reminds the viewer of Augustus' divine descent from Venus through Aeneas and hence of his inborn claim to rule over Aeneas' posterity, the Roman people.

At the magnified scale of this statue, both the conceptual independence of the components and their encoding through calculated juxtapositions and superimpositions into a single system of meaning are obvious enough. Such an image manifestly exists not for itself, but for the spectator whose active intellectual cooperation is demanded and in whose synthetic mental act the image attains its unity and significance. Its status among other images, like that of its components among one another, is not so much inherent as positional—in a wider range of reference like individual words within a semantic field.

In Augustus' portrait head itself—as we see it in the Prima Porta statue—the iconographic system already posited in veristic portraiture reaches an astonishing richness and complexity of meaning. The godlike youthfulness of the face (as Caesar's heir, Augustus had seized a position at the center of Rome's political life, in defiance of the usual norms, at the age of 18, but his portraits retain youthful features through the rest of his long life) stands in deliberate and striking contrast to the tired and wizened faces of the old-school politicians whom the veristic style represents for us. Those exhausted faces, whose muscular spasms reflect the tangle of encumbering circumstances in which they were enmeshed, convey only hopelessness; by contrast, the new image of Augustus offers the freshness and boundless possibilities of youth, the freedom to make the world anew. Against their gazes blank with despair or sunken in bitter defiance, that of Augustus is brilliant and piercing, full of intellectual power; far-seeing, his face comprehends and dominates the *orbis terrarum* and the vast horizons of time and history. His electrical gaze, through which the force of the personality is poured out, is a device borrowed from Hellenistic royal portraiture where it had denoted the heroized, superhuman stature of the kings. But Augustus was too astute to attempt (as his unsuccessful predecessors, the would-be dynasts of the late republic, had

to some degree done) to impose the formulae of Hellenistic portraiture with its emotional pathos, its exaltation of individual personality and will, upon a Roman public which reacted to such associations with deep resentment and distrust. Instead, the dominating gaze is incorporated into a facial mimetics which reflects—in the same traditional way as that of the *Capitoline Brutus*—the old-Roman virtues of rigorous self-control and implicit acceptance of the binding force of social order. (When Greek sculptors in the East had occasion to copy Augustus' portrait, they rarely failed to restore to it, in conformity with their concept of royal representation, the dramatic emotionalism which he had so carefully purged.) Integrating all is the neo-classic style of the head, with its broad, clear planes and severely contrasted verticals and horizontals, whose harmony, balance and Apollonian intellectual order proclaim the animating principles of the new universal order which Augustus has miraculously brought to a tormented world. Here style, too, is reified into a separable meaning-unit (for it is not of course the style of the Classical age in its integral reality but a calculated reminiscence of it superimposed upon an underlying and profoundly different contemporary formal structure) which is invoked not only for its inherent expressive content but also for its associative value as emblematic of what was now revered as a past golden age—that of the Athens of Pericles—whose luster might appropriately be borrowed to clothe the new.

The extraordinary synthesis of meanings accomplished in the portrait of Augustus, precisely calculated with reference to the play of contemporary hopes, passions and exigencies, made this work a political icon of matchless cogency and density of content. Once achieved, it immediately became itself a defined and available unit of meaning within the expanding referential system of Roman portrait iconography. Augustus' immediate successors illustrated their claim to authority by carefully approximating their portraits in style and format to his, while attempting as well to inflect the inherited system in terms of their own diverse ideological leanings and their perceptions of political necessity. The last of them, Nero, in the Hellenistically tinged pathos and romantically sinister personalism which, straining the Augustan format to its breaking point, he reintroduced into his portrait, announced only too clearly the incompatibility of his political program and conception of rulership with the traditionalist values and self-interest of the ruling class; his assassination and with it the end of the Julian dynasty were foregone conclusions.

It was against this background of peer-group resentment toward the dynastic pretensions of the Julian family, as expressed by the elegant neo-classicism of their portraiture, with its exalted and superior tone, that the portrait of Nero's ultimate successor, Vespasian, is to be understood. Here in modified and updated form (incorporating, indeed, Augustan elements), the veristic portrait style is reintroduced at the center of power as the visible expression of new attitudes of businesslike sobriety and republican-flavored traditionalist virtues. Now the veristic style itself is no longer a spontaneous expression but has been abstracted and reified into an independently manipulable variable in the expanding referential system. It is

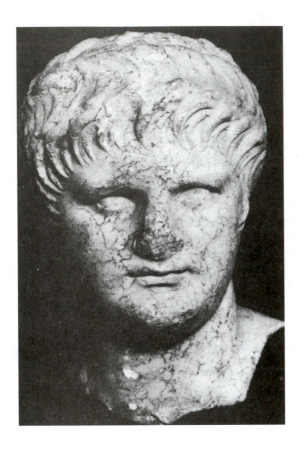

FIGURE 5 Nero, c. A.D. 60,
Marble *(Worcester Art Museum,
Worcester, Massachusetts)*

unnecessary here to relate how this system was amplified with new meanings and
new techniques of reference in kaleidoscopic interchange by the emperors of the
second and third centuries beginning with Trajan, or how Gallienus in the third
century and Constantine and his successors in the fourth reinvoked as sanction for
their programs of renovation the memory of the portrait of Augustus. It is clear
that such a system of portraiture, combining and recombining ideologically signif-
icant references into an abstract meaning-structure cannot adequately be encom-
passed by the concept of realism.

A more suitable name can indeed be found for the kind of portraiture devel-
oped by the Romans. Like the imperial commemorative (so-called "historical")
reliefs, like the mythological sarcophagi of the second and third centuries and, as
has been persuasively argued, like the mythological painting-cycles of Pompeii
and Herculaneum, the content of the Roman portrait is allegorically structured.
Despite their elaborately staged effect of multifarious variety and freely unfolding
action, each imperial relief is organized around a theme drawn from a rather lim-
ited repertory of recurrent, ideologically significant actions whose condensed ges-
tural expression forms the immediately recognizable armature of the composition.

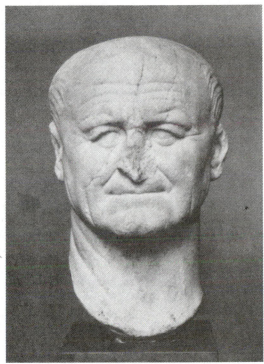

[handwritten marginal notes, partially illegible]

FIGURE 6 Vespasian, c. A.D.
70, Marble *(Ny Carlsberg
Glyptotek, Copenhagen).*

Whatever particular occasion may be commemorated in these scenes, their essential content is of another and more general order. Each of them illustrates in typical form one quality from the canon of imperial virtues: *pietas* in the scenes of sacrifice, *clementia* in the scenes of pardon extended to supplicating barbarians, *virtus* in the scenes of military conquest, *concordia* in the scenes of address and counsel. It is on these and similar qualities that the emperor's fitness to govern the state and hence his claim to rule are based. The contingent action is no more than the outer hull of a moral content which is its effective meaning, and this meaning in turn is directly relevant to, and directly addressed to, the spectator in his concrete historical circumstances.

In the same fashion the contingencies of individual physiognomy which are rendered with such liveliness and piquancy serve to rivet the spectator's attention through a sense of the immediacy of represented action, but in fact they are only the setting for the formalized reiteration of ideologically significant traits of character as they can be read in certain conventions of facial mimesis and, to a larger extent, as they can be personified through attributes (as, e.g., styles of wearing the hair and beard). It is this ethical content which constitutes the effective meaning of the portrait and justifies the claim to status which the portrait statue by its very existence asserts. As in the medieval art which succeeded and indeed derived from it, so already in Roman art the realm of value does not so much inhere in imme-

diate life as transcend it, becoming a moral realm accessible only indirectly
through the senses and appealing essentially to the eye of the intellect.

All of this has had to be stated to provide the context without which the Roman
portrait cannot be understood. But none of it explains that strange quality of pres-
ence, of contact with the inner essence of a man which imbues the Roman portrait
with its unique power to engage and move the spectator. Compared to a portrait
conceived in the new Roman system, even such an accomplished masterpiece of
late Hellenistic portrait art as the bronze head from Delos (now in the National
Museum, Athens), with all of its quivering emotion and acutely registered involve-
ment in the experience of the moment, seems somehow remote, unreal. We
behold, admiringly, an intense pathos, but we are untouched by it. The events
narrated in a Greek portrait exist in an objectified, self-enclosed capsule of narra-
tive time, a dramatic unity from which the spectator within his own time of ongo-
ing events is excluded. For the subject of a Greek portrait, the spectator does not
exist; totally absorbed in his own world, unconscious of being observed, he gives
himself over spontaneously and without reserve to his action and feeling. The man
and his situation are one; their seamless completeness is that of mythic time.

By contrast, the formalized gestures and self-consciously assumed attitude of
a Roman portrait statue, and the equally self-conscious composure, or constrained

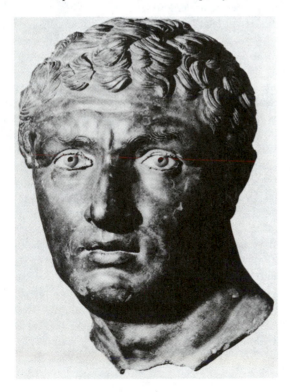

FIGURE 7 Late Hellenistic
Head from Delos, c. 100 B.C.,
Bronze *(National Museum, Athens)*

emotion of a Roman face, reflect an acute awareness of the spectator; indeed, they are intended on the spectator's behalf. For the first time in the history of art, the subject of the portrait reflects an awareness of being portrayed; the Roman's gaze is directed upon the spectator (or, if it is averted into private thought, we feel this as only a transient and incomplete withdrawal), and he feels in turn, as we can read in his expression, the gaze of the spectator upon him. The capsule is broken open: the narrative time of the portrait subject is now the ongoing real time of the spectator, and the space between them the charged one of confrontation.

The openness of the Roman portrait to the world of the viewer is accomplished not only on the representational level of psychological mimesis but on the more abstract level of formal construction as well. The powerful rhythmic unity which binds all the forms of the Greek head together refers them exclusively to one another and to their ideal center, just as on the narrative level the avowed completeness and self-sufficiency of their interplay excludes any admission of outside factors and hence any recognition of the spectator and his world. In a Roman portrait, this closed rhythmic system is disrupted. The individual component forms are perceived more independently; separately, they are well-suited to accommodate, on the representational level, a corresponding variety of characteristic and sharply individualized physiognomic detail. It should be emphasized that it is not the mere presence of such "realistic" details which helps to confer upon the Roman portrait its strikingly life-like effect; for they had already been profusely employed in Hellenistic portraiture. Rather, this effect is attained through the emphatic and discordant contrasts which these details are enabled to assert among themselves owing to their emancipation from an immediately perceptible and all-dominating principle of formal unity. The final unity of the form, no longer immediately evident, must be sought for and grasped across an interval by an intellectual effort of the spectator. The multiple and conflicting directions of the parts thus acquire something of the character of contingent events taking place not in a self-proclaimed and exclusive microcosm but directly in the spectator's world of ongoing and uncertain actions. The image which results from the concatenation of these events comes to be infused with some of the liveliness, unpredictability and immediacy which characterize entities existing concretely in that world. And inasmuch as the unifying form of that image, urgently sought for by the mind, must be attained to through the screen of contingent, localized forms, our attention is drawn *through* them toward an as yet invisible depth, toward a truth which is not so much within visible things as forever beyond them.

This perceptual depth is paralleled by a new psychic depth in the representation of character. The emotional states represented so forcefully and with such keen observation in Hellenistic portraiture are wholly consistent, homogeneous ones—distilled categories of feeling. Their diffusion in the narrative complexities of the muscular action do not contrast real possibilities of conflicting feeling but, rather, illustrate a single impulse in a faceted variety of phases and conditions. As against this monumentalized, unapproachable purity of feeling, the consciousness of the subject in Roman portraits is a divided one; the motions of the psyche, we

feel, enact a real conflict that takes place before us—indeed, in some degree with regard to us. In the emotional play of the facial musculature, there may be separated two independent levels which mutually define, qualify and undercut one another. One is the assumed mask of the persona, the self-conscious set of the face composed by one who is aware of being observed and who wishes to make the proper impression, implicitly acknowledging as he does so the constraint of the social world of conventional attitudes and values which, though invisible, surrounds the subject of the portrait and embraces him in its order, as it does also the spectator. In the Greek portrait we perceive in the subject something of the magnificent independence of the wild beast: a man is what he is; in the Roman, we are aware of a complicity, a secret pact solicited by the subject which enmeshes us in a tissue of reciprocal obligations. To the social world, defined as external, there must correspond the interior world of private experience, and this second level too is visible in the Roman portrait, in the involuntary, hence spontaneous, twitching of the smaller muscles that is revelatory of quite other feelings than those affirmed by the official mask, and in the distorted inflection of that mask itself. A mindscape of shifting feelings, memories and hopes is thus projected through the subtle displacements and reciprocal tensions of the mobile elements of the physiognomy; doubts, anxieties, hesitations are sometimes writ large in the play

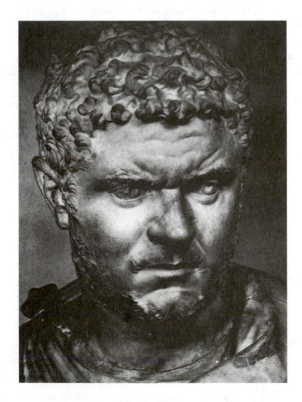

FIGURE 8 Caracalla, c. A.D. 212, Marble *(Louvre, Paris)*

of strong emotion, sometimes elusive and hardly registered as nameable events. Greek portraits betray no such *arrière-pensées*. This double-layered system of facial mimetics—the act of willful self-presentation and the action of the inner world glimpsed behind it—invests the psychological content of the portrait with new and unparalleled depths. Aware as we are now of the variety, the elusiveness, the contradictoriness of the multiple inner feelings, we are lured into the interior of the represented psyche, probing its recesses with imaginative empathy and hanging expectantly upon the course of the inner struggle. These feelings, their impact quickened in mutual interplay, become real for us through our participation and confer upon the image an astounding concreteness of psychic presence and emotional richness. Recognizing as we do the signs of the pressure of our own gaze upon the portrait subject, we are engaged with it, for the first time in the history of art, in mutual and overt psychic interaction within a shared intersubjective space.

The two layers of feeling, reflected and spontaneous, do not, however, exhaust the psychic depth of the Roman portrait image. They are mutually contradictory: one wills a conscious act which is not spontaneously desired; the other spontaneously dissents, yet the act is carried out. A third term standing above these troubled feelings is needed to reconcile and unify the divided psyche. It is for this deep-lying ultimate center of selfhood that we are drawn to seek as we strive to comprehend the humanity with which we are confronted, and it is this which ultimately confers upon the portrait its unprecedented and ineffable quality of *presence*. In the interplay of the mimetic representation each muscular motion qualifies, subverts or contradicts the other, emphasizing their mutual relativity and contingency. The key to the absolute unity of the person cannot be found among them. A physiognomic element fit to represent it would have to be unqualifiable, nonrelative. In Roman portraits it is the gaze of the eyes which, surrounded by muscular movements reflecting changing affective states but itself fundamentally unconditioned by them, visibly incarnating the attention, the focused awareness, of the subject, responding more directly and swiftly to inner promptings than any other organ—it is the gaze which assumes the role of expressing the final inwardness, the human essence. Greek portraits too had built the gaze as the dramatic focus of the personality, but there it was necessarily bound in to the comprehensive rhythm, to the systematic orchestration of organic relationships, and hence, as it were, naturalized.

In the portraiture of the early centuries of the Roman empire the waning of this system of organic relationships allows the gaze increasingly to break free of the slower, more corporeal elements of physiognomic representation and to assert itself more and more directly as manifestation of the spiritual source at the core of the empirical personality, the climactic and unifying term in the mimetic discourse. At the threshhold of late antiquity, the beginning of the third century A.D., a drastic reformulation of plastic structure freed the image from the remaining trammels of an inherited and now outworn organization based on objectivistic conceptions.

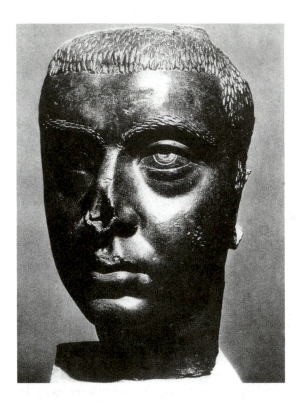

FIGURE 9 Gordian III, A.D. 238, Bronze *(National Archaeological Museum, Sofia)*

Instead of an architectonically organized system whose rhetoric of volumetric displacements is directly enacted in the observer's space, the new system posits a neutral volumetric shell behind which all the plastic interactions of the modeling take place. These are thus "suspended," as it were, in a space inaccessible to the observer like that of the theatrical stage—with all the advantages to their subjective emotional force which such "imagizing" removal can give. Upon this neutral shell, as upon a pictorial screen, the volumetrically insignificant, essentially linear displacements of the mobile organs of facial physiognomy are projected with a now unrivalled force and assemble themselves in their momentary interactions into a controlling visual armature.

These mobile elements, immediately responsive to the promptings of interior experience, now come to serve as the basis of a new language of human representation, in which it is not corporeal states and their objective interrelationships but states of experience—unmistakable evidence of human awareness itself—which are directly communicated through the structure of the image. Within this language, the facial organs, released from considerations of determinate volumetric organization and objective organic interconnections, are free to restructure themselves as diagrammatic emblems of emotional states, as a hierarchy of feeling-signs within which the gaze of the eyes assumes an uncontested dominion, organizing round itself the entire system of the mimetic play.

The late antique portrait represents the climax and conclusion of Roman portrait art. Here the principles of function contained in the new conception of portraiture erected in the first century B.C.—that of an image informed by an awareness of, and full presence in, the concrete circumstances in which it is experienced—come to full expression. The elaborate mimetic paraphernalia through which the complexities of a naturalistic psychology (itself the final residuum of the objectivistic world of the Greek portrait) had expressed themselves fall away like an outworn garment. Formerly the inner principle of awareness—the *self* itself—had shone its beam through layer after layer of empirical psychological modifications, communicated in the dense notation of physiognomic signals and expressive of the contingent circumstances of social and personal existence. Centuries of tradition and by now almost automatic skill in the incisive notation of the particularities of human appearance do not dissipate at once, and we are succinctly informed in late antique portraiture of the distinctive natural physiognomy ("after the flesh") of the represented subject: we know if he was fleshy or bony of face, smooth or wrinkled of skin, hooked or straight of nose. But these properties dwindle into insignificance as mere memories of another mode of existence. In the gaze of the great eyes, magnified now to tremendous scale, turned frontally upon us with the full force of their attention, we encounter unqualified presence, no longer limited by empirical time, place or contingent experience. No faces had ever been so totally, unqualifiedly present as these that accept no distance from us, no social pretense or merely personal, psychological obstacle; none had ever been so naked, stripped of everything but that one thing through which all else exists and is here declared the unqualified essence of humanity. It is absolute pure awareness, the principle itself, freed of all individualistic and subjectivistic determinations.

The awareness whose blinding light floods us from those eyes is in fact not different from the awareness with which we see them. It is the supreme intellect, the *nous,* that which, at our own inmost center, is the presence and the substance of the divinity. "The eye with which I see God is the same eye with which God sees me." It is the conception and gradual realization of a form of representation which was structured not around the idea of man as defined by his corporeal existence and the determinations which follow from it but around this perception of inward presence calling forth from the spectator his own, unqualified presence, which is perhaps the greatest achievement of Roman art and its enduring contribution—in more ways than can be recounted here—to all the later art of our culture.

POSTSCRIPT

This essay seeks to identify the defining characteristics and mode of operation of the Roman portrait genre. In the vast specialist literature on the subject, this had not, so far as I could discern, been previously attempted. (The closest approach to such an undertaking had been L. Curtius, "Physiognomik des römischen Por-

träts,'' *Die Antike* 7 [1931]: 226 ff.) It appeared in 1975 in a special issue on portraiture of the journal *Art in America,* written for a broad non-academic audience and hence dispenses with scholarly apparatus. Some additional general remarks on the genre as a whole, particularly its social and ideological contexts, may be found in the author's short introduction to the catalogue *Roman Portraits: Aspects of Self and Society* (The J. Paul Getty Museum, 1980): 15–18. For further consideration of the development of the genre's distinct narrative structure, see S. Nodelman, ''The Portrait of Brutus the Tyrannicide,'' in *Ancient Portraits in the J. Paul Getty Museum* I (1987): 68 ff. An approach related in many respects to that developed here would subsequently be pursued by L. Giuliani, *Bildnis und Botschaft. Hermeneutische Untersuchungen zur Bildniskunst der römischen Republik* (Frankfurt 1986).

In a broader perspective, this essay appears to have been one of the first manifestations of a new critical approach to Roman art, which has gained in influence in the ensuing years. It was preceded by Lisa Vogel's significant and unjustly neglected ''Flexibility versus Formalism,'' *Art Journal* 27 (1968): 271–78. This method proposes an alternative conceptual model—one based upon rhetorical categories for the understanding of Roman art, in place of the organismic model that has long prevailed in the history of art, whether in the analysis of individual works or in the description of developmental patterns, and by which Roman art in particular has been ill-served. For a recent exposition of this viewpoint, see T. Hölscher, *Römische Bildsprache als semantisches System* (Heidelberg 1987).

The Great Friezes of the Ara Pacis Augustae. Greek Sources, Roman Derivatives, and Augustan Social Policy

DIANA E. E. KLEINER

Despite the considerable number of studies that have been devoted to the Ara Pacis Augustae (13–9 B.C.) since the late 19th century, some important questions concerning the monument remain. Among these are the following: Is the frieze of the Parthenon really the sole formal source for the processional friezes of the precinct wall of the Ara Pacis? Is it true, as is widely maintained, that the Augustan altar friezes served as models only for works commissioned by the emperor and the upper classes of Roman society? Why do women and children figure so prominently in the processional friezes? This article deals with these three issues.[1]

I. THE ARA PACIS AND THE PARTHENON

It has been generally accepted since E. Courbaud's 1899 discussion of the Ara Pacis that the Panathenaic procession frieze of the Parthenon served as the formal model for the processional friezes of the north and south precinct walls of the Ara Pacis Augustae.[2] This point of view has been taken up once again in the most recent serious study of the Augustan altar by A. Borbein,[3] and a few striking similarities between the two friezes fully justify the traditional association of the Roman and Athenian monuments. These similarities may be stated briefly here

Reprinted with permission from the Mélanges de l'École Française à Rome, 90.2 (1978): 753–85.

because they have been adequately discussed in the previous literature. Both processions move in parallel lines along the north and south sides of a religious building and both friezes represent an actual religious procession. The Athenian frieze depicts the great Panathenaic festival procession which took place every four years after its institution by Peisistratos in c. 566 B.C. (although no specific procession is represented), and the Roman frieze (Figures 10–14) depicts the procession in honor of the consecration of the Altar of Peace in 13 B.C. after Augustus' return from Spain and Gaul.[4] Stylistic similarities may also be cited. The figures in both friezes are carved in low relief against a neutral background, and the mood of both processions is, on the whole, classicizing, with idealized personages following one another in a solemn manner.

These frequently-cited points-in-common should not, however, obscure the equally striking differences between the two friezes, because they are, in fact, quite distinctive. Borbein has rightly pointed to important differences in the handling of spatial depth by the fifth-century and first-century sculptors,[5] and his observations need not be repeated here. There are, however, other considerations which are at least as important and these differences are rarely acknowledged in the vast body of literature on the subject.

First and foremost it must be recognized that only a small fraction of the 524-foot Parthenon frieze is in any way comparable in composition to the processional reliefs of the Ara Pacis. Most of the Athenian frieze is devoted to the representation of horses and horsemen, chariots and charioteers, pitcher-bearers, musicians, sacrificial animals, and seated gods and goddesses; none of these motifs appear in the precinct wall processions of the Altar of Peace. One cannot speak of similarities between the Parthenon frieze and that of the Ara Pacis, but only of similarities between a small section of the Athenian frieze and the Roman frieze. Motifs similar to those on the Ara Pacis can be found only in small sections of the Parthenon frieze near the end of the north and south sides and on the east side. The south frieze of the Parthenon, e.g., consists primarily of galloping horses ridden by Athenian citizens, chariots and armed men, and temperamental sacrificial animals led by youths. The often vigorous motion of the lively and anecdotal procession is broken briefly only at a point about two-thirds of the way along the frieze by a group of elders who are walking slowly and talking to one another.[6] Only here may one speak of a group which is comparable in motif, mood, and composition to any part of the Ara Pacis procession. The similarity between this Athenian group and the togati in the front row of the panels of the north frieze of the Ara Pacis (Figure 10) is, in fact, quite striking.[7] Part of the east frieze of the Parthenon is also given over to a solemn procession which is not unlike that of the Roman altar. Young women proceed from both ends toward the group of seated gods and goddesses who flank the central peplos ceremony.[8]

Yet even in these small sections of the Parthenon frieze there is one significant difference that sets the Athenian and Roman friezes apart. The groups of the Panathenaic procession are segregated by sex. Men alone are represented on the west, north, and south friezes. Women appear only on the east frieze, and men are

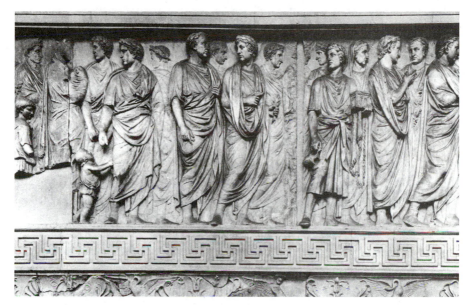

FIGURE 10 Ara Pacis, North Frieze, Detail *(Photo courtesy of German Archaeological Institute, Rome, neg. no. 72.2402)*

excluded from this section. Furthermore, children are, almost without exception, absent from the Panathenaic procession. Some of the horsemen are accompanied by boy attendants—one on the north frieze, e.g., ties the belt of his master's tunic[9]—and on the east frieze a child (its sex is disputed) takes part in the peplos ceremony beside the *archon basileus.*[10] But nowhere in the Panathenaic frieze have children been combined with men and women to form integrated family groups such as may be found on the Ara Pacis. Indeed, it is universally recognized that the charming and anecdotal family groups of the Ara Pacis are the most distinctive feature of that monument. The Parthenon frieze could not have served as the model for the Roman family portraits.

There can be no doubt that the presence of such Imperial family groups on the Ara Pacis was dictated by political considerations which are discussed fully below.[11] In this context it is only significant to note that, since the Parthenon frieze did not incorporate such groups, the Augustan artists either had to adapt the segregated motifs of the Parthenon to their own needs or they had to seek additional formal and composition models. If it could be shown that the Roman sculptors followed the second course and if such models could be identified, then one could no longer speak of the Parthenon frieze as the single pictorial source for the Ara Pacis friezes.[12]

It is already generally accepted that the form of the Altar of Peace and its decorative ornament are based on multiple sources. H. Thompson has convincingly demonstrated that the late fifth-century Altar of the Twelve Gods in the

Athenian Agora was the architectural model for the Ara Pacis[13] and it has also been established that the acanthus ornament of the Roman altar is based ultimately on Pergamene reliefs, probably with an Attic intermediary.[14] There is no reason to believe that there were not also multiple sources for the great friezes of the Ara Pacis. The Parthenon is clearly the primary model, but I believe that other models were used for the all-important family groups of the Ara Pacis. These models appear to have been overlooked in all discussions of the Ara Pacis although they are products of the same general artistic orbit as the Parthenon friezes, i.e., classical Greek marble relief. Family groups are not unknown in classical relief sculpture. Quite the contrary. It is the Parthenon which is the exception rather than the norm. Family portraits similar to those on the Ara Pacis may be found on many of the extant Greek funerary stelai and those which postdate the Parthenon are also much closer in style to the Augustan groups than are the Parthenon friezes.

II. THE ARA PACIS AND GREEK FUNERARY STELAI

The reliefs on the north and south precinct walls of the Ara Pacis Augustae represent two parallel parts of a single procession which move towards the west side of the monument and the steps which lead to the sacrificial altar (Figures 10 and 11).

The imperial family is represented on the south frieze, headed by Augustus, his lictors, and other figures, to which over half the length of the frieze is devoted.

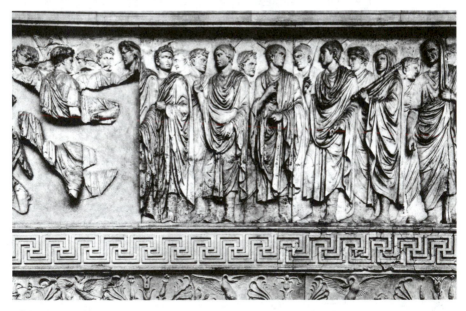

FIGURE 11 Ara Pacis, South Frieze, Detail *(Photo courtesy of German Archaeological Institute, Rome, neg. no. 72.2400)*

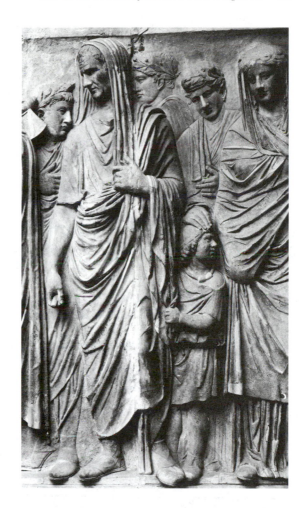

FIGURE 12 Ara Pacis, South Frieze, Detail *(Photo courtesy of German Archaeological Institute, Rome, neg. no. 37.1730)*

There follow three family groups in which children are prominently represented in the foreground row. The first group (Figure 12) is not strictly a family. It consists of a man, woman, and child, but not of a father, mother, and their child. Marcus Agrippa and the empress Livia are represented flanking a male child who has been variously identified as either Gaius or Lucius Caesar or a foreigner of princely descent.[15] All three figures are placed in the foreground and are carved in the highest relief used for the frieze, as are the other family groups. Figures in the background and in lower relief often interact with the foreground groups. In this case a woman stands between and behind Agrippa and Livia and places her right hand on the boy's head. She is probably the boy's mother, if he is a foreign prince, or is a nameless attendant of Gaius or Lucius.[16]

 The group of Agrippa, Livia, and the boy is not completely unified. Livia stands almost frontally with her left leg bent. She wears a palla over her tunic, an

edge of which is drawn up over her head as a veil. Her right hand is completely covered by the drapery but nonetheless she grasps a fold of her garment at the level of her right thigh. She turns her head to her right, towards Agrippa. The child wears a short tunic and a torque around his neck. His body is turned slightly towards Agrippa and he clutches an edge of Agrippa's toga with his left hand and appears to cling to him. He turns his head abruptly, however, in the opposite direction to gaze up at Livia. It is Agrippa's pose which breaks the unity of the group. Agrippa, who wears a tunic and toga with an edge drawn over his head, turns partially towards his right, towards Augustus and the head of the procession. He glances in that direction as well and not towards Livia and the boy. He is united with them, however, by the boy's grasping gesture.

The second group (Figure 13) represents Augustus' niece, Antonia the Younger, Livia's second son, Drusus the Elder, and their two-year-old son, Germanicus.[17] The group is thus a family unit. It is also more unified compositionally than the first group. Antonia's stance is almost frontal. She wears a tunic and palla and her right arm lies in a sling formed by draping the upper edge of the palla around the arm and over the left shoulder. Her left arm falls to her left side. Drusus is represented in profile. He turns towards his wife and they gaze into each other's eyes. He wears a short military tunic and *paludamentum*. Germanicus stands fron-

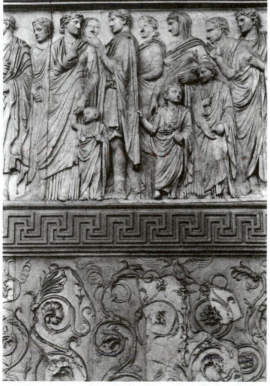

FIGURE 13 Ara Pacis, South Frieze, Detail

tally between and in front of his parents. He wears a tunic, toga *praetexta*[18] and *bulla,* and raises his right arm to grasp the fingers of his mother's left hand. Germanicus, however, does not look up at his parents, but rather at the procession ahead of him.

The third group (Figure 13) seems to represent a family: Antonia the Elder, the older sister of the other Antonia, her husband, Lucius Domitius Ahenobarbus, and their two children, Domitius and Domitia.[19] This group is, however, not as tightly composed as the other two family groups on the south frieze. Domitius, who wears a *bulla* and is dressed in tunic and toga *praetexta* stands almost frontally and turns his head to look at his sister.[20] Despite this visual connection to his sister, Domitius pulls on the *paludamentum* of his uncle Drusus, who belongs to the preceding group. He is thus linked to both family groups. Domitia's stance is also nearly frontal. She is dressed in a tunic and palla and turns her head to look at her younger brother Domitius. Antonia stands with her head in profile, her body in a three-quarter position, looking straight ahead at the procession. Her right hand lightly grazes the right shoulder of her son Domitius, thereby establishing a physical link between adult and child, as in the other groups. Ahenobarbus stands to the left of his daughter in an almost frontal pose, but his head is turned sharply to his right. His attention seems directed at the procession and not at his family, but the artist has placed his open right hand not far from his daughter's head, and a composition link is thus established between the two.

Family groups with children are also present in the procession of the north frieze. The procession begins with lictors and togati but at the end of the third panel (Figures 10 and 14) a very young child is introduced. He wears a short tunic, a torque around his neck, and he has long curly hair. He has, therefore, like the boy in the south frieze, and for the same reasons, been identified by some as a foreign prince.[21] The child is shown in profile. He grasps the fold of drapery covering the right thigh of the togatus in front of him and holds the right hand of another togatus placed between and behind them in lower relief. These three figures form a group with a fourth figure, a veiled woman who follows them in the procession and who is located at the juncture of the third and fourth panels of the north frieze. This woman has been identified as Julia, the daughter of Augustus and widow of Agrippa.[22] She is in a profile position and is swathed in a thick palla with her right arm and hand completely enveloped. The fringed shawl or *ricinium* of a widow is draped across her left shoulder. This group of four figures is unified compositionally. The woman and two men look at one another and the child glances up at the first togatus, grasps his garment and, at the same time, holds the right hand of the second togatus. As was the case with the first group on the south frieze, the group is not a family. Julia and the child, if he is indeed a foreigner, are certainly not related. The identity of the other two men is impossible to determine because their heads, as most on the north frieze, are modern restorations. Neither can be, however, Julia's husband Agrippa, who is represented on the south frieze.

The boy who follows Julia (Figure 14) has been identified as one of her sons, perhaps Gaius Caesar.[23] He is also in profile and is dressed as a *camillus,* with a short tunic and fringed mantle. He does not make any physical contact with the

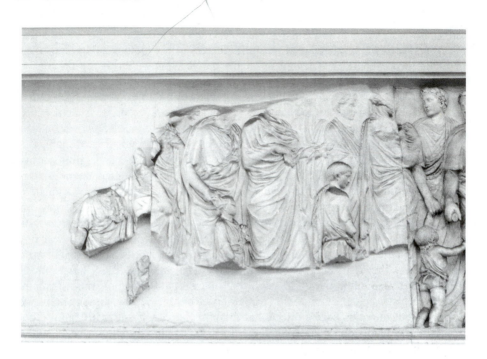

FIGURE 14 Ara Pacis, North Frieze, Detail

figures of the first group, despite his possible familial relationship to Julia. He serves, however, as a link between this group and the second one on the north frieze.

The second group (Figure 13) is composed of three figures—a man, woman, and little girl. The woman is in a three-quarter position and headless. She is dressed in a heavy palla in which her right arm and hand are completely enveloped. She carries a branch of laurel in her left hand and wears a *ricinium,* indicating that she is a widow. She is followed by a togatus, also headless and also represented in a three-quarter posture. The man places his right hand on the head of the girl. She is dressed in a toga,[24] wears a distinctive «Melonenfrisur» and also carries a branch of laurel in her left hand. The members of this group do not confront one another, but rather all look forward. The personages are difficult to identify because of the missing heads. Augustus' sister Octavia, her stepson and son-in-law Jullus Antonius, and Julia's daughter Agrippina, are among the proposed identifications.[25]

A boy in a toga is represented on the last preserved fragment of the north precinct wall frieze. He has not been identified[26] and the group to which he belonged cannot be reconstructed at this time.

Such integrated family groups of man, woman, and child do not appear in the Panathenaic procession frieze of the Parthenon. Such groups are the rule, how-

ever, in Greek funerary reliefs of the fifth and fourth centuries B.C. Great numbers of these reliefs are in public and private collections today and many more would have been standing in Augustan times. The designer of the Ara Pacis was unquestionably familiar with the Parthenon, the Altar of the Twelve Gods, and Attic acanthus ornament.[27] It would be surprising if he were not also aware of the existence of Greek funerary stelai in Attica, the area which appears to have provided the primary immediate models for the Altar of Peace and its ornament.

The fact that the monuments of ancient Athens were known to artists in Rome during the Augustan period is well documented. Athens and Rome exchanged artists, materials, and ideas. Augustus' close friend and one-time heir-apparent, Marcus Agrippa, was involved with major building programs in both cities. In Rome this included a Pantheon (dedicated in 25 B.C.) with a caryatid porch, the work of an Athenian sculptor named Diogenes.[28] Agrippa's caryatids are no longer extant but it is likely that they, like the better-known caryatids of Augustus' forum (dedicated in 2 B.C.), were based upon those of the Erechtheion in Athens.[29]

In Athens Agrippa was primarily concerned with the Athenian Agora, where he built an odeion in ca. 15 B.C.[30] The Romans also carried out architectural projects on the Akropolis itself in Augustan times. The Erechtheion was repaired in 27 B.C.[31] Immediately thereafter a small round temple was erected in honor of Roma and Augustus, the Ionic capitals of which are exact copies of those of the Erechtheion.[32]

Although many of the Greek grave stelai which these Augustan artists would have known do not resemble the Ara Pacis friezes, there are enough correspondences between the Augustan altar friezes and the Greek stelai to suggest that the Greek family group reliefs provided a model for the Roman family groups on the Ara Pacis. The extant Attic material alone includes several reliefs which incorporate motifs that are paralleled on the Roman altar. A few reliefs, chosen on the basis of the similarity of the group-portrait motifs to those on the Ara Pacis, will serve to illustrate the striking affinities between this class of Greek reliefs and the relief friezes of the Altar of Peace. The association between the two is underscored when one takes into consideration that nowhere else in pre-Augustan Greek, Etruscan, or Roman art do such intimate family groups appear at all.

Such a group is represented on a Greek funerary relief from Athens of the fourth century B.C. (Figure 15).[33] The figures are accompanied by an inscription which gives the names of those represented: Onesimos, the man at the right, Protonoë, the woman at the left, Eukoline, the little girl between them, and Nikostrate, the woman in the background. The inscription does not designate the relationships among the four, but one may assume that a father, mother, and daughter are represented, accompanied either by a female relative or a nurse. The scene is an intimate one. Protonoë, depicted in a three-quarter position and dressed in a chiton and himation, looks lovingly at her daughter. She places her left hand beneath her daughter's chin and raises her daughter's face up to meet her own glance. She lightly touches Eukoline's right forearm with her right hand. Eukoline

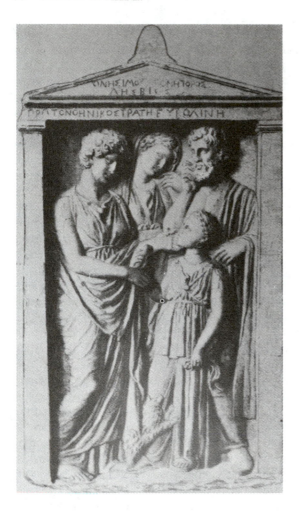

FIGURE 15 Greek Funerary Stele *(National Museum, Athens)*

is also standing in a three-quarter position. She wears a girded *peplos* with cross straps; a mantle falls behind her, an edge of which she grasps with her left hand. She holds a bird in her upraised right hand. Her head is turned to meet the glance of her mother. A dog, surely Eukoline's pet, jumps playfully up to the level of her left knee. Onesimos stands behind and slightly to the left of his daughter. He is also seen in a three-quarter view and he is dressed in a mantle which leaves his chest bare. His left hand is poised just above Eukoline's left shoulder and he strokes his beard with his right hand while he gazes at his wife. Nikostrate stands behind and between Protonoë and Onesimos. She wears a chiton and a mantle drawn up over her head. She inclines her head to the left and presses her left cheek against her upraised left hand in a pensive pose while she looks at Eukoline.

This quiet, intimate group is strikingly similar to the group of Antonia the Younger, Drusus the Elder, and their young son Germanicus, on the south frieze

of the Ara Pacis (cf. Figure 13). Both groups are self-contained—the Greek group isolated within its own frame, the Ara Pacis group, although part of a long procession, set apart from the others in the procession by the figures' stances, gestures, and glances. Antonia and Drusus turn towards one another and are united by a loving glance, and Antonia grasps the right hand of young Germanicus. A veiled female figure stands behind and between the two adults in both reliefs and in both cases is represented in lower relief than the neighboring three figures.

The distinction between relief levels adds an element of depth to both reliefs which is absent in the Panathenaic procession frieze. It has often been noted that one of the major differences between the Parthenon reliefs and the Ara Pacis friezes is this element of spatial recession.[34] The Panathenaic procession proceeds along a single relief plane whereas two or more relief planes are regularly suggested on the Ara Pacis (Figures 10–14). We are dealing on the Ara Pacis with a manner of depicting tridimensional space which was not achieved until after the mid-fifth century. The similarity in the handling of figures in space in the fourth-century funerary reliefs and in the Ara Pacis is an additional reason for postulating that these reliefs rather than the Parthenon frieze served as models for the family groups of the Ara Pacis.

A number of distinctive motifs used in the family group portraits of the Ara Pacis can also be traced back to Greek sources. In two instances on the Roman altar an adult places his hand in a protective gesture on a child's head. In the south frieze one woman places her right hand gently on a boy's head (Figure 12), and in the north frieze the man identified as Jullus Antonius touches little Agrippina's head with his right hand (Figure 14). The motif appears in Attic funerary reliefs of the second half of the fifth and of the fourth century B.C. In a relief from Piraeus now in the Piraeus Museum, e.g., a seated woman places her right hand on the head of her standing child and holds the child's right hand with her left.[35] Another Attic relief, now in the Athens National Archaeological Museum, portrays two standing figures, a nude youth and his male servant boy, also nude. The youth, whose name is given as Deinias, places his right hand on the boy's head.[36]

Another protective gesture found twice on the Ara Pacis is that of an adult holding a child's hand. Antonia holds Germanicus' hand on the south frieze (Figure 13) and an unidentified togatus holds the hand of an unidentified (foreign?) boy on the north frieze (Figure 10). A striking comparison can be made between the group of Antonia and Germanicus and a pair of figures on a fourth-century Attic relief now in the Metropolitan Museum of Art in New York (Figure 16).[37] A woman standing in profile on the right in the New York relief holds the right hand of her daughter with her left hand. The daughter's position is similar to that of Germanicus on the Ara Pacis.

Another intimate gesture between adult and child which is found on the Altar of Peace and is also utilized in the family groups of classical Greek grave stelai is that of an adult placing a hand on child's shoulder in a protective manner. Antonia the Elder lightly places her right hand on her son Domitius' right shoulder (Figure 13). A similar gesture is depicted on a second Attic stele in New York

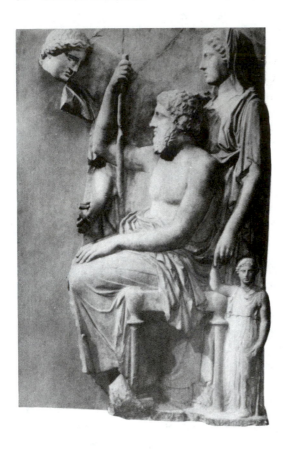

FIGURE 16 Greek Funerary
Stele *(Metropolitan Museum of
Art, New York, Rogers Fund,
1911.11.100.1.2)*

(Figure 17), datable to the mid-fourth century.[38] A woman rests her left hand on
the left shoulder of a little girl who reaches toward a seated woman with her left
hand. The hand-on-shoulder motif also appears on a grave stele found near the
Dipylon Gate and now in the Athens National Museum (Polyxene and her son),[39]
and on an Attic stele in a private collection in Athens (Melis and Antiphanes).[40]

The most unusual motif which appears in the family group portraits of the
Ara Pacis is the anecdotal motif of a child pulling on the drapery of an adult. The
motif appears three times. On the south side a boy pulls on Agrippa's mantle (Fig-
ure 12) and Domitius grabs the *paludamentum* of his uncle Drusus (Figure 13). On
the north side a child pulls on the garment of a togatus (Figure 10). The motif
appears to have no exact parallel in earlier Greek, Etruscan, or Roman art, and to
be the invention of an Augustan artist, probably the designer of the great frieze
himself. There are numerous instances, however, in the Attic funerary reliefs of a
child stretching out his hand towards an adult and even touching the drapery lightly
(e.g., Figure 17),[41] but in no instance does the child *pull* on the garment. The
motif is a good example of the Roman artist's adaptation of the repertory of clas-

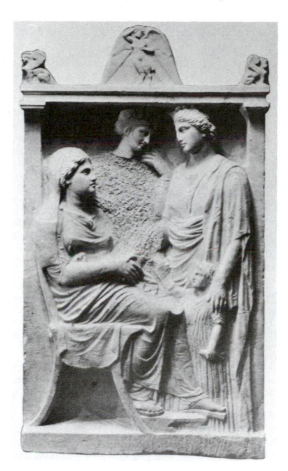

FIGURE 17 Greek Funerary
Stele *(Metropolitan Museum of
Art, New York, Harris Bisbane Dick
Fund, 1965.65.11.11)*

sical Greek family group motifs in a manner consistent with the style and spirit of
his models.

Comparisons have thus far been made only between the Ara Pacis friezes
and late classical Greek funerary reliefs. Children and adults do, however, appear
together elsewhere in Greek art, but in no other class of monuments can similar
family group motifs be found. Children are grouped with adults, e.g., on fourth-
century votive reliefs representing processions towards a deity, usually Asklepios.
But in the votive reliefs the children are depicted as independent members of the
procession; the processions are not broken up into isolated or semi-isolated groups
in which adults and children exchange glances and are bound together by intimate
gestures.[42]

Later Greek reliefs also do not incorporate family groups comparable to
those of the Ara Pacis friezes. In Athens itself the sumptuary law of Demetrios of
Phaleron of 317/316 B.C. put an end to funerary stelai with elaborate figural

groups. There were, consequently, no Hellenistic funerary reliefs with family portraits in Athens which might have served as sources for Augustan artists in search of models. Elsewhere in Greece grave stelai were produced during the Hellenistic period, especially in Asia Minor, but these reliefs are quite different in character from their classical predecessors and from the family groups of the Ara Pacis. Children and/or diminutive male or female servants are represented beside full-size adult figures, but the large and small figures are not composed in intimate groups. They are aligned frontally without any visual or physical contact between members of the group, and appear more like groups of independent statues than interacting relief figures.[43]

Closer in geographical and chronological terms to the Ara Pacis are the reliefs on the late Hellenistic Etruscan cinerary urns which sometimes are decorated with processional friezes. Children are generally excluded from these representations, but even when they are included, as on the front of a first-century B.C. Volterran urn in the Museo Guarnacci,[44] men and women are segregated and father-mother-child(ren) groups are not represented.

Thus it is only in the Greek funerary reliefs of the late classical period that possible models for the Ara Pacis family groups may be found, and the similarities in composition and spirit between the Greek and Augustan reliefs make it very likely that the funerary reliefs did provide the inspiration, and perhaps also specific motifs, for the Ara Pacis friezes.

III. THE ARA PACIS AND ROMAN FUNERARY RELIEFS

It is often stated in recent literature that the Ara Pacis and Augustan classicism in general exerted little influence on the art of any class of Roman society other than the aristocracy, i.e., the court and the *nobiles*.[45] The only monument in Rome thought to be based specifically on the Ara Pacis is the Ara Pietatis Augustae, vowed by Tiberius in A.D. 22 in honor of his mother Livia and completed by Claudius in A.D. 43.[46]

This is not, however, the case. During the Augustan period itself—indeed, immediately following the completion of the Ara Pacis—marble reliefs with family group portraits based directly upon those of the Altar of Peace were commissioned and carved in Rome. The patrons of these portrait reliefs were not drawn from the aristocracy, but rather from the Roman middle class. The reliefs were destined to be placed in the facades of tombs lining the roads leading out of the city. Three such reliefs of Augustan date with full-length representations of a father, mother, and child are extant and there must have been many more in antiquity. All three were middle-class commissions; the patrons were probably freedmen or their immediate freeborn descendants. No other class of Augustan patrons seems to have commissioned reliefs emulating the Ara Pacis friezes.[47]

The first of these reliefs is now in the Villa Doria Pamphili in Rome (Figure 18).[48] The relief is made of marble and is datable to the last decade of the first

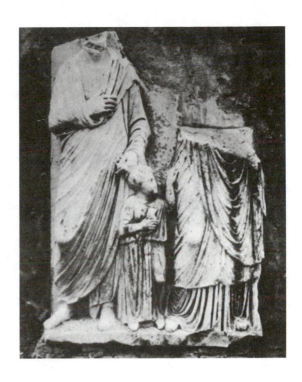

FIGURE 18 Roman Funerary
Relief *(Villa Doria Pamphili,
Rome)*

ca 10 B.C.

century B.C. on the basis of its drapery and portrait styles.[49] A father and mother
are represented with their daughter standing between them. The headless father is
placed in a frontal position and is dressed in a toga and tunic. His right arm rests
in a sling formed by the upper edge of the toga. The folds of the sling merge with
those of the upper left shoulder to form a kind of «sleeve».[50] The man's left arm
falls at his left side. He holds a scroll (now fragmentary) in his left hand. The
musculature of his neck indicates that his head was originally turned towards his
wife.

The woman is preserved only from the waist down. She is frontally posi-
tioned and wears a multilayered palla of mid-Augustan date[51] over a very long
tunic which almost hides her feet. Her daughter stands between her and her hus-
band in a three-quarter position. She turns both her body and her head towards her
mother. She is dressed in a long girded tunic resembling a Greek peplos.[52] She
wears her hair in a style popularized in Hellenistic times, the so-called «Melonen-
frisur»,[53] characterized by numerous parts between which the hair is combed in
long rolls. The hair is gathered into a large rolled bun at the back of the head. The
same coiffure is worn by the young Agrippina on the north frieze of the Ara Pacis
(Figure 14).

The girl in the Doria Pamphili relief holds a bird in her right hand.[54] She
grasps a fold of her mother's palla in her left hand. This anecdotal motif of a child
pulling on the garment of an adult has already been shown to be an invention of

the Ara Pacis designer and does not appear in classical Greek or Hellenistic funerary or votive reliefs, Etruscan urns, or Roman relief sculpture prior to the Ara Pacis. There can be no doubt that this three-figure group was modeled upon the family groups of the Augustan altar friezes.

The second relief with full-length representations of a father, mother, and child is now in the chapel of the Villa San Michele on Capri (Figure 19), but was undoubtedly carved in Rome.[55] The relief can be dated to the closing years of the first century B.C. on the basis of its portrait and drapery styles.[56]

The relief is weathered and fragmentary; only the mother and son are preserved. The right half of the relief would have portrayed the missing father; the child was thus situated between two adult figures, as in the Doria Pamphili relief and the friezes of the Ara Pacis. The mother is represented in a frontal position. She wears a long tunic, which almost obscures her feet, and a palla, the upper edge of which is pulled over her head as a veil. Her right arm rests in a sling formed by another edge of the upper part of the palla. Her left arm falls at her side and she lightly grasps her own garment with her left hand. The woman's portrait is classicizing with idealized features.[57] Her coiffure is lightly waved with a flat *nodus* pulled back in the center from the forehead.[58]

The woman's young son stands to her left in a three-quarter position. He is dressed in a short-sleeved tunic, the typical dress of Roman boys under sixteen.[59] Over the tunic he wears a cloak, probably a *lacerna,* attached by a brooch to the

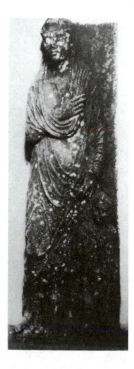

End lot c. BC

FIGURE 19 Roman Funerary
Relief *(Villa San Michele, Capri)*

tunic at his right shoulder—an unusual garment for a Roman child.[60] The *bulla* worn around his neck indicates that he is a freeborn child, probably the son of a freedman and freedwoman.[61] The boy is planted firmly on two feet with his weight equally distributed. His left arm falls at his left side and his right arm is raised to the center of his chest where he grasps a fold of his cloak. The boy has a round face which is treated in the same classicizing manner as his mother's. He has long curly hair reaching to his shoulders. His hairstyle is reminiscent of that of some of the children on the Ara Pacis (Figures 10 and 12).

The third relief of Augustan date with Ara Pacis–type family portraits is now in the giardino of the Museo Nazionale Romano.[62] It is also of marble and fragmentary, but originally portrayed a man, a woman, and their son. It can be dated to the late first century B.C. on the basis of the portrait style and the coiffure of the child.[63]

The father is placed frontally, although he turns his head to his left, towards his wife. He wears a tunic, toga, and *calcei*. His coiffure and portrait are Republican in style and outdated at this time.[64] The togatus is joined in a *dextrarum iunctio*[65] with his wife, of whom only the right hand is preserved. Their young son stands between them, dressed in a short-sleeved tunic. The boy's head is turned toward his left and he turns his head sharply to look up at his mother in a manner reminiscent of that of some of the children on the Altar of Peace friezes. He raises his left arm and hand, probably to grasp part of his mother's palla in his left hand—a motif whose source is clearly the Ara Pacis Augustae.

It is important to note that the three reliefs just discussed are not the first Roman funerary reliefs to incorporate full-length figures. Such reliefs were manufactured in Rome as early as about 75 B.C., but it is not until the mid-Augustan period, after the erection of the Ara Pacis, that children appear with their parents in these reliefs.

A similar phenomenon may be documented in the closely-related series of middle-class funerary reliefs with horizontally-aligned bust-length portraits. With one exception,[66] all reliefs of this type which incorporate images of children are also datable to the Augustan period. Eleven such Augustan funerary reliefs are preserved. In six examples the father and mother flank the young child as they do in the three full-length reliefs and in almost all cases on the Ara Pacis itself:

1. Relief of C. Livius Alexander, Aemilia Clucera, and their son Apollonius. Rome, Musei Vaticani, Galleria Lapidaria, no. 39a.[67]

2. Relief of a man, woman, and their son. Rome, Musei Vaticani, Galleria Lapidaria, inv. 9398.[68]

3. Relief of L. Vibius, Vecilia Hilae (Vibia Prima), and their son L. Vibius Felicio Felix. Rome, Musei Vaticani, Museo Chiaramonti, inv. 2109.[69]

4. Relief of a man, woman, and their son. Rome, Musei Vaticani, ex Museo Lateranense, inv. 10490.[70]

5. Relief of C. Gavius Dardanus, Gavia Asia, and their son C. Gavius Rufus. Rome. S. Giovanni in Laterano, chiostro, no. 103.[71]

6. Relief of L. Vettius Alexander, Vettia Hospita, and their two daughters, Vettia Polla and Vettia Eleutheris. Rome, Museo Nazionale Romano delle Terme, chiostro, ala III, inv. 125830.[72]

In five other Augustan reliefs with bust-length portraits the child is placed to the right or left of his/her parents:

7. Relief of Q. Servilius Hilarus, Sempronia Eune, and their son P. Servilius Globulus. Rome, Musei Vaticani, ex Museo Lateranense, inv. 10491.[73]
8. Relief of a mother, father, and their son. Rome, Musei Vaticani, Museo Chiaramonti, no. 13a.[74]
9. Relief of Caius Vettius Nicephor, Antonia Rufa, and their son Caius Vettius Secundus. Rome, via Po, no. 1a.[75]
10. Relief of a man, woman, and their son. Rome, Via di Portico di Ottavia.[76]
11. Relief of M. Servilius Menophilus, Servilia Thais, and their son Lucinius. Rome, Villa Wolkonsky.[77]

These horizontal bust-length reliefs are not dependent upon the Ara Pacis friezes in formal terms, as are the three vertical full-length reliefs, but they are further documents of the sudden appearance of parent-and-child groups in Augustan art. The prevalence of family groups in all these Augustan reliefs, including—indeed especially—the Ara Pacis Augustae, is not an isolated artistic phenomenon, but rather the artistic reflection of Augustus' social policy.

IV. THE ARA PACIS AND AUGUSTAN SOCIAL POLICY

Any analysis of the place of the Ara Pacis in Roman art must take into consideration the fact that no earlier Roman state relief includes representations of family groups, and that children appear infrequently in earlier Roman art in general. Youthful portraits, e.g., are quite rare during the Republic. The presence of women and children among those celebrating religious rites on the Ara Pacis is, in fact, astonishing when viewed against the background of Roman Republican art, but it is thoroughly consistent with the social policies of Augustus. Children are not included in the Ara Pacis reliefs because the designer thought they would add charm and variety to the procession, but because children (and families) were held in high esteem by Augustus. The Ara Pacis friezes, as all state-commissioned reliefs, portray important people. In Augustan times children were considered to be important. They played an important role in Augustus' social legislation and children consequently figured prominently in the pictorial propaganda of the Altar of Peace.

Augustus himself took a great personal interest in his young adopted heirs Gaius and Lucius Caesar, the sons of Marcus Agrippa and Augustus' daughter Julia. The emperor paid special attention to the education of his grandsons. According to Suetonius, Augustus was rarely separated from the boys. They sat

beside him at dinner and accompanied his carriage on journeys. Augustus was personally involved with the education of his heirs; he taught them to read and to swim and even to imitate his own handwriting.[78]

Official numismatic and sculptured images of Gaius and Lucius were produced from their infancy on. In 13 B.C. the mint of Rome struck denarii with a portrait of Augustus on the obverse and busts of Gaius, Lucius, and their mother Julia on the reverse.[79] Sometime after 2 B.C. the imperial mint at Lugdunum struck both aurei and denarii with full-length veiled togate figures of Gaius and Lucius accompanied by shields, spears, and religious instruments on the reverses.[80] Numerous statues of both Gaius and Lucius were erected and distributed widely throughout the Empire. According to F. Chamoux the only member of the imperial family with more portraits was the emperor himself. As of 1950, Chamoux had collected thirty-three statue-base inscriptions for Gaius and twenty-nine for Lucius.[81] The two boys were usually either represented in paired portraits, such as those on the coins from Lugdunum, or were included in more extensive imperial statuary groups.[82]

It is beyond the scope of this article to discuss the portrait types of Gaius and Lucius Caesar, but it is relevant to note that the princes were closely allied with Augustus in their portrait types. The hairstyles chosen for the boys' portraits (by Augustus himself?) have a specific iconographic significance. Lucius' hairstyle is a variant of the Augustan Actium type and Gaius' a variant of the Primaporta hairstyle. Lucius is represented as the new Octavian and Gaius as the new Augustus.[83]

The title of *princeps iuventutis* bestowed upon Gaius in 5 B.C. and upon Lucius three years later is especially interesting in view of the incorporation of children into family groups on the Ara Pacis Augustae. *Collegia iuvenum* appear to have had a long history in Italy, but such colleges of youths were revived by Augustus.[84] Boys of the upper classes joined sports clubs prior to assuming the *toga virilis*. There they exercised and learned horsemanship. Their talents were displayed in the *Lusus Troiae* or Trojan Games. The boys remained members of these clubs until the age of seventeen when they joined the *collegia iuvenum*, in which they became versed in the martial arts prior to assuming duties as army officers. The *Iuventus* was part of Augustus' larger social plan to give upper-class Italian youth common interests and obligations.[85]

After establishing peace abroad, Augustus had to face a number of serious domestic problems. The great influx of slaves threatened to make these immigrants outnumber the indigenous Romans. There is no doubt that the slaves, many of whom were eventually freed, contributed much to Roman society in their capacity as professionals and businessmen, but their high birthrate and the increased frequency of their manumission combined with the declining birthrate among the nobility made it apparent to Augustus that the *nobilitas* was in danger of extinction.[86] With its demise the entire imperial system as envisioned by Augustus would also die. The rise in the cost of living even for the nobility made smaller families more attractive. Marriages were easy to dissolve and, with increased women's rights and independence, fewer men wanted to marry women of equal

status. Some turned instead to enfranchised slaves over whom they could exert greater power.[87]

To deal with these problems Augustus had a series of laws enacted. To diminish the proportion of non-Romans and freed slaves in the population a quota for immigrants was established and manumission was made more difficult.[88] Other laws, intended primarily to enhance the prestige of the Roman family, encouraged marriage and childbirth, and these laws are those which are of particular relevance to the iconography of the friezes of the Ara Pacis.[89]

The *lex Julia de adulteriis* promoted marriage by bringing adultery under court jurisdiction rather than allowing it to remain a private affair. Placing marriage under state protection did not, however, insure an increased birthrate. To stimulate childbirth the *lex Julia de maritandis ordinibus* was enacted at Augustus' instigation in 18 b.c. The law was amended in a.d. 9 by the *lex Papia Poppaea*. Together these two laws removed stringent restrictions on marriage and stimulated the raising of children. Freeborn people, with the exception of senators and their sons, were allowed to marry *libertini,* except those in questionable professions such as acting. Freedwomen with three or more children were not required to have a legal guardian. Men between the ages of 25 and 60 and women between the ages of 20 and 50 were supposed to marry and raise children. Stiff consequences were suffered by those who remained celibate. Childless men and women were denied their inheritances unless they came from a soldier's will. Childless women, whether married or unmarried, had to pay heavy property taxes. Divorced women and widows were required to remarry within six months and one year respectively. Most important perhaps, men of the *nobilitas* in public life were favored if their families were large. If two men ran for the same office and received an equal number of votes, the man with the larger family was declared the victor. Men could even become eligible to run for office if they were below the minimum age by adding one year to their age for every child they had fathered.

Seen in this light it is not at all surprising that many of the men on the Ara Pacis are portrayed *with their families.* The chief reason for the inclusion of women and children in the processional friezes of the Altar of Peace was to place before the eyes of the Roman public an image of the emperor and his associates as heads of families. The emperor and his retinue were thus depicted as the embodiment of the Augustan social program; they set a standard for the rest of the population to emulate. There is thus a strong connection between the social policy of Augustus and the processional friezes of the Ara Pacis Augustae. This aspect of the iconographical program of the altar ought now to receive proper recognition.

ADDENDA

Since this article went to press I have learned of an interesting lost relief from Athens representing four men and a woman accompanied by two nude children (putti?) in what appears to be a solemn procession. One of the children is inti-

mately grouped with a man and a woman and pulls on the garment of the man. The relief was drawn by J. Stuart and N. Revett, *The Antiquities of Athens*, I (London 1762), Pl. VI, fig. 1, and associated with the Ilissos temple in Athens. If the relief indeed belonged to the late 5th century temple, it would be an important precedent for the Ara Pacis family group and the anecdotal motif of children pulling on the drapery of adults. The slab probably did not, however, belong to the frieze of the Greek temple, and is now generally believed to be of Roman or later date. The Athenian relief may, in fact, be based on the Ara Pacis. (The Tellus-Italia panel was imitated as far away as Carthage; see Kleiner, 177, note 57). For the Ilissos relief, see M. Robertson, *A History of Greek Art* (Cambridge 1975), p. 348 and C. A. Picón, *The Ilissos Temple Reconsidered*, in *AJA* 82 (1978): 47 ff., esp. 58 f., with earlier bibliography.

I was not able to obtain a copy of Z. Kiss, *L'iconographie des princes julio-claudiens au temps d'Auguste et de Tibère* (Warsaw 1975) in time to cite the author's identifications of the Ara Pacis figures or discussion of the portraiture of Gaius and Lucius Caesar, 31–64.

NOTES

1. I am indebted to my husband, Fred S. Kleiner, for discussing the issues raised in this article with me and for reading the manuscript and offering many useful suggestions. Some of the issues treated here were discussed very briefly in my book *Roman Group Portraiture* pp. 172–79. Abbreviations used in the notes are as follows: Gercke-Voss = W. Gercke-Voss, *Untersuchungen zum römischen Kinderporträt von den Anfängen bis in hadrianische Zeit* (Hamburg 1969). Kleiner = D. E. E. Kleiner, *Roman Group Portraiture. The Funerary Reliefs of the Late Republic and Early Empire* (New York and London 1977). Moretti = G. Moretti, *Ara Pacis Augustae* (Rome 1948). Petersen = E. Petersen, *Ara Pacis Augustae*, in *Sonderschriften des Österreichischen Archäologischen Institutes in Wien 2* (Vienna 1902). Simon, *Ara Pacis* = E. Simon, *Ara Pacis Augustae* (Tübingen 1967).

2. E. Courbaud, *Le bas-relief romain a représentations historiques* (Paris 1899), p. 84. Of the later studies, see esp. Petersen 165–69. J. Charbonneaux, *L'art au siècle d'Auguste* (Lausanne 1948), p. 69. H. A. Thompson, *The Altar of Pity in the Athenian Agora*, in *Hesperia* 21 (1952): 80–81. K. Hanell, *Das Opfer des Augustus an der Ara Pacis*, in *OpRom* 2 (1960): 90. A. Bonanno, *Roman Relief Portraiture to Septimius Severus*, in *BAR*, Suppl. Ser. 6 (1976): 24.

3. A. Borbein, *Die Ara Pacis Augustae*, in *JdI* 90 (1975): 252 ff.

4. This has been disputed, but the ceremony of 13 B.C. is now widely accepted as the subject of the processional friezes. See esp. J. M. C. Toynbee, *The Ara Pacis Reconsidered and Historical Art in Roman Italy*, in *ProcBritAc* 39 (1953): 72.

5. Borbein, *JdI* 90 (1975): 256 ff. The different manner of rendering space in the friezes of the Parthenon and the Ara Pacis had been discussed before. See esp. J. Sieveking, *Das römische Relief*, in *Festschrift für Paul Arndt* (Munich 1925), pp. 16 ff. G. Kaschnitz von Weinberg, *Römische Kunst II, Zwischen Republik und Kaiserzeit* (Reinbek 1961), pp. 77 ff. Kaschnitz, *Mittelmeerische Kunst*, Ausgewählte Schriften III (Berlin 1965), pp. 467 ff.

6. M. Robertson, *The Parthenon Frieze* (London 1975) South XXXIV–XXXVI. T. Bowie and D. Thimme, *The Carrey Drawings of the Parthenon Sculptures* (Bloomington and London 1971), pl. 23.1.

7. Simon, *Ara Pacis*, pls. 16.2, 17.2.

8. Robertson, *Parthenon Frieze*, East I–III, VII–IX.

9. Robertson, *Parthenon Frieze*, North XLII, 133–134.

10. Robertson, *Parthenon Frieze*, East V, 34–35.

11. See *infra*, pp. 772–76.

12. This would contradict Borbein's statement, *JdI* 90 (1975): 252, that the great frieze of the *Ara Pacis* «zitiert nicht ingendwelche griechischen Formen, sondern ein einzelnes Monument, den Fries des Parthenon auf der Akropolis in Athen.»

13. Thompson, *Hesperia* 21 (1952): 79 ff. H. A. Thompson and R. E. Wycherley, *The Agora of Athens, The Athenian Agora* 14 (Princeton 1972), pp. 129–36. H. A. Thompson, *The Athenian Agora. A Guide to the Excavation and Museum* (Athens 1976), pp. 96–98. Travlos, *Athens*, pp. 458–61.

14. O. Deubner, *Pergamon und Rom*, in *Marburger Jahrb. f. Kunstwissenschaft* 15 (1949–50): 102–3, 113–14. T. Kraus, *Die Ranken der Ara Pacis* (Berlin 1953). L. Bijvanck-Quarles van Ufford, *Die Ranken der Ara Pacis. Études sur la décoration à rinceaux pendant l'époque hellénistique*, in *BABesch* 30 (1955): 39–56. H. P. L'Orange, *Ara Pacis Augustae. La zona floreale*, in *ActaIRN* 1 (1962): 7–16; reprinted in *Likeness and Icon* (Odense 1973), pp. 263–77. C. Börker, *Neuattisches und Pergamenisches an den Ara Pacis-Ranken*, in *JdI* 88 (1972): 283–317.

15. The boy wears a short tunic, a torque, and has long curly locks. His identification is controversial. Because of his proximity to Agrippa the boy has usually been identified as Gaius or Lucius Caesar. For Gaius, see esp. V. Poulsen, *Studies in Julio-Claudian Iconography*, in *Acta Arch* 17 (1946): 4. Moretti 270 (Gaius in the guise of Julus-Ascanius). C. Pietrangeli, *Ara Pacis*, in *EAA* I (1958): 525. For Lucius, see esp. Petersen, 108. A. von Domaszewski, *Die Familie des Augustus auf der Ara Pacis*, in *ÖJh* 6 (1903): 62. *RE* XVIII, 2 (1942): 2099, *s.v. Ara Pacis Augustae* (Riemann). J. R. Crawford's suggestion (*A Child Portrait of Drusus Junior on the Ara Pacis*, in *AJA* 26 (1922): 313–15) that the boy is Drusus the Younger, son of Tiberius and Vipsania has not met with any acceptance. The facial features and long curly hair of the boy are not, however, consistent with secure portraits of the two grandsons of Augustus. The torque was usually associated with certain foreigners, but could be worn by a child of imperial or patrician rank. The torque is, in any case, a restoration based on a drawing in the Codex Ursinianus in the Vatican (no. 3439). See Toynbee, *ProcBritAc* 39 (1953): 84, note 5. See also *RE*, 2nd. ser. VI (1937): 1800–1805, *s.v.* Torques (Schuppe). L. Bonfante Warren, *Roman Costumes. A Glossary and Some Etruscan Derivations*, in *ANRW* I⁴ (1973): 613. The boy on the south frieze of the Ara Pacis and a similar child on the north frieze (Figure 14) might be identified more plausibly as Gallic children, because of their hairstyles and the torques. Their presence on the altar frieze could be interpreted as a reference to Augustus' visit to Gaul and the peace between the Gauls and the Romans achieved by that visit. Gercke-Voss 140. E. Simon (*Das neugefundene Bildnis des Gaius Caesar in Mainz*, in *MZ* 58 (1963): 9; Helbig⁴ II, 686, no. 1937; *Ara Pacis* 18) has identified the boy as a foreign prince. The diadem in his hair indicates a princely rank. Simon's suggestion is accepted by Gercke-Voss 136 ff., esp. 140–41 (identification of the boy as a foreigner from Gaul, the land from which Augustus had just returned). For a tabulation of identifications of all figures on the *Ara Pacis* proposed prior to 1934, see G. Monaco, *L'iconografia imperiale nell'Ara Pacis Augustae*, in *BullCom* 62 (1934): 17–40.

16. For the identification of the boy's mother as a foreigner, see E. Simon, Helbig⁴ II, 683, no. 1937. Simon, *Ara Pacis* 18. The woman has also been identified as Julia, the daughter of Augustus and wife of Agrippa, by the following: P. Ducati, *L'arte classica* (Turin 1920), p. 683., *RE* XVIII, 2 (1942): 2099, *s.v. Ara Pacis Augustae* (Riemann). Moretti 272. I. S. Ryberg, *The Procession of the Ara Pacis*, in *MemAmAc* 19 (1949): 85. H. Kähler, *Die Ara Pacis und die augusteische Friedensidee*, in *JdI* 69 (1954): 76. W. H. Gross, *Julia Augusta* (Göttingen 1962), p. 74. It is unlikely that Julia, Augustus' daughter and only child, would have been represented as a secondary figure in low relief on the Ara Pacis. She probably appears instead on the north frieze (Figure 13). A. von Domaszewski, *Ojh* 6 (1903): 62, has proposed Vipsania Polla, Agrippa's sister.

17. These three identifications are now generally accepted. V. Poulsen, *ActaArch* 17 (1946): 5. E. Simon, Helbig⁴ II, 684, no. 1937. Simon, *Ara Pacis*, 19. Bonanno, *Roman Relief Portraiture*, 27, 29. Gercke-Voss 133 f. discusses briefly the various other identifications of the boy (Agrippa Postumus, Claudius, Lucius Caesar). H. Riemann, *RE* XVIII, 2, 2100, has suggested that the veiled female standing behind and between Antonia and Drusus is Octavia, Augustus' sister and Antonia's mother. Simon (Helbig⁴ II, 684, no 1937; *Ara Pacis*, 19) identifies the woman as a «silence-keeper,» a priestly woman who puts her left index finger to her lips to remind the imperial family, and especially the children, of the solemnity of the occasion.

18. The toga *praetexta*, or special toga with a purple border, was worn by young boys of high birth.

See L. M. Wilson, *The Roman Toga* (Baltimore 1924), pp. 51–52. Wilson, *The Clothing of the Ancient Romans* (Baltimore 1938), pp. 130–31. L. Bonfante Warren, *ANRW* I[4] (1973): 591, 611.

19. E. Simon, *Helbig*[4] II, 685, no. 1937. Simon, *Ara Pacis,* 19. Bonanno, *Roman Relief Portraiture,* 27. These identifications are now generally accepted. For a list of other proposals, see Gercke-Voss 134–35.

20. Domitius' head is restored, but the position seems correct.

21. E. Simon, *Helbig*[4] II, 686, no. 1937. Simon, *MZ* 58 (1963): 9. Simon, *Ara Pacis,* 21. Gercke-Voss 139–40. Moretti 270 ff. identifies the child as Lucius Caesar in the guise of Romulus, the counterpart of Gaius Caesar as Julus-Ascanius on the south frieze. These identifications imply that the symbolic overtones of the Aeneas and Romulus-Remus panels on the west side of the altar precinct have been incorporated into what otherwise appears to be a straightforward representation of a historical event. See also Kähler, *JdI* 69 (1954): 81.

22. E. Simon, *Helbig*[4] II, 686, no. 1937. Simon, *MZ* 58 (1963): 9–10. Simon, *Ara Pacis,* 21. Gercke-Voss 135–36 follows Hanell's earlier identification (*OpRom* 2 [1960] 87) of the woman as a Vestal Virgin. See also *infra,* note 23.

23. The figure has been identified as Lucius Caesar by Simon, *MZ* 58 (1963): 9–10. Cf. Simon, *Ara Pacis,* 21 (one of Julia's two sons). The figure has also been identified as Gaius Caesar. L. Fabbrini, *Di un ritratto inedito di giovinetto nei Musei Oliveriani in Pesaro,* in *RendLinc* (1955), pp. 469 ff. L. Polacco, *La festa della pace nell'Ara Pacis,* in *Atti dell'Ist. Veneto di Sci., Let. e Arti* 119 (1960): 607, note 1. This identification seems more plausible. Gaius was seven years old in 13 B.C., whereas Lucius was only four. On the basis of physiognomy and hairstyle this boy is the most likely candidate on the Ara Pacis to be one of the two princes. See Bonanno, *Roman Relief Portraiture,* 32. Gercke-Voss 135–36 points out, however, that a condition of being a *camillus* was to have two living parents. Julia is represented in widow's garb, which alludes to Agrippa's death in 12 B.C. Gercke-Voss thus returns to earlier identifications of the boy as a nameless *camillus* and the woman as a Vestal Virgin. See, e.g., *RE* XVIII, 2, 2101–2102, *s.v. Ara Pacis Augustae* (Riemann). Hanell, *OpRom* 2 (1960): 87.

24. Literary sources tell us that young girls wore the toga in early Roman times. The *Ara Pacis* girl is our only pictorial confirmation of the written testimony. It is impossible to determine whether the custom had survived until Augustan times or whether it was revived by Augustus for young female members of his family. Wilson, *Roman Toga* 27, 51. Wilson, *Clothing of the Ancient Romans,* 135–37.

25. E. Simon, *Helbig*[4] II, 686, no. 1937. Simon, *Ara Pacis,* 21. Gercke-Voss 136.

26. E. Simon, *Helbig*[4] II, 686, no. 1937. Simon, *Ara Pacis,* 22.

27. See *supra,* pp. 753–57.

28. Pliny, NH XXXVI. 38. F. W. Shipley, *Agrippa's Building Activities in Rome* (St. Louis 1933). A. Boëthius and J. B. Ward-Perkins, *Etruscan and Roman Architecture* (Middlesex and Baltimore 1970), p. 86.

29. Boëthius and Ward-Perkins, *Etruscan and Roman Architecture,* p. 186. P. Zanker, *Forum Augustum* (Tübingen 1968), pp. 12–13, figs. 25–26. E. E. Schmidt, *Die Kopien der Erechtheionkoren,* in *AntPl* 13 (1973).

30. Boëthius and Ward-Perkins, *Etruscan and Roman Architecture,* pp. 379–80. H. A. Thompson, *The Odeion in the Athenian Agora,* in *Hesperia* 19 (1950): 31–141. Thompson, *Hesperia* 21 (1952): 81–82. Thompson and Wycherley, *Agora of Athens* 111–14. Thompson, *Athenian Agora. Guide,* 110–15. Travlos, *Athens,* 365–77.

31. Travlos, *Athens,* 214.

32. W. Binder, *Der Roma-Augustus Monopteros auf der Akropolis in Athen und sein typologischer Ort* (Stuttgart 1969). Travlos, *Athens,* 494–97.

33. Conze II, 245, no. 1131, pl. 238. M. Bieber, *Griechische Kleidung* (Berlin and Leipzig 1928), pp. 36–37, pl. 5, fig. 1.

34. See most recently Borbein, *JdI* 90 (1975): 255 ff.

35. Conze I, 20, no. 60, pl. 27. See also no. 61, pl. 27.

36. Conze II, 223, no. 1044, pl. 207.

37. G. M. A. Richter, *Handbook of the Classical Collection, Metropolitan Museum of Art* (New York 1930), pp. 258–59, fig. 180. Richter, *Handbook of the Greek Collection, Metropolitan Museum of Art* (Cambridge, Mass. 1953), p. 142, pl. 121 c.

38. B. F. Cook, *An Attic Grave Stele in New York,* in *AntPl* 9 (1969): 65–72, pls. 40–45.

39. Inv. 723. Conze I, 62, no. 284, pl. 66.

40. Conze II, 191, no. 894, pl. 175.

41. For examples from Attica, see Conze II, 228, no. 1061 a, pl. 214; 231, no. 1069, pl. 196. H. Diepolder, *Die attischen Grabreliefs des 5. und 4. Jahrhunderts v. Chr.* (Berlin 1931), pl. 2.1. K. Friis Johansen, *The Attic Grave-Reliefs of the Classical Period* (Copenhagen 1951), fig. 23. For a brief survey of the representations of children on Attic grave reliefs, see Gercke-Voss 144–46.

42. See, e.g., U. Hausmann, *Griechische Weihreliefs* (Berlin 1960), fig. 40. I have not yet seen G. Neumann, *Hauptprobleme des griechischen Weihreliefs* (Tübingen 1977). The elaborate late Hellenistic relief (ca. 130 B.C.) of the «Apotheosis of Homer,» now in the British Museum, does have a group with a child who faces and reaches towards an adult, a motif we have already seen on Attic funerary reliefs of the late fifth and fourth centuries B.C., from which the motif was surely drawn. See *supra,* p. 765. The group in the British Museum relief is located at the bottom right of the slab. D. Pinkwart, *Das Relief des Archelaos von Priene,* in *AntPl* 4 (1965): 55–56, pls. 28, 31.

43. See, e.g., a relief from Ephesos, now in the Ephesos Museum. E. Atalay, *Ein späthellenistisches Grabrelief aus Ephesos,* in *AA* 88 (1973): 231–43, figs. 1–3. Atalay illustrates comparable examples now in Vienna (fig. 4), Izmir (fig. 5), and a second example in Ephesos (fig. 6). See also E. Pfuhl, *Das Beiwerk auf den ostgriechischen Grabreliefs* I, in *JdI* 20 (1905): 47–96, figs. 2, 5, 7–8, 10–10a, 11–12; II, *JdI* 20 (1905): 123–55, figs. 22–23. The only comprehensive study of this material thus far is E. Pfuhl, *Die ostgriechischen Grabreliefs* (Mainz 1977), which I had not seen before this study was completed.

44. Inv. 155. H. Brunn-G. Körte, *I rilievi delle urne etrusche,* III (Rome 1916), p. 111, pl. 91.2. B. M. Felletti Maj, *Il fregio commemorativo dell'arco di Susa,* in *RendPontAcc,* 33 (1960–61), 143, fig. 6.

45. See esp., R. Bianchi Bandinelli, *Rome. The Center of Power* (New York 1970), p. 202.

46. For the *Ara Pietatis Augustae,* see H. Bloch, *L'Ara Pietatis Augustae,* in *MEFR,* 56 (1939): 81–120. M. Cagiano de Azevedo, *Le antichità di Villa Medici* (Rome 1951), pp. 56–64. I. S. Ryberg, *Rites of the State Religion in Roman Art,* in *MemAmAc* 22 (1955): 65 ff. F. S. Kleiner, *The Flamen of the Ara Pietatis,* in *AJA* 75 (1971): 391–94. Many altars were set up in Rome and in the provinces under Augustus, but their form is either uncertain or unlike that of the Ara Pacis. G. Fuchs, *Architekturdarstellungen auf römischen Münzen der Republik und der frühen Kaiserzeit* (Berlin 1969), 38, pl. 5, nos. 61–62 (Artemis, Rome); 38, pl. 6, no. 75–76 (Roma and Augustus, Lugdunum); 39, pl. 7, nos. 79–82 (Fortuna Redux, Rome); 44, pl. 9, nos. 105–106 (Providentia, Rome). A Benjamin and A. E. Raubitschek, *Arae Augusti,* in *Hesperia,* 28 (1959): 65–85 (62 altars dedicated to Augustus in the Greek world, 15 of which in Athens).

47. None of the three reliefs was found with an accompanying inscription, but the three can be grouped with nearly 100 other funerary reliefs from Rome which were commissioned by freed slaves or their free-born offspring. See Kleiner 13 ff. P. Zanker, *Grabreliefs römischer Freigelassener,* in *JdI* 90 (1975): 281 ff., figs. 13–14.

48. Matz-Duhn III, no. 3796. E. E. Schmidt, *Römische Frauenstatuen* (Munich 1967), pp. 5–6. Zanker, *JdI* 90 (1975): 280, fig. 14. Kleiner Cat. no. 66, fig. 66.

49. Schmidt, *Frauenstatuen* 1–19. Kleiner 114, 149–51, 155–57, 233.

50. For this «sleeve» motif, see Kleiner 151.

51. Schmidt, *Frauenstatuen,* 1–19. Kleiner 155–56.

52. For the Roman *peplum,* see Wilson, *Clothing of the Ancient Romans,* 134–35, figs. 87, 89.

53. The «Melonenfrisur» was especially popular in Egypt. Portraits of both Berenice I and II wearing this coiffure are known. G. M. A. Richter, *The Portraits of the Greeks* (London 1965), III, pp. 261, 263–64, figs. 1776, 1779–1780, 1820–1823. The «Melonenfrisur» was still current in the second half of the first century B.C. Cleopatra VII wears her hair combed in this fashion on a coin struck in Askalon in 38 B.C. Richter, *Portraits* III, 269, figs. 1857–1859, 1862–1864.

54. Children with pet birds were frequently represented on classical Greek grave stelai. See, e.g., the stele of Eukoline (Figure 15). Numerous other examples are illustrated in Conze I and II. Children also hold pets in the Roman funerary reliefs. Kleiner 83, figs. 66, 90.

55. J. Oliv, *Axel Munthe's San Michele. A Guide for Visitors* (Malmo 1954) without pagination. A. Andren, *Classical Antiquities of the Villa San Michele,* in *OpRom* 5 (1965): 135, no. 25. Kleiner Cat. no. 64, fig. 64.

56. Kleiner 108, 110–11, 155, 232.

57. Kleiner 110–11.

58. For this type of coiffure on Roman funerary reliefs, see Kleiner 131 ff., with bibliography.

59. Wilson, *Roman Toga,* 52. Noble boys under sixteen could wear the *toga praetexta;* see *supra,* note 18.

60. For the different varieties of Roman cloaks, see Wilson, *Clothing of the Ancient Romans* 87–129. It is difficult to determine the specific type worn by the boy on the Capri relief, but it is probably a *lacerna.* The *lacerna* could be worn by boys of any rank. For the *lacerna,* see also Bonfante Warren, *ANRW* I, 4 (1973): 608.

61. For the *bulla,* see Wilson, *Clothing of the Ancient Romans,* 131–32. Bonfante Warren, *ANRW* I, 4 (1973): 605. Noble children wore golden *bullae;* the sons of lower class Romans wore leather ones.

62. Zanker, *JdI* 90 (1975): 280, fig. 13. Kleiner, 232–33, Cat. no. 65, figs. 65a and 65b.

63. Kleiner 114, 126, 232–33.

64. For the trends in late Republican and Augustan male hairstyles, see Kleiner 118–27. For the old-fashioned portrait style, see Kleiner 108–9.

65. For the significance of the *dextrarum iunctio* on Roman funerary reliefs, see Kleiner 23–25, with earlier bibliography.

66. The sole exception is an unusual travertine relief with bust-length representations of a man and two women and a full-length figure of a boy. It was found in the interior of a columbarium on the Esquiline hill in Rome and is now in the chiostro of the Museo Nazionale Romano delle Terme. It dates to 75–50 B.C. Kleiner 243, Cat. no. 83, fig. 83, with previous bibliography.

67. *CIL* VI, 21381. W. Altmann, *Die römischen Grabaltäre der Kaiserzeit* (Berlin 1905), p. 19. Amelung, Vat. Kat. I, 196–97, no. 39a. Kleiner, Cat. no. 67, fig. 67.

68. Amelung, *Vat. Kat.* I, 225–26, no. 80a. O. Vessberg, *Studien zur Kunstgeschichte der römischen Republik* (Lund and Leipzig 1941), pp. 198, 203. P. L. Williams, *Two Roman Reliefs in Renaissance Disguise,* in *JWCI* 4 (1940–41): 47–66. E. Buschor, *Das hellenistische Bildnis* (Munich 1971), p. 63. V. von Heintze, Helbig[4] I, 295, no. 389. Kleiner, Cat. no. 68, fig. 68.

69. *CIL* VI, 28774. Altmann, *Grabaltäre,* 199. Amelung, *Vat. Kat.* I, 348, no. 60E. A. N. Zadoks Josephus-Jitta, *Ancestral Portraiture in Rome* (Amsterdam 1932), p. 56. F. W. Goethert, *Zur Kunst der römischen Republik* (Berlin 1931), p. 46. Vessberg, *Studien* 201–2, 271. Buschor, *Bildnis,* 56, 64. H. von Heintze, Helbig[4] I, 291–292, no. 381. Zanker, *JdI,* 90 (1975): 294, fig. 29. Kleiner, Cat. no. 69, fig. 69.

70. *CIL* VI, 17204. Benndorf-Schöne 319, no. 454. Vessberg, *Studien,* 190, 267. B. Schweitzer, *Die Bildniskunst der römischen Republik* (Leipzig 1948), p. 133. A. Giuliano, *Catalogo dei ritratti romani del Museo Profano Lateranense* (Rome 1957), p. 1, no. 1. H. von Heintze, Helbig[4] I, 816–17, no. 1135. Kleiner, Cat. no. 70, figs. 70a and 70b.

71. *CIL* VI, 9411. Matz-Duhn III, 162, no. 3824. Vessberg, *Studien* 186–87, 267. E. Josi, *Il chiostro lateranense* (Vatican 1970), p. 15, no. 103. Zanker, *JdI* 90 (1975): 295–96, fig. 32. Kleiner, Cat. no. 82, fig. 82.

72. B. M. Felletti Maj, *NSc* (1950), pp. 84–85. Zanker, *JdI* 90 (1975): 294, fig. 24. Kleiner Cat. no. 85, fig. 85.

73. *CIL* VI, 26410. Benndorf-Schöne 15, no. 23. Altmann, *Grabaltäre,* 199. Vessberg, *Studien,* 192, 201. Giuliano, *Ritratti,* 3, no. 3. H. von Heintze, Helbig[4] I, 812–13, no. 1132. Zanker, *JdI* 90 (1975): 290, fig. 19. Kleiner Cat. no. 71, fig. 71.

74. *CIL* VI, 10808. Amelung, *Vat. Kat.* I, 321–22, no. 13a. Zanker, *JdI* 90 (1975): 293, fig. 27. Kleiner Cat. no. 81, fig. 81.

75. W. von Sydow, *AA* 88 (1973): 620, fig. 62. Zanker, *JdI* 90 (1975): 290, fig. 25. Kleiner Cat. no. 84, fig. 84.

76. Matz-Duhn III, no. 3825. Zanker, *JdI* 90 (1975): 293, fig. 26. Kleiner Cat. no. 90, figs. 90a–90c.

77. *CIL* VI, 26375. R. Lanciani, *BullCom* (1881): 198–201. Fiorelli, *NSc* (1881): 137. Altmann, *Grabaltäre,* 196. Zanker, *JdI* 90 (1975): 294, fig. 30. Kleiner Cat. no. 92, figs. 92a–92g.

78. Suet., *Aug.* II. 64.3.

79. *BMC, Empire* I, 21–22, pl. 4.3, 4.5.

80. The reverse legend designates the boys as *principes iuventutis.* See *infra* p. 774 *BMC, Empire* I, 88–91, pl. 13.7–20; 14.1–4. See also M. Vollenweider, *Principes iuventutis,* in *SchwMbll* 14 (1964): 76–81.

81. F. Chamoux, *Gaius Caesar,* in *BCH* 74 (1950): 250–64. For the inscribed statue bases, see also C. Hanson and F. P. Johnson, *On Certain Portrait Inscriptions,* in *AJA* 50 (1946): 389–400.

82. Some of the groups postdate the deaths of the princes. The most famous posthumous group in which Gaius and Lucius are represented with Augustus was found in the Julian basilica at Corinth and is now in the Corinth Museum. See E. H. Swift, *A Group of Roman Imperial Portraits at Corinth,* in *AJA* 25 (1921): 337–63. F. P. Johnson, *The Imperial Portraits at Corinth,* in *AJA* 30 (1926): 142. Johnson, *Corinth IX. The Sculpture* (Cambridge, Mass. 1931), pp. 72–73, no. 135. Johnson, *Gaius and Lucius Caesar,* in *AJA* 45 (1941): 603–9. For the portraits of Gaius and Lucius in general, see esp. the following: L. Curtius, *Ikonographische Beiträge zum Porträt der römischen Republik und der iulisch-claudischen Familie, XIII. Die Söhne des Agrippa,* in *MdI* 1 (1948): 53–67. F. Chamoux, *Un portrait de Thasos. Lucius Caesar,* in *MonPiot* 44 (1950): 83–96. Chamoux, *Nouveaux portraits des fils d'Agrippa,* in *RA* 37 (1951): 220. C. Pietrangeli, *EAA* 2 (1959): 524 ff., *s.v. Gaio e Lucio Cesare.* F. Chamoux, *Un nouveau portrait de Gaius Caesar découvert a Mayence,* in *BAntFr* (1963), 205–6. Simon, *MZ* 58 (1963): 1–18. P. Zanker, *Studien zu den Augustus-Porträts I. Der Actium-Typus* (Göttingen 1973), pp. 47–51. J. Borchhardt, *Ein Kenotaph für Gaius Caesar,* in *JdI* 89 (1974): 217–41.

83. Zanker, *Actium-Typus,* 50–51.

84. Some interest in these colleges had also been shown by Sulla and Caesar. H. Last, in *CAH* 10 (1934): 463.

85. Suet., *Aug.* I. 43.2. H. Last, in *CAH* 10 (1934): 462–63.

86. T. Frank, *Race Mixture in the Roman Empire,* in *AHR* 21 (1915–16): 696 ff.

87. H. Last, in *CAH* 10 (1934): 439–40.

88. H. Last, in *CAH* 10 (1934): 429–34.

89. For the laws, see H. Last, in *CAH* 10 (1934): 443–56. P. E. Corbett, *The Roman Law of Marriage* (Oxford 1930), pp. 31 ff., 118 ff. E. Ciccotti, *Profilo di Augusto. Con un' appendice su le leggi matrimoniali di Augusto* (Turin 1938), pp. 93 ff., 136 ff. H. T. Rowell, *Rome in the Augustan Age* (Norman, Oklahoma 1962), pp. 209–10.

"Princes" and Barbarians on the Ara Pacis

CHARLES BRIAN ROSE

ABSTRACT

The two children in foreign dress on the Ara Pacis Augustae are usually iden-tified as Gaius and Lucius Caesar, the sons of Agrippa who were adopted by Augustus in 17 B.C. They are here reidentified as barbarians from eastern and western regions of the Empire who were brought to Rome in 13 B.C., the year in which the altar was voted. The child on the south frieze and the woman standing behind him are identified as Bosporan royalty directly connected to Agrippa's political activities in the East between 16 and 13 B.C.; a Gallic identity is proposed for the child on the north frieze, and he is associated with Augustus's reorganization of Gaul and Spain during the same period. Together these children functioned as illustrations of the Pax Augusta *brought about through the combined efforts of Augustus and Agrippa.*

It is also argued that two youths on the north frieze are identifiable as Gaius and Lucius. It seems as if the designers of the altar deliberately placed the two boys on the north side and Augustus and Agrippa on the south in order to avoid the problems entailed in grouping them with either their biological or natural father. The appearance of Gaius can be compared with the camillus, *here identified as Iulus, who stands before Aeneas in the Sacrifice at Lavinium*

Reprinted with permission of the *American Journal of Archaeology* 94 (1990): 453–67.

relief. The presentation of Augustus and Gaius as priest and camillus *is evocative of the figures of Aeneas and Iulus performing the same actions on the altar.**

The year 13 B.C. marked the return of Agrippa to Rome after his three-year campaign in the East as well as the *adventus* of Augustus from his reorganization of Gaul and Spain.[1] Peace had ostensibly been established in both eastern and western regions of the Empire as a result of the campaigns of both commanders, and their military partnership was emphasized on gold and silver coins struck at the mint of Rome in 13 and 12 B.C.[2] These included an issue with portraits of Augustus and Agrippa on the obverse and reverse respectively, and also coins of Augustus with a reverse type of two togate men seated on a platform that seems to refer to their joint administrative and political activities. These numismatic issues were, however, balanced by another issue that was specifically dynastic in intent. In 12 B.C. denarii of Augustus were issued with a reverse type of Julia, his daughter, set beneath a *corona civica* and flanked by portraits of her sons Gaius and Lucius Caesar.[3] The *corona civica* had been awarded to Augustus in 27 B.C. and was placed above the entrance to his house on the Palatine;[4] it seems to have been used in this scene to highlight the position of the two boys within the Julian family and to emphasize Julia as the transitional link between them and the emperor.[5]

The themes advertised in the numismatic issues of 13–12 B.C.—triumph, the partnership of Augustus and Agrippa, and dynastic succession—were repeated and amplified in the decoration of the Ara Pacis Augustae, which was voted in 13 B.C. and completed four years later in 9 B.C.[6] The relationship among these themes has not, I believe, been sufficiently explored, and I intend to show that a proper understanding of these issues is directly related to the presentation of children on the altar. In addition to serving as illustrations of Augustan social policy and legislation,[7] the children were used to signify the establishment and future maintenance of the *Pax Augusta*.

The Ara Pacis is the first known monument in the city of Rome in which the imperial family was represented. The majority of the imperial family members on the Ara Pacis are so idealized that identification based on physiognomy alone is extremely difficult, but individualized portrait types have been supplied for two men on the south processional frieze who can be identified as Augustus and Agrippa (Figure 11, sixth from left and far right, respectively).[8] Their connection to the political significance of the altar has frequently been misunderstood, on the basis of two serious misidentifications. Gaius Caesar has traditionally been identified as a boy in eastern dress on the south side who stands next to Agrippa and pulls on his toga (Figures 12 and 20–21).[9] In spite of the unusual and thoroughly non-Roman costume worn by the youth, scholars have consistently argued that this identification is one of the safest, since the close proximity of the boy to Agrippa implies the connection of a father to his son, and Gaius would logically have been positioned next to his father. As a result of this identification, a smaller boy in

similar garb on the northern side of the altar has been identified as Gaius's brother Lucius (Figures 10 and 22). The costumes of the two youths, however, are those of barbarian children, and they are directly related to the military exploits of Augustus and Agrippa.

THE BARBARIAN ON THE SOUTH FRIEZE

Since scholars have traditionally assumed that the child next to Agrippa represents Gaius, they have not really analyzed his clothing and portrait type. An examination of the child's appearance, together with that of the woman standing behind him (Figure 12), enables one to fix their geographical provenance fairly precisely. The portrait itself (Figure 20) does not in any respect resemble images of Gaius but rather that of an eastern prince:[10] the diadem wrapped tightly around his forehead clearly marks him as the member of a royal family and the hairstyle, which features a series of fairly long corkscrew locks reaching down to his shoulders, is paralleled in portraits of eastern kings, specifically those of the Bosporus and Parthia.[11] The shoes also are distinctively eastern: the tongue of the shoe has been pulled up and over the front, and long laces hang down at the sides. The same type

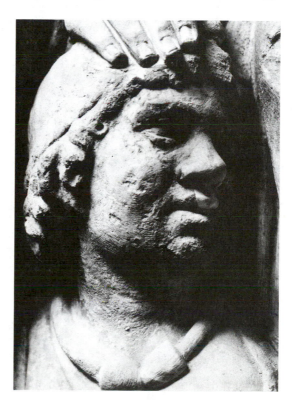

FIGURE 20 Ara Pacis, South Frieze, Detail: Eastern Barbarian *(Photo courtesy of German Archaeological Institute, Rome, neg. no. 32.1738)*

of shoe is worn by the Phrygian god Attis as well as by generic eastern barbarians with Phrygian caps.[12] The torque necklace that he wears would be appropriate for either an eastern or western barbarian, but considering the clear eastern components of the youth's dress it seems likely that the torque is used here as an indication of eastern provenance.[13]

Behind the child appears a woman in low relief who rests her hand on the child's head and looks down toward him (Figures 12 and 21). She also wears a royal diadem and is consequently identifiable as an eastern queen, yet the diadem is bound at the top of the forehead, rather than circling the hair, and it thus differs from the traditional practice. Such a placement of a diadem or fillet is paralleled only in representations of Dionysus, Ariadne, and the maenads, and it seems as if the designers wanted to indicate that this queen's kingdom or family was in some way connected to Dionysus.[14] These two figures are therefore marked as eastern royalty, probably a mother and son, judging by their interaction. Both of them are overlapped by the body of Agrippa and the boy grasps the folds of the commander's toga, thereby establishing an unmistakable link between the two. The historical identities of these two eastern figures are difficult to establish, although an investigation of Agrippa's activities prior to the *constitutio* of the Ara Pacis in 13 B.C. provides a potential solution.

In late 17 or early 16 B.C., after having received a five-year renewal of his proconsular imperium and a grant of *tribunicia potestas* of equal duration, Agrippa and his wife Julia set out for a three-year tour of the Greek East;[15] he returned to

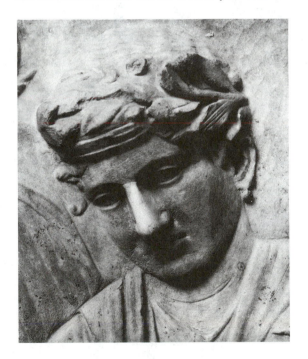

FIGURE 21 Ara Pacis, South Frieze, Detail: Eastern Queen *(Photo courtesy of German Archaeological Institute, Rome, neg. no. 32.1737)*

Rome in 13 B.C., probably at or around the same time Augustus arrived in Rome from Gaul.[16] Many of the details of this tour are unknown, but it is clear from the accounts of Josephus and Dio Cassius that Agrippa's travels were fairly extensive, encompassing Greece, Asia Minor, Syria, and Judaea, and when Agrippa returned to Rome in 13 B.C. he brought with him Antipater, the eldest son of Herod the Great.[17]

One of the most important of Agrippa's activities during this period was his intervention in the affairs of the Cimmerian Bosporus in 14 B.C., which is described in some detail by Dio Cassius:

> And the revolt among the tribes of the Cimmerian Bosporus was quelled. It seems that one Scribonius, who claimed to be a grandson of Mithridates [Eupator] and to have received the kingdom from Augustus after the death of Asander, married Asander's wife, named Dynamis, who was really the daughter of Pharnaces and the granddaughter of Mithridates and had been entrusted with the regency by her husband, and thus he was holding Bosporus under his control. Agrippa, upon learning of this, sent against him Polemon, the king of that part of Pontus bordering on Cappadocia. Polemon found Scribonius no longer alive, for the people of Bosporus, learning of his advance against them, had already put him to death; but when they resisted Polemon through fear that he might be allowed to reign over them, he engaged them in battle. But although he conquered them, he was unable to reduce them to submission until Agrippa came to Sinope with the purpose of conducting a campaign against them. Then they laid down their arms and were delivered up to Polemon; and the woman Dynamis became his wife, naturally not without the sanction of Augustus. For these successes sacrifices were offered in the name of Agrippa, but the triumph which was voted him was not celebrated.[18]

The marriage of Polemon and Dynamis effectively unified the kingdoms of Pontus and the Bosporus, and the triumph voted to Agrippa by the Senate commemorated the apparent establishment of peace in the former kingdom of Mithridates.[19] Our knowledge of Dynamis is not as complete as one would wish, but it is generally accepted that her union with Polemon lasted not much longer than a year;[20] in 13 or 12 B.C. Polemon married another woman named Pythodoris, and there is no record of Dynamis in the area again until 8 B.C. when her monogram reappeared on Bosporan coinage.[21] After Polemon was killed by a neighboring tribe called "Aspurgiani," Dynamis resumed control of the Bosporan kingdom and seems to have ruled until A.D. 7–8.[22] The location of Dynamis between the breakup of her marriage in 13 B.C. and her reappearance in 8 B.C. has never been easy to explain. Rostovtzeff thought that she might have sought refuge with neighboring Sarmatian tribes although he could produce no documentation in support of this.[23] Another scenario is possible, one that has a direct bearing on the iconography of the Ara Pacis: she may have accompanied Agrippa to Rome in 13 B.C., like the son of Herod, and remained there until Polemon's death. The year that marks the beginning of her absence from the area coincides with the time when Agrippa left Asia Minor to return to Rome. Moreover, following her return to the Bos-

porus, Dynamis honored the Augustan family in several significant ways. She dedicated three statues to Augustus and Livia as her saviors and benefactors and issued a series of gold staters bearing the portraits of Augustus and Agrippa; in addition, the city of Phanagoreia was renamed Agrippia.[24] The figures of the eastern queen and prince represented on the Ara Pacis may therefore be depictions of Queen Dynamis and her son, and their position next to Agrippa would consequently be explained by the fact that they were directly related to his activities in Asia Minor.[25]

Such an identification would also explain the use of a Dionysian diadem for the Ara Pacis queen. Dynamis was the granddaughter of Mithridates Eupator, who had emphatically stressed his connection with Dionysus,[26] and an important sanctuary of Dionysus was located in the Bosporan capital of Panticapaeum.[27] The use of this particular type of diadem therefore marked the queen as a member of a family with strong Dionysian associations. It is noteworthy that a personification of the Bosporan people was featured among the "*simulacra gentium*" panels in the Aphrodisias Sebasteion, and one of the reliefs discovered in that complex features a woman wearing a diadem in exactly the way the Ara Pacis queen does.[28] In his article on these reliefs, R.R.R. Smith proposed the Bessi as a possible attribution for this panel, although in light of the theory proposed above, the relief should perhaps be connected with the Bosporus instead.

The presence of Dynamis and her son on the Ara Pacis is perfectly compatible with the central theme of this monument. The wars between Rome and Mithridates Eupator had been among the fiercest of the late Republic; in 88 B.C. Mithridates ordered the slaughter of all Romans and Italians in Asia Minor, and the death toll reportedly reached 80,000.[29] The inclusion of his descendants marching in an official Roman procession and mixing freely with the participants would have served as a concrete indication that peace between Rome and the Bosporan/Pontic kingdom had been definitively achieved. Their presence on the Ara Pacis would also have functioned as visual references to a passage in the *Res Gestae,* where Augustus enumerates the foreign rulers and members of their families who sought refuge or residence with him in Rome.[30]

Although the historical sources inform us that Dynamis was married three times, they are silent on the issue of her children, and it is therefore impossible at present to compare the presentation of the boy on the Ara Pacis with any biographical information on the descendants of Dynamis. The *communis opinio* is that she gave birth to a son named Aspurgos while married to her first husband Asander,[31] yet this assertion is extremely problematic. The evidence rests entirely on one inscription where Aspurgos, ruler of the Bosporos in the late Augustan and Tiberian periods, is described as "ἐκ βασιλέως Ἀσανδρόχου."[32] "Asandrochou" is admittedly close to "Asander" and for this reason it has been assumed that the father's name in the inscription is merely a scribal error for "Asandrou." This theory, if correct, would pinpoint Aspurgos as a son of Dynamis and Asander and supply a name for the eastern prince on the south frieze of the Ara Pacis. The genitive "Asandrochou" would, however, be an unusual mistake for the correct

"Asandrou," and until more conclusive evidence appears, it is difficult to sub-
scribe to this thesis. One can nevertheless safely conclude that the iconography of
the barbarian mother and son on the Ara Pacis indicates their association with the
East, specifically Asia Minor, and the attributions proposed for them above would
fit well with Agrippa's political activities immediately prior to the *constitutio* of the
altar.

THE BARBARIAN ON THE NORTH FRIEZE

On the north processional frieze (Figure 10), the small child traditionally associ-
ated with Lucius Caesar (Figure 22) can also be identified as a barbarian. The por-
trait type features long curly locks centrally parted and bears no relationship to the
portraits of Lucius.[33] Furthermore, the child has been posed so that his uncovered
buttocks are clearly visible to the spectator, and such a presentation of a member
of the imperial family is unprecedented at any time during the Roman Imperial
period.[34] The child is also the only figure on the north and south friezes who wears
no shoes. Like the Bosporan prince on the south processional frieze this child
wears a torque, although the two torques are not the same in design.[35] The neck-
lace here is twisted rather than plain and it seems as if the designers wanted to
indicate that these children were associated with two different regions in which
torques formed part of the traditional costume.

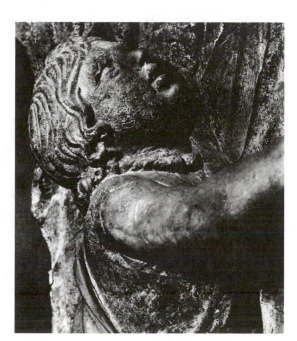

FIGURE 22 Ara Pacis, North
Frieze, Detail: Western Barbar-
ian *(Photo courtesy of German
Archaeological Institute, Rome,
neg. no. 37.1727)*

The child grasps the hand of the man standing behind him and, like the child on the south frieze, tugs at the toga of the man beside him. There are fortunately two iconographic parallels for this boy that aid considerably in his identification. The first and most important occurs on one of the so-called Boscoreale Cups formerly in the Rothschild collection (Figure 23).[36] Augustus is shown seated on a *sella castrensis* and faces three bearded Celtic chiefs all of whom are accompanied by their young sons. Two of these Celtic men push their children toward the emperor and appear to be offering them to Augustus. As H. de Villefosse noted in 1899, the Celtic children on the Boscoreale cups bear an unmistakable resemblance in both pose and appearance to the long-haired child on the north frieze of the Ara Pacis, and he connected this scene to the Celtic campaigns of Augustus, Drusus the Elder, and Tiberius between 16 and 13 B.C.[37] De Villefosse's analysis of the cups has now been expanded in a magisterial study by A. Kuttner, who views this scene as a representation of a visit to Lugdunum by Augustus on the occasion of the inauguration of the cult of Roma and Augustus in 10 B.C.[38] A shorthand version of the same scene appears again on coins from the mint of Lugdunum in 8 B.C. (Figure 24).[39] The implication here is that Celtic chieftains offered their sons to Augustus as expressions of loyalty between their regions and Rome; the children would have received a Roman education and would then presumably pursue a pro-Roman policy once they returned to their homes in Gaul or Germany.[40]

FIGURE 23 Boscoreale Cup: Augustus and Celtic Chieftains *(After MonPiot 5, 1899, pl. 33,2)*

FIGURE 24 *Denarius* of Augustus *(After J. Giard,* Le monnayage de l'atelier de Lyon: des origines au règne de Caligula, *Wetteren 1983, pl. 64.2a)*

While the Bosporan prince and queen on the south frieze served as an illustration of Agrippa's role in securing peace in Asia Minor, the child on the north side functioned as an evocation of the peace Augustus had established in the western regions of the Empire during his reorganization activities in Gaul between 16 and 13 B.C.[41] Although the altar was ostensibly vowed in honor of Augustus's safe return to Rome, it in fact functioned as a testament to the diplomatic activities of both the emperor and Agrippa prior to 13 B.C. These two foreign children were associated with regions and peoples who had caused significant military setbacks to the Romans throughout the Republic; their participation in the Roman *supplicatio* indicated that peace with these regions had finally been achieved through the efforts of Augustus and Agrippa.[42]

This juxtaposition of East and West would accord well with the relief decoration of the inner altar of the Ara Pacis, which seems to have contained a relief with provincial personifications,[43] and other Augustan monuments stress the same East–West theme. Alternating masks of Egypt and Gaul decorated the Forum of Augustus,[44] the Parthian soldier on the breastplate of the Primaporta Augustus was flanked by personifications of Gaul and Spain,[45] and on the Grand Cameo of France a seated Oriental captive with Phrygian cap is placed above a register filled with Celtic prisoners.[46] This motif is also used by Vergil in the *Aeneid:* the shield that Aeneas received in Book VIII featured an image of the battle of Actium juxtaposed with the defeat of the Gauls in 387 B.C.[47]

The advertisement of the joint diplomatic efforts of Augustus and Agrippa on the Roman coinage of 13–12 B.C. was therefore directly related to the visual commemoration of their achievements on the Ara Pacis. The iconography of the

Aeneas relief on the southwest side of the altar may also be associated with their political partnership (Figure 25). The identity of the man standing behind Aeneas is problematic yet his placement next to Aeneas as well as the near join of their staffs indicates a close connection between the two men.[48] There are only two likely possibilities: Anchises and Achates.[49] The mythological tradition concerning the life of Anchises is somewhat varied: although in the *Aeneid* Anchises died before the Trojans reached Latium, Dionysius of Halicarnassus recorded that he remained alive until the fourth year after the founding of Lavinium.[50] Anchises, however, is never shown in Latium in any of the surviving representations of the Aeneas story; moreover, according to the literary tradition, Anchises was lame and he is always shown as such in the scenes where he does appear.[51] Only part of the figure in the Aeneas relief is preserved, but he seems to be a robust man with no apparent physical infirmity.

An identification of this man as Achates, the faithful companion of Aeneas, is much more attractive.[52] The only securely identifiable images of Achates appear in the Late Antique Vatican Vergil: Achates is always dressed in Trojan costume, holds a spear, and stands to the side of Aeneas.[53] Although the manuscript is considerably later than the Ara Pacis, the iconography of Achates in the Vatican Vergil

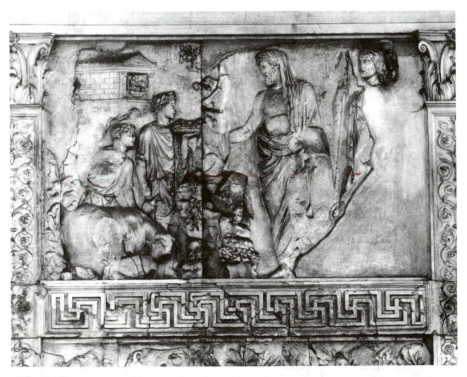

FIGURE 25 Ara Pacis, Sacrifice of Aeneas Relief *(Photo courtesy of German Archaeological Institute, Rome, neg. no. 77.648)*

conforms closely to the figure in question on the Aeneas panel. Achates assisted Aeneas in the exploration of foreign territories, fought by his side in battle, and served in general as his confidant. He appears to have been a Vergilian creation,[54] and scholars of the *Aeneid*—which was published ten years before the construction of the altar—have noted that the character and actions of Achates are so close to those of Agrippa that the latter seems to have served as a model for the former.[55] The Ara Pacis marks the first known appearance of Achates in Roman art, and considering the prominence accorded to both Augustus and Agrippa in the altar's program, it seems likely that the juxtaposition of Aeneas and Achates in the western panel was intended as a mythological evocation of the two generals. It is noteworthy that the *adventus* of Aeneas and Achates as depicted in this scene would have neatly echoed the comparable *adventus* of Augustus and Agrippa in the year in which the altar was voted.

THE PLACEMENT OF GAIUS AND LUCIUS CAESAR

In addition to Augustus and Agrippa, an individualized portrait type has been supplied for a male youth on the northern side of the altar (Figures 14 and 26). The proportional structure of this portrait, and in particular the two pincer-like locks

FIGURE 26 Ara Pacis, North Frieze, Detail: Gaius Caesar

over the right eye, duplicate the portrait type of Gaius Caesar, the elder of the adopted sons of Augustus, as he appears on the altar from the Vicus Sandalarius dedicated in 2 B.C. to commemorate the inauguration of his eastern campaign.[56] There are, in fact, a considerable number of replicas of this portrait type, several of which have been discovered together with portraits of Augustus in dynastic group monuments.[57]

A *mappa* or fringed cloth has been draped over Gaius's shoulder, and this marks him as a *camillus* or acolyte who assists at an offering—presumably the offering that would have been performed by Augustus himself at the time when the altar was dedicated. Although the object he originally held in his right hand is broken, the surface of the break on the lower part of the relief indicates a pitcher as the most likely attribute, and the *camillus* in front of Gaius holds a pitcher in the exact way (Figure 10).[58] Gaius is the only child on the processional frieze to have been presented as an actual participant in the official ceremony, and his presence is further highlighted by the figures flanking him. The woman behind Gaius (Figure 14), perhaps Octavia Minor, holds her two laurel branches almost directly over the head of Gaius; this was possibly an allusion to the two laurel trees that flanked the Palatine house of Augustus. Moreover, both she and the woman in front of Gaius, probably his mother Julia, wear fringed shawls organized in such a way that they hang directly in front of and behind Gaius, thus in a sense constituting formal parentheses around the boy and highlighting his own fringed cloak, which identified him as a *camillus*.[59]

The size of the boy would not be inconsistent with the age of Gaius at the time the altar was erected, although this raises an interesting issue concerning the presentation of children on the monument. Since the altar was vowed in 13 B.C. and not dedicated until 9 B.C., the ages at which the children could be presented were quite flexible. The size of a particular child could be governed by his or her age in 13 B.C., or the designers could increase the height of the child in anticipation of the more advanced age that he or she would have reached at the time the altar was dedicated. Born in 20 B.C., Gaius would have been seven when the altar was voted and eleven at the time it was finished; the size of Gaius as presented in the relief is therefore perfectly compatible with the age range of the boy during the period in which the altar was being constructed.

Behind the figure of Gaius on the north frieze are two children, a boy about the same height as Gaius, clad in a toga and wearing a *bulla,* and a girl considerably younger than either of the two boys who, like many of the other figures in the frieze, carries two laurel branches (Figure 14).[60] In every Julio-Claudian dynastic group I have surveyed, when the children of an individual are included in a monument they are always presented together in a closely knit group.[61] It would seem logical that the remaining children of Agrippa—Lucius Caesar and Julia—were represented here, with the infant Agrippina I possibly included in the missing section of the frieze at the left. The presentation here also requires a remark concerning the height of the boy identified as Lucius, since he was three years younger than Gaius and yet both are essentially the same height. This practice of presenting two princes of slightly differing ages as basically the same height is not

uncommon in the Julio-Claudian period; it is also used for representations of Britannicus and Nero, sons of Claudius.[62] In fact, on a coin struck in Rome one year after the altar was voted, Gaius and Lucius appear on the reverse with their mother Julia and their portraits are of identical size.[63] The presentation of Gaius and Lucius as the same height would also have underscored the fact that Augustus adopted both youths at the same time, not one by one.[64]

In this arrangement, then, Gaius and Lucius were presented on the north side of the altar while Augustus and Agrippa, their adoptive and natural fathers, respectively, appeared on the south side.[65] In dealing with the issue of why the fathers were separated from the sons, one must view the Ara Pacis in the context of other monuments in which the families of Agrippa and Augustus were featured. First, however, a few words regarding the adoption of the two boys in 17 B.C. are necessary. Since Augustus had no sons of his own, the emperor adopted Gaius and Lucius Caesar, the sons of his daughter Julia by Agrippa. While adoption or *adrogatio* played a significant role in the Roman Republic, this was the first known instance in which all of the sons of a *paterfamilias* had been adopted by another, thereby leaving no one to continue the family or *gens*. The designers of imperial statuary groups faced the problem of how to reconcile the visual representation of these two boys with the fact that there were two fathers involved—one biological and the other legal.

While there is no shortage of dynastic monuments in which Gaius and Lucius were represented with their adoptive father Augustus, there is only one extant group in which they were included with their natural father Agrippa. A large statuary group was set up at Thespiae in Central Greece between 16 and 13 B.C. that featured Livia, Agrippa, and Julia, and their children Gaius, Lucius, and Agrippina.[66] During the period in which the group at Thespiae was erected, Agrippa was actually present in the Greek East with full proconsular power. The town of Thespiae apparently intended to honor Agrippa by erecting a monument featuring him with his family, but in composing the honorific inscriptions the designers faced a problem. Gaius and Lucius could not have been listed as sons of Agrippa since the title was no longer valid, yet describing them as sons of Augustus would have highlighted the fact that Agrippa's sons were no longer legally his own, nor were there any additional sons at this time who could have carried on the Vipsanian *gens*. The name "Caesar" has been used in the inscriptions to Gaius and Lucius, thereby indicating that they had been adopted into the Julian *gens,* yet the father's name has been omitted from their inscriptions although it has been supplied for everyone else in the group. The lack of instances in which Gaius and Lucius were associated with their natural father Agrippa, coupled with the evidence from the monument at Thespiae, suggests that there was considerable concern in the Augustan period with the diplomatic difficulties occasioned by the adoptions of 17 B.C., when the sons of Agrippa legally became children of the emperor.

The Ara Pacis is unique among dynastic groups in being the only known monument in which Gaius and Lucius were represented with both their natural and adoptive fathers. This was a state monument of high visibility, and the designers

of the altar consequently faced the problem of where to position the two boys with respect to their two fathers. The placement of the children in close proximity to Augustus would have highlighted the fact that Agrippa died with no male heir to succeed him, and their inclusion in the vicinity of Agrippa would have visually negated the legal paternity of Augustus. It seems that the designers of the Ara Pacis deliberately placed Gaius and Lucius on the north side specifically to avoid the problems entailed in grouping them with either their biological or legal father at the south. Conceptually, this solution is not far removed from the Thespians' decision to omit the names of Augustus and Agrippa from the two boys' inscriptions.[67]

Although Gaius was separated from his adoptive father Augustus in terms of their placement on opposite sides of the altar, there are formal evocations of both father and son in the Aeneas relief by the western entrance (Figure 25). While scholars have often pointed out the similarity in pose and gesture between the figure of Augustus, and that of the sacrificing Aeneas (cf. Figures 11 and 25),[68] no one has noted the similarities between Gaius Caesar and the *camillus* of Aeneas in the sacrifice at Lavinium relief (Figures 26 and 27).[69] Considering the iconographical traditions associated with the Aeneas legend, the safest identification of this figure is Iulus, the son of Aeneas. Scholars of the Ara Pacis have generally assumed the presence of Iulus in the Aeneas panel, especially considering the pronounced emphasis on children in the altar's decorative program.[70] F. Studniczka

FIGURE 27 Ara Pacis, Sacrifice of Aeneas Relief, Detail
(Photo courtesy of German Archaeological Institute, Rome, neg. no. 72.648)

first identified this youth as Iulus and such an identification is perfectly in accord with the representations of Aeneas and Iulus in Italy.[71] In scenes of the flight from Troy, arrival in Latium, and the sacrifice of the Lavinium sow, Iulus always appears as a child, about the same age as Gaius Caesar in the north frieze, and Vergil specifically notes that after Iulus's arrival in Italy he took part in the *ludus Troiae,* which was intended for children seven or eight years of age.[72]

Unlike Aeneas and Achates, Iulus wears contemporary Roman garb and this was probably intended to highlight his connection to Gaius. Although they are not of identical size, both are dressed as young *camilli* with the fringed *mappa* and they each would have held the sacrificial pitcher in their lowered right hands. The similarities in pose between the two *camilli* as well as between Augustus and Aeneas do not seem to be accidental, and the designers appear to have structured the iconography of the Aeneas panel as a deliberate reference to Augustus and his elder adopted son. Even though Augustus and Gaius—priest and *camillus*—were separated on the processional friezes, their combined presence was formally evoked in another sacrifice scene featuring the Trojan founders of the Julian family. It seems likely that Gaius would have served an an acolyte to Augustus just as Iulus assisted Aeneas, and this is probably the reason why Gaius is the only *camillus* in the procession who is not shown in the company of a pontifical college. This association between Gaius Caesar and Iulus was especially appropriate since Gaius had participated in the *ludus Troiae* in 13 B.C., presumably shortly after Augustus's *adventus.*[73] Also relevant in this context is the iconography of the Venus/Terra Mater scene on the east side of the altar.[74] This is the first example in which the goddess is shown with two children rather than one, and it is contemporary with a unique passage in Ovid in which Venus is described as *"geminorum mater amorum."*[75] The emphasis on two children in the Ara Pacis panel as well as in Ovid's poem would in a sense have constituted another reference to Romulus and Remus, yet the fact that the artistic and literary imagery begins to appear at this time suggests that it was conditioned by a specific event. The most logical motive would have been the appearance of the two heirs of the emperor.

In discussing the Ara Pacis, one can therefore speak of an assimilation between historical and mythological figures, yet the connection is not as pronounced as scholars have assumed. The mode of presentation could more effectively be classified as subliminal advertising rather than explicit statement. The similarities in appearance between Aeneas/Augustus and Iulus/Gaius are readily apparent if one views these figures side by side and segmented from the rest of the *supplicatio* participants. Yet such an immediate comparison would not have been possible for the Roman spectator. The historical and legendary figures are placed on different sides of the monument and Gaius and Augustus are not significantly isolated from the rest of the procession. The Trojan/Roman iconographic assimilations were presented in subtle fashion and would probably have registered only subconsciously in the mind of the viewer. Augustus was in the process of creating a dynasty, yet his plans and innovations were always carefully balanced by a keen sense of political realities. The blatant advertisement of his sons as Trojan princes

on a major public monument would have created the appearance of kingship, and the use of a diadem for Gaius less than 20 years after Actium would have fostered politically damaging associations between the Augustan family and eastern royalty. There is no attempt to confer a legendary status on any of the *supplicatio* participants through the use of Trojan costumes; instead, the two attendants at the sacrifice of Aeneas have been dressed as contemporary Romans, and the Trojan past is consequently assimilated to the historical present.

In conclusion, the first representation of the imperial family in Rome was placed in the context of a monument that celebrated the fruits of peace in both the eastern and western regions of the Empire as a result of the campaigns of both Augustus and Agrippa. On a secondary level, the designers focused attention on the two heirs of Augustus, Gaius and Lucius, who were carefully segregated from both their natural and adoptive fathers yet subtly connected to Augustus through the agency of the mythological panels. The central message of the Ara Pacis was closely tied to the "princes" and barbarians who figure in the decoration of the altar. Rome's bellicose relationship with past Celtic and Bosporan/Pontic rulers would now be eradicated through the Romanization of their descendants, and pacific relations would consequently prevail in the future. By the same token, the Pax Augusta achieved through the combined efforts of Augustus and Agrippa would now be continued by their sons. The concept of peace itself therefore acquires a temporal structure here—as if several tenses were conflated in one image. Toward the close of a century of incessant war—both civil and foreign—the hope for the future maintenance of peace lay with the children.

NOTES

*Earlier versions of this article were presented in an abridged form at the Canadian Cultural Institute in Rome in 1986, and at the 1986 AIA meetings in San Antonio (*AJA* 91 [1987]: 280). I would like to thank the following scholars for their comments and assistance, although they do not necessarily agree with my arguments: Richard Brilliant, Marleen Flory, Barbara Kellum, Diana E.E. Kleiner, Fred S. Kleiner, Gerhard Koeppel, John Pollini, Louise Rice, James Russell, and Russell Scott. I am especially indebted to Ann Kuttner for her generous advice and perceptive criticisms.

The following abbreviations have been used:

Fullerton	M. Fullerton, "The Domus Augusti in Imperial Iconography of 13–12 B.C.," *AJA* 89 (1985): 473–83.
Gajdukević	V. Gajdukević, *Das bosporanische Reich* (Berlin 1971).
Giard	J. Giard, *Le monnayage de l'atelier de Lyon: des origines au règne de Caligula* (Wetteren 1983).
Kaiser Augustus	*Kaiser Augustus und die verlorene Republik* (Berlin 1988).
Koeppel	G. Koeppel, "Die historischen Reliefs der römischen Kaiserzeit V: Ara Pacis Augustae," *BonnJbb* 187 (1987): 101–57.
La Rocca	E. La Rocca, *Ara Pacis Augustae* (Rome 1983).
Moretti	G. Moretti, *Ara Pacis Augustae* (Rome 1948).
Pollini 1978	J. Pollini, *Studies in Augustan Historical Reliefs* (Diss. Berkeley 1978).
Pollini 1987	J. Pollini, *The Portraiture of Gaius and Lucius Caesar* (New York 1987).
Roddaz	J.M. Roddaz, *Marcus Agrippa* (*BEFAR*, 253, Rome 1984).
Rostovtzeff	M. Rostovtzeff, "Queen Dynamis of Bosporus," *JHS* 39 (1919): 88–109.
Simon 1967	E. Simon, *Ara Pacis Augustae* (Greenwich 1967).

Simon 1986 E. Simon, *Augustus* (Munich 1986).

Torelli M. Torelli, *Typology and Structure of Roman Historical Reliefs* (Ann Arbor 1982).

1. Dio Cass. 54.25.1–4; 28.1.

2. Fullerton 474, 475, 480; *BMCRE* I, 21, no. 103; 22, no. 107; 23–24, nos. 110–117; 25, no. 121. The issues of 13–12 B.C. are convincingly dated by H. Mattingly (*BMCRE* I, xcvii) and Fullerton to 13–12 B.C., but there is some confusion about the years to which each group of moneyers should be assigned. Both scholars date the issues of C. Antistius Reginus, C. Sulpicius Platorinus, and C. Marius Tro. to 13 B.C., while the issues of L. Caninius Gallus, Cossus Cornelius Lentulus, and L. Cornelius Lentulus are assigned to 12 B.C. This arrangement must, however, be reversed. Each of the obverse types from the first group (Fullerton 474–75), features a *lituus* in the obverse field for the first time, and the reverse types consist of a) sacrificing priests, b) *simpulum, lituus,* tripod, and patera, c) a priest driving a yoke of oxen, and d) a veiled priest holding a *simpulum.* These types deal directly with priests and sacrificial implements and can most logically be associated with Augustus's elevation to the rank of *pontifex maximus* in 12 B.C., rather than 13, when the office was still held, if in name only, by Lepidus. Fullerton and Mattingly's Group I should therefore be moved to 12 B.C. and Group II to 13 B.C.

3. *BMCRE* I, 21–22, nos. 106, 108, 109; Fullerton 475. The moneyer was C. Marius Tro. For the placement of this series in the year 12 B.C. see supra n. 2. Another denarius struck by the same moneyer (*BMCRE* I, 21, nos. 104–105) contains a reverse type of Diana that is commonly identified as a portrait of Julia in the guise of the goddess (Fullerton 476). The features of this numismatic portrait are not individualized nor does the coiffure match the other numismatic and sculptured portraits of Julia. There is absolutely no reason why the type should be regarded as anything other than a representation of Diana.

4. Dio Cass. 53.16.4; A. Alföldi, *Die zwei Lorbeerbäume des Augustus* (Bonn 1973), p. 12.

5. This coin was preceded by an issue in 13 B.C. bearing a reverse type of the *corona civica* set above the house of Augustus (*BMCRE* I, pl. 4.15). In viewing the reverse of this coin in comparison with that of Julia and her sons struck in the following year, one sees that the position of the *corona civica* remained constant yet the image of the actual house of Augustus has been replaced by the portraits of his daughter and adopted sons, the "dynastic household," in a sense, of the emperor. For the dating of these coins, see supra n. 2.

6. For the basic bibliography on the Ara Pacis, see S. Settis, "Die Ara Pacis," in *Kaiser Augustus* 400–26; La Rocca; Torelli 27–61; Pollini 1987, 21–28, 1978, 75–172, and "Ahenobarbi, Appuleii and Some Others on the Ara Pacis," *AJA* 90 (1986): 453–60; D.E.E. Kleiner, "The Great Friezes of the Ara Pacis Augustae. Greek Sources, Roman Derivatives, and Augustan Social Policy," *MEFRA* 90 (1978): 753–85; Simon 1967; I. Ryberg, *Rites of the State Religion in Roman Art* (Rome 1955), pp. 38–48; Moretti.

7. For the connection between Augustan social policy and the representation of children on the Ara Pacis, see Kleiner (supra n. 6) 772–76, and "Private Portraiture in the Age of Augustus," in R. Winkes ed., *The Age of Augustus* (Providence 1985), pp. 116–18.

8. For the portraiture of Augustus, see B. Schmaltz, "Zum Augustus-Bildnis Typus Primaporta," *RM* 93 (1986): 211–43; K. Fittschen and P. Zanker, *Katalog der römischen Porträts in der Capitolinischen Museen und der anderen kommunalen Sammlungen der Stadt Rom,* I: *Kaiser und Prinzenbildnisse* (Mainz 1985), pp. 1–10, nos. 1–9; A.K. Massner, *Bildnisangleichung: Untersuchungen zur Entstehungs- und Wirkungsgeschichte der Augustus Porträts 43 v. Chr.-68 n. Chr.* (*Das römische Herrscherbild* 4, Berlin 1982), pp. 6–41. For the portraiture of Agrippa see Roddaz 613–33, and F. Johansen, "Ritratti marmorei e bronzei di Marco Vipsanio Agrippa," *AnalRom* 6 (1971): 17–48. There has been considerable discussion concerning the object Augustus held in his hand. Pollini 1978, 87–89, has advanced the theory that the emperor originally held a *lituus*, and this proposal has been looked on favorably by Simon 1986, 38; P. Zanker, *Augustus and the Power of Images* (Ann Arbor 1988), p. 121; and La Rocca 38. There is no evidence, however, that the *lituus* was ever carried openly in a public procession; it seems rather to have been used by the *pontifex maximus* specifically in the context of an ongoing *tripudium* (R. von Schaewen, *Römische Opfergeräte, ihre Verwendung im Kultus und in der Kunst* [Berlin 1940], pp. 66–68; F. Dick, *Lituus und Galerus* [Diss. Vienna 1973]). It is clear from the appearance of Augustus's hand, however, that he did hold an attenuated object that was separately attached, and therefore undoubtedly made of bronze. A survey of the participants on both the northern and southern pro-

cessional friezes indicates that each person with his or her hand outstretched in the same manner as that of Augustus carried the laurel branch, especially appropriate for a *supplicatio*. Laurel would be the most likely object to restore in the hand of the emperor, and its bronze appearance would have rendered it the most prominent of the branches carried in the procession. In addition, the members of the imperial family who carry laurel on the Ara Pacis are shown with two branches rather than one. If two laurels were also placed in the hand of Augustus, which seems logical, then a clear connection would have been established between the Domus Augusti and the two laurel trees planted in front of the Palatine house of Augustus by the Senate in 27 B.C. (see Alföldi [supra n. 4]). It is also noteworthy that coins struck from the mint of Rome in 13 B.C. featured a reverse type of the two laurel trees flanking the house of Augustus (Fullerton 475).

9. This identification appears in most of the studies on the Ara Pacis: Zanker (supra n. 8), 215–18; La Rocca 24–31; Torelli 49–50; Pollini 1978, 106–7 (identification since given up); Moretti 270–71. There are few scholars who have identified this boy and the foreign child on the north side as barbarians. Simon 1967, 18 and 21, proposed eastern princes as a possibility; W. Gerke-Voss, *Untersuchungen zur römischen Kinderporträt* (Hamburg 1969), p. 140; Kleiner (supra n. 6), 757, n. 15; and Pollini 1987, 27, postulated that the two youths were Gauls.

10. For the iconography of Gaius Caesar see Pollini 1987, 41–75.

11. Parthia: Tiraios II and Attambelus I (R.R.R. Smith, *Hellenistic Royal Portraits* [Oxford 1988], pl. 78.6–7); Bosporus: Asander (Smith, pl. 77.17) and Rhescuporis II (*BMC* Pontus and Bosporus, pl. 12.3 and p. 54, no. 1).

12. For the shoes of Attis see *LIMC* III, 1, nos. 46, 90, 115, 117, 216, 261, 262; for the Oriental barbarians see R.M. Schneider, *Bunte Barbaren* (Heidelberg 1986) catalog entries KO 1, 2, 3, 9, and 11.

13. On the subject of torques, see Moretti 270–71; G. Becatti, *Oreficerie antiche* (Rome 1955), pp. 104–5; DarSag 5, 375–78; *RE* 2.12 (1937) 1800–1805, s.v. torques (E. Schuppe).

14. A. Krug, *Binden in der griechischen Kunst* (Hösel 1968), pp. 114–18.

15. For Agrippa's travels in the East, see D. Magie, *Roman Rule in Asia Minor* (Princeton 1950), pp. 476–79; Roddaz 419–75; H. Halfmann, *Itinera principum* (Stuttgart 1986), pp. 163–66.

16. The exact date of Agrippa's return to Rome from the East is uncertain. The accounts of Josephus (*AJ* 16.3.3[86]) and Dio Cassius (54.28.1) indicate that Agrippa spent the winter of 14/13 B.C. on the island of Lesbos after which he returned to Rome with Antipater, the son of Herod; at the beginning of winter in 13 B.C. he set out to command the armies in Pannonia. It is likely that he was present in Rome at least by the end of June, 13 B.C., when his powers of *tribunicia potestas* and proconsular imperium were voted and renewed, respectively, along with those of Augustus: Roddaz 477, n. 1; M. Reinhold, *Marcus Agrippa* (Geneva 1933), 122, 124, n. 1; P. Grenade, *Essai sur les origines du principat* (*BEFAR* 197, Paris 1961), 194; *RE* 9A1 (1961): 1266, s.v. Vipsanius (P. Hanslik).

17. Josephus, *AJ* 16.3.3; D. Braund, *Rome and the Friendly King* (London 1984), p. 10.

18. Dio Cass. 54.4–10, trans. E. Cary, Loeb edition, [1917] 1980.

19. Dio Cass. 54.24.7; Roddaz 463–68.

20. The only extensive treatment of Dynamis has been that of Rostovtzeff. See also R.D. Sullivan, "Dynasts in Pontus," *ANRW* II 7.2 (1980): 919–20; Gajdukević 327–32; G. Macurdy, *Vassal Queens* (Baltimore 1937), pp. 29–33.

21. Rostovtzeff 100–102; Gajdukević 327–32; E. Olshausen, "*Pontus und Rom*," *ANRW* II 7.2 (1980): 911; A. Barrett, *Historia* 27 (1978): 438; Roddaz 468; D. Kienast, *Augustus, Prinzeps und Monarch* (Darmstadt 1982), pp. 281–82; *CAH* X, 266–70. The chronology of Polemon's marriage to Pythodoris has been disputed (Magie [supra n. 15] 1341, n. 32), but Rostovtzeff's analysis of the situation still seems the most convincing. For the marriage between Polemon and Pythodoris see Strabo 12.3.29.

22. Rostovtzeff 100–105.

23. Rostovtzeff 103. Rostovtzeff 88–95, pl. 3 has convincingly argued that a bronze female portrait bust found in the Crimea represents a member of the Bosporan royal family. The woman depicted wears a diadem and a Phrygian cap decorated with stars, and her hairstyle is composed of long corkscrew curls that fall to the shoulders. Rostovtzeff's attribution of this portrait to Dynamis is, however, questionable. The features and hairstyle of the portrait are much closer to the coin por-

traits of Gepaepyris, daughter of Cotys VIII and Antonia Tryphaena (*BMC* Pontus-Bosporus 51 and pl. 11.8). The bust is now in the Hermitage, inv. no. 1726: G. Sokolov, *Antique Art on the Northern Black Sea Coast* (Leningrad 1974), p. 117, no. 120.

24. *IGR* I, 875, 901, 902; Rostovtzeff 100–101. In each of these inscriptions, Dynamis is called "philorhomaios." See B. Funck, "Das bosporanische Reich und Rom zur Zeit des Kaisers Augustus," *Das Altertum* 32 (1986): 27–35, and Braund (supra n. 17) 120, n. 92.

25. The only secure portrait of Dynamis is preserved on a gold stater minted in the Bosporus in 17/16 B.C. (Rostovtzeff pl. 4.4). The coin is unfortunately rather worn and the portrait is in profile; it is therefore difficult to compare the physiognomy of the numismatic portrait with the frontally posed queen on the Ara Pacis. There is no evidence regarding the date of her birth or her marriage to Polemon, and her age in 13 B.C. is consequently impossible at present to determine.

26. B.C. McGing, *The Foreign Policy of Mithridates VI Eupator, King of Pontus* (*Mnemosyne* suppl. 89, 1986), 55, 102, 95–97; M.J. Price, "Mithridates VI Eupator Dionysus, and the Coinages of the Black Sea," *NC* 1968, 4; O. Neverov, "Mithridates as Dionysus," *Soobscenija Dosud. Ermitaza* 40 (1973): 41–45; Smith (supra n. 11), 123–24.

27. Gajdukević 175, 182.

28. R.R.R. Smith, "Simulacra Gentium: The Ethne from the Sebasteion at Aphrodisias," *JRS* 78 (1988): 55, no. 5, and 66–67. On the inscriptions accompanying the provincial personifications in the Sebasteion, see J. Reynolds, "New Evidence for the Imperial Cult in Julio-Claudian Aphrodisias," *ZPE* 43 (1981): 317–27, and "Further Information on Imperial Cult at Aphrodisias," *StClass* 24 (1986): 109–17.

29. Val. Max. 9.2. ext. 3; Memnon 31.4; McGing (supra n. 26) 113; Magie (supra n. 15), 216–17.

30. *Res Gestae,* 32. The most complete treatment of foreign royalty in Rome during the Augustan period is Braund (supra n. 17).

31. *IGRR* I, 879; V. Latyschev, *Inscriptiones antique orae septentrionalis Ponti Euxini graecae et latinae* (St. Petersburg 1890) 2, no. 36; *RE* 4 (1896): 1739–40, s.v. Aspurgos (P. von Rohden); Gajdukević 328, n. 69; L. Zgusta, *Die Personennamen griechischer Städte der nördlichen Schwarzmeerküste* (Prague 1955), pp. 363–64. The identification was questioned by Rostovtzeff 103, n. 27, who proposed instead that Dynamis married Aspurgos following Polemon's death, but the inscriptions and coins do not support this.

32. *IGRR* I, 879.

33. Pollini 1987, 77–87.

34. For the traditional dress of Roman children, see Gercke-Voss (supra n. 9) and H. Gabelmann, "Römische Kinder in Toga Praetexta," *JdI* 100 (1985): 497–541, esp. 522–27.

35. The torque worn by the boy on the south frieze is partially restored but its original design is nevertheless quite clear.

36. *BMCRE* I 84–85, nos. 492–95. For the Boscoreale cups see H. de Villefosse, "Le Trésor de Boscoreale," *MonPiot* (1899), 133–68; L. Polacco, "Il trionfo di Tiberio nella tazza Rothschild da Boscoreale," *Atti e memorie dell' Accademia patavina di scienze lettere ed arti,* 67:3 (1954/1955), 3–20; A. Kuttner, *The Boscoreale Cups* (Diss. Berkeley 1987) and "Lost Episodes in Augustan History: The Evidence of the Boscoreale Cups and the Ara Pacis," *AJA* 91 (1987): 297–98; K. Schumacher, *Germanendarstellungen* (Mainz 1935), p. 36, no. 146.

37. De Villefosse (supra n. 36), 150–56, and 162, n. 1.

38. Kuttner (supra n. 36).

39. *BMCRE* I, 84–85, nos. 492–95; Giard 41–42, 93–95.

40. The other issue from the mint of Lugdunum in 8 B.C. featured a reverse type of Gaius Caesar on horseback (Giard 96–97; J. Pollini, "The Meaning and Date of the Reverse Type of Gaius Caesar on Horseback," *ANSMN* 30 [1985]: 119–23). This is clearly a reference to Gaius's participation in military exercises in Gaul at that time, and the coins may well have been distributed to the soldiers as donatives on the occasion of the exercises. These two gold and silver issues were undoubtedly planned to complement each other: one type focused on a Gallic child about to be taken by Augustus to Rome, and the other concerned the son of the emperor who had left Rome for exercises in Gaul. The free movement of children between Rome and Gaul was in itself an indication of the *Pax Augusta.*

41. The success of Augustus's activities in Gaul was also advertised on denarii minted in Rome by L. Caninius Gallus in 13 B.C., which featured a reverse type of a kneeling Gallic barbarian holding a *vexillum* (*BMCRE* I, 27, nos. 127–30). Fullerton 477, n. 35, hesitates in assigning a significance to this coin, but the issue of a Gallic type in the year after Augustus's return from Gaul was surely intended as an indication of the emperor's achievements there.

42. For a stimulating article regarding attitudes toward war and peace in the Augustan period see E. Gruen, "Augustus and the Ideology of War and Peace," in *The Age of Augustus* (supra n. 7), 51–72.

43. Smith (supra n. 28), 72–73; Koeppel 148–51; R. de Angelis Bertolotti, "Materiali dell'Ara Pacis presso il Museo Nazionale Romano," *RM* (1985): 230–34; H. Kähler, "Die Ara Pacis und die augusteische Friedensidee," *JdI* (1954): 89–100.

44. P. Zanker, *Forum Augustum* (Tübingen 1968), pp. 12–14; J. Ganzert and V. Kockel in *Kaiser Augustus* 192–94. Similar masks have been discovered in Spain at Tarraco and Augusta Emerita: see M. Squarciapino, "Ipotesi di lavoro sul gruppo di scultura da Pan Caliente," in *Augusta Emerita* (Madrid 1976), pp. 55–62, and A. García y Bellido, *Esculturas romanas de España y Portugal* (Madrid 1949), pp. 414–16, nos. 416 and 417.

45. H. Kähler, *Die Augustusstatue von Primaporta* (Cologne 1959); T. Hölscher in *Kaiser Augustus* 386–87, no. 215.

46. W.R. Megow, *Kameen von Augustus bis Alexander Severus* (*AMUGS* 11, Berlin 1987), pp. 202–7, no. A85.

47. *Aen.* 8.652–713; G. Binder, *Aeneas und Augustus* (Meisenheim 1971), pp. 185–258; H. Gabelmann, "Zur Schlussszene auf dem Schild des Aeneas," *RM* 93 (1986): 281–300. See also Horace, *Odes* 4.14.41–52, who describes Roman victories over eastern and western regions of the empire.

48. The head of the young man that appears above this figure has been incorrectly restored, and probably belongs to the "Roma" panel on the northeast side of the altar.

49. An identification of this figure as Iulus is highly unlikely. See infra p. 465.

50. Dion. Hal., *Ant. Rom.* 1.64.5; *LIMC* I, 1, 762 (F. Canciani).

51. *LIMC* I, 1, 386–96, 761–64 (F. Canciani); *Aen.* 2.647–49. The possibility of an Anchises identification was mentioned by Koeppel 111.

52. For a discussion of Achates see W. Lossau, "Achates, Symbolfigur der 'Aeneis'," *Hermes* (1987): 89–99. The Achates identification was first proposed by F. Studniczka, "Zur Ara Pacis," *AbhLeip* 27 (1909): 923, and was followed by Moretti 153, and J. Toynbee, "The Ara Pacis Reconsidered and Historical Art in Roman Italy," *ProcBritAc* (1953): 78. It was first altered, without explanation, by S. Weinstock, "Pax and the Ara Pacis," *JRS* 50 (1960): 57, who stated that the individual was Iulus. This identification, again without discussion, has been repeated by Simon 1967, 23, Torelli 37, and La Rocca 40. The figure of Iulus or Ascanius is, however, to be found in front of Aeneas; this is discussed infra p. 465.

53. J. de Wit, *Die Miniaturen des Vergilius Vaticanus* (Amsterdam 1959), pls. 6, 7, 18.

54. *RE* I (1894): 211–12, s.v. Achates (O. Rossbach). See also M. Lossau (supra n. 52), 89–99.

55. D.L. Drew, *The Allegory of the Aeneid* (Oxford 1927), pp. 85–87; M. Lee, *Fathers and Sons in Vergil's Aeneid* (Albany 1979), pp. 106–8; Lossau (supra n. 52), 90.

56. This identification was first suggested by E. Fabbrini, "Di un ritratto inedito di giovinetto nei Musei Oliveriani di Pesaro," *RendLinc* (1955), 478–80, and has been followed by R. Syme, *AJA* 88 (1984): 588, A. Stavridis, *RM* 92 (1985): 336, and Pollini 1987, 22–25, although these scholars have not analyzed the significance of his placement or his costume.

57. See C.B. Rose, *Julio-Claudian Dynastic Group Monuments* (Diss. Columbia Univ. 1987) catalog entries Ocriculum 01, 244–47; Corinth 01, 376–79; Rome 03 (Altar from the Vicus Sandalarius), 280–84.

58. For the implements carried by a *camillus* see von Schaewen (supra n. 8), 65–66. I have examined this relief in the Louvre, and it is clear that this broken area relates in no way to the drapery folds of the woman in front of Gaius.

59. While the fringed shawl may have had some significance aside from its use as a formal device, it would be wrong to identify it as a *ricinium*, or dress appropriate for Roman widows, as does Simon 1967, 21. Julia was betrothed to Tiberius shortly after Agrippa's death, and had already been his wife for two years at the time in which the altar was inaugurated.

60. For the identification of this child as Julia, sister of Gaius and Lucius, see Pollini 1987, 24, n. 28.

61. The 125 extant Julio-Claudian statuary groups have been catalogued and analyzed in Rose (supra n. 57), currently being revised for publication. On the subject of early Imperial statuary groups see also C. Hansen and F.P. Johnson, "On Certain Portrait Inscriptions," *AJA* 50 (1946): 389–400; G.-C. Picard, "Groupements statuaires pour familles impériales," *RA* 17 (1941): 110–11; C. Pietrangeli, "Principali gruppi di ritratti giulio-claudi rinvenuti nel mondo romano," in *Studi Siciliani di archeologia e storia antica* 3 (1949): 30–34.

62. In the unpublished dynastic group from Rusellae now in Grosseto, the statues of Nero, Britannicus, and Octavia as children are all of identical size: see Rose (supra n. 57), 316–21. The two Julio-Claudian princes in a relief from Aphrodisias, probably representing Nero and Britannicus rather than Gaius and Lucius, are also the same height. See R.R.R. Smith, *JRS* 77 (1987): 123–25.

63. *BMCRE* I, 21, no. 106. Gaius and Lucius are also shown as the same size on an issue of aurei and denarii that was first minted in 2 B.C.: *BMCRE* I, 88–91, nos. 513–43.

64. Pollini 1987, 22–28, has argued that the togate boy behind Gaius was too large for Lucius, and suggested that he was originally represented in the missing area of the north frieze. His argument, however, is based upon contemporary growth charts for children and this does not seem applicable to Roman art, where figures were regularly enlarged or diminished in size based upon their importance in the scene.

65. It seems to me likely, as Pollini 1978, 78–80, has argued, that the north and south friezes were meant to indicate two sides of one procession. Nevertheless, the friezes were placed on opposite sides of the altar and are consequently *perceived* by the spectator as two individual scenes, not as a unified group.

66. See the catalog entry for Thespiae 01 in Rose (supra n. 57), 415–20, and A. Plassart, "Inscriptions de Thespiae," *BCH* (1926): 447–51.

67. There are two specific instances in the Julio-Claudian dynasty in which dual paternity was acknowledged. Augustus erected an arch in honor of his natural father Gaius Octavius that featured a statuary group of Apollo and Diana in a quadriga (Pliny *HN* 36.36; F.S. Kleiner, "The Arch in Honor of C. Octavius and the Fathers of Augustus," *Historia* 37 [1988]: 347–57), and at the beginning of his reign Nero paid high honors to his natural father Gn. Domitius Ahenobarbus (Suet. *Nero* 9) and asked the Senate to erect a statue of him (Tac. *Ann.* 13.10). But neither of these instances involved a monument that represented the emperor together with his natural father, and there are no examples in the Julio-Claudian period in which a member of the Imperial family was shown with his biological and legal fathers. J. Pollini has attempted to reidentify the cuirassed commander on the Ravenna relief as Domitius Ahenobarbus ("Gnaeus Domitius Ahenobarbus and the Ravenna Relief," *RM* 88 [1981]: 117–40), yet his new attribution is based on no firm iconographic or archaeological evidence.

68. Simon 1986, 36; Simon 1967, 24; S. Settis in *Kaiser Augustus* 418; K. Galinsky, *Aeneas, Sicily, and Rome* (Princeton 1969), p. 195.

69. Koeppel 110, no. 2.

70. Iulus has usually been identified as the adult male behind Aeneas, but this does not conform well with the iconographic comparanda. For the identification of this figure as Achates, see supra p. 462.

71. Studniczka (supra n. 52) 923. The representations of Aeneas and Iulus after the Trojan War are now conveniently assembled in *LIMC* I, 1, 386–96 (F. Canciani), and *LIMC* II, 1, 860–63 (E. Paribeni).

72. For the *ludus Troiae* see J. Neraudau, *Être enfant à Rome* (Paris 1984), pp. 234–36. The only known instance in which Iulus appears as a young man occurs on a second-century A.C. child's sarcophagus from the Via Cassia in Rome, now in the Terme Museum: *Museo Nazionale Romano, Le sculture I*, 1 (Rome 1979), 318–24, no. 190; Helbig III, 4, no. 2162; *LIMC* I, 1, 391, no. 161; II, 1, 861, no. 11. The front of the sarcophagus features two scenes from the *Aeneid*. At the left side, Aeneas and Dido prepare for the hunt in front of her palace in Carthage; the center and right side are devoted to an episode in Book 7, where Iulus and his dogs wound the stag of Tyrrhus (7.475–502). The sarcophagus was intended for a seven-year-old child who was discovered within it at the time of excavation, and this may explain the emphasis in the decoration on the son of Aeneas rather than the Trojan hero himself.

73. Dio Cass. 54.26.1.

74. Koeppel 111–13; La Rocca 43–48; Simon 1967, 26–29. Here I follow the identification proposed by K. Galinsky (supra n. 68), 191–241. For an attempt to identify this goddess as Ilia see L. Berczelly, ''Ilia and the Divine Twins: a Reconsideration of Two Relief Panels from the Ara Pacis Augustae,'' *ActaAArtHist* 5 (1985): 89–149.

75. Ov. Fasti 4.1; A. Wlosok, ''Geminorum Mater Amorum,'' *Monumentum Chiloniense: Studien zur augusteischen Zeit, Festschrift E. Burck* (Amsterdam 1975), 514–23.

Sculptural Programs and Propaganda in Augustan Rome: The Temple of Apollo on the Palatine

BARBARA KELLUM

Creators of a new world order, bent on establishing an apposite iconography—a new mythology—sometimes make use of different artistic styles to convey different aspects of their message. Thus Napoleon profited both from Ingres' conscious archaism in the creation of his iconic, Olympian Zeus-like *Napoleon Enthroned* as well as from Gros' romantic vision of the emperor as healer among the plague-stricken at Jaffa. In this as in so many things, Napoleon's ultimate exemplar, whether he knew it or not, was Rome's first emperor Augustus. For though art of the Augustan age is often correlated with that of Periclean Athens, there is now evidence that, at least at the beginning of his reign, Augustus experimented with a somewhat different artistic vocabulary.

In 1968 Carettoni's excavations on the Palatine brought to light an extensive series of archaizing terracotta plaques of the so-called Campana type.[1] These plaques, in conjunction with the other sculptural finds, not only confirm the site as that of Augustus' first and most sumptuous temple, the Temple of Apollo on the Palatine, but also yield insight into the archaizing flavor of some of the temple's decoration. Vitruvius had already hinted that the very form of the temple itself was in a sense archaizing. To him the temple appeared to be diastyle—each intercolumniation equal to the thickness of three columns, (Vitruvius, *De arch.*,

Reprinted with permission from Art and Archaeology Publications of the Center for Old World Art and Archaeology, Brown University; from *The Age of Augustus*, ed. R. Winkes (Louvain and Providence 1986), pp. 169–76.

3.3.4)[2]—as close as possible to the ancient Tuscan style of temples as was achievable in marble, of which, as we know from Propertius and Vergil, the Temple of Apollo on the Palatine was built (Propertius, 2.31.9; Vergil, *Aen.*, 6.69). This may well have been in emulation of the lines of the magnificent Capitolium, the Temple of Jupiter Optimus Maximus, Juno and Minerva, which crowned the adjacent hill and from which the Temple of Apollo was to receive the hallowed Sibylline books (Vergil, *Aen.*, 6.72, etc.). The Tuscan temple—with its terracotta decorations—was, of course, the traditional choice. The use of diastyle spacing to approximate those lines here may also have been a kind of conscious archaism— for which we will see parallels in the sculpture—evidently employed as a means of adapting the very new regime's very new temple to the centermost and most venerable hill in Rome.

In this context, the archaizing terracotta plaques, far from being the merely decorative works they have always been taken to be, have meaning in both style and content. The scene of which there are the most preserved examples—those depicting the struggle of Hercules and Apollo over the Delphic tripod—provide case and point. The story involved here is an old and familiar one: Hercules, seeking absolution for a murder he has committed, goes to Apollo's shrine at Delphi. He receives no oracle, and, in a fit of rage, tries to steal Apollo's tripod, attempting to carry it off to establish his own oracle. Eventually the adversaries are separated by Zeus' thunderbolt; the tripod stays with its rightful possessor Apollo and Hercules is sold into slavery to the Lydian queen Omphale. The attempted theft is a very frequent scene in Greek vase painting, especially on the Phintias amphora at Tarquinia: here Hercules grasps the tripod firmly, brandishing his club at

FIGURE 28 Terracotta Plaque:
Apollo and Hercules
*(Antiquarium of the Palatine,
Rome)*

Apollo, who tries to prevent the theft.[3] The popularity of this motif in vase painting has often been linked with historical power struggles at Delphi itself. However, though the heroic nude body types, hairstyles, etc. on the Augustan terracotta plaques are those of the red-figure tradition as well as of early fifth-century sculpture, it is not this most common vase painting composition, where Hercules has the tripod well in hand, that the Augustan artist chooses to use. Rather, he reaches back to the early archaic version of the scene as seen on a mid-sixth-century pyxis (Boston MFA 61.1256), where an earlier moment in the contest is represented;[4] Apollo with his bow and Hercules with his lion skin and club flank a most formidable tripod which, it appears, Hercules would have some trouble shouldering.

The plaques are themselves archaizing in style—though seen here perhaps only in the tiptoe stance of the two adversaries, other of the plaques show the swallowtail drapery folds and other costume details associated with archaizing works of art. However, there was more to the thematic and compositional choice than this. The archaic composition places the two protagonists on an equal footing, but the conclusion of the contest—the ultimate vindication of the rightful possessorship of Apollo—is a foregone one.

After all, Apollo was the god of the temple, having come to the aid of Octavian, and, as Octavian would have it, the whole Roman world, at the battle of Actium, routing the forces of Antony and Cleopatra. Moreover Apollo was reputedly Octavian's divine father. Antony had even accused him of having impersonated the god at the notorious banquet that Suetonius has recorded (*Aug.*, 70) and Octavian on coins contemporary with the temple, although he avoids outright identification with the god, nonetheless draws parallels; for example, he and Apollo appear as obverse types wearing the same distinctive loopless laurel crown.[5]

Equally, however, Antony had associated himself with his ancestor, Hercules. He advertised his descent from Hercules on the reverse of his triumviral portrait gold of 42, and, as Plutarch reports, prided himself on his physical resemblance to the hero, masquerading in Herculean fashion in the streets of Rome (*Ant.*, 4.1–2). As Cicero notes, there was even a statue of Hercules-Antonianus in Rome (*ad Caes. Iun.*, fr. 7). Appian has the young Octavian set the antithesis in the most direct possible terms: the youth, in addressing Antony says (*BCiv.*, 3.16):

> you would have been adopted by him [by Caesar] no doubt if he had known that you would accept kinship with the family of Aeneas in exchange for that of Hercules; for this created doubt in his mind when he was thinking strongly of designating you as his successor.

Our representation of the struggle between the divine progenitors of Octavian and Antony is, then, I believe, an allusion to the historical conflict of Actium, with Apollo appearing in exactly the role Octavian found most suited to himself—that of defender and righteous protector, devoted to maintaining Roman power at Rome—and not Alexandria.

The tripod they struggle for—Apollo's legitimate possession—is a symbol rich in its potential meaning. On Octavian's coinage the tripod had already

appeared labeled RPC—*Rei publicae constituendae*. But golden tripods had also long been a traditional victorious general's dedication at Delphi, even for Roman generals. That this tripod is also specifically to be linked to victory is made self-evident by the winged Nikes with which it is decorated. Lest there be any doubt which victory, one need only refer to the unique lower border[6] which is made up of pendulous lotus blossoms; their association with Egypt and hence with the victory over Cleopatra are clear.

It was, indeed, technically against Cleopatra, the venomous foreign queen, that war had been declared (Dio., 50.4.4). Naturally, she too is depicted here in precisely the same thinly-veiled allegorical manner. The terracotta sima decorations show the same figure repeated again and again: Isis pinioned between a pair of sphinxes. Octavian had banned Isis worship inside the pomerium in 28 (Joseph., *Ant. Jud.*, 18.3) and her presence here would be inconceivable were it not for Cleopatra's own identification with Isis and her portrayal as such in other pieces of Augustan propaganda. Tacked up like a victory trophy, she appears to be waving her sistrum, just as Cleopatra does to summon her animal-headed minions against the virtuous forces of Octavian and Apollo in Vergil's description of the Battle of Actium (*Aen.*, 8.696).

Cleopatra—"The accursed monster" as Horace styles her (*Carm.*, 1.37.21)—was associated with all things female and evil in Augustan poetry (also Horace, *Epod.*, 9; Propertius, 3.11, etc.). She was the real threat, "the frenzied queen . . . 'gainst the Capitol and destruction of the empire" (Horace, *Carm.*, 1.37.6–8). It therefore seems likely that it is again Octavian's victory over her that is mirrored both more and less subtly in others of the series of terracotta plaques from the temple. Even though not all the iconographical nuances of each are discussed, they include a series depicting a youthful Perseus displaying, with Minerva's help, a huge fearsomely humanized Medusa's head, and, in another series, two maidens in eclectic archaizing garments solemnly decorating a betile. The latter seems to be a purposeful Augustan co-option of a symbol once favored by the Ptolemies. Dorothy Burr Thompson has traced this type of pillar monument in Ptolemaic art up to and including a bronze plaque which she believes shows busts of Cleopatra and Antony flanked by the same *meta*-like pillars.[7] The betile on the Palatine example, however, is now clearly Apollo's: the god's cithara, bow and quiver are attached to the shaft itself. Such Apollo pillar monuments are known in Greece and, specifically, the type that seems most to resemble ours is found on the coins of Apollonia, the very town where Octavian was at the university when word of Caesar's assassination reached him. It was also there at Apollonia that Octavian for the first time had had his destiny as a world leader predicted to him (Suetonius, *Aug.*, 94.12). Madame Picard-Schmitter has already pointed out that the Apollo pillar monument of Apollonia must have had a personal importance for Octavian, for such a monument is also reproduced in the Room of the Masks, in the House of Augustus on the Palatine.[8] The terracotta version, then, with the maidens bedecking the peculiarly Augustan Apollo monument type seems like the rest of the terracotta decorations to be in celebration of Apollo's—and Octavian's—

FIGURE 29 Terracotta Plaque: Two Maidens Decorating a Betile *(Antiquarium of the Palatine, Rome)*

greatest victory, the battle of Actium, the association once again confirmed by the unique lower border of pendulous lotus blossoms.

It was not without reason that the Temple of Apollo on the Palatine was popularly known as the Temple of the Actian Apollo (Propertius, 4.6.67). The theme sounded in its archaistic terracottas was, to judge by the literary testimony and the other extant remains, re-echoed throughout the exterior sculpture of the temple. Only a fragment of the temple's marble door frame survives, decorated with the god's own tripod and griffins. We know from Propertius (2.31.12), however, that the doors which once fitted in this door frame were decorated with ivory panels. They showed, on one side, the attempted sack of Delphi by the Gauls in 279, and on the other, the slaughter of the children of Niobe by Apollo and Diana.

In the context of the Temple of Apollo on the Palatine, it would seem to be the victorious Apollo that was celebrated in these ivory panels, just as in the terracotta plaques. Here Apollo is once again the rightful possessor and successful defender of Delphi, this time against the Gauls, as he had been against Hercules. Here too, in what perhaps seems to us the more gruesome choice, the slaughter of the Niobids, Apollo, the loyal son, appears in the role of the just avenger, meting out the punishment for a mortal's insult to his mother. As with the famous panels on the doors of the Temple of Apollo at Cumae, the scenes here may well have been meant to reflect something about the dedicator of the temple as well as the god he honored. At the beginning of Book 6, Vergil envisions Aeneas' arrival at the Cumae Temple—restored in actuality in the Augustan period—and has the hero

lovingly describe the ivory panels decorating the door, all revolving more or less around Daedalus the founder of the temple. The *Aeneid* passage ends with Aeneas' promise to Apollo for a future temple to be built to him in "solid marble" where the Sibylline books will be stored (6.69–74)—the contemporary Temple of Apollo on the Palatine itself, of course. Its own doors are too surely a testament to Augustus' own abilities as a defender of the Roman world at Actium and as the avenger of his divine adopted father, Iulius Caesar, once again mirrored in the deeds of Apollo.

One final exterior sculptural group should be discussed, on first impression a seeming anomaly among the other victory trappings of the temple. Unfortunately, it is a group of which we have no monumental remains, but it is the one that is perhaps most often mentioned by contemporaries. In numbers alone the group must have been overwhelming, for these were statues of Danaus and his fifty daughters the Danaids. The context itself was special, for they appeared in the intercolumniations of the portico that surrounded the temple, the columns of which Propertius tells us were of Punic marble (2.31.3), *giallo antico,* yellow marble splotched with blood-red. Most apt for the ladies that stood between them, for the Danaids of course are the fifty brides who—save one—on their father's orders, murdered their cousin-husbands on their wedding night. Though we have only the word of a late scholiast on it, the ill-fated bride-grooms, the fifty sons of Aegyptus, may also have been present here in the form of fifty equestrian statues (*Schol. Pers.*, 2.56). Be that as it may, the grouping of Danaus and his daughters for which we do have contemporary literary evidence is in itself unique. For it was not, as Gagé has tried to explain it away, a Neopythagorean display for connoisseurs.[9] He compares it to the representation of the Danaids in the so-called Neopythagorean Basilica at the Porta Maggiore—here appearing as they almost invariably do in art, as watercarriers in the underworld, symbols of the uninitiated. But the Danaids in the portico of the Temple of Apollo were of a very different sort—this was a representation of the crime in progress. Ovid tells us specifically that Danaus himself the *barbarus pater* stood here with sword drawn (*Tristia,* 3.1.60–62) mustering his daughters to their deed.

What, then, were statues of the Danaids doing in the portico of the temple? Aeschylus pictured the Danaids in his *The Suppliants* as briefly considering seeking aid from Apollo (1.214.215) and this could be their role, but there is something far more threatening and more sinister about them as well.

A closer look at the Danaids themselves can be illuminating. They were descendants of that ill-fated Argive priestess of Hera, Io who, loved by Zeus, aroused the jealousy of Hera. She was turned into a heifer, guarded by Hera's Argus until her release by Hermes. Finally she was chased remorselessly by the gadfly sent by Hera until she reached, of all places, Egypt. Here she was received by Isis: this was a scene that was popular in Pompeian painting as in this version from the Temple of Isis in Pompeii with Isis, a snake coiled around one arm, seated in the foreground welcoming Io. Io herself, the priestess who had once been a heifer, was readily identified with Isis, who had her own association with the

Egyptian cow-goddess Hathor. It was in Egypt that Io bore her child by Zeus, Epaphus and here that Epaphus in turn sired the line that led down to the quarreling brothers Aegyptus and Danaus and, respectively, their fifty sons and fifty daughters. Like the Ptolemies, these were Greeks that were taken to be Egyptians, and, for whatever reason, it is interesting that in both Apollodorus' and Hyginus' lists of the Danaids, one of them is named Cleopatra (Apollodorus, *Bibl.*, 2.1.5, 4 and 7; Hyginus, *Fab.*, 1.70). In broader terms, however, these statues in the temple portico served not only as Cleopatra surrogates, but as an ultimate symbol of fratricide and civil war.

The rare iconography of the crime of the Danaids, after all, makes one other significant appearance in Augustan art—their *nefas,* their impious crime—''the youthful band foully slain on one nuptial night, and the chambers drenched with blood'' (*Aen.*, 10.497–498)—is engraved on Pallas' fatal balteus which plays such a crucial role in the final scene of the *Aeneid*. Though the balteus is something that existed only in Vergil's imagination, a line drawing of a balteus or sword-belt decorated, in this case, with signs of the zodiac serves to suggest it. Two small but precious fragments of a south Italian bell krater are the only representations we have of the bloody wedding night itself—repeated male figures blissfully sleeping on couches with here a telltale scabbard on the ground, and there a female figure with a knife in hand.[10] In the *Aeneid* the balteus on which this scene was represented is ripped from Pallas' dead body by the victorious Turnus—who, in so doing, as Vergil points out in one of his rare asides, seals his own fate (*Aen.*, 10.496–502). Turnus puts the balteus on his own shoulders—a double-edged irony in this, since, in one sense, this spoils-prize, the belt of Pallas, is a more appropriate badge for Turnus: Turnus, like the Danaids and sons of Aegyptus engraved on the belt, was of Argive descent (*Aen.*, 7.370–372); while the center device of Aeneas' shield looked to the future with its depiction of the battle of Actium, Turnus' looked to the past, for his device was a portrayal of his ancestress, Io (*Aen.*, 7.789).

In the final moments of the *Aeneid,* when Aeneas is seriously considering Turnus' plea for mercy, it is the sight of Pallas' balteus ''that memorial of cruel grief'' that not only recalls to the hero his obligations to Pallas and his father Evander, but fires him ''with fury and terrible wrath'' to the point that he immolates Turnus. In doing this, of course, he kills one embodiment of *furor impius,* who was at the time wearing a representation of another—that scene of cousins killing cousins, the wedding night of the Danaids.

It was exactly this kind of madness that Octavian claimed to have imprisoned with his victory over Antony and Cleopatra and the closing of the gates of Janus in 29—as celebrated by Vergil in *Aeneid*, 1.293–296 and by Augustus himself in his *Res Gestae*, 2.13. The Danaids stood in the portico of the temple as reminders in themselves of the bloody past over which Apollo—and Octavian—as advertised in the terracotta decorations and the ivory door panels—had triumphed.

The Age of Apollo was at hand and so too the all-important peace and return to order that that implied. The visitor to the temple, after surveying the thinly

veiled allegorical victory trophies on the exterior of the temple, celebrating the battle that had won Octavian his *auctoritas*—Actium—would then have proceeded inside the temple to experience in three-dimensional terms the central message of the peace brought by that victory. For here were ranged three of those pieces of sculptural booty from Greece, three fourth-century originals, at least according to Pliny: an Apollo by Skopas, accompanied by images of his mother, Leto by Cephisodotus, and his sister, Diana by Timotheus (*Nat. Hist.,* 36.25; 24; 32). Fragments of drapery and a much-battered colossal Apollo head have been discovered recently. Fortunately, however, we also have a reproduction of all three, lined up as if for the camera, on the Sorrento base—Apollo in the middle, striding forward slightly, carrying his cithara on his left arm and holding the remains of a patera in his right hand; flanked by his sister to his right carrying a torch and his mother to his left. The statue of Apollo alone appears on mint of Rome coins in the Augustan period; here the god extends his patera over an altar and he is clearly labeled as the Actian Apollo (the ''ctio'' of Actio visible at the bottom of the coin). That the statues may have been utilized in a tableau is at least strongly implied, I think, by a series of Neo-Attic reliefs that have always been dated—and justifiably so—to the Augustan period.[11] The Actian Apollo type is exactly parallel to that on the coin, though joined again here, as we know from Propertius he was in the temple display (2.31.15–16), by Diana with her torch and Leto. Though the scene of the reliefs has often been taken to be Delphi, I would point out that not only are the statue types those we have seen on the Augustan coin and the Sorrento base, but that the temple in the background is in each of the reliefs not the Delphic Apollo temple but invariably a very florid Corinthian order temple just as we know the Temple of Apollo on the Palatine was.[12]

The grouping of the figures relates back again to Greek vase painting where Apollo appears, cithara in one hand and patera in the other, assisted by his mother and sister in making an offering. The motif of the offering Apollo in vase painting has been studied by E. Simon, who has determined that this is an act of the youthful Apollo (almost boylike in this version by the Pan Painter [Br. Mus. E579]) and, in fact, a depiction of the offering Apollo made in absolution to Zeus and the powers of the lower world after he had had to kill that horrible female snake monster, the Pytho, in order to take rightful possession of Delphi.[13] The Greek version of the offering Apollo scene—found also in another version on an amphora in Karlsruhe (205 B2402)—was parallel to scenes of human warriors assisted by the female members of his family making a sacrifice either departing to or returning from battle. Apollo, after all, in seeking absolution for killing the Pytho was to become himself the great granter of absolution to mortals. The sight of Apollo making an offering in the inner sanctum of the Temple of Apollo on the Palatine may well have reminded a Roman visitor of the action that had first precipitated the offering—the killing of the Pytho (conceivably yet another allusion to Cleopatra)—but also of the god's role as a giver of absolution. Horace, in bemoaning the horrors of civil war in *Odes* 1.2, seeks expiation for the nation's sins and his first thought is of *augur Apollo,* his final one of *the* youth himself, Octavian/

Augustus. Indeed, as Augustus himself states in the *Res Gestae* pardon was a part of the Augustan peace (1.3). But in good Roman fashion too, there is also the reminder that this was a peace that stemmed from victory, for it is not Artemis as on the Karlsruhe vase but a winged Nike who assists Apollo in making his offering.

In the cult statues themselves the message that underlay all the sculpture from the temple culminated. A celebration of the victory of the youthful Apollo—and, through him, of the youthful Octavian—with its promise of a new era of expiation and peace is given three-dimensional reality.

Clothed in its eclectic, archaistic splendor, the Temple of Apollo on the Palatine—like the *Aeneid* itself—linked the Augustan present to the remote heroic past, celebrating Octavian's Actian victory in the guise of the deeds of Apollo.

But, if this was the message, how successful was the statuary program in conveying it? Of course this is an area in which our insight is, at best, severely limited; yet, as luck would have it, some evidence does survive which pertains. For, with the Augustan peace came prosperity and a whole line of consumer and luxury goods that featured reproductions of the cult statues themselves—on an Arretine bowl one sees the standard sacrifice scene, Apollo and Nike with altar, Diana and Leto (Boston MFA 98.867). And then on a beautiful Augustan candelabrum base in the Conservatori Palace is Apollo on one side, Diana with her torch on the next, and finally Leto (Helbig[4] 1662). There is no better testimony, I think, to the comprehension of the message of the statuary program at the Temple of Apollo on the Palatine and to its popularity.

NOTES

1. G. Carettoni, in *RendPontAcc* 39 (1966–1967): 69–75; *RendPontAcc* 44 (1971–1972): 123–39.
2. Though technically systyle (P. Gros, *Aurea Templa* (*Bibl. Éc. Franc. Fasc,* 231), Rome (1976) p. 214, the Temple of Apollo on the Palatine is surely Vitruvius' *Apollonis et Dienae aedes* 3.3.4, *cf.* Vergil, *Aen.*, 6.69.
3. D. von Bothmer, in U. Höckmann and A. Krug, eds., *Festschrift für Frank Brommer* (Mainz 1972), pp. 51–63.
4. Ibid., pp. 51–52.
5. D. Mannsperger, in *Gymnasium* 80 (1973): 318–404, esp. 396–97.
6. M.A. Rizzo, in *RivIstArch* 23–24 (1976–77): 50, on rare border type. The Egyptian association is my own.
7. D.B. Thompson, *Ptolemaic Oinochoai and Portraits in Faience* (Oxford 1973), pp. 62–69.
8. M. Th. Picard-Schmitter, in *MonPiot* 57 (1971): 78 ff.
9. J. Gagé, *Apollon romain* (*Bibl. Éc. Franc.*, 182), (Paris 1955), pp. 582–29.
10. L. Curtius, in *JOEAI* 39 (1952): 17–21.
11. Helbig[4], 3240.
12. H. Bauer, in *RM* 76 (1969): 183–204.
13. E. Simon, *Opfernde Götter* (Berlin 1953) pp. 13–46.

Alcestis on Roman Sarcophagi

SUSAN WOOD

ABSTRACT

The sarcophagus of Caius Junius Euhodus and Metilia Acte belongs to a small group of Roman sarcophagi which depict the death of Alcestis. Unlike most other members of the group, however, the Euhodus sarcophagus also portrays Alcestis's return from death in a prominent position on the front of the box. This variation in the use of the mythological theme suggests that while in most cases the story of Alcestis was chosen because of its pathos, the theme of possible triumph over death may also have appealed to some of the clients who commissioned the sarcophagi. The inscription of the Euhodus sarcophagus confirms that the couple for whom it was made subscribed to the cult of the Magna Mater, a cult which evidently did believe in the possibility of life after death.

The language of symbolism on this monument, however, seems to be derived not from mystery rites but from familiar scenes of everyday life. The scene in which Alcestis is restored to her husband by Heracles bears a strong resemblance to a conventional wedding scene. Such a visual reference would underscore the theme of reunion implicit in the story of Alcestis and Admetus. Euhodus and Metilia, whose portrait faces appear on the mythological figures, expected to be united in death at least in a physical sense, since their bodies were to be interred in the same sarcophagus. In view of their religious beliefs, they may have hoped for a reunion in a life after death as well.

Reprinted with permission from the *American Journal of Archaeology* 82 (1970): 499–510.

The degree to which religious symbolism was intentionally incorporated into the decoration of Roman sarcophagi, and the extent to which that symbolism referred to the hope for a life after death, have long been the subject of one of the liveliest controversies in the study of Roman art. In view of the diversity of religious beliefs and experiences in the society of imperial Rome, as well as the natural differences of faith or skepticism among human beings, the symbolic content of sculptured sarcophagi probably differed considerably depending on the beliefs of the clients who commissioned them and the ability of the craftsmen who executed them to manipulate visual imagery. The precise prevalence or rarity of eschatological symbolism could never be completely assessed unless the precise variations in religious and philosophic beliefs of the commissioners of sarcophagi could be known, clearly a nearly impossible goal. In a few instances, however, we are fortunate in knowing something of the religious beliefs of the individuals who commissioned sarcophagi, and this knowledge can help us to understand the visual imagery on their funerary monuments.

Such a monument is the sarcophagus of C. Junius Euhodus and Metilia Acte[1] (Figure 30), a work of unremarkable artistic quality, but one which possesses both a highly informative inscription and an exceptionally rich, coherent iconography. The inscription on the lid of this sarcophagus reads:

<div align="center">

D. M.

C.IVNIVS.PAL.EVHODVS.MAGISTER.QQ

COLLEGI.FABR.TIGN.OSTIS.LUSTRI.XXI

FECIT.SIBI.ET.METILIAE.ACTE.SACERDO

TI.M.D.M.COLON.OST.COIVGSANCTISSIM

(*CIL* xiv, 371)

</div>

To the Manes: C. Junius Euhodus of the tribe Palatina, five-year magistrate of the twenty-first lustrum of the guild of carpenters at Ostia, made (this monument) for himself and for his wife, Metilia Acte, priestess of the Great Mother of the gods at the colony of Ostia, most sacredly (or, alternatively, "most saintly woman").[2]

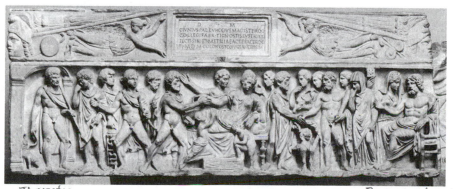

FIGURE 30 Euhodus Sarcophagus *(Vatican, Museo Chiaramonti: photo courtesy of German Archaeological Institute, Rome, neg. no. 72.590)*

Therefore, the sarcophagus is conventionally dated to the first decade of Marcus Aurelius's reign (A.D. 161–170), during which the twenty-first lustrum of the guild of Ostian carpenters would have taken place, though a slightly earlier date, at the end of the reign of Antoninus Pius, has also been proposed, based on a different reckoning of the era.[3]

The sculptural program of the sarcophagus depicts the myth of Alcestis, using figural groups common to a number of sarcophagi which portray the same story, but altering and recombining the composition to lay more than usual stress on Alcestis's victory over death. The frieze thus expresses not only the couple's pride in their virtues during life—in particular, their devotion and family solidarity—but their belief in a life after death. The hope for a possible reunion of the pair in the afterlife is suggested through identification of themselves with those mythical archetypes of marital devotion who achieved a similar sort of reunion.

Only the front of the lid and the front of the box are fully decorated with sculpture; a griffin is carved in shallow relief on the left short side of the sarcophagus, but the other short side is blank. The central tabula on the lid, which bears the inscription, is flanked and supported by two winged victories; above them are two horizontal torches, their flames inclined slightly downward toward the outer edges of the lid. The spaces below the flames of the torches and beyond the feet of the victories are filled with apparatus related to the cult of the Magna Mater,[4] cymbals, drums, and flutes, while the corners are finished with acroterial heads of young men wearing Phrygian caps, probably representations of Attis.[5]

Before describing the reliefs on the body of the sarcophagus, a brief recapitulation of the myth, or more correctly, the folk tale of Alcestis would be useful.[6] Alcestis, a daughter of Pelias, was won in marriage by King Admetus of Pherae. Admetus learned on his wedding day that he was fated to die young; a late interpolation into the story[7] states that he incurred this fate by neglecting to sacrifice to Artemis, who filled the bridal chamber with snakes as a sign of her wrath. Apollo, who had befriended Admetus while serving him as a punishment for killing the Cyclopes,[8] persuaded the Fates to allow Admetus to live if a friend or relative would die in his place. Admetus asked his parents to die for him, but they refused; Alcestis then volunteered to take her husband's place, and died for him.

In most versions of the myth earlier than Euripides' drama, all these events seem to have taken place on the couple's wedding day. Euripides was evidently the first to give greater depth to the couple's relationship by establishing that they had been married several years and were the parents of children.[9] After Alcestis's death, Heracles, who was a guest in Admetus's house, rescued her and brought her spirit back to the world of the living. According to some versions of the story, as in Euripides' *Alcestis* (1141–1142), Heracles met and struggled with Thanatos above ground; however, Plato (*Symp.* 149 b–c) and Apollodorus (I.ix.14) state that Alcestis descended to the underworld before she was rescued.

The principal relief on the sarcophagus[10] depicts Alcestis's death and her return from the underworld, the former scene occupying the center and left side of the front. Admetus and Alcestis bear the portrait faces of C. Junius Euhodus and

Metilia Acte in this scene. The monument is thus one of the earliest examples of sarcophagi which thrust real people into mythological contexts.[11] The artist seems quite undisturbed either by the incongruity of the aging, homely faces and youthful bodies or by the largeness of the heads in proportion to the rather short, squat figures, a system of proportions typical of Roman folk art and quite prevalent in sarcophagi of this period.[12] Alcestis is sinking backward on a couch, surrounded by attendants and mourners. Admetus, the most conspicuous male figure of the group, strides forward from the left and stretches out his right arm to his wife. In front of the couch are two small, weeping children, while behind the couch are two women. The woman to the left shows traits of advanced age and is probably meant to represent Alcestis's mother. An old man leaning on a staff, who appears in the background of the relief just behind Admetus, probably represents her father.[13]

Behind Admetus in the foreground is Apollo, identifiable by his bow and tripod, who runs away toward the left since he cannot be contaminated by being present in a house of death (Euripides, *Alc.* 22–23). Beyond Apollo are two male attendants, possibly Admetus's hunting companions.[14] One, in the background, gazes toward Alcestis, while the other, in the foreground, averts his eyes sorrowfully and holds a rotulus which may represent the Delphic prophesy of Admetus's death.[15] At the far left stands a man, framed by an arched doorway, who carries a spear and leads a dog. Robert identifies him, probably correctly, as Thanatos.[16]

The scene of Alcestis's return occupies a little more than a third of the front. In this scene, only Admetus bears a portrait face: Alcestis here is an idealized youthful female. Directly to the right of the death bed, Admetus stands clasping hands with Heracles across a low, cave-like archway in which Cerberus appears. Behind Heracles stands the deeply veiled figure of Alcestis's ghost. Alcestis inclines her head but raises her left hand as though about to unveil herself. Behind her stands Proserpina,[17] who holds a torch in her right hand and lays her left affectionately on the shoulder of her enthroned husband Pluto, as though pleading for Alcestis's release, while Pluto gestures acquiescence with his right hand.[18] In the background of the frieze three female figures, possibly representing either the Fates or three heroines in the underworld,[19] can be seen between the figures of the protagonists.

The familiarity of the designer of the sarcophagus with Euripides' version of the Alcestis myth is demonstrated by details such as the presence of Apollo and Thanatos in the death scene,[20] and the manner in which Heracles presents the rescued Alcestis to her husband.[21] Yet the scenes on the front of the Euhodus sarcophagus contain two noteworthy divergences from Euripides' version: the presence of the parents of Alcestis in the death scene and the presence of Pluto, Proserpina, and Cerberus in the return scene. The former feature, shared by most other Alcestis sarcophagi, can be easily explained as part of the identification of the deceased with Alcestis, in an effort to portray thoroughly the grief of the surviving relatives.[22]

The appearance of underworld deities in the return scene, however, though not consistent with Euripides' version, is justified by other literary sources.[23] This

version of the Alcestis story permits greater moral commentary on the heroine's actions, in that the gods of the underworld can be shown voluntarily releasing Alcestis as a reward for her courage. Plato tells the story in this way for precisely this reason and omits all mention of Heracles, implying that Alcestis's release was a purely voluntary decision of the gods.

> And again, nothing but Love will make a man offer his life for another's—and not only man, but woman, of which last we Greeks can ask no better witness than Alcestis, for she was ready to lay down her life for her husband. . . . But hers was accounted so great a sacrifice, not only by mankind but by the gods, that in recognition of her magnanimity it was granted—and among the many doers of many noble deeds there is only the merest handful to whom such grace has been given—that her soul should rise again from the Stygian depths.
>
> (*Symp.* 179 b–c, Joyce trans.)

Some Alcestis sarcophagi like the one from the Villa Faustina at Cannes[24] depict Alcestis before Pluto and Proserpina, while other mythological sarcophagi which use some of the same cartoons, such as the Proserpina sarcophagus in Florence, show the heroine being led toward the gate of the underworld by Hermes.[25] Naturally, that version of the story which reflects most favorably on the virtue of Alcestis and, by analogy, the deceased, would be favored by designers of sarcophagi. But only the Euhodus sarcophagus emphasizes the agreement of the underworld gods to her return. On the short side of the Cannes sarcophagus, for example, Alcestis approaches the enthroned Pluto, as if at the moment of her arrival in the underworld, while on the Euhodus sarcophagus she moves away as Pluto gestures in release and farewell. The departure scene on the Euhodus sarcophagus is created by a synthesis of the two isolated scenes of Alcestis's arrival in and return from Hades usually relegated to the short ends of sarcophagi. Both are given added importance by placement on the front of the monument.

Even here, of course, the return scene is clearly subsidiary in the composition to the central scene of Alcestis's death; the tripartite grouping of the figures causes attention to focus on the scene expressing Euhodus's immediate grief at the loss of his wife.[26] But where other sarcophagi hint tentatively at the hope for a life after death for the deceased and for a favorable judgment by the gods, the Euhodus sarcophagus boldly asserts that Metilia Acte, like Alcestis, has earned victory over death by her virtue and wifely loyalty.

Since the sarcophagus was intended not only for Metilia but for her husband as well, C. Junius Euhodus's virtue and consequent right to victory over death are likewise stressed by selective adherence to Euripides' version of the story and to the conventional format for Alcestis sarcophagi. The scenes generally shown on the sarcophagus fronts of the Alcestis type are, of course, Alcestis's death, in the center; to the left, Admetus pleading with his father whom he asks to die in his place; and to the right, Heracles' farewell to the newly reunited couple, represented by a handclasp between Heracles and Admetus.[27] The Cannes sarcophagus

and a sarcophagus in the Villa Albani at Rome (Figure 31)[28] typify this arrangement. The Euhodus sarcophagus retains the handclasp between Admetus and Heracles, but completely omits the confrontation of Admetus and Pheres. Thus, it suppresses all reference to the cowardice and selfishness of both father and son, which was so mercilessly and memorably depicted by Euripides (*Alc.* 614–740).[29]

The sarcophagus of Ulpia Cyrilla[30] and a sarcophagus in Genoa[31] similarly suppress the scene between Admetus and Pheres, the latter substituting for it the scene of Alcestis's return. The Genoa sarcophagus is the only extant example of the type besides the Euhodus sarcophagus to show this scene on the front.[32] But the Euhodus sarcophagus further flatters Admetus's character by giving him a prominent place as a distraught mourner in the death scene.[33] In addition, the prominence of the return scene on this monument stresses not only Alcestis's reward for courage but Admetus's reward for his hospitality to Heracles through the restoration of his wife. Furthermore, the notion that the couple's reward for virtue takes the form of a happy reunion is emphasized on this sarcophagus as on no other.[34]

When used on sarcophagi, the theme of Alcestis was probably chosen in the majority of cases because of its motif of untimely death.[35] The flattering analogy of the deceased to a courageous woman would also have been an attractive aspect of the theme. The implications of resurrection were unavoidable but were usually carefully deemphasized, as would be expected in monuments made for the comparatively wealthy and well-educated classes of imperial Rome in the Antonine period. Such patrons would have been exposed to a variety of conflicting religious and philosophic beliefs about a life after death, and could hardly be expected to have strong convictions of their own on the subject.[36] Metilia Acte, however, was a priestess of the Magna Mater, as the inscription on her sarcophagus informs us. Thus, she subscribed to a cult which had not only been associated with funerary rites since earliest times but also promised immortality to its initiates through identification of themselves with Attis, the god of vegetation who dies and is reborn every year.[37]

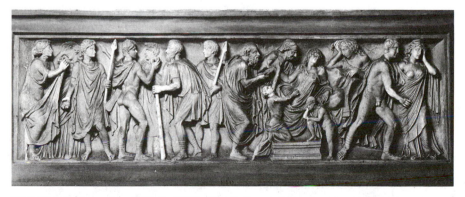

FIGURE 31 Sarcophagus in the Villa Albani, Rome *(Photo courtesy of German Archaeological Institute, Rome, neg. no. 54.434)*

This cult, one of the major cults of the Roman state religion since the second Punic war, enjoyed special importance at Ostia.[38] Euhodus, who commissioned the sarcophagus, presumably shared his wife's beliefs, and for this reason chose, or directed the sculptors of the monument to invent, a composition which stressed the salvational aspect of the myth.

Franz Cumont rightly suggested that in light of the inscription one should perhaps seek overtones of ritual in the scenes depicted on this sarcophagus.[39] A specific reference to the rites of the Magna Mater is not impossible, for as Amelung observed Alcestis, as she is led back from the underworld, bears some resemblance to a fairly common statuary type of Ceres.[40] However, the central composition of Alcestis's death scene and elements of the composition of the return scene are shared with sarcophagi of women who had no demonstrable connection with the cult of the Magna Mater. Whether or not sarcophagi of the Alcestis type are based on a lost painting, as Giglioli suggested,[41] the compositions were known to the general public and not merely to devotees of the cult of the Magna Mater.

The designer of the Euhodus sarcophagus may instead have sought to remind the viewer of a far more familiar rite: the ceremony of marriage. Such a reference would have been highly effective in stressing Alcestis's and Admetus's roles as devoted wife and husband, while expressing the joy of their reunion by analogy with the happiness of their original wedding. In the pre-Euripidean version of the story, the reference would also have been justified by the fact that Alcestis died on her wedding day. That the Euripidean version is followed here is clear from the presence of the children in the death scene, but a reminiscence of the earlier form of the folk tale is not impossible.

Wedding scenes are abundantly represented in the visual arts, especially the sarcophagi and funerary altars, of Rome and Italy. The formula of the *dextrarum iunctio,* or handclasp, between bride and bridegroom was used to represent the wedding ceremony on an Etruscan sarcophagus as early as the late fourth or early third century B.C.[42] and survived substantially unchanged into early Christian art. Symbolic figures were added in imperial times which provided shorthand references to other parts of the ceremony. A female figure usually appears in the background, placing a hand on the shoulder of each marriage partner. Her diadem identifies this figure as Juno Pronuba or Concordia, but in leading the couple together she performs the function which in an actual ceremony would have been performed by the *pronuba,* or matron of honor.[43]

Hymenaeus is usually represented, taking the form of a small boy between the bride and bridegroom who strides forward carrying a large torch, glancing back over his shoulder at the husband, and leading him forward. Hymenaeus may incorporate a symbolic reference to a human participant in a later phase of the festivities, the boy who would lead the torchlit procession which escorted the bride to her new home in the late afternoon or evening.[44]

The basic group of four figures—husband, wife, *pronuba,* and Hymenaeus—could be expanded with additional references to the *domum deductio.* The bride-

groom may be followed by the two young men who will walk alongside the bride in the procession, and the bride by a young female attendant dressed as an unmarried woman, possibly a personification of Peitho, or Suada.[45] The handsome sarcophagus in the church of S. Lorenzo fuori le Mura in Rome (Figure 32)[46] provides an excellent example of such a wedding scene.

One important variation in the representation of wedding scenes should be noted: in some sarcophagi, Hymenaeus takes the form not of a boy but of a full-sized young man who follows the bride carrying a torch which extends to the upper border of the frieze. A good example of this type is a sarcophagus in the Hermitage Museum in St. Petersburg (Figure 33).[47]

Nearly every figure of the typical wedding scene finds a parallel in the scene of Alcestis's return on the Euhodus sarcophagus. First, and most important, the veiled figure of Alcestis closely resembles a conventional bride. Her upper body is enveloped in a *palla* which is drawn over her head and conceals much of her face, just as the brides in all wedding scenes are veiled with a *flammeum*, a yellow *palla* which was considered the distinguishing mark of a bride. So important was the symbolic value of the *flammeum* in the wedding ceremony that some cloth dyers in Rome manufactured nothing else, while the veil could be used to describe by metonymy the entire ceremony, in phrases such as "*mulier nubit*."[48]

Alcestis's veil may also indicate that she is a ghost.[49] In Euripides' drama Alcestis is led onstage in the final scene so deeply veiled that Admetus does not recognize her (*Alc.* 1031–1123). But she also shares with conventional brides cer-

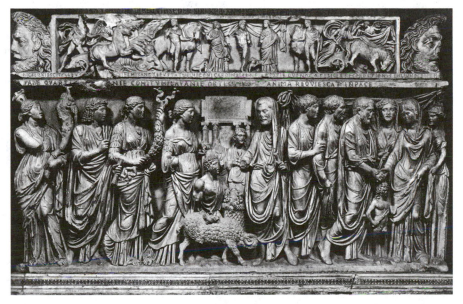

FIGURE 32 Sarcophagus in S. Lorenzo fuori le Mura, Rome *(Photo courtesy of German Archaeological Institute, Rome, 57.320)*

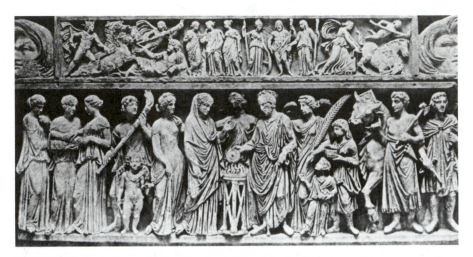

FIGURE 33 Sarcophagus in the Hermitage Museum, St. Petersburg *(Photo courtesy of Hermitage Museum)*

tain gestures, such as raising one hand as though about to unveil herself; close parallels can be found in the sarcophagus of the emperor Balbinus[50] and the lid of the great battle sarcophagus from the Via Tiburtina.[51]

Alcestis's left arm hangs at her side and is enveloped by the *palla,* but her left hand grips the edge of the material and draws it slightly upward. This gesture is familiar among representations of brides, including those portrayed on the S. Lorenzo sarcophagus and a sarcophagus in the Palazzo Ducale in Mantua (Figure 34)[52] among many others. The bride on the Mantua sarcophagus forms an especially striking visual parallel to the returning Alcestis on the Euhodus sarcophagus. Indeed, the only real difference between conventional brides and Alcestis in this scene is that she uses both hands to adjust her drapery instead of extending one

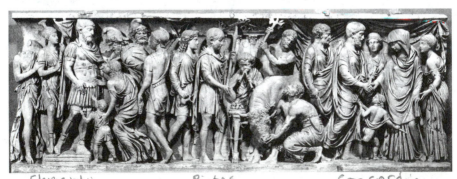

Clementia Pietas Concordia

FIGURE 34 Sarcophagus in the Palazzo Ducale, Mantua *(Photo courtesy of German Archaeological Institute, Rome, neg. no. 62.126)*

hand to her husband. The modest inclination of her head is shared by virtually every bride.

Not only the figure of Alcestis but the overall grouping of the return scene echoes a typical wedding: husband and wife stand facing one another, and are drawn together by an intermediary, though in this case Concordia and Hymenaeus are replaced by the adult, male Heracles. This substitution does not seem so outlandish in view of the existence of a comparable wall painting in the house of Loreius Tiburtinus at Pompeii[53] (Figure 35). This long frieze, dealing with Heracles' sack of Troy, includes the marriage of Priam and Hecuba, represented by a conventional *dextrarum iunctio* except that Heracles rather than Concordia stands between the couple. In the Euhodus sarcophagus, his presence may serve a more than narrative function, since Heracles' well-known funerary associations—as defender of mankind against deadly monsters, as hero who successfully descended to and returned from Hades, and as mortal who earned apotheosis[54]—would underline the hope implicit in the Alcestis story that death can be overcome by a virtuous individual. The presence of Cerberus at his feet reminds the viewer of another of the hero's exploits in connection with the underworld.

On the Euhodus sarcophagus, as in many wedding scenes, a female figure stands behind the wife (in this case, Proserpina rather than Suada), and—most important of all—a large torch is carried directly behind Alcestis, as in the bridal sarcophagus in the Hermitage Museum. A torch is present in almost all wedding scenes, although it is more often carried between the couple by a diminutive Hymenaeus than alongside them.

The torches carried in the *domum deductio* were of far more importance than mere practical sources of illumination or decoration, since they were carried even when the procession took place in broad daylight. They may have symbolized the fertile and generative power of nature believed to be embodied in the element of fire.[55] The fact that the torchbearer who led the procession had to be a boy whose parents were still living strongly supports the hypothesis that the torches symbolized fertility. The yellow color of the bridal veil may have had a similar significance.[56] In any case, the *flammeum* and the torches of the procession are frequently mentioned together as the most conspicuous visual elements of a wedding ceremony:

> Tollite, o pueri, faces:
> Flammeum video venire,
> Ite, concinite in modum
> O Hymen Hymenaee io,
> O Hymen Hymenaee.
> (Catullus, 61, 117–121)

If the veil and the torches were in fact so closely related in symbolic function, the juxtaposition on the Euhodus sarcophagus of a torchbearer and a veiled woman would have been a particularly powerful reminder of the wedding ceremony.

FIGURE 35 Wall Painting in the House of Loreius Tiburtinus *(Photo courtesy of German Archaeological Institute, Rome, neg. no. 57.879)*

Finally, the fact that the upright torch, symbolic of life, is carried by Proserpina, emphasizes the victory over death involved in Alcestis's reunion with Admetus, and by implication, Metilia's with Euhodus. The torch was as closely associated with the funeral ceremony in Roman custom as with marriage; however, in the visual arts torches were invariably represented in an inverted position to represent the setting of the sun or the end of life.[57] Sleeping putti leaning on inverted torches formed a common theme of funerary statuettes in the Hellenistic period and, later, an equally common motif on imperial Roman sarcophagi.[58] Therefore, the association of an upright torch with the king and queen of the underworld may have been startling and striking to a Roman audience. The two torches on the lid of the Euhodus sarcophagus may allude to the deaths of the two people for whom the sarcophagus was intended, since the flames are inclined downward. If so, the presence of torches both in the non-narrative decoration of the lid and the mythological scene on the box of the sarcophagus might have reinforced and elaborated the significance of both as images of death and new life.

It is significant that another sarcophagus depicting the myth of Alcestis also closely associates the wedding of Admetus and Alcestis with their reunion, though in a somewhat different manner. A fragmentary sarcophagus lid in the Palazzo Rinuccini[59] (Figure 36) depicts several scenes not usually included on the front of a conventional Alcestis sarcophagus, one of which it no doubt supplemented. These scenes include Apollo's entry into Admetus's service (now lost, but preserved in an earlier drawing), Admetus's victory in the competition for Alcestis's

FIGURE 36 Sarcophagus Lid in the Palazzo Rinuccini, Florence *(Photo courtesy of German Archaeological Institute, Rome, neg. no. 72.199)*

hand, the couple's wedding, and Alcestis's return.[60] The last two are juxtaposed, in defiance of chronological order, and closely linked.

In the wedding scene of the Rinuccini lid, Admetus, while clasping Alcestis's hand, turns as though startled and glances over his shoulder, probably to indicate that he has seen the snakes sent by Artemis as an evil omen.[61] An attendant behind the couple drops his torch in surprise, another evil omen, and of course, as mentioned above, a familiar visual symbol for death. Yet as Admetus turns he seems directly to meet the gaze of Hermes, who along with Heracles is escorting the veiled ghost of Alcestis from the underworld in the adjoining scene. Hermes, in turn, gestures toward the bridegroom and seems to address him.

Whether or not the Rinuccini lid alludes to the hope of the client or clients for whom it was made for a life after death cannot be stated with as much certainty as in the case of the Euhodus sarcophagus. Few couples were as considerate as Euhodus and Metilia in leaving us written testimony as to their religious convictions. Euhodus and Metilia were, at any rate, by no means unique in wishing to commemorate their marital devotion through visual allusions to the ceremony of marriage. The sheer quantity of marriage sarcophagi which have survived to the present day[62] demonstrates the importance of family solidarity in the thinking of Roman citizens of imperial times. The wedding scene was frequently juxtaposed to illustrations of other achievements in which the deceased took pride: a scene of philosophic debate, for example, as in the "two brothers" sarcophagus in Naples.[63]

There is good reason to believe that the popular *vita humana* sarcophagi (Figure 34), which generally depict, from left to right, a general granting clemency to captives, a man performing public sacrifice, and a wedding, use the activities not merely as literal biographical vignettes but as epitomes of the virtues of *clementia, pietas,* and *concordia.*[64] Such admiration for and allegorical exaltation of marriage must have had its roots at least partly in the many philosophic systems of the Hellenistic period which found reasons for justifying marriage as a duty to society and to nature.[65] Such philosophic systems, especially Stoicism, would

have influenced the thinking of educated Romans of the imperial period. It is not impossible that at least some of the Romans who chose sarcophagi with biographical wedding scenes shared the hope of Metilia and Euhodus for a reunion in another life; Cumont, at least, proposed such an explanation for the juxtaposition of wedding scenes to symbols of eternity such as the Dioscuri.[66] However, the exact nature of the religious beliefs of most patrons who commissioned such sarcophagi can never be known.

To sum up briefly, the sarcophagus of Euhodus and Metilia uses a standard vocabulary of figures and groups drawn from the iconography of Alcestis to express coherently a number of beliefs. These beliefs include the couple's pride in their devotion to one another, their expectation that life after death can be earned through virtue, and their hope that their devotion could be rewarded by a posthumous reunion. The couple would in any case be united in death, since their bodies were to be placed in the same sarcophagus, but the use of the Alcestis myth and the strong emphasis on rescue from death suggest strongly that Euhodus and Metilia hoped for a reunion of souls as well. Many of these beliefs and wishes may have been shared by other Roman couples who expressed similar pride in their marital devotion by choosing or commissioning sarcophagi that commemorated their weddings. The designer of the Euhodus sarcophagus has borrowed a good deal from such wedding scenes. The funerary monument of this couple, however, through its unique combination of a mythological scene with the iconography of autobiographical sarcophagi, achieves an especially rich expression of beliefs.

POSTSCRIPT

In the thirteen years since this article appeared, the study of Roman funerary sculpture has continued apace. This is not the appropriate forum for a complete bibliographical update, but three articles of particular relevance to the subject at hand, by Peter Blome,[1] Carola Reinsberg,[2] and Glenys Davies,[3] should be mentioned.

Blome's 1978 article examines how Roman sculptors adapted mythological narratives to incorporate familiar icons of the Roman virtues of *concordia, virtus,* etc. He examines three groups of mythological sarcophagi that share themes of return from the dead and of the triumph of love over death: the myths of Alcestis, Protesilaos and Laodamia, and Proserpina. These stories are sometimes juxtaposed on the same monuments, like the great Velletri sarcophagus with its encyclopedic mythological program, and the Proserpina sarcophagus in Florence, cited above, on which the shallow reliefs of the left and right ends depict, respectively, Hermes leading Alcestis to the underworld, and Heracles leading her back.[4] Among the five extant sarcophagi devoted primarily to Alcestis, a transformation can be traced from the earlier examples, which follow the myth more faithfully, to the later and more symbolic treatments of the story.[5] In the Genoa sarcophagus, the transformation of Alcestis's return to a conventional *concordia* group between husband and wife is even more striking than in the Euhodos-Metilia sarcophagus.[6]

Blome also points out another parallel to the so-called biographical, or *vita humana* sarcophagi (Figure 34): in at least two and possibly three examples (the questionable one being the Euhodos-Metilia monument), Admetus appears at the far left in the guise of a hunter, an image with no relevance to the story, but a standard image for the *virtus* (which in Latin means "manly courage") of the deceased. According to this interpretation, the bearded man standing under the arch at the left of the frieze, leading a dog and holding a spear, would be not Thanatos, as I stated (following Robert), but a third portrait of Euhodos as Admetos.[7] The face does not exactly match that of the other two portraits, but it resembles them closely and appears to be portrait-like rather than ideal. The deviations of its profile should not necessarily preclude identification of all three as replicas of a common portrait type, since as Michael Pfanner has recently demonstrated, exact replicas were far more difficult to achieve in relief than in sculpture in the round. Relief faces had to be executed freehand, with the slab in a vertical position, rather than with the measuring devices that could achieve accurate results on a horizontally positioned statue or bust.[8] The man with the dog and spear faces more frontally forward than the Admetos of the death and return scenes, whose faces are turned at virtually the same angle to the background and so could more easily be made to resemble each other.

Blome does not interpret the return scenes in Alcestis sarcophagi as referring specifically to the wedding ceremony, preferring the more general designation of "*concordia* group." In another of the sarcophagi he discusses, however, a Proserpina sarcophagus in the Capitoline museum of the earlier third century A.D., the scene of Proserpina's violent abduction to the world of the dead is unmistakably transformed into a triumphant wedding procession, an adaptation not inappropriate to the story of the bride of Hades.[9] The guests at this wedding include Heracles accompanied by Cerberus, another allusion to the possibility of triumph over death and return from the next world.

If Blome's conclusions tend to support mine, Reinsberg's article casts doubt on the relevance of the St. Petersburg sarcophagus (Figure 33) as evidence for the ceremony of marriage. Sarcophagi of this format, she argues, do not represent weddings: there is no literary evidence that Roman marriage ceremonies involved animal sacrifice.[10] Instead, wedding offerings consisted of wine and of grain, with its familiar symbolism of fertility—a ritual not unlike the modern custom of throwing rice. The sarcophagi that depict a couple at an altar would represent a public sacrifice, most probably to the god *Honos* (personified "Honor"), one of the few deities to whom Roman men could appropriately sacrifice with their heads uncovered in the Greek manner, as represented in all these monuments.[11] The diademed goddess who unites the couple is, of course, Concordia, but she is not solemnizing their marriage; rather, she incorporates into the scene of *pietas* the image of another of their virtues, while the Victoria who crowns the husband adds an allusion to *virtus*.

Reinsberg makes another important observation about this group of monuments: although they portray the same set of virtues as the biographical sarcoph-

agi (Figure 34) with many of the same actions and gestures, they are not variants
of that type but constitute a distinct category made for a different class of patrons.
The men of the biographical sarcophagi (Figure 34) wear the elaborate high boots
of the senatorial class. The scene of sacrifice in military uniform seems to identify
the deceased not only as a senator but as one who had governed a province as
legatus Augusti pro praetore, a position of authority second only to that of the
emperor himself.[12] The man on the St. Petersburg sarcophagus, and his counter-
parts on similar monuments, wear the simpler shoes of an equestrian—a class for
whom the sacrifice to Honos would be particularly appropriate.

Davies, finally, reviews the uses of the handshake gesture from archaic
Greek art through Roman imperial times, pointing out its variety of possible mean-
ings and its potential for deliberately ambiguous applications. Thus, two figures
clasping hands on a tomb monument could indicate either parting or reunion in the
next world, or both simultaneously, depending on the viewer's inclination.[13] When
a mortal clasps the hand of a god or hero, particularly that of Hercules, with his
special funerary associations, the implication could be that of elevation to a heroic
realm: thus it is most significant that in the Euhodos-Metilia sarcophagus, Euho-
dos clasps the hand not of his returning wife but of her divine escort, implying that
he, as well as she, could be rescued from death and raised to a status equal to the
hero's.[14]

On the more straightforwardly biographical sarcophagi, Davies doubts that
the handshake portrays the specific event of the wedding ceremony, regarding it as
a more timeless image of the couple's *concordia.*[15] In light of her arguments and
those of Reinsberg, I would today more cautiously describe the return scene on the
Euhodos-Metilia monument as a reference not to the couple's wedding but to their
marriage bond, which was to continue after death when their bodies shared the
same resting place. As Blome observes, this image of *concordia* is not the only
reference to their virtues; in addition to the figure of Euhodos-Admetos as a hunter
embodying *virtus,* the quality of *pietas* is implicit throughout the story. The
designer of this monument has conveyed this message in a genuinely original
fashion: instead of borrowing the vocabulary of biographical sarcophagi, he prom-
inently presents the two gods who benefited from and subsequently rewarded the
pietas of Admetos. Apollo and Heracles face the viewer frontally, in heroic nudity
and in similar postures, with the right hand extended, neatly bracketing the suffer-
ing but ultimately fortunate couple of the death scene. The figures of Apollo and
Admetos have a striking visual relationship, arranged as they are in close juxtapo-
sition and in stances that almost mirror one another, reminding the viewer of the
special relationship of Apollo to his mortal protégé.[16]

Reinsberg's observations about the social classes of patrons may explain why
designers adapted Greek myths, sometimes by rather Procrustean means, to con-
vey the beliefs and aspirations of their clients.[17] If the *vita humana* sarcophagi
(Figure 34) belonged exclusively to the senatorial class, and the so-called wedding
sarcophagi that in fact represent a public sacrifice to Honos (Figure 33) to the
equestrian order, what options remained for Euhodos and Metilia, who were freed-
men? (Their Greek names may indicate that both were born in slavery.)[18]

Liberti could become rich and socially ambitious, a type that Petronius lampooned in the character of Trimalchio.[19] Ostian tradesmen like Euhodos were probably less wealthy than Petronius's fictional *nouveau riche*, but were well off enough to afford impressive tombs: marble sarcophagi, even of mediocre workmanship, were not cheap, nor were the richly decorated family mausolea that housed them in the Isola Sacra Necropolis of Ostia.[20] But freedmen could never forget their low rank in society; the ridicule that the aristocratic Petronius heaps on Trimalchio for planning an ostentatious tomb is probably typical of the social pressure on such people to stay in their place.[21]

Euhodos and Metilia could not have contemplated a format for their sarcophagus appropriate to a higher class; they could, however, purchase or commission one that borrowed liberally from such imagery for a scene from Greek mythology that was more or less in the public domain. Even these discreetly allusive reliefs would have been visible only to a few family members who could enter the tomb when celebrating feasts in honor of the dead couple; the exteriors of tombs on the Isola Sacra were more modestly decorated with terracotta plaques mundanely recording the profession of the deceased.[22] Rarely do sarcophagi survive in their original context, but Eve D'Ambra has reconstructed the public and private sculptural program of such a tomb; here again, the more pretentious mythological imagery (which had, however, personal significance for its patron) was confined to the sarcophagus inside the monument.[23]

Few extant mythological sarcophagi have inscriptions as helpful as that of Euhodos and Metilia. One cannot generalize on the basis of this one sarcophagus that most such adaptations of Greek mythology served the needs of freedmen. It is, however, noteworthy that one other Alcestis sarcophagus was made for a woman with a Greek cognomen—Ulpia Kyrilla—and that not only her name but the entire inscription is written in Greek.[24] Such monuments, like the great volume of funerary inscriptions of freedmen that Lily Ross Taylor has analyzed, record not only the hopes of the deceased for a happy existence in the next world, but his or her greatest achievement in this one: the attainment of freedom and Roman citizenship. The inscription on the lid of the sarcophagus of Caius Junius Euhodos proudly identifies him by the triple name of a free citizen, while the mythological relief demonstrates the virtues—*virtus, pietas, concordia*—that good Roman citizens should have.[25] We may recall that Trimalchio also wished his tomb to include a list of his virtues: "He was pious, brave and loyal, rose from humble beginnings, left an estate of 300 sestertii, and never studied under any philosopher."[26]

NOTES

1. Displayed in the Museo Chiaramonti of the Vatican, inv. 1195, discovered in Ostia, 1826. Measurements: h. 0.54 m., l. 240 m., d. 0.92 m. Published: W. Amelung, *Die Sculpturen des Vaticanischen Museums* (Berlin 1903), v.1[2] pp. 429–30, no. 179; G. Hanfmann, *Roman Art* (New York 1955), pp. 113–14, no. 120; Helbig[4] I (1963), 229–30, no. 291; O. Pelikàn, *Vom antiken Realismus zur spätantiken Expressivität* (Prague 1965), pp. 42–43; C. Robert, *Die antiken Sarkophagreliefs*, v.3[1], "Einzelmythen erste Abteilung: Actaeon—Heracles" (Berlin 1897),

pp. 31–33, no. 26; H. Sichtermann and G. Koch, *Griechische Mythen auf römische Sarkophagen* (Tübingen 1975), pp. 20–21, no. 8, pl. 16, 17–2, 18, 19; J. Toynbee, *The Hadrianic School* (Cambridge 1934), pp. 198–200, pl. 42–1; R. Turcan, *Les Sarcophages romains à représentations dionysiaques* (Paris 1966) passim (Index p. 653). The sarcophagus is also mentioned by: B. Andreae, "Imitazione e originalità nei sarcofagi romani," *RendPontAcc* 41 (1968–1969): 147–48; T. Brennecke, *Kopf und Mask. Untersuchungen zu den Akroteren an Sarkophagdeckeln* (dissertation, Freie Universitat, Berlin 1970), 21–22; F. Cumont, *Recherches sur le symbolisme funéraire des Romains* (Paris 1942), p. 30, no. 4; G. Giglioli, "*Sarcofago di Genova col mito di Alcesti,*" *ArchCl*, 5 (1953): 222–23: K. Lehmann-Hartleben and E.C. Olsen, *Dionysiac Sarcophagi in Baltimore* (Baltimore 1942), p. 57, fig. 36 and M. Wegner, "*Datierung römischer Haartrachten,*" *AA* 1938: cols. 324–25, figs. 24–28.

2. Robert (supra n. 1), 33. I am indebted to Prof. William Harris of Columbia University for his kind assistance in the interpretation of this inscription.

3. Robert (supra n. 1), 33 and Turcan (supra n. 1), 44–45.

4. Amelung (supra n. 1), 429.

5. Brennecke (supra n. 1), 21–22 and Robert (supra n. 1), 34.

6. Sources for the story as narrated here: W.H. Roscher, s.v. Alkestis, *Ausführliches Lexicon der griechischen und römischen Mythologie*, v.1 (1884–1890), 233–35 (R. Engelmann); Apollodorus 5. 9. 14; Euripides, *Alcestis*. For a discussion of the folk tale origins of the story, see A. Lesky, "Alkestis, der Mythos und das Drama," *SBWien, Phil.–Hist. Klasse* 203 (1925): 20–42; additions to argument in *Gnomon* 7 (1931): 137–41.

7. Lesky (supra n. 6), 38.

8. For a discussion of the original meaning of Apollo's servitude and later reinterpretations in Hellenistic and Roman literature, see G. Solimana, "Il mito di Apollo e Admeto negli elegiaci latini," *Scripta in honorem Marii Untersteiner*, ser. Mythos, v.30 (Geneva 1970), pp. 255–68.

9. Lesky (supra n. 6) 27–29, and A. Lesky, *Geschichte der griechischen Literatur* (Bern 1957–1958), p. 344. See also K. von Fritz, "Euripides Alkestis und ihre modernen Nachahmer und Kritiker," *Antike und Abendland*, 5 (1956), 57.

10. For a thorough stylistic analysis of the sarcophagus, see Toynbee (supra n. 1), 198–200. A discussion of hairstyles and the chronological value of the work is given by Max Wegner, *AA* 1938, 324–25.

11. Pelikàn (supra n. 1), 61.

12. Pelikàn (supra n. 1), 43; Toynbee (supra n. 1), 188–89.

13. Robert (supra n. 1), 25, Amelung (supra n. 1), 428. I am indebted to Prof. Brunilde Ridgway for pointing out to me that the old man and woman here could conceivably be interpreted as Admetus's parents rather than Alcestis's. I am inclined, however, to agree with Robert that they represent her parents, since the same couple appears on other Alcestis sarcophagi on which Admetus is omitted from the death scene, e.g. the Albani sarcophagus (references infra n. 28). If Admetus is regarded as superfluous in the death scene on these sarcophagi, then his parents certainly would be. Though the Euhodus sarcophagus adds the figure of Admetus to the death scene, it obviously follows the same cartoon used for sarcophagi in which he is omitted.

14. Sichtermann and Koch (supra n. 1), 20.

15. Amelung (supra n. 1), 429.

16. Robert (supra n. 1), nos. 24 and 26, pp. 30, 32. See also Amelung (supra n. 1), 429. Amelung disputed the identification, proposing that the face, with its realistic signs of age, might be a portrait, and therefore that the figure must be a mortal attendant.

17. Robert (supra n. 1), 33 and Amelung (supra n. 1), 430.

18. Robert (supra n. 1), 33 and Helbig[4] I, 229, no. 291.

19. Helbig[4] I, 229, no. 291.

20. Robert (supra n. 1), 33.

21. Euripides, *Alc.* line 76 and 1007–1163. In the scene of Alcestis's return, most Alcestis sarcophagi merely depict Heracles leading Alcestis by the hand, and omit Admetus completely. Robert (supra n. 1), nos. 22 and 31[1], p. 28, pl. V.II, and Giglioli (supra n. 1), 222–31.

22. Robert (supra n. 1), 25.

23. Lesky (supra n. 6), 35. The story of the wrestling match with Death is probably truer to the original folk tale, the moralizing gloss of voluntary release by Proserpina a late variant.

24. Robert (supra n. 1), no. 22, pl. 6, figs. a–c. Drawing of the short ends: p. 28, figs. 22a and b. Present whereabouts of the sarcophagus unknown; see G. Koch, "Verschollene mythologische Sarkophage," *AA* (1976): 104.

25. Robert (supra n. 1), 35.

26. Turcan (supra n. 1), 59 and passim; Pelikàn (supra n. 1), 43. Pelikàn describes this tendency toward centralization, along with the squat proportions of the figures, as features of ancient Italian folk art.

27. Robert (supra n. 1), 25.

28. Robert (supra n. 1), 28–29. no. 23 and pl. VI; Sichtermann and Koch (supra n. 1), 21–22 and pl. 17–1; Helbig[4] IV. 263–64, no. 3293. Dated to the late Antonine period, possibly A.D. 170–180. Faultily restored; the weeping woman at the far right is modern. The original presence of Heracles can be inferred from the close similarity of the pose of Admetus to that of Admetus on the Cannes sarcophagus.

29. Ethical judgments in the presentation of Admetus's behavior were of course foreign to the original folk tale of a young man miraculously rescued from death by the self-sacrifice of a devoted friend (Lesky [supra n. 6], 78). That Euripides applied such ethical criteria in his adaptation of the folk tale to a tragedy seems undeniable, however, and Euripides' version was clearly uppermost in the mind of the designer of this sarcophagus. For a discussion of the values by which Euripides intended the character to be judged, and a summary of critical controversy on the subject, see A. Lesky, "Der Angeklagte Admet," *Gesammelte Schriften* (Bern and Munich 1966), pp. 281–94; also K. von Fritz (supra n. 9), 55–67.

30. Robert (supra n. 1), 29–30, no. 24.

31. Giglioli (supra n. 1), 222–31, and C. Dufour-Bozzo, *Sarcofagi romani a Genova* (Milan 1964), no. 25, pp. 48–50.

32. Giglioli (supra n. 1), 228. It is conceivable that the lost fragment of the Albani sarcophagus showed Alcestis returning, but this can never been known. Helbig[4] IV, 264, no. 3293.

33. From which he is frequently omitted altogether. Robert (supra n. 1), 25.

34. For a similar point of view, see Toynbee (supra n. 1), 200.

35. The cautions expressed by Arthur Darby Nock, "Sarcophagi and Symbolism," *AJA* 50 (1946): 140–70, must of course be borne in mind when analyzing the symbolic content of any sarcophagus. The degree of symbolism with which the same theme was endowed might well vary, however, from patron to patron. For differences in types of symbolism, see Karl Schefold, "La force créatrice du symbolisme funéraire des Romains," *RA* 2 (1969): 177–209.

36. Comprehensively discussed by F. Cumont, *After Life in Roman Paganism* (New Haven 1922) passim. For an excellent discussion of the role of religion and philosophy in the attitudes of the ordinary citizen toward death, see Richmond Lattimore, *Themes in Greek and Latin Epitaphs* (Urbana 1962), pp. 73–74.

37. Cumont (supra n. 36), 35–36.

38. M.F. Squarciapino, *I Culti orientali ad Ostia*, v.3 of *Études Préliminaires aux religions orientales dans l'empire romain* (Leiden 1962), pp. 1–18.

39. Cumont (supra n. 1), 30, n. 4.

40. Amelung (supra n. 1), 430. An example of the type is no. 2, Galleria Lapidaria, discussed in v.I[1], 163.

41. Giglioli (supra n. 1), 227–30.

42. R. Herbig, *Die jungeretruskischen Sarkophage*, ASR 7 (Berlin 1952), no. 5, pp. 13–14; G. Hanfmann, "Etruscan Reliefs of the Hellenistic Period," *JHS* 65 (1947): 45, pl. VIII.

43. L. Reekmans, "La dextrarum iunctio," *Bulletin de l'Institut Belge de Rome* 31 (1958): 37.

44. A. Rossbach, *Römische Hochzeits-und Ehedenkmäler* (Leipzig 1871), p. 15.

45. Rossbach (supra n. 44), 45–47.

46. For a recent discussion of date and iconography, as well as up-to-date references, see K. Fittschen,

"Hochzeitssarkophag San Lorenzo," from "Symposion über die antiken Sarkophag-reliefs," ed. H. Wiegartz, *AA* (1971): 117–19. An early but still valuable description is given by Rossbach (supra n. 44), 54–68.

47. Rossbach (supra n. 44), 108.

48. F. Dana, *The Ritual Significance of Yellow among the Romans* (Philadelphia 1919), p. 12.

49. Toynbee (supra n. 1), 199–200.

50. Reekmans (supra n. 43), 41–42.

51. Reekmans (supra n. 43), 41; P. Hamburg, *Studies in Roman Imperial Art* (Uppsala 1945), pp. 176–79.

52. Reekmans (supra n. 43), 41; A. Levi, *Sculture greche e romane del Palazzo Ducale di Mantova* (Rome 1931), no. 186, p. 86.

53. G. Picard, *Roman Painting* (Greenwich, Conn.: 1968), pp. 80–81, fig. LV.

54. J. Bayet, "Hercule funéraire," *MélRome* 39 (1921–1922), and 40, 2 (1923): 52–56 and 244–47.

55. Dana (supra n. 48), 17–20.

56. Dana (supra n. 48), 21–22.

57. Dana (supra n. 48), 23. For a differing view, see R. Turcan, "Masques corniers d'orientaux: Attis, Ganymede, ou Arimaspes," *Mélanges de philosophie, de litterature, et d'histoire ancienne offerts à Pierre Boyancé* (Rome 1974), pp. 729–30.

58. Cumont (supra n. 1), 409.

59. Robert (supra n. 1), no. 32.

60. Robert (supra n. 1), 36–37.

61. Robert (supra n. 1), 36–37.

62. Rossbach (supra n. 44), 12.

63. Reekmans (supra n. 43), 44–45.

64. Reekmans (supra n. 43); Piero Barrera, "Sarcofagi romani con scene della vita privata e militare," *Studii Romani: Rivista di Archeologia e Storia* 3 (1914): 93–120.

65. For a comprehensive discussion of attitudes toward marriage and women, see Claude Vatin, *Recherches sur le mariage et la condition de la femme mariée à l'époque hellénistique* (Paris 1970).

66. Cumont (supra n. 1), 82. A similar point of view is expressed by Pelikàn (supra n. 1), 77.

POSTSCRIPT NOTES

1. P. Blome, "Zur Umgestaltung griechischer Mythen in der römischen Sepulkralkunst: Alkestis-, Protesilaos-, und Proserpinasarkophage," *RM* 85 (1978): 435–57, pl. 142–147.

2. C. Reinsberg, "Das Hochzeitsopfer—eine Fiktion: zur Ikonographie der Hochzeitssarkophage," *JdI* 99 (1984): 291–317.

3. G. Davies, "The Significance of the Handshake Motif in Classical Funerary Art," *AJA* 89 (1985): 627–40.

4. Blome (supra n. 1), 445, 448, 451. On the Velletri sarcophagus: Marion Lawrence, "The Velletri Sarcophagus," *AJA* 69 (1965): 207–22, pls. 45–54. Proserpina sarcophagus in Florence: C. Robert, *ASR* 3, pt. 1, 35; H. Sichtermann and G. Koch, *Griechische Mythen auf römische Sarkophagen* (Tübingen 1975), p. 57, no. 60, pls. 147–151.

5. Blome (supra n. 1), 435–45.

6. Blome (supra n. 1), 440–41, 452.

7. Robert (supra n. 4), nos. 24 and 36, pp. 30–32; Wood (supra n. 4), 501 n. 16; Blome (supra n. 1), 438–39; 443–44 on the problem of the portraits of Euhodos.

8. M. Pfanner, "Über das Herstellen von Porträts," *JdI* 104 (1989): 217–18.

9. Blome, *RM* (1985): 451. Capitoline Museum inv. 249, *ASR* 3, pt. 3, 392. Sichtermann and Koch (supra n. 4), 57–58, no. 61, pls. 148, 1; 151, 2.3; 152–154.

10. Reinsberg (supra n. 2), 291–92.

11. Reinsberg (supra n. 2), 293–97, 300, 305.

12. Reinsberg (supra n. 2), 306.

13. Davies (supra n. 3), 639–40. I independently reached a similar conclusion in an unpublished research paper at Columbia University in 1974.

14. Davies (supra n. 3), 636.

15. Davies (supra n. 3), 632–35, 638–39.

16. Blome (supra n. 1), 442–43.

17. For a fuller discussion of the ways in which narrative could be manipulated for allegorical purposes, see R. Brilliant, *Visual Narratives* (Ithaca and London: Cornell University Press, 1984), esp. pp. 150 and 161–65.

18. L. R. Taylor, "Freedmen and Freeborn in the Epitaphs of Imperial Rome," *AJP* 82 (1961): 114–15.

19. Petron. *Sat.* 26. 7–79.

20. See Eve D'Ambra, "A Myth for a Smith: A Meleager Sarcophagus from a Tomb in Ostia," *AJA* 92 (1988): 85–86; Russell Meiggs, *Roman Ostia* (Oxford: Clarendon Press, 1973), pp. 455–70.

21. Petron. *Sat.* 71–79.

22. Meiggs (supra n. 20), 434, 460.

23. D'Ambra (supra n. 20), 87–99 and 311.

24. Sarcophagus of Ulpia Kyrilla: Chateau St. Aignan, Robert, (supra n. 4), 24; Blome (supra n. 1), 436–38, fig. 1. On the significance of Greek *cognomina,* see supra n. 18.

25. Taylor (supra n. 18), 128–32. Meiggs (supra n. 20), 468–70, argues that in most cases, the purpose of tomb sculpture in the Isola Sacra of Ostia is commemorative rather than eschatological, although he cites the program of the Euhodos-Metilia sarcophagus as a special case in which an allusion to an afterlife seems clear.

26. *"Pius, fortis, fidelis, ex parvo crevit, sestertium reliquit trecenties, nec umquam philosophus audivit."* Petron. *Sat.* 71.12.

The Cult of Virtues
and the Funerary Relief
of Ulpia Epigone

EVE D'AMBRA

The funerary relief of Ulpia Epigone, which is now on view in the Museo Grego-
riano Profano in the Vatican, originally adorned the facade of the Tomb of the
Volusii on the via Appia outside of Rome (Figure 37).[1] The relief is made of mar-
ble from Luni and is .92 m tall and about 2 m. long.[2] It dates to the late first or
early second century A.C., although the latter is more likely.[3] The relief, with its
portrait of the deceased, is exceptional in its combination of elements from differ-
ent traditions of Roman commemorative art. A mythological portrait and an
emblematic representation of the traditional virtues are both suggested within the
format of the *kline* relief.[4]

The taste for emblematic attributes and mythological allusions may in part be
the result of the patron's social rank, which is alluded to in the accompanying epi-
taph.[5] For an understanding of the meaning and the social context of this work, a
discussion of the epitaph and the iconography of the relief is necessary.

The epitaph located below the relief gives the deceased's name as Ulpia
Epigone.[6] However, the rest of the inscription, *Dis Manibus, permissu L.Ñ.*,
appears to have predated the inscription of Epigone; it was prepared for an epitaph
that was never used.[7] At a later date, the slab was completed for Ulpia Epigone.[8]
She may not have had any direct relationship to the freedmen of the Volusii: in the
second century some stones of the Tomb of the Volusii were used by freedmen
apparently unrelated to them.[9]

Reprinted with permission from *Latomus* 48.2 (1989): 392–400.

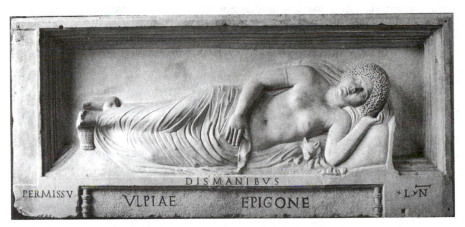

FIGURE 37 The Relief of Ulpia Epigone *(Vatican, Museo Gregoriano Profano: photo courtesy of Barbara Bini and the Fototeca Unione, Rome)* Ca 100 A.D.

Epigone's name is not accompanied by *Aug(usti) l(iberta)* which would identify her as an imperial freedwoman from the period of Trajan.[10] Explicit statements of status, however, were often omitted from epitaphs in the second century.[11] Ulpia Epigone therefore may have been a Trajanic freedwoman, a descendant of a Trajanic freedman, a freedwoman or descendant of an Ulpius previous to Trajan such as his father, or a woman, freed or freeborn, with no relationship to the imperial family.[12]

In a deeply recessed rectangular frame, Epigone is shown lying on a *kline,* which is indicated by its legs framing the epitaph and a layer of upholstery under the deceased's torso and head. The depiction of a reclining figure in relief is itself based on freestanding sculptures of the *kline* type that decorated tombs.[13] Often the reclining figures, portraits of the deceased, are shown fully draped and hold attributes such as garlands, cups, or small animals.[14] The relief of Ulpia Epigone resembles a *kline* sculpture in the Cortile Ottagono of the Vatican (Figure 38).[15]

A portrait depicted in relief is less costly than one carved in the round.[16] This format, together with the placement of the relief of Ulpia Epigone on an already prepared slab of the Tomb of the Volusii, suggests certain financial restrictions.[17] It appears as if the sculptor based the relief on a work of freestanding sculpture and merely depicted Epigone tipped up on her side parallel to the relief's front plane: hence the awkward position of the left ankle and the flattening of the forms of the left arm where it reached the relief frame.[18] In other aspects, such as the modeling of the torso, the sculptor was more accomplished.

The portrait head of Epigone is that of an individual represented within the schema of the court style (Figure 39). Compared to a well-known portrait of Julia Titi in the Museo Nazionale Romano (Figure 40), that of Ulpia has the same bow lips and the large, heavy-lidded eyes set far apart that bulge under the pressure of a low brow.[19] Julia Titi is represented as a young woman, perhaps

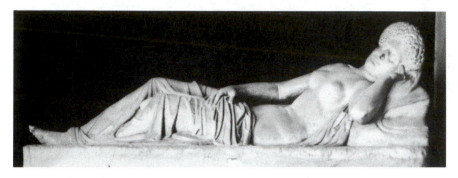

FIGURE 38 Kline Statue *(Vatican, Cortile Ottagono: photo courtesy of Alinari/Art Resource, neg. no. 27004)*

seventeen years old, and the portrait can be dated to A.D. 80–81 through comparisons with coin types.[20]

Epigone's face is fleshy as well, but it shows the marks of age that are absent in the imperial portrait. Epigone has prominent cheekbones with downward-sloping lines at the inner corners of the eyes and also at the corners of the mouth. The chin is full, and further signs of maturity are evident in the concentric lines on the neck. Similar features are apparent in the Flavian portrait of a woman on a funerary altar now in the Metropolitan Museum of Art (Figure 41).[21] The altar's inscription states that the deceased was almost twenty-eight years old. Although

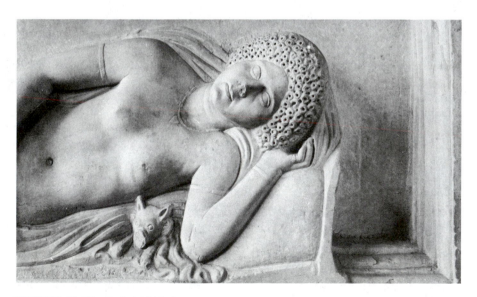

FIGURE 39 The Relief of Ulpia Epigone, Detail *(Vatican, Museo Gregoriano Profano: photo courtesy of Barbara Bini and the Fototeca Unione, Rome)*

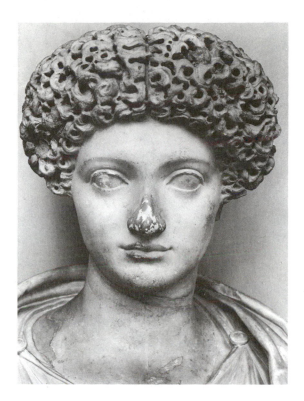

FIGURE 40 Portrait of Julia Titi *(Museo Nazionale Romano, Rome: photo courtesy of the German Archaeological Institute, Rome, neg. no. 57.618)*

such features indicating either the approach or the arrival of maturity in antiquity were conventional in the funerary portraits of matrons, the depiction of Ulpia Epigone with lined cheeks and neck probably suggests that she was in her late twenties or early thirties.[22]

The hairstyle worn by Ulpia Epigone is one that was popular during the Flavian and early Trajanic periods.[23] Often enhanced through wigs, this coiffure consisted of a fan of about five rows of ringlets framing the forehead and temples while the rest of the hair is pulled to the back of the head in thin braids which are gathered in a knot. The so-called *Ringlockentoupet,* worn by Ulpia Epigone, was common in the Domitianic and early Trajanic periods, and the relief probably dates to the latter.[24] Other elements which suggest an early second century date include the pose and partial nudity of the reclining figure.

The representation of the deceased in partial nudity is derived from the mythological funerary portrait.[25] Epigone's drapery reveals the part of her anatomy most representative of the feminine form and its sexual appeal. The ample but not heavy breasts suggest that she is healthy, fertile, and desirable. The gesture of the hand resting on the genitals recalls depictions of the goddess Venus, most notably the Capitoline Venus type.[26] Epigone is differentiated, however, from the Capitoline Venus by the drapery, the recumbent pose, and the fact that she gestures with her right hand rather than the left.

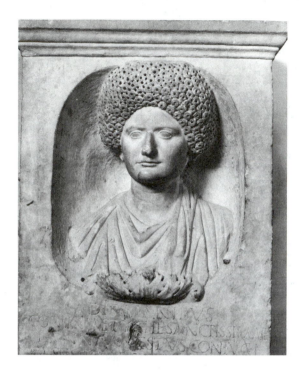

FIGURE 41 Funerary Altar of Cominia Tyche *(The Metropolitan Museum of Art, New York, Gift of Philip Hofer, 1938, 38.27, neg. no. 122191)*

Funerary portraits of women in the guise of Venus were in vogue from the Flavian period and throughout the second century.[27] Henning Wrede has observed that portraits of imperial women in the Capitoline Venus type probably inspired the popularity of such works among the lower orders.[28] Julia Titi's identification with Venus is attested by one extant portrait and two replicas, the coin types of Venus Augusti, and Martial's description of a statue of Julia Titi portrayed as Venus.[29] The mythological funerary portrait was commissioned by elite and nonelite patrons: there is evidence that the wives of a Domitianic court official, T. Flavius Abascantus, and a Trajanic imperial freedman, M. Ulpius Crotonensis, were commemorated by portrait statues depicting them as Venus.[30] It appears as if these patrons followed the imperial example.

A full-length portrait statue of a woman depicted in the Capitoline Venus type, now in Copenhagen, can be compared to the portrait relief of Ulpia Epigone.[31] The subject of the Copenhagen portrait wears the late Domitianic coiffure with its row upon row of ringlets arching over the forehead in more regular rows above. The same basic configuration of the head with a squarish jaw, heavy-lidded eyes, and low brow is apparent. The Copenhagen head, like that of Ulpia Epigone, appears to be of a mature woman with lined cheeks. The gesture of one hand over the genitals appears in both although the Copenhagen figure also covers her breasts. The depiction of Ulpia Epigone represents a free adaptation of the Capitoline Venus type within the context of the *kline* relief.

Jewelry is also displayed in the relief portrait. Four bracelets adorn the deceased's wrists and upper arms, a pendant graces the neck, and a ring is on the little finger of the left hand (Figure 39). Pliny recounts that the custom of wearing a single ring upon the little finger was no more than an ostentatious advertisement that the owner has property of a more precious nature under seal at home.[32]

The heart shape of the pendant may indicate that it is an amulet.[33] Amulets were frequently used to protect women from illness or to insure success in love, marriage, and childbirth.[34] The bracelets, probably close-fitting bands of precious metal, complete the ensemble of feminine adornment.[35] The jewelry serves to display wealth and enhance the fashionable milieu.

A Roman matron traditionally wore the *stola* and the *palla,* garments which also suggested that she upheld certain standards of behavior.[36] Often funerary portraits depict the matron in this attire. The relief of Ulpia Epigone, however, departs from this tradition with its mythological portrait of the partially nude and bejeweled deceased.

Yet the relief represents two attributes, the dog and the basket, which allude to the tradition of depicting the virtues of the veiled and *stola*-clad matron. The dog may have been a pet and the basket an implement for daily chores but they may also be interpreted as emblems of domestic virtue.

Both the dog and the basket are depicted in reduced scale. The little dog appears tucked under Epigone's elbow, and its head with a cylindrical snout and pointed ears pokes out from the excess drapery at her side (Figure 39). Dogs are also represented at the side of the deceased in other *kline* sculptures.[37] Martial describes a similar pet, Publius's lap dog Issa, who is eulogized in sentimental terms.[38] Epigone's dog was probably depicted in the relief as a constant companion, and its place at her side exemplifies ideals of fidelity and trust.[39]

The final attribute is the basket which props up Epigone's feet (Figure 37). Instead of the small cylindrical basket with steep sides, a cushion would have been more customary to support her feet. The presence of the basket requires an explanation. The basket is not shaped like a *liknon,* a flat and broad open container, nor does it appear to be the *cista mystica* of Bacchic or Isiac rites.[40]

Instead it is a basket for wool. Similar examples in Roman art are found in cinerary urns in the form of baskets that were probably receptacles for the remains of women.[41] Furthermore, a basket-shaped urn from Aquileia is surmounted by a small dog that resembles the hound on the relief.[42] Other weaving implements appear as emblems in this context: a first-century funerary relief from Este depicts the wool basket along with the spindle and distaff as the attributes of the exemplary matron.[43]

The wool basket is also depicted in works of official art such as the frieze of Domitian's *Forum Transitorium* in Rome.[44] The latter depicts a scene from the Arachne myth as a moralizing *exemplum* and is flanked by groups of women spinning and weaving as paragons of virtue.[45]

Weaving is an activity which is synonymous with domestic virtue from Homer's image of Penelope at her loom to Suetonius's account of Livia weaving

the toga of Augustus.[46] The lives of less illustrious matrons were summed up by the simple phrase, *lanam fecit,* inscribed as an epitaph.[47] The weaving motif represents the matron's chastity and purity.

The funerary relief of Ulpia Epigone combines the tradition of the commemoration of the virtues of the deceased in emblematic form and the mythological portrait. Epigone's portrayal as Venus is not incompatible with the image of the dutiful and industrious matron. One can compare the juxtaposition of ideals to the epitaph of Allia Potestas, an inscription in verse found in the via Pinciana in Rome.[48] Allia Potestas was a freedwoman. In the earlier literature a third- or fourth-century date has been assigned to the epitaph of Allia Potestas, but more recently a second-century date has been suggested.[49]

The first section of the poem lists Allia's traditional accomplishments as the faithful guardian of her master's house: she was quiet, obedient, hard working—the first to rise in the morning and the last to retire in the evening—and her wool never left her hands without good cause (lines 9–14). Then the poem continues with a detailed description of her beauty: her ivory complexion, golden hair, shapely breasts, and graceful figure (lines 17–23). Mythological reference is also present: Allia is compared favorably to Atalanta, and Helen is evoked. Richmond Lattimore has summarized the content of this epitaph as "a union of beauty with old-fashioned virtue."[50] This may also apply to the portrait of Ulpia Epigone, an image of both physical perfection and moral rectitude.

Perhaps this juxtaposition of motifs can be attributed to the status and background of Ulpia Epigone. In works of state art, the combination of the Venus portrait and the woolworking motif does not appear. Rather Minerva is depicted as the goddess of the spindle and distaff in the frieze of the *Forum Transitorium.*[51]

The freedwoman Allia Potestas and Ulpia Epigone are commemorated with both mythological allusions and the traditional virtues. Epigone's partial nudity, elaborate coiffure and jewelry are not seen as *luxuriae,* but rather as attributes of physical grace which complement her fulfillment of the domestic ideal. She is a model of *uenustas* and *castitas.* Her beauty is adorned by her virtue.

NOTES

1. O. Benndorf and R. Schöne, *Die antiken Bildwerke des lateranensischen Museums* (Leipzig 1867), pp. 314–15, no. 448. W. Altmann, *Die römischen Grabaltäre der Kaiserzeit* (Berlin 1905), p. 58, no. 16, fig. 50. R. West, *Römische Porträtplastik, II* (Munich 1933), pp. 48–49, no. 10, pl. 14, fig. 46. F. Cumont, *Recherches sur le symbolisme funéraire des Romains* (Paris 1942), p. 400, fig. 42, 2. Helbig[4], I, 741–42, no. 1030 (H. von Heintze). This paper was first developed for a presentation delivered at the meeting of the Archaeological Institute of America in New York City in December 1987. I thank the audience there for their comments and criticisms and am indebted to Diana E. E. Kleiner for her suggestions, which improved the presentation and article. Much is owed to Carole Paul for her patient and perceptive reading of the material at various stages. Karin Einaudi assisted in obtaining photographs.

2. I thank Joanna Dougherty for verifying the dimensions of the relief for me in Rome in May 1988.

3. See *infra,* n. 24.

4. Henning Wrede has contributed much to the study of the funerary art commissioned by non-elite patrons. The following abbreviations have been used: H. Wrede, *Das Mausoleum der Claudia Semne und die bürgerliche Plastik der Kaiserzeit*, in *RM* 78 (1971): 125–66 = Wrede, *Claudia Semne;* Id., *Stadtrömische Monumenten, Urnen und Sarkophage des Klinentypus in den beiden ersten Jahrhunderten n. Chr.*, in *AA* (1977): 395–431 = Wrede, *Stadtrömische Monumente;* Id., *Die Ausstattung stadtrömischer Grabtempel und der Übergang zur Körperbestattung*, in *RM* 85 (1978): 411–33 = Wrede, *Die Ausstattung;* Id., *Klinenprobleme*, in *AA* (1981): 86–131 = Wrede, *Klinenprobleme;* Id., *Consecratio in formam deorum, Vergöttlichte Privatpersonen in der römischen Kaiserzeit* (Mainz 1981) = Wrede, *Consecratio*. See also, D. E. E. Kleiner, *Second-Century Mythological Portraiture: Mars and Venus*, in *Latomus* 40 (1981): 512–44.

5. Wrede, *Consecratio*, pp. 159–64. *CIL*, VI, 7394.

6. See *infra*, n. 10.

7. M. Buonacore, *Schiavi e liberti dei Volusii Saturnini, Le iscrizione del colombario sulla via Appia antica* (Rome 1984), pp. 109–10, on the reuse of the relief. Several libertine epitaphs from this monument include similar formulations to the *permissu/L.Ñ.* on the relief of Ulpia Epigone (*CIL*, VI, 7366; 7375; 7376; 7380; 7389). Therefore, the phrase may be understood as *permissu L(ucii) n(ostri)*, or "permission to set up this memorial given by our patron Lucius Volusius Saturninus." The Lucius concerned may be L. Volusius Saturninus, *cos.* A.D. 87. See U. Hausmann, *Bildnisse zweier junger Römerinnen in Fiesole*, in *JdI* 74 (1959): 174, n. 37. D. Manacorda, *Un' officina lapidaria sulla via Appia* (Rome 1980), p. 102, prefers the identification of the Augustan consul of A.D. 3. F. Coarelli, *I praedia volusiana e l'albero genealogico dei Volusii Saturnini*, in *I Volusii Saturnini, una famiglia romana della prima età imperiale* (Rome 1982), 37–43.

8. An analogous example is found on another slab of the tomb of the Volusii: *CIL*, VI, 7394 has *D. M./permissu/L. N.* inscribed at one time with the *nomina* of the deceased left blank. Similarly, the inscription and the relief of Ulpia Epigone were added later to a stone not necessarily originally intended for her.

9. Buonacore, *op. cit.* (n. 7), 110.

10. H. Solin, *Die griechischen Personennamen in Rom. Ein Namenbuch* (Berlin 1982), I, pp. 964–65, and III, p. 1340, on the appearance of the *cognomen* Epigone in servile contexts. A. M. Duff, *Freedmen in the Early Roman Empire* (Cambridge 1958), pp. 53–55. S. Treggiari, *Roman Freedmen during the Late Republic* (Oxford 1969) pp. 250–51, on the nomenclature of freedmen in general. P. R. C. Weaver, *Familia Caesaris* (Cambridge 1972).

11. L. R. Taylor, *Freedmen and Freeborn in the Epitaphs of Imperial Rome*, in *AJP* 82 (1961): 120–22, notes the decline of the use of *libertus* in inscriptions of the late first and early second centuries although *Augusti libertus* was often recorded as a title during this period. Taylor, p. 127, on the Greek *cognomen* as sign of freedman status. P. R. C. Weaver, '*Cognomina Ingenua' : A Note*, in *CQ* 58 (1964): 311–15, on the difficulty of distinguishing between the upper classes and slaves and freeborn in the second century on the basis of personal nomenclature. Treggiari, *op. cit.* (n. 10), 5–7, on the problem of determining the origins of freedmen from their names. M. L. Gordon, *The Freedman's Son in Municipal Life*, in *JRS* 21 (1931): 76, on the popularity of names suggesting good luck, and 77 on the possibility of the indiscriminate use of Greek names among the slave and freed populations.

12. Of course, the *praenomen* Ulpia seems to assert a relationship with the Trajanic house while the *cognomen* Epigone probably indicates servile status. Solin, *op. cit.* (n. 10), I, pp. 964–65, and III, p. 1340. On Trajan's father, Marcus Ulpius Traianus, see R. Paribeni, *Optimus Princeps* (Messina 1927), pp. 47–51. R. Syme, *Tacitus* (Oxford 1963), I, p. 30 f.

13. J. M. C. Toynbee, *Death and Burial in the Roman World* (London 1971), p. 268, argues that *klinai* were not sarcophagus lids but served as independent couches on which effigies of the dead lie recumbent. L. Berczelly, *A Sepulchral Monument from Via Portuense*, in *Acta A* 8 (1978): 52–53, proposes that *klinai* were used in a variety of ways. See Wrede, *Stadtrömische Monumente*.

14. For example, Wrede, *Stadtrömische Monumente*, 420, fig. 105 (Paris, Louvre, Réserve Napoléon); p. 421, fig. 106 (Rome, Terme, Inv. 72879). Wrede, *Claudia Semne*, fig. 78, 2.

15. W. Amelung, *Die Sculpturen des Vaticanischen Museums*, II (Berlin 1908), pp. 147–48, no. 58, fig. 16. West, *op. cit.* (n. 1), II, 49, no. 11. Cumont, *op. cit.* (n. 1), 401, fig. 80. Wrede, *Stadtrömische Monumente*, 410, and 414, figs. 92, 93. Musei Vaticani, Inv. 878. Hausmann, *op. cit.* (n. 7), 174, n. 37. The facial type resembles that of Domitia Longina, and the coiffure differs

slightly from that of Ulpia Epigone and may be Domitianic as well. Both this *kline* figure and Ulpia Epigone wear a seal ring on the small finger of the left hand. The sculpture is .57 m. in height and 1.47 m. in length.

16. Evidence for the cost of statues and altars with reliefs is only beginning to be examined. D. E. E. Kleiner, *Roman Imperial Funerary Altars with Portraits* (Rome 1987), pp. 28–29. R. Duncan-Jones, *The Economy of the Roman Empire. Quantitative Studies* (Cambridge 1974), pp. 78–80. R. P. Saller and B. D. Shaw, *Tombstones and Roman Family Relations in the Principate: Civilians, Soldiers and Slaves,* in *JRS* 74 (1984): 124–56, esp. 128–29, state that the cost of memorial stones was not beyond the means of modest individuals. R. Weynand, *Form und Dekoration der römischen Grabsteine der Rheinlande im ersten Jahrhundert,* in *BonnJbb* 108–9 (1902): 185–238, primarily on the development and the dating of types. It is clear that a freestanding marble sculpture costs more than a relief of the same material.

17. Ulpia Epigone may have had some relationship (perhaps as wife or concubine) to one of the contemporary Volusian *liberti*. This may explain her use of a slab partially prepared for a freedman of the Volusii.

18. Cumont, *op. cit.* (n. 1), p. 401, proposes that the Vatican *kline* may have served as a model for the relief of Ulpia Epigone although this is unlikely.

19. Rome, Terme, Inv. 8638. Helbig[4], III, no. 2361 (H. von Heintze). G. Daltrop, U. Hausmann, and M. Wegner, *Die Flavier: Das römische Herrscherbild,* 2, 1 (Berlin 1966), p. 118, fig. 42. U. Hausmann, *Zu den Bildnissen der Domitia Longina und der Julia Titi,* in *RM* 82 (1975): 315–28. A. Giuliano, ed., *Museo Nazionale Romano, Le sculture,* I, 5 (Rome 1983) pp. 32–36 (L. de Lachenal).

20. Daltrop, et al., *op. cit.* (n. 19), 118.

21. I would like to thank R. R. R. Smith for calling my attention to this work. Metropolitan Museum inv. 38.27. *MMA Bulletin* 33 (1938): 103–5, figs. 1–3. *CIL* VI, 16054. F. Matz and F. von Duhn, *Antike Bildwerke in Rom,* III (Leipzig, 1882), no. 3912. Altmann, *op. cit.* (n. 1), 213, no. 274, fig. 171. G. M. A. Richter, *Roman Portraits in the Metropolitan Museum* (New York 1948), n. 56. M. M. Wegner, *Die Herrscherbildnisse in antoninischer Zeit: Das römische Herrscherbild,* 2, 4 (Berlin 1939), p. 289. Hausmann, *op. cit.* (n. 7), p. 173, n. 27. H. Jucker, *Das Bildnis im Blätterkelch. Geschichte und Bedeutung einer römischen Porträtform* (Otten 1961), I–II, p. 21, no. G6., pl. 3. A. M. McCann, *Roman Sarcophagi in the Metropolitan Museum of Art* (New York 1978), p. 19, fig. 8. Kleiner, *op. cit.* (n. 16), 160–62, pl. xxviii, 1–2, cat. no. 44. The inscription reads, "To the most saintly Cominia Tyche, his most chaste and loving wife, [from] Lucius Annius Festus. [She] died at the age of 27 years, 11 months, 28 days. Also for himself and his descendants." The relief dates to A.D. 85–100. The coiffure is also similar to that of the portrait relief of Cornelia Glyce. See Altmann, *op. cit.* (n. 1), p. 122, no. 130, fig. 98, and Kleiner, *op. cit.* (n. 16), 138–39, pl. xviii, 1–2, cat. no. 27. Also, on the altars: D. Boschung, *Antike Grabaltäre aus den Nekropolen Roms* (Bern 1987).

22. Wrede, *Claudia Semne,* pp. 127–28 and 131–33. Kleiner, *op. cit.* (n. 16), 29, on the problem of portraits that do not seem to correspond with the age of the deceased at death as stated in epitaphs. This may be attributed to the purchase of stock workshop pieces that served as the portraits of the deceased.

23. Hausmann, *op. cit.* (n. 7), 164–80, on the development of the Flavian coiffure. The shape of the individual curls, their arrangement over the forehead in rows or in less orderly groupings, and the spherical or angular profile of the wig determine the typology of the coiffure. See also Kleiner, *op. cit.* (n. 16), 93.

24. Hausmann, *op. cit.* (n. 7), 173–75. The *Ringlockentoupet* is characterized as having neat, flat rows of curls and was worn into the Trajanic period as attested by the portraits of mature women on funerary reliefs and altars. The schematic arrangement of curls of a similar size and shape tends to indicate an early Trajanic date. The height and pointed apex of some versions of the coiffure also indicate a late date. See also Kleiner, *op. cit.* (n. 16), 170–72, pl. xxxi, 1–3, cat. no. 49.

25. Wrede, *Claudia Semne,* pp. 131 and 136–66. Wrede, *Consecratio,* pp. 158–75. Kleiner, *op. cit.* (n. 4), pp. 512–44.

26. W. Amelung, *Führer durch die Antiken in Florenz* (Munich 1897), pp. 46–47, no. 67, on the Medici Venus type. H. Stuart Jones, *A Catalogue of the Ancient Sculptures Preserved in the*

Municipal Collections of Rome. The Sculptures of the Museo Capitolino (Oxford 1912), I, pp. 182–84, pl. 45. B. Felletti-Maj, *Afrodite pudica: saggio d'arte ellenistica,* in *ArchCl* 3 (1951): 33–65. D. M. Brinkerhoff, *Hellenistic Statues of Aphrodite. Studies in the History of their Stylistic Development* (New York and London 1978), pp. 100–104. The Capitoline Venus type was probably developed in Asia Minor shortly after 200 B.C. W. Neumer-Pfau, *Studien zur Ikonographie und gesellschaftlichen Funktion hellenistischer Aphrodite-Statuen* (Bonn 1982).

27. A. Hekler, *Römische weibliche Gewandstatuen,* in *Münchener archäologische Studien dem Andenken Furtwänglers gewidmet* (Munich 1909), p. 220, n. 1, on the nude portrait in the Flavian and Trajanic periods. Wrede, *Claudia Semne,* pp. 154–63. Venus was more popular as a vehicle of private commemoration than Fortuna or Spes.

28. Wrede, *Consecratio,* pp. 76, 110, and 306–8. Wrede, *Claudia Semne,* pp. 144–57. The Capitoline Venus type was popular in the late first and early second centuries.

29. Martial, *Epigrams,* 6.13. Daltrop, et al., op. cit. (n. 19), 115, for a portrait of Julia Titi in the Ny Carlsberg Glyptotek, no. 657, which may also represent her as Venus. A portrait in the Musei Vaticani, Braccio Nuovo, no. 78, and another in the Museo Nazionale in Naples are replicas of the Copenhagen portrait. H. Mattingly, *Coins of the Roman Empire in the British Museum,* II (London 1932), p. 247, nos. 140–143.

30. Wrede, *Claudia Semne,* pp. 144–57. Statius, *Siluae,* 5.1.233.

31. G. Lippold, *Kopien und Umbildungen griechischer Statuen* (Munich 1923), p. 100. R. West, op. cit. (n. 1), II, 92, no. 5, pl. 26, fig. 96. Felletti-Maj, op. cit. (n. 26), 62–63. F. Poulsen, *Catalogue of Ancient Sculpture in the Ny Carlsberg Glyptotek* (Copenhagen 1951), pp. 375–76, no. 541. Hausmann, op. cit. (n. 7), 170. V. Poulsen, *Les portraits romains,* II (Copenhagen 1962), pp. 48–49, no. 14, pl. 25 and 27. G. Saflund, *Aphrodite Kallipygos* (Stockholm 1963), pp. 13–14, fig. 3. Wrede, *Consecratio,* pp. 306–8. Hausmann, op. cit. (n. 19), 320, fig. 109, 1, on a similar portrait in Paestum that he identifies as Domitia Longina and dates to the period of Nerva.

32. Pliny, *HN,* 33.22–25.

33. *Encyclopaedia of Religion and Ethics,* III, ed. J. Hastings (New York and Edinburgh 1913), *Charms and Amulets (Roman)* pp. 461–65 (R. Wünsch). C. Bonner, *Studies in Magical Amulets* (Ann Arbor 1950), pp. 9 and 52, cat. nos. D80–82. C. Barini, *Ornatus Muliebris: i gioielli e le antiche romane* (Turin 1958), p. 56. R. MacMullen, *Enemies of the Roman Order. Treason, Unrest and Alienation in the Empire* (Cambridge 1966), p. 323, n. 24.

34. Bonner, op. cit. (n. 33), pp. 51–54, and 92–94, cat. nos. D145–47.

35. F. Coarelli, *Greek and Roman Jewelry* (Milan 1966), p. 143.

36. L. M. Wilson, *The Clothing of the Ancient Romans* (Baltimore 1938), pp. 148 and 155–57. P. Zanker, *The Power of Images in the Age of Augustus,* trans. A. Shapiro (Ann Arbor 1988), pp. 162–66.

37. For example, see Wrede, *Stadtrömische Monumenten,* p. 423, fig. 108; p. 429, fig. 115; also Cumont, op. cit. (n. 1), 392, fig. 4, and 497, fig. 105. See also Petronius, *Satyricon* 71.

38. Martial, *Epigrams,* 1.109.

39. Cumont, op. cit. (n. 1), 402. J. M. C. Toynbee, *Beasts and Their Names in the Roman Empire,* in *PBSR* 16 (1948): 35, pl. 9, fig. 26. J. M. C. Toynbee, *Animals in Roman Life and Art* (London 1973), pp. 108–12. Dogs also attended underworld deities and, in this aspect, may signify the hope for rebirth and eternal life. See Toynbee, *Animals,* pp. 122–23.

40. Pauly-Wissowa, *RE,* III (Stuttgart, 1899), col. 2591–2606 (A. Mau). Altmann, op. cit. (n. 1), 233, 236, fig. 190a, and 239. J. Schelp, *Das Kanoun. Der griechische Opferkorb* (Würzburg 1975), p. 11. C. Berard, *Le Liknon d'Athéna,* in *AntK* 19 (1976): 101–14. S. K. Heyob, *The Cult of Isis Among Women in the Graeco-Roman World* (Leiden 1975), p. 61. Kleiner, op. cit. (n. 16), 102–4, pl. iv, 3–4, cat. no. 5. The *liknon* frequently is similar to a winnowing basket. The *cista mystica* is usually represented as a round basket with a raised lid that reveals a coiled snake. Other Bacchic symbols such as ivy wreaths often appear as well.

41. An example of a cinerary urn in the form of a basket is on view in the Metropolitan Museum. Invoice no. 37.129a–b. *MMA Bulletin* 33 (1938): 52, fig. 3. It may date to the first or second century A.C. The baker Eurysaces may have placed his wife's ashes within the tomb in a breadbasket,

in hoc panario (*CIL*, VI, 1958). F. Sinn, *Stadtrömische Marmorurnen* (Mainz 1987), pp. 62–63, states that the basket urns cannot be identified as cistae mysticae; she adds, however, that the form may have been appropriate for members of certain professions, e.g., the baker Eurysaces. See also, P. Ciancio Rossetto, *Il sepolcro del fornaio Marco Virgilio Eurisace a Porta Maggiore* (Rome 1973), pp. 30–31, n. 19, fig. 28.

42. G. Brusin, *Il museo archeologico di Aquileia* (Rome 1936), p. 15, fig. 42. Toynbee, op. cit. (n. 13), 255, on three round *cineraria* in the form of baskets. One marble urn is in the Galleria Lapidaria of the Musei Vaticani while the other two stone urns, including the example above, are from Aquileia. Brusin, 13, figs. 32 and 33, on a basket urn with a banquet scene carved in relief. Toynbee considers the basket urns to have symbolized the need for provisions in the next world. Altmann, op. cit. (n. 1), 238–39 and 253, fig. 198.

43. G. Zimmer, *Römische Berufsdarstellungen* (Berlin 1982), p. 63, 193, cat. no. 133, on the funerary altar from Este in the Museo Nazionale Atestino, Inv. 1347, which dates to the first century A.C.

44. P. H. von Blanckenhagen, *Flavische Architektur und ihre Dekoration, untersucht am Nervaforum* (Berlin 1940), pp. 118–27, pl. 41.

45. E. D'Ambra, *Private Lives, Imperial Virtues: The Frieze of the Forum Transitorium in Rome* (Princeton 1993).

46. Livy, 1, 57, 9–10. Suetonius, *Aug.*, 73. J. Gagé, *Matronalia. Essai sur les dévotions et les organisations cultuelles des femmes dans l'ancienne Rome* (Bruxelles 1963).

47. R. Lattimore, *Themes in Greek and Latin Epitaphs* (Urbana 1942), p. 297.

48. *CIL*, VI, 37965. W. Kroll, *Die Grabschrift der Allia Potestas*, in *Philologus*, 27 (1914): 274–88. Lattimore, op. cit. (n. 47), pp. 298–99, with bibliography. N. Horsfall, *CIL, 6.37965 = CLE, 1988 (Epitaph of Allia Potestas): A Commentary*, in *Zeitschrift für Papyrologie und Epigraphik* 61 (1985): 256.

49. A. E. Gordon, *Illustrated Introduction to Latin Epigraphy* (Berkeley 1983), pp. 146–48. Conversation with Silvio Panciera, Rome, February 1986. The epitaph may even date from the first century.

50. Lattimore, op. cit. (n. 47), 299.

51. W. Schürmann, *Untersuchungen zu Typologie und Bedeutung der stadtrömischen Minerva-Kultbilder* (Rome 1985), pp. 11–13. D'Ambra, op. cit. (n. 45).

Social Status and Gender in Roman Art: The Case of the Saleswoman

NATALIE BOYMEL KAMPEN

One of the crucial issues in the women's movement of the late 1970s and early 1980s has been the relationship between social class and gender as determinants of women's condition in the world.[1] The argument over the primacy of capitalism or patriarchy as the factor most responsible for women's oppression is by no means a reductivist search for prime movers; the issue is one which not only provides a basis for political choice, but which affects the interpretation of history as well. The art historian can make some useful contributions to the question of the relationship between class and gender. Approaching the question from the point of view of nonverbal, visual language, the art historian can uncover valuable information about social position and attitudes of both patrons and protagonists of works of art. Particularly for social groups lacking substantial written documentation (and ancient women fit here because they so seldom speak for themselves), deductions from visual imagery may provide important links with silent populations.

The interaction of status with gender is a subject rarely investigated in the history of Roman art, and only recently has increased attention turned to this relationship in Roman history.[2] In this essay, I will explore the relation of gender and status for one group, Roman working people, and will show how gender and social

Reprinted with permission from HarperCollins Publishers, from *Feminism and Art History*, eds. M.D. Garrard and N. Broude, (New York 1982), pp. 60–77.

status interacted as determinants of visual images along with such other variables as period, artist's or patron's taste, or function of the object. The hypothesis of this essay is that a woman's position in the social matrix of Roman life helped to determine her iconography in Roman art.

Roman society was both stratified and patriarchal, its codes of public and private behavior based on status and gender power relationships. Stratification meant that there were definable levels in society, recognizable sometimes even on the street by the clothing people wore, but that upward mobility was possible.[3] A slave could become a freedman or freedwoman (*libertus* or *liberta*); a *liberta*'s children might grow up to be rich and their children to hold office beside men whose grandfathers had been great landowners and members of the highest group, the senatorial order. Birth, both in the slave system and in the class/order system, went along with wealth, service to the community, and nature of occupation, to place an individual in a social stratum. Unfortunately, the many strata of Roman society are not adequately described by our modern terms—upper class, *bourgeoisie,* or working class—and so the reader will find "class" as a concept less frequently used than "stratum." Stratum will refer to a recognizable level in Roman society, but it will not be synonymous with economic class.

Roman society was not only stratified, it was also patriarchal, in that public and private institutions supported an unequal power relationship between men and women that favored men. Position in the stratification system qualified these power relationships; a poor man would have had less power or privilege than a wealthy woman of the aristocracy, but the woman would have experienced these benefits of status *de facto* more often than *de jure*. Women could neither fight nor govern Rome (except through influence behind the scenes), and so stood outside the system of duties and honors open to the full (i.e., male) citizen. Although free Roman women in many parts of the Empire were unlike Athenian upper-class women in that they had considerable freedom of movement and were able to manage property and personal affairs with a measure of autonomy, they still remained legal dependents with little institutionalized power, even in their own houses.[4]

Roman women's experience of the world was thus conditioned by gender, by social status, and by lives led in a stratified and patriarchal society. To assess the influence of status and gender on one another as determinants of visual iconography, I shall present a group of images which shows working women and men. Some of these images, those illustrating working women selling foodstuffs to customers, represent an important sample for several reasons: they offer clear evidence of women at work; there are written parallels to the visual evidence; and images of male vendors exist for comparison. After analyzing the vendor images, I shall offer comparative images of other kinds of male and female workers whose status differed from that of the vendor. These comparisons will reveal the ways in which social status and gender affected a woman's visual image within the "working stratum" of the Roman Empire.

From Ostia, the port of ancient Rome, come two small marble reliefs of women selling foodstuffs. Both are now in the Museo Ostiense at Ostia, and both

date from the late second or early third century A.D. The more complex of the two, (Figure 42), was found in the Via della Foce, a street of shops and apartments; probably a shop decoration or sign, it shows a woman surrounded by poultry, produce and customers.[5] She stands in the center of the relief behind a counter made of rows of cages with rabbits and chickens. Around the saleswoman, creating a realistic clutter, are platters of fruits or vegetables, game hanging from a gibbet, a snail basket with a snail emblem on the wall nearby. Just behind the principal figure, a second person, perhaps an assistant, hovers almost out of sight, while on the right end of the counter sit two pet monkeys kept for the amusement of passers-by. Finally, three men, including a customer buying a piece of fruit, occupy the left third of the relief with their gesticulating conversation. The entire scene radiates a good-natured concern with the particulars of daily life.

The central focus on the seller recurs in the second Ostia relief (Figure 43).[6] There, a crudely carved seller in tunic and shawl stands behind a makeshift trestle counter displaying vegetables. The scene is again filled with detail, from the counter with its zucchini and scallions to the speaking gesture of the vendor. Because the site where it was found is unknown, the function of this relief remains unclear, but it must have been either for a tomb or for a shop.

The two reliefs, both small in size and modest in technique, share a number of formal and iconographic characteristics which indicate the presence of a firmly established visual language for commercial scenes. In both cases, the vendors stand behind their impromptu counters; they are centrally placed and made clearly visible by frames of objects and people. In the case of the poultry vendor, placement above the other figures helps to make her noticeable as well. Pose and gesture also distinguish the seller from other people and identify her as a worker. Both vendors touch the goods they offer for sale, and in the poultry vendor relief the saleswoman is identified by the act of giving a piece of fruit to a customer, who is identifiable by his outdoor cloak and shopping bag. The vegetable vendor addresses her customers (us, the viewers) not by handing goods to us, but by rais-

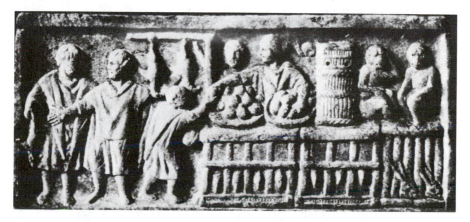

FIGURE 42 Poultry Vendor Relief, Late Second or Third Centuries A.C. *(Museo Ostiense, Ostia: photo courtesy of the Fototeca Unione, Rome)*

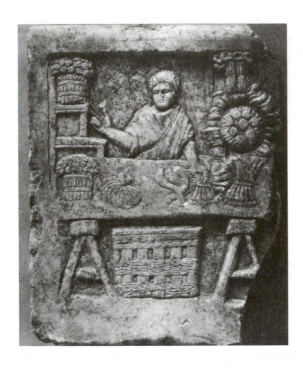

FIGURE 43 Vegetable Vendor
Relief, Late Second or Third
Centuries A.C. *(Museo Ostiense,
Ostia: photo courtesy of the
Fototeca Unione, Rome, neg. no.
2303)*

ing her hand in the speaking gesture which Roman literature describes as a signal for attention.[7]

Along with placement, pose and gesture, costume serves to identify a vendor. The women wear simple tunics with or without shawls, their hair dressed simply in styles unrelated to the fashionable coiffures of the court. These vendors do not wear the *stola*, a long and elaborate dress that identified the upper-class matron. Rather, as can be seen in representations of other working women, they wear simple garments that were not associated with any special class.[8] Thus placement, pose, gesture, costume and hairstyle all function as ways of identifying female vendors and distinguishing them from customers or from women of higher classes.

The few existing funerary inscriptions made for saleswomen give the same careful attention to the identity of the vendor *qua* worker as do the Ostia reliefs. These inscriptions name the women and sometimes identify their relatives and—if they were *libertae*, freed slaves—their patrons, those who freed them. For example, M. Abudius Luminaris made a funerary monument for Abudia Megiste, his wife and former slave,[9] and Aurelia Nais' inscription mentions her *libertus* patron.[10] Most clearly stated in both inscription and image is the woman's occupation, that which defines her role in the world. We learn what she sold and often where she sold it. Abudia Megiste sold grain at Rome's Middle Stairs, Aurelia Nais sold fish at the Warehouses of Galba, and Pollecla sold vegetables on the Via Nova.[11] Others in Rome and elsewhere in the Latin-speaking western Empire are

commemorated as having sold seed, beans, dyes, nails and ointments.[12] This clear statement of commodities and occupations is the verbal equivalent of the evident delight in visually presenting objects and gestures to identify a woman's occupation in art; both stress her role in society.

The emphasis on role is equally present in representations of saleswomen from areas other than Ostia. Two female vendors appear in paintings from Pompeii, one from the Praedia Iulia Felix and the other from the dye shop of Verecundus. Among the many sales vignettes in the forum paintings that decorated the Praedia Iulia Felix (a building that may have had rental shops as well as living spaces) is one of a small female who stands beside a trestle counter covered with vegetables. She touches the greens as a youth approaches, presumably to buy.[13] The standard iconography of vendor and customer thus may have applied in a domestic context as well as in shops. On the left door post of the dye shop of Verecundus, on Pompeii's Via dell'Abbondanza, appears a depiction of a low table with indeciferable objects, perhaps shoes or things made of felt. Behind the table a woman sits and touches the objects, as a youth seated beside the table watches her.[14] This scene is a pendant to the image on the right door post, which shows the dyers at work and the proud Verecundus displaying a finished piece of cloth. In the context of a shop, these literally presented commercial scenes are undoubtedly a form of advertising, and the emphasis on role and occupation is completely appropriate.

The characteristic features of role images for women vendors in Ostia and Pompeii reappear in a large funerary monument called the Pilier du Cultivateur from Arlon, Belgium (Figures 44 and 45).[15] The Pilier is a tall oblong monument made of large blocks of local stone and carved with portraits and quasi-biographical images on three sides. It belongs to a group of funerary monuments from late second- and third-century Gallia Belgica, especially Arlon, Trier-Neumagen and Luxembourg.[16] The Pilier du Cultivateur is so named because, in addition to the portraits of a man and a woman on the front (Figure 44), its sides present four different scenes of agricultural life. On the right are a cart and driver above an image of a man displaying a tipped basket of fruit for another. On the left side, above a pair of men hoeing the earth, a sale scene occurs (Figure 45). It contains many of the usual elements, from the trestle counter to the sellers' gestures. The customer, who may in this case be the estate owner inspecting the goods for sale, is distinguished from the vendors by his outdoor cloak and his position to the right of the counter. The vendors, a man handing some fruit to the customer and a woman at the left arranging fruit, wear simple indoor garments, stand behind the counter and touch the goods displayed. Although it is by no means clear whether these vendors are the same people as those who appear on the front of the Pilier or their employees/slaves, the roles are once again primary.

Three conclusions emerge from comparison of the Pilier du Cultivateur with the vendor images of Italy. First, the artists of Arlon used the same forms that appeared in Italy from the first through the third centuries; second, they applied the same visual language to a funerary monument as that which was appropriate for

FIGURE 44 Pilier du
Cultivateur: Front, Late Second
or Third Centuries A.C. *(Photo
courtesy of Musée
Luxembourgeois, Belgium)*

shop and domestic decoration; and last, they permit us to see that the same visual conventions may apply to both male and female vendors. The visual language defines a common occupational and social role for both sexes, and this, as we shall see later, is limited to a recognizable social stratum.

The Arlon Pilier du Cultivateur is hardly unique in its use of the same visual language for male and female vendors. The attention-drawing placement of the vendor above and behind the sale counter appears in a Pompeian painting of a bakery or bread distribution from the Casa del Panettiere (first century A.D.),[17] and in the funerary monument with a wine shop from Dijon (second–third century A.D.).[18] Lucifer Aquatari, the water seller whose tomb of about A.D. 130 in Ostia's Isola Sacra Necropolis is decorated with small terracotta relief pendants, stands behind his counter and is further identified by plaques near him which give his name.[19] Pose and gesture identify salesmen as they did saleswomen. The cutlery vendor of the late first-century A.D. altar of Atimetus in the Vatican (Figure 46) stands next to a display of goods, with his right hand in the speaking gesture familiar from the relief of the Ostia vegetable vendor.[20] In all these representations, the salesmen and saleswomen wear simple short or long tunics, while the customers wear either the *togae* and *stolae* of prosperous citizens (e.g., altar of Atimetus, where the *togatus* may be an owner, as in the Pilier du Cultivateur), or the outdoor cloak (Panettiere painting and Dijon monument). The basic elements which identify male and female vendors in the art of Italy and the northern prov-

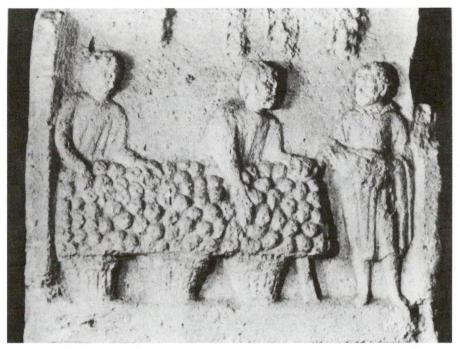

FIGURE 45 Pilier du Cultivateur: Upper Left Side, Late Second or Third Centuries A.C.
(Musée Luxembourgeois, Belgium)

inces are the same, even though men's images outnumber those of women and the men sell a far greater variety of goods. In iconographic terms, then, role and social stratum are more important in determining vendor images than gender.

The question now to be asked is whether male and female workers are represented in similar ways in other occupations. This question will be put to images of three different occupations that are representative of several social levels: the rich merchant, the medical practitioner, and the artisan.[21]

The merchant differs from the vendor by owning a larger establishment, the scope of which extends beyond the neighborhood. Rather than setting up a trestle counter in the marketplace, the merchant produces or moves goods in quantity and reaps larger profits. This is the person whom Cicero described in *De Officiis* as distributing goods in great volume to many without misrepresentation; he went on to say: "It [the merchant's occupation] even seems to deserve the highest respect if those who are engaged in it, satiated, or rather, I should say, satisfied with the fortunes they have made, make their way from the port to a country estate. . . ."[22] The rich merchant presumably dealt honestly with the public, took no part in retail sales (which Cicero thought involved lying for profit), and eventually invested his great income in land and respectable leisure. Although Cicero disparaged small retailers and hired laborers as vulgar, dishonest and unworthy, his conservative

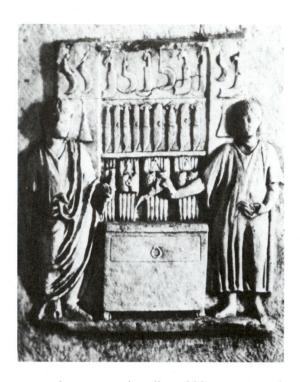

FIGURE 46 Altar of Atimetus:
Side, Late First Century A.C.
(Vatican, Galleria Lapidaria)

upper-class perspective allowed him to respect the tycoon for his potential absorption into the ranks of gentlemen.

Representations of wealthy merchants have a distinguishable language of their own, which communicates status by using the model of the customer rather than the vendor. The altar of Q. Socconius Felix in Rome shows a banquet with a reclining couple, Socconius Felix and his wife, on the front; on the back, a man wearing a toga (again Socconius) sits in an elaborately carved chair and watches three men in workers' tunics display a large piece of cloth.[23] A similar image appears on two provincial funerary monuments, the Igel column near Trier[24] and the Pilier du Marchand de Drap from Arlon (Figure 47).[25] Both come from Gallia Belgica, which played a major role in the Roman cloth trade. In each one, a richly dressed man sits at a desk as fabric is displayed for him. That he is not a customer but the merchant himself is likely, in view of the presence of other scenes of this mercantile world on the monuments. The images clearly differentiate the status of the seated merchant, shown like a customer, from the employees who share iconography with vendors or attendants.

No comparable images of female merchants exist. This is not, however, because there were no such women, since inscriptions on bricks and lead pipes, as well as comments by writers about women who owned merchant ships, prove that women owned and operated businesses on a grand scale.[26] Nowhere do these

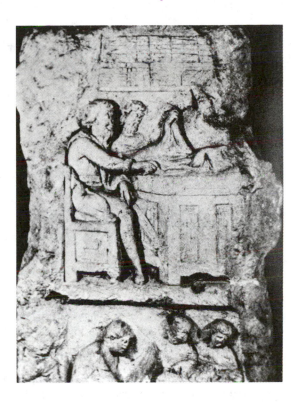

FIGURE 47 Pilier du Marchand de Drap Side: Third Century A.C. *(Musée Luxembourgeois, Belgium)*

women appear in art, nor do the women on the monuments of male merchants play any role in business. They stand for their portraits holding little dogs or spindles, or they sit quietly while their maids dress their hair.[27] In other words, they are presented as evidence of the wealth of their husbands in that they need do nothing but attend to their appearance and leisure.

Women with wealthy husbands or with enough wealth of their own to invest in business were given a traditional public image. As we have seen in Cicero, "gentlemen" might work at governing, fighting for Rome, or agriculture, but they did not work in "trade." Similarly, "ladies," Roman matrons, could run great households, manage huge businesses or carry on disreputable affairs with gladiators, but all clung to the *mores maiorum,* the ways of the ancestors, according to which all matrons were supposed to be at home, raising their children and working wool with their faithful slaves. The ideology of gender division of labor was firmly entrenched even when reality daily violated it.

In the aristocracy and the wealthy merchant/landowner stratum in Rome and the provinces, women were not shown at work even though they did sometimes work. Perhaps this was because the wealthy merchant stratum valued the *mores maiorum* as a public image or wished to appropriate it to gain status. For men like the cloth merchants, a pampered wife could signal upward mobility; however, the

source of their wealth in business still mattered enough for them to have it represented. They had not yet moved up into the stratum of gentlemen, whose values precluded mercantile work.

The case of medical workers is less clear than that of merchants because doctors and midwives offer less coherent evidence about the social strata to which they belonged. They are known to have been imported often as slaves from the Greek-speaking East, at least in the Republic. About half of the preserved inscriptions which document women doctors and midwives in Latin identify them as *libertae,* often associated with the households of the very wealthy.[28] There are, however, many inscriptions for male and female doctors which give no evidence of legal status and which sometimes suggest an independent practice with a definite location.[29] Furthermore, a certain amount of equality for male and female medical practitioners seems indicated by Ulpian, the jurist, when he states that obstetricians had the same status as doctors (male and female), regardless of the fact that they worked mainly with female patients.[30] (This would apply to medical professionals rather than to folk midwives and healers.) That status Cicero explained by saying that professions which benefit humanity, such as education and medicine, were not to be condemned as lowly and were respectable for those whose status they suited (!).[31] Thus medical workers stood outside the upper class but could have gained some status, even as slaves, through their occupation; that status, according to the written sources, could have been equal for women and men.

Although there are not many surviving images of male or female medical practitioners, we can nevertheless see a clear iconographic stereotype for male doctors which does not apply to midwives and female doctors. In virtually every case, the image of the male doctor draws upon the iconography of either a Greek philosopher or the healing god Aesculapius. The connection is made, for example, in a funerary stele of the Attic doctor Jason, here illustrated (Figure 48), as well as in a small and crudely executed terracotta relief that decorated tomb 100 in Ostia's Isola Sacra Necropolis, and even in elegantly carved gems (all of the second century A.D.).[32] All wear the Greek *himation,* are bearded, and sit examining or treating a patient who is often smaller than the doctor; all are presumably ennobled by the iconographic models they employ.

In contrast to male medical imagery, three examples of women doctors or midwives—which are all that survive for this period—present three very different iconographic schemes. The terracotta relief of a midwife-obstetrician birthing a baby, pendant with the doctor relief from the Isola Sacra cited above, is utterly simple and literal (Figure 49). A Pompeian ivory plaque, probably from the first century A.D., shows the same childbirth composition, but with a landscape setting and attributes suggestive of some unknown myth.[33] The third example, a funerary stele from Metz (second–third century), eschews action of any kind and instead presents a standing woman with a box in her hand (Figure 50). Only the fragmentary inscription, INI FII MEDICA, indicates her occupation.[34] This kind of standing portrait is traditional for women's funerary reliefs from late Republican Rome to

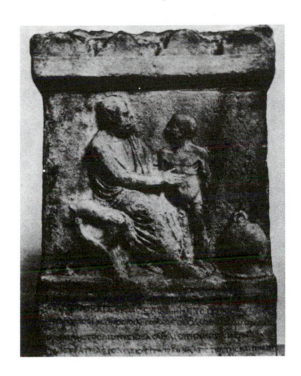

FIGURE 48 Stele of Doctor Jason, from Attica, Second Century A.C. *(British Museum, London)*

late Imperial Gaul. It carries with it no associations with work, any more than do the representations of doctors on stelae from the Greek world, where women sit or stand with family or friends, and only inscriptions identify their profession.[35]

The small amount of evidence for the iconography of medical practitioners thus indicates that images of men and women did not share the same visual vocabulary, in spite of the equality described in the written sources. Women doctors may appear as matrons in portraits, or as idealized participants in myth, but men are routinely presented as themselves, their specific identities reinforced by the status-enhancing association with Aesculapius or a philosopher. Iconographic differences depend on the gender of the protagonist as well as the content and function of the image.

Iconography again varies according to the worker's gender when men and women do artisan work. Not surprisingly, a large number of representations in paint and relief show men working at all kinds of artisan occupations; they are ship-builders, masons, smiths, perfumers, carpenters and the like.[36] In most instances, the representation of men at work documents them quite literally, as in the case of the ship-builder Longidienus of Classis, who is shown working on a boat.[37] No allegory, no mythological overlay interferes with communication of these men's identities as workers. Women artisans, much smaller in number, partake of a very different iconography, since with few exceptions they appear only in an allegorical or mythological context. The occupations are generally limited to

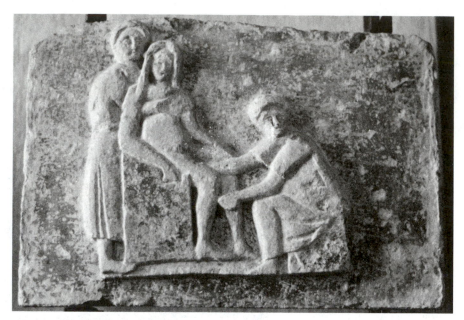

FIGURE 49 Terracotta Relief of a Midwife-Obstetrician, Second Century A.C. *(Museo Ostiense, Ostia)*

fabric work: spinning, weaving, repairing cloth, garland-making, and in one instance, perfume production.[38] In the Minerva and Arachne frieze of the Temple of Minerva in Rome's Imperial Fora, women are not human weavers and spinners but mythic parts of an allegory of the state.[39] Such images are by no means comparable in iconography or function to the small stelae and reliefs of male artisans from all over the western Roman Empire.

Despite the fact that inscriptions report a few women metalworkers (one a smith married to a smith), as well as weavers and garland makers, and in spite of the undoubted presence of some female slaves and family members in small production shops, the visual imagery offers little evidence for the existence of these women.[40] Although wool baskets and spindles appear on funerary reliefs from Gaul to Asia Minor, they denote women's feminine virtues rather than their moneymaking occupations.[41] By contrast, male artisans are both liberally and literally documented, not only because they were plentiful and visible, but also because they gained status within their own social stratum through their work. By contrast, the work of a woman, whether in her own shop or that of her father, husband or owner, was either not recognized as conferring status or was actually considered to lower her status.

A few other occupations should be noted in passing, those which represent the least prosperous and least autonomous of workers. Hairdressers and nurses are invariably shown as women, not men, in scenes which subordinate their labor to the identity and status of the people they serve. Nurses on biographical and myth-

FIGURE 50 Stele of a Doctor, Second or Third Centuries A.C. (*Musée Archéologique, Metz*)

ological sarcophagi (Figure 51), like hairdressers on Gallic funerary monuments (Figure 52), offer information about their mistresses and masters, but they are far too mythologized or conventional in type to tell much about themselves.[42] This is hardly surprising in light of the texts and inscriptions which indicate that many, perhaps most, of the women in these jobs were slaves or *libertae* attached to wealthy households.[43] The monuments show us owners attended by faithful but ultimately anonymous retainers. Status and gender combine to deprive the hairdressers and nurses of personal autonomy in these images.

In all the occupations discussed in this section, women are differentiated iconographically from men. Merchants are always male, while hairdressers and nurses are always female. Although medical practitioners and artisans can be male or female, their iconographies differ radically. A quasi-divine model is invariably used for male doctors, whereas it is never used at all for female doctors. Male artisans normally appear in a very literal form, one which emphasizes role and work, in contrast to female artisans, who become part of a mythologized scheme, their actual work rendered trivial or unreal.

The comparative documentation in this section demonstrates that men's work images are plentiful and popular at almost every stratum below the upper class. The images occur in a variety of types and frequently in large quantities for all occupations seen as acceptably male. The reasons for the popularity of male worker images are twofold: first, the images document a reality which was visible to the patron or public and which at the same time was acceptable, in the sense of fitting into the dominant ideological system of male behavior in a given social

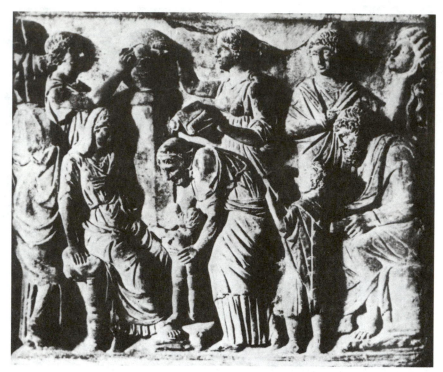

FIGURE 51 Biographical Sarcophagus: Side, Second Half of the Second Century A.C. *(Uffizi, Florence)*

class. Second, these images enhanced the social status of the worker, as in the case of the merchant who looked like a customer, or the artisan who advertised himself through his role. Self-commemoration, employing iconographies which differed according to the status of the patrons or subjects, became role-commemoration.

Women workers might have their roles commemorated in their epitaphs, as did men, but those roles seldom took a literal visual form. Women's work tended to be either invisible or transformed for purposes other than literal documentation of role. When women held the same jobs as men, their imagery was based on different models and iconographies, generated by a combination of role, gender and status. To whatever extent the working roles of Roman men and women may have differed in real life, even more did their identities as workers diverge in their images in works of art.

Two questions remain to be considered. First, why is women's work so much more fully acknowledged in literature and inscriptions than in the visual arts? And second, what can we say, on the basis of the material considered here, about the relationship of gender and social status as variables which help to determine the iconographic structure of works of art?

FIGURE 52 Monument of the Parents (Elternpaarpfeiler): Detail, First Half of the Third Century A.C. *(Landesmuseum, Trier)*

The first step in answering both these questions is to describe two rather different constraints which applied in varying degrees to the different parts of Roman society. Art patrons of high class and status, or with aspirations to join that level of society, seem to have operated under an ideological constraint which held that work was unacceptable for women unless it was centered in their own households and executed for their own families. The ideology, based on traditional notions about the life and conduct of the old-fashioned Roman Republican matron, was, as we have seen, frequently divorced from the practical realities of life, from the first century B.C. on. This denial of experience helped to preserve in ideological form a gender division of labor while at the same time it negated the reality of the working lives of women—slaves and *libertae* especially—who violated the ideological norm. In theory, women stayed at home and cared for their particular domain, the place in which their status resided. Works of art that contradicted this principle had to show the female worker as mythological or entertaining, or as an adjunct to the patron's own status; otherwise she might not appear.

The second constraint applied to men and women of the lower classes, who possessed less wealth and status than those we have just been discussing and whose aspirations and daily experience are much less clearly understood. For them, financial constraint undoubtedly limited the purchase of work representations even more severely than it limited the purchase of commemorative inscrip-

tions. (The greater number of inscriptions than work images for both men and women suggests that inscriptions cost less.) Such financial constraint may have especially affected women, who are likely to have worked less often, for fewer years, and for lower wages, than men.

To ask why only vendors share a cross-gender iconography is in fact to confront the question of how often and to whom in the lower classes the ideological constraint applied. The answer is to be found in the special conditions of vendors' work, conditions which made them different from the other workers in the same social stratum.

The vendors for whom inscriptions and images remain inhabited a narrow stratum below the aristocracy and the rich merchants and gentry, but above the poorest members of the lower class. They had greater prosperity and autonomy than the anonymous slaves-of-all-work, field hands and mine workers, and they certainly enjoyed greater social status than the whores, waitresses and entertainers whose names were scribbled on barroom walls. They belonged instead to the upper working class/lower middle class, to that stratum that also included prosperous artisans, midwives and doctors, innkeepers, and perhaps even some skilled and valued household slaves; they could be freeborn, *liberti* and *libertae,* or slaves. Their attributes included skill, a degree of financial autonomy, social status within their immediate communities, or proximity to a benevolent owner-patron. These were the people who either had money to record their own work or whose work was so valued that others documented it. At the same time, they are people with enough pride in their work to want to give it public form, in writing or art.

Within this social stratum, the experience of women sometimes differed from that of men, and the differences were heightened in art. Women tended to be shown in jobs related to traditional female domestic occupations: fabric work, work with food, health and child care, and care for personal appearance, and this work often took place in private houses rather than public settings. The public saw women at work less often than it saw men, and it saw women doing things they would do at home for no wages. This perception, further reinforced by art, was perhaps responsible for diminishing the public image of women as real workers, thus preserving the ideology of gender division of labor which kept the "ideal woman" at home at her loom.

The vendor is the most obvious exception to this rule. Both men and women worked as vendors, performing the same actions, using the same gestures, selling the same goods to the same people in the same setting. The occupation seems not to have had a traditional association with either sex, and may have granted the same degree of prosperity and independence to both sexes. Perhaps most important, however, is the fact that this was a public occupation which could not be mistaken for anything other than money-earning. It represented one of the very few instances when men and women were seen doing exactly the same work in circumstances which were undeniably the same—public and economically motivated. These conditions of work must, I believe, have caused the public to perceive male and female vendors as more similar than men and women in other jobs. It is this

perception that allowed vendors to share an iconography in artistic images when other workers did not.

The works of art we have examined here reveal the existence of variations in social and gender experience within the lower classes of Rome as well as differences between upper- and lower-class values. For women as for men in the Roman world, gender experience changed from one social level to the next, even though the dominant and visible ideologies of the first, second and third centuries were aristocratic and patriarchal. To understand this interaction between class and gender and between ideology and material reality is to see more clearly some of the factors that determine the structure of both a work of art and a society.

NOTES

Author's note: This essay was written at the Penland School, Penland, North Carolina; I thank the people there for providing a wonderful working environment. I also wish to thank John Dunnigan and Dobie Snowber.

1. L. Sargent, ed., *Women and Revolution,* (Boston 1981); and Z. Eisenstein, ed., *Capitalist Patriarchy and the Case for Socialist Feminism* (New York 1978).

2. Very little work has yet been done on these issues; I mention a few of the most recent works here. On Roman working women, S. Treggiari, "Jobs for Women," *American Journal of Ancient History* 1 (1976): 76–104; and "Questions on Women Domestics in the Roman West," *Schiavitù, manomissione e classi dipendenti nel mondo antico:* Università degli studi di Padova, *Pubblicazioni dell'Istituto di Storia Antica,* 13 (Rome 1979), 185–201. My thanks to Sarah Pomeroy for bringing these articles to my attention. On worker imagery, B. M. Felletti Maj, *La tradizione italica nell'arte romana,* (Rome 1977); and G. Zimmer, *Römische Handwerkdarstellungen,* Rome, in preparation. On class as a determinant of visual imagery, R. Brilliant, *Gesture and Rank in Roman Art* (New Haven, Conn. 1963); R. Bianchi-Bandinelli, "Arte plebea," *Dialoghi di archeologia* 1 (1967): 7–19; and D. E. Kleiner, *Roman Group Portraiture,* (New York 1977). On class and gender, N. Kampen, *Image and Status* (Berlin 1981).

3. J. Gagé, *Les classes sociales dans l'Empire romain* (Paris 1965).

4. There were certain exceptions, e.g., women who had three or four children and were therefore exempt from the need for a male legal guardian through whom to conduct their business: *Gaius,* 1.194; and S. B. Pomeroy, *Goddesses, Whores, Wives, and Slaves: Women in Classical Antiquity* (New York 1975) pp. 151–52.

5. Kampen, op. cit., 52–59; and R. Calza, *Scavi di Ostia,* 9: *I Ritratti,* 2 (Rome 1978), no. 48.

6. Kampen, op. cit., pp. 59–64; and R. Calza and M. F. Squarciapino, *Museo Ostiense* (Rome 1962), no. 12. The figure can be identified as female by her hairstyle, a type not seen in male images, and by her nonbearded face. In the Hadrianic period, in which this relief can securely be dated, virtually all males are shown as bearded.

7. Apuleius, *Metamorphoses,* 2. 21.

8. Figures 4, 11, 15.

9. *Corpus Inscriptionum latinarum* (Berlin 1862 *et seq.*), VI. 9683. (Hereafter cited as *CIL.*)

10. *CIL,* VI. 9801.

11. E. Diehl, *Inscriptiones Latinae Christianae veteres* (Berlin 1925–67), 685b.

12. *CIL,* XIV. 2850; III. 153; VI. 9846, 9848, 37820; V. 7023; VI. 10006, 333928; and X. 1965.

13. W. Helbig, *Wandgemälde der vom Vesuv verschütteten Städte Campaniens* (Leipzig 1868), no. 1500.

14. V. Spinazzoli, *Pompei alla luce degli scavi nuovi di via dell'Abbondanza* (Rome 1953) pp. 189–210, f. 237–38.

15. A. Bertrang, *Le Musée Luxembourgeois: Annales, Institut archéologique du Luxembourg*, 85 (Arlon 1954), no. 10.

16. F. Drexel, "Die Belgisch-germanischen Pfeilergrabmäler," *Mitteilungen des Deutschen Archäologischen Instituts, Römische Abteilung* 35 (1920): 27–64; W. von Massow, *Die Grabmäler von Neumagen* (Berlin and Leipzig 1932); and J. J. Hatt, *La Tombe gallo-romaine* (Paris 1951).

17. Helbig, op. cit., no. 1501.

18. E. Esperandieu, *Recueil général des bas-reliefs, statues et bustes de la Gaule romaine* (Paris 1907–66) no. 3469.

19. M. F. Squarciapino, "Piccolo Corpus dei mattoni scolpiti ostiensi," *Bullettino della commissione archaeologica comunale di Roma*, 76 (1956–58), 192–99.

20. W. Helbig, *Führer durch die öffentlichen Sammlungen klassischer Altertümer in Rom* (4th edn., directed by H. Speier, Tübingen, 1969–72), I, no. 400.

21. These are hardly the only occupations possible; one could easily substitute shoemakers, waiters and waitresses, or agricultural laborers, among others.

22. Cicero, *De Officiis*, 150–51.

23. F. W. Goethert, "Grabara des Q. Socconius Felix," *Antike Plastik*, 9. 1–7 (1969), 79–86.

24. H. Dragendorff and E. Krueger, *Das Grabmal von Igel* (Trier 1924).

25. Bertrang, op. cit., no. 48.

26. E.g., *Notizie degli Scavi*, 7 (1953), 116, no. 27; and 174, no. 39. Suetonius, *Claudius*, 18–19.

27. Massow, op. cit., no. 184–85.

28. Treggiari, "Jobs for Women," 86–87; and Kampen, op. cit., 116–17.

29. E.g., *CIL*, VI. 9720 and 9477.

30. *Digest*, 50.13.1.2; and *Code of Justinian*, 6.43.3.1.

31. Cicero, *De Officiis*, 150.

32. Ostia relief: Kampen, op. cit., no. 16. Jason stele: V. Zinserling, "Zum Menschenbild im klassischen attischen Grabrelief," *Klio*, 56 (1974), 370–74. Gems: G. M. A. Richter, *Engraved Gems of the Romans* (London 1971), no. 362.

33. Ostia relief: Kampen, op. cit., 69–72; and Naples, Museo Nazionale relief, inv. 109905: Kampen, ibid., 70, n. 145.

34. Metz, Musée Archéologique, *La civilisation gallo-romaine dans la cité des Mediomatriques* (Metz 1964), pp. x–xi.

35. E.g., N. Firath, *Les stèles funéraires de Byzance greco-romaine* (Paris 1964) no. 139.

36. H. Gummerus, "Darstellungen aus dem Handwerk auf römischen Grab- und Votivsteinen," *Jahrbuch des Deutschen Archäologischen Instituts* 28 (1913): 63–126.

37. G. Mansuelli, *Le Stele romane del territorio ravennate e del Basso Po* (Ravenna 1967), no. 12.

38. As psyches they make garlands or perfume in the House of the Vettii in Pompeii; A. Sogliano, *La Casa dei Vettii in Pompei* (Milan 1898), pp. 233–388.

39. P. H. von Blanckenhagen, *Flavische Architektur und ihre Dekoration untersucht am Nervaforum* (Berlin 1940).

40. CIL, V. 7044; VI. 6939, 9211; III. 2117; Treggiari, "Jobs for Women," 82–84.

41. F. Noack, "Dorylaion: Grabreliefs," *Mitteilungen des Deutschen Archäologischen Instituts, Athenische Abteilung* 19 (1894): 315–34.

42. Hairdressers: Kampen, op. cit., nos. 30–38; nurses: nos. 21–29.

43. Treggiari, "Jobs for Women," 88.

Patrons, Painters, and Patterns: The Anonymity of Romano-Campanian Painting and the Transition from the Second to the Third Style

ELEANOR WINSOR LEACH

The direction to be taken in the study of patronage in Romano-Campanian painting has been dictated by those accidents of survival that have left us a large number of paintings located almost entirely in houses, while almost all paintings in public buildings have been lost. Where our interest in literary patronage centers primarily upon the author's career and his work, here it is less the painter than the patron we want to investigate. To what extent did the decorations of his house reflect his social standing, the rituals of his life, the level of his culture, or even his private fantasies?[1]

Fragments of painted plaster from the archaic houses on the Via Sacra suggest that the custom of painting interiors is very old,[2] although our literary evidence is generally thought to describe only those traditions of the Pompeian first style which may have begun some time in the second century B.C. Similarly, scraps of literary evidence suggest that the public tradition may be even older than the domestic, but we are even less able to trace this tradition back to its beginnings or to follow it very accurately in its development.[3] No more can we be certain how patronage first began to become involved in either private or public painting, in spite of a legendary tradition that made Demaratus of Corinth, father of Tarquin, the first to import a painter into Italy (Pliny *HN* 35.16). Our understanding of

Reprinted from "Patrons, Painters, and Patterns", by Eleanor Winsor Leach, in *Literary and Artistic Patronage in Ancient Rome*, edited by Barbara K. Gold, © 1982. By permission of the author and the University of Texas Press.

Roman traditions is faced with the virtual anonymity of patrons and painters alike. Although in public Roman art the anonymity of the artist may be a true reflection of the dominant shaping purpose of the patron, in private art the traditions established by the painters render the patrons anonymous.

The few remarks made by Pliny the Elder on the history of Roman painting suggest that its public and private traditions stood apart not so much on account of patronage or the artistic merit of the productions or even the difference between painted walls and *tabulae,* but rather because of their orientation toward either the domestic or civic sphere.[4] We have reason to assume that a public tradition still flourished under patronage in the late republic and early empire alongside the many Greek paintings then on display, but we must also assume that this tradition differed considerably from those of the domestic painting that we know.

If we were able to approach the interpretation of painting within the private tradition through our knowledge of patronage in the public world, we would naturally feel more secure, but these efforts would probably be misdirected even if the necessary information could be gathered.[5] In the essay "Roman Art in Modern Perspective," Otto Brendel emphasizes the distance between the imagery of those public monuments that give us the core of Roman art history and of decorative painting in the private sphere. In no period is the total artistic production uniform, but always the official art of Rome is isolated as a special class. Such a division, Brendel notes, "was itself typically Roman, but so were the two kinds of art that followed from this dualism, representing not only two separate strains of tradition, but also two sides of an identical historical situation that produced them both."[6] Neither is more Roman than the other.

We can make an approximation of such a distinction between the two types of art by contrasting two works executed in different media: the landscape designs of the sculptured end walls of the Ara Pacis and a wall painting from the Villa at Boscotrecase of a roughly contemporary date. Although each presents problems of interpretation, the problems are different in a manner that reflects the differing concerns of public and private patronage, even if the understandable urge to find links between the works of a period has led some to find their common inspiration in the optimistic spirit of Augustan Rome.[7] The Ara Pacis panels are not in fact landscapes but allegorical and historical compositions employing abstract elements of natural symbolism. The great maternal figure sits surrounded by emblems of abundance. Behind the children in her lap are poppies and grain that do not grow out of any solid base of earth but hang suspended in air. The upturned urn by her side pouring forth a stream of water is likewise iconographical. In spite of the token animals in the foreground, this is not a pastoral scene but a well-balanced gathering of figures outside of space and time. In the panel representing a sacrifice (Figure 25), the rough altar of piled stones that provides an organizing center for the action vaguely suggests primitive times. The rocky background supporting a small temple at an ambiguous distance from the foreground is no doubt equally primitive, but it is only from the figures and their action that we draw such con-

clusions about these elements. In themselves, they are no more than compositional props for the ritual scene.

The painted landscape also presents an image of ritual (Figure 53), but one that is both in composition and idea wholly unrelated to the Ara Pacis scene. Both allegory and narrative are absent; we appreciate this piece on compositional principles alone, observing its spatial juxtapositions and contrasts of forms within a symmetrical order that produces an impression of great tranquillity. This calm atmosphere is nonetheless neither archaic nor timeless, for the elegant background buildings invoke the contemporary world. At the same time that this is a more coherent landscape, however, it is harder to interpret than the Ara Pacis panels. If the specific identity of the maternal figure raises questions,[8] her appropriateness to the contextual theme of Pax remains self-evident. Likewise the sacrificer has an understandable place in the rites of the state religion, his gesture representing a significant moment in Rome's legendary history that merges present and past. But the rural shrine with its villa background may be seen in mutually contradictory ways—as an elicitation of pristine *pietas* in full Augustan moral dress or as a fashionably sentimental fantasy of the lure of the countryside.[9] Should we think of eighty-two temples rebuilt in accordance with senatorial decree, or of Horace's and Tibullus' exploitation of the ethic of simplicity in the service of the self-satisfied

FIGURE 53 Villa of Agrippa Postumus at Boscotrecase, Sacral-idyllic Landscape from the North Wall of the Red Room *(Photo courtesy of the German Archaeological Institute, Rome, neg. no. 59.1973)*

private life? In precisely such efforts at interpretation we crave a missing knowledge of the communication between patron and painter to supply us with the equivalent of a poetic context.

Not only are accounts of such communication lacking in our ancient literary discussions of painting, but also the tradition that has governed scholarship on Roman painting since the late nineteenth century has fixed its attention upon the study of painters and the evolution, almost *sua sponte,* of their work. Out of the chronological system of the four styles has developed an interest in refining the internal chronology of each style in such a manner as to give each house in Rome or Campania its relative position within a theoretical history of artistic evolution. In first developing his four stylistic categories, August Mau proceeded upon the assumption that the patterns for each style—and thus the shape of the entire chronology—had their backgrounds in Eastern cities from where, step by step, they migrated to Rome.[10] His pioneering discussion left virtually no place for the taste of a patron in determining the decoration of his house. Although succeeding scholars have refined Mau's theories, and the issue of indigenous origins for or influences upon the designs has been continually debated, the assumptions underlying our interpretations of painting have remained evolutionary. We are left with the fact that a system based primarily upon a self-generating progress in style does not fully account for the role of the decorated wall in shaping the environment of Roman domestic life, nor fully exploit the potential significance of Roman themes in Roman art.

Toward an investigation of these matters, the literary evidence has perhaps one contribution to offer. Where it touches upon the periods of the second and early third style, our stylistic chronology corresponds with the testimony of Vitruvius, a writer of Augustan date whose *Decem libri de architectura* provides our only extensive description of the appearance of paintings. Within the context of animadversions against contemporary taste and judgment, Vitruvius drops what may well be our best hints of the influence of patron upon painter, even if his account leaves many questions unanswered and the information to be gleaned comes as much from grammatical inference as from direct statement.

The ancients (*antiqui*), Vitruvius observes, painted walls in imitation of marble revetments and went on to place stones and cornices in varied arrangements. Throughout his brief outline of the decorative modes we identify as the first and second styles he makes no mention of patrons, but rather his verbs in the third person plural refer to the painters and to their productions (7.5.1–3). The artists progressed, as he puts it (*ingressi sunt*), to the point of rendering architectonic forms or projecting columns and gables along with a number of popular topics: landscapes in *exedrae,* stage fronts, megalographic deities, and heroic scenes. Although this range of possibilities might seem to have offered some choice to patrons, what Vitruvius emphasizes instead is the suitability of some topics to the spaces afforded by particular kinds of rooms. Commending all these subjects for their preservation of fidelity to natural appearances, he then goes on to expostulate: "haec quae ex veris rebus exempis sumebantur, nunc iniquis moribus

improbantur.'' With this last word, spectators enter whose fickle disregard of natural truth plays an active role in influencing art. There follows a list of monstrous images defying probability: reeds set up in place of columns, candelabra supporting pediments, calyxes sporting figures of men and beasts—"things that never are, nor could be, nor have been.'' The fault, Vitruvius continues, lies with judges whose poor taste has defeated the virtues of art: "at haec falsa videntes homines non reprehendunt, sed delectantur, neque animadvertant si quid eorum fieri potest nec ne.'' Although there is no hint of the sources from which painters might have derived their new fancy for unnatural innovations, their persistence through encouragement is clear.

Vitruvius' standards are conservative and his analysis of contemporary decoration, as I shall later show, reveals an almost perverse blindness to the nature and function of its ornamental components. All the same his indication of an alteration in taste accompanied by a new reciprocity between patron and painter in establishing the representational trend of decoration is in agreement with the evidence offered both by Rome and by Pompeii, and makes it possible to piece together more than he tells us when we turn to the evidence itself. The rich period of the late republic and early Augustan age that his remarks encompass is one in which the subjects represented in paintings can be read very clearly, and where our ability to read them has been greatly enhanced by recent discoveries that give a new order to the corpus. Although the variety of the second style is considerable, we can sort out two major subjects that constituted, I believe, the basis for competition between workshops. These subjects were so well adapted to the needs and desires of their purchasers as to provide apt settings for the rituals of Roman life. Within this context, the transition from second to third style is less an evolution than a revolution, one based upon the widespread appeal of a single subject. One forerunner of third-style painting can be seen among the productions of second-style workshops in Pompeii. Although the emergence into popularity of this type cannot be traced, once it had reached its ascendency it dominated Romano-Campanian mural painting for sixty years. The popularity of the new style can be explained by its capacity for balancing the interests of painters and patrons; it was a format that offered choices to the patron yet gave the painter full opportunity for innovation. The one major revolution that took place within the traditions of Romano-Campanian painting was fully Roman in character and, at its inception, wholly in keeping with the social disposition of the Augustan age.

To understand the significance of recent discovery, we must first go back to a room that has long been at the center of all controversy surrounding the meaning and development of the second style: the familiar room from the villa of P. Fannius Sinistor at Boscoreale now in the possession of the New York Metropolitan Museum of Art (Figure 54). Of the several painted rooms of a rather substantial villa on the slopes of Vesuvius excavated in the 1920s, this is the only one now to be seen in its complete form, the two walls of the stylistically related "summer triclinium'' having been divided between the Museo Nazionale in Naples and the Chateau de Mariemont in Belgium. Along with the paintings in the

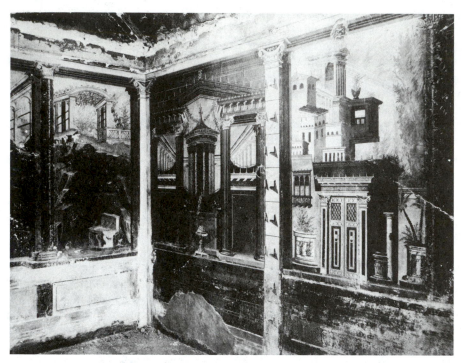

FIGURE 54 Villa of P. Fannius Sinistor at Boscoreale, Cubiculum in the Metropolitan Museum of Art, New York *(Photo courtesy of the German Archaeological Institute, Rome, neg. no. 56.937)*

Pompeian Villa dei Misteri, the Casa del Labirinto, and the Casa del Criptoportico, Boscoreale has, until recently, constituted our largest single portion of the corpus of the second style.

Among these examples the complexity of the New York room is unique. The decoration divides the walls into an antechamber and alcove, each part distinguished by a symmetrically ordered set of three panels. On the side walls forming the antechamber, a great gate standing before a statue within a *syzygia* is flanked by matching panels with a panorama of doors and balconies, while the side panels of the alcove show hollow pediments framing a tholos. The design of the rear wall is that of a grotto and arbor. This room, commonly called a cubiculum, has been assigned its chronological place at the climax of second-style evolution marking the stage at which the architectonic design achieves its greatest degree of openness and its greatest depth of spatial illusion.[11] Before this, the stylistic march is said to have progressed gradually from the representation of projecting columns standing out before a series of elongated orthostats to half glimpses of an illusionistic architecture seen through openings in the upper zone of the wall. Succeeding to this movement toward openness is a reversal of sorts effected by the reclosing of the lateral parts of the wall until its central aedicula remains the only open area,

and thus the high point of its symmetry. The entire history of these stages of second-style decoration is conventionally given a chronological range from about 65 to 30 B.C., and within this span the openness of the Boscoreale wall with its complete immersion of the spectator within its fictive prospects has been matched until recently by only one other example: that of a Corinthian oecus in the Casa del Labirinto whose right wall centers about the tholos motif (Figure 55), while its rear wall, although faded, shows traces of a gateway and balcony panorama almost identical with that of Boscoreale.

In itself, the position of Boscoreale within the program of second-style evolution has never been considered controversial; rather, controversy has focused upon conflicting interpretations of the subjects imitated by its designs. Shortly after the discovery of the paintings, scholars proposed that their megalographic architecture must be based upon, indeed quite directly copied from, the decorations of the Hellenistic stage.[12] This theory rests upon the testimony of several ancient references to stage paintings, including comments that seem to indicate its realization of a form of single vanishing-point perspective, but especially upon passages in Vitruvius. As I have already mentioned, his descriptions of paintings representing the forms of buildings or of projecting columns and pediments fit the conspicuous features of the second style (7.5.1–2). Along with this description goes mention of several specific subjects such as spacious *exedrae* decorated "tragico aut comico aut satirico more." For the meaning of these terms we turn back to the chapters on the theater where Vitruvius defines the tragic mode as a decoration formed of columns, pediments, statues, and other objects suited to kings; the comic as a

FIGURE 55 Casa del Labirinto, Pompeii, Corinthian *oecus (Photo courtesy of the German Archaeological Institute, Rome, neg. no. 56.1235)*

composition of balconies and views representing rows of windows such as those in everyday houses; and the satiric as a landscape of trees, caverns, mountains, and other rustic features represented in a topographical manner (5.6.9). This passage led scholars to propose that the New York room with its gateway, balconies, and grotto might be interpreted as a compendium of the three dramatic settings, with additional proof given by the series of Silenus masks hanging suspended in the centers of the panels. When expanded to encompass the architectonic features of the Boscoreale summer triclinium with its more homogeneous decorations of doors and columns, as well as similar motifs in other contemporaneous paintings, this theory has made theatrical imitation the basis for the entire second style. Thus H. G. Beyen's comprehensive study of the evolution of this style, which remains the standard point of reference, is accompanied by a number of reconstruction drawings that abstract from second-style paintings several hypothetical schemes for the architecture of the *scaenae* frons.[13] In keeping with general concepts of chronological evolution, the stages that follow after Boscoreale's open walls are represented by a panel of unknown provenience in the Naples museum whose closed lateral areas set off an open aedicula framing the view of a tholos, by a room on the Palatine excavated in the 1950s by Carettoni whose architecture includes projecting gables and porches (Figure 56), and finally by the complex, double-storied balcony patterns to be seen in the bath quarters of the Casa del Criptoportico.[14]

While the stage decoration theory thus encompasses the greater part of the second-style corpus, the alternative theory developed to explain the Boscoreale

FIGURE 56 Ambiente delle Maschere, Palatine, Rome *(Photo courtesy of the Gabinetto Fotografico Nazionale, neg. no. E47767)*

paintings includes only the rooms of the villa and their counterparts in the Casa del Labirinto. Challenging the identification of these designs with stage settings in large part on the grounds that Vitruvius never says that the tragic, comic, and satiric modes were combined in single rooms, Phyllis Williams Lehmann argues instead that the scenes are illusionary views of the grounds of a Roman villa, a villa not unlike this Boscoreale residence yet somewhat grander in keeping with the owner's dream of what an ideal villa might be.[15] Within the context of her identification, the great gate becomes the entrance to a villa sanctuary; the flanking doors are the actual entrance portals while the towers and balconies approximate dovecotes and other traditional buildings of the farmstead. The tholos is a temple of Aphrodite presiding over the fertility of the farm, and the grotto on the rear wall is a feature of a landscaped garden complete with its fountain and a trellis that demonstrates a traditional Italian method of yoking vines. The wider implications of this theory are to make the paintings neither copied nor derivative from Hellenistic models, but wholly Roman in subject and conception. Because of its attractive common sense, this theory has not gone without support and further development,[16] but still has never wholly triumphed over the stage decoration theory. As the situation has stood, neither is more capable of conclusive proof than the other, since we have no better evidence for the actual buildings of a Roman farm villa than we have for the structure and decoration of the Hellenistic *scaenae frons*. Insofar as the two theories touch upon the question of patronage, their implications are precisely opposite, for the *scaenae frons* theory, involving as it does the notion of pictures copied from patterns, places the second-style tradition wholly within the hands of the painters, while Lehmann's villa theory assigns the conceptual genesis of the paintings to the patron.

The only way of resolving such a conflict of rival interpretations is by the introduction of new evidence. In this respect the study of Pompeian painting has had in the past decade the dramatic good fortune of Alfonso de Franciscis' excavation of a large seaside villa at Torre Annuziata, three miles northeast of Pompeii, to which he has given the name Oplontis. The villa has a core of five fully decorated rooms that can be attributed to the mid first century.[17] The question one might ask in the abstract of any addition to the second-style corpus is whether it would so completely repeat known designs as to demonstrate an absolute lack of originality among the painters, or conversely whether it would differ so radically from familiar material as to disprove the whole stylistic order of the period. The Oplontis paintings do neither, but in fact give us further parallels for the Boscoreale motifs within compositional formats that are still unique unto themselves. In a large triclinium we find the familiar tholos, the garden statue, the majestic gateway, and the jewel-inlaid columns of Boscoreale not simply juxtaposed in contiguous panels but interrelated within a spacious and coherent design that fills its entire wall (sala 14). In a second, even larger oecus (Figure 57) is a variation upon this design in a double-tiered "porticus" of truly regal proportions seen through the apertures of a grandiose propylon whose central arch frames a great tripod (sala 15). It is a new set of motifs, yet one that fits the familiar repertoire. To these rooms, however, the house adds something new by way of a very large atriu

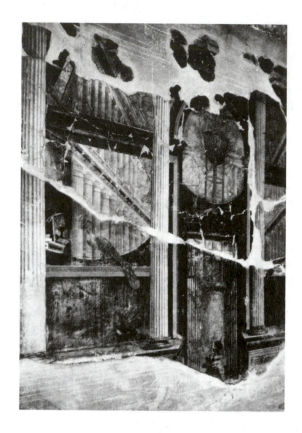

FIGURE 57 Villa Romana di
Oplontis, Torre Annunziata,
Sala 15 *(Photo courtesy of German
Archaeological Institute, Rome,
neg. no. 74.2689)*

first surviving example of atrium decorations in the high second style. This room
alone breaks the rules hitherto formulated for the style in such a manner as to cast
new light upon its decorative intentions as a whole. Such a unique combination of
the formulaic and unprecedented makes Oplontis the key to second-style work-
shops.

Both the illusion of spatial openness and the centrally oriented symmetry of
other walls are missing in the atrium, whose mode of decoration is demonstrably
appropriate to the nature of the room (Figure 58). The function of the atrium in
the daily rituals of the Roman man of affairs is well known. With its adjoining
tablinum and laterally placed *alae* to the rear, it forms the spatial and practical
framework of the morning *salutatio,* chief ceremony of the patron-client relation-
ship.[18] Formal atria in the houses of the Pompeian tufa and limestone periods fol-
low a standard pattern that visually demonstrates their function: they are at once
꞊ipal rooms of the house, surrounded by small side chambers for sleeping
and the grand reception room exhibiting the status of the master. The
second-century Casa di Sallustio exemplifies the traditional plan. But
꞊ Oplontis atrium, which forms a laterally closed rectangle at the
꞊, these functional aspects of the room survive only in visual

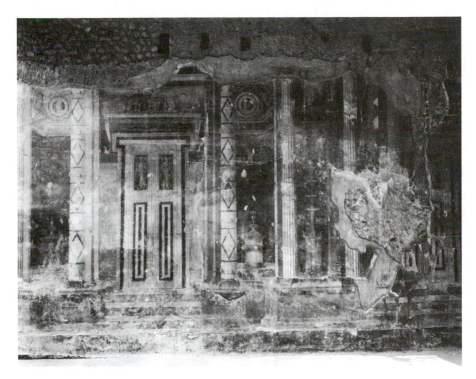

FIGURE 58 Villa Romana di Oplontis, Torre Annunziata, Portion of the Atrium Wall
(Photo courtesy of the German Archaeological Institute, Rome, neg. no. 74.2692)

The patterns of the two side walls echo each other with only small variations in detail. In the places where real doors customarily open are painted facsimiles flanked by projecting columns and set within recessed alcoves.[19] While the architectural framework of the door closer to the impluvium is symmetrical, in the case of the second pair of doors this order is broken in a peculiar way. Although three columns flank this door on either side, their placement is uneven since the inside left column actually overhangs and obscures a part of the door while that on the right is spatially separated from it. Furthermore the door itself, although set back within its alcove on the left side, projects into open space on its right. The surface of the right hand wall is located behind the door, and the three columns form a line that recedes backwards and continues beyond the freestanding corner of the wall. When viewed from a vantage point opposite the first door, it gives the impression of a wall ending abruptly before a transverse passageway.[20] This illusionary lateral expansion of the room occupies the position of the traditional *alae,* and one may assume that these are what it is intended to represent. Quite clearly the decorations of the room recreate the architectural pattern of an atrium, but this atrium is intended less for practical business than for show.

At the same time this fictive decoration is one of the greatest opulence. The doors are of ivory inlaid with tortoise shell, such doors as Virgil mentions in *G.*

2.461–64 to symbolize wealth and power. The corridor columns are of alabaster; the others of *giallo antico*.[21] There were of course no rooms so luxurious in the Pompeii of the late republic, nor does Rome itself offer remains of any such houses from the period, and yet literary sources suggest that they did indeed exist. In 95 B.C. the orator Licinius Crassus had columns of Hymettian marble originally bought to decorate a theater installed in his Palatine house (Pliny HN 36.2.7–8). Although there were only 6 columns, and these a modest twelve feet high, his showiness won him the nickname "Palatine Venus." In 78 B.C. Marcus Lepidus built his doorframes of Numidian *giallo antico*. According to Pliny (36.34.109), there was no house in the Rome of that day more beautiful than Lepidus', but thirty-five years later a hundred houses were rated higher. Among these must have been the house of Marcus Scaurus who, as aedile in 58 B.C., created a scandal by decking the stage of a temporary theater with 360 columns of dark Melian marble, the largest of which he later set up in his atrium (36.2.5–6). Finally, the notorious Mamurra of Catullan fame was by Pliny's account (36.7.48) the first Roman to cover walls throughout his whole house with marble revetments and to have all his columns of marble. Surely it is to such showplaces that Horace refers in the disclaimer that closes *Odes* 3.1:

> Cur invidendis portibus et novo
> sublime ritu moliar atrium.

Although no description supplies such precise details as how and where marble columns were incorporated into these lofty atria, the elaboration of the traditional pattern at Oplontis would suggest that its decorators had taken their inspiration from the fabled luxury of contemporary Rome.

Second only to the atrium in the unusual nature of the decoration and also in its appropriateness to its physical context is a double alcove room at the western corner of the building with a door and a window opening onto an ambulacrum. Both the Villa dei Misteri and the Casa del Labirinto have rooms of this shape, which Lawrence Richardson has identified as one typical of women's dining rooms.[22] The alcoves, he proposes, were meant for couches on which the women dined seated. Such rooms always have their counterparts in larger dining rooms with reclining couches for men. Women probably joined their husbands in these for the entertainment that followed the meal. The Villa dei Misteri has four such pairs of rooms in accordance with the Roman need for different exposures for different seasons. The Oplontis room also has a larger counterpart, although its second-style decoration has been painted over.[23]

All previously known examples of the double alcove room have modest decorations of orthostat walls well suited to their shape and size with apertures only in their upper zones, but at Oplontis the rear walls of both alcoves are fully opened by illusionistic prospects.[24] That of the left-hand alcove offers a view through a broken pediment into a colonnaded courtyard with a *syzygia* at its center, while the side walls are pierced by framed windows opening onto massed foliage that screens any further view. The stone-and-metal balustrades that finish these aper-

tures give them the appearance of balcony windows. Within the right-hand alcove an interrupted architrave that appears to be located beyond the surface of the wall is framed by the arch of a grotto farther on. Its ledgelike rocks are clearly rendered with sharp angles and strong highlights. Both in shape and in surface they are similar to the rocks of the Boscoreale grotto, even if this very symmetrical cavern is less interesting than the other with its fountain and its arbor above. The combination of this topographical feature with the elegant architrave clearly indicates that this grotto forms no part of a setting for a satyr drama, but rather belongs to a stylized garden landscape. The two real openings into the ambulacrum on two sides of the room are matched by fictional apertures giving onto more sumptuous illusionary gardens. The decoration of the room has been closely coordinated with its setting to create a partially walled enclosure, half out of doors, half within—a shell of space pierced by apertures linking the interior with its exterior environment.

Turning back from Oplontis to Boscoreale and its contemporary analogues, we can recognize sufficient similarities and repetitions of motif to be certain that we are dealing with four houses decorated by the same workshop, and it is logical to assume further that the significance of the designs should in all cases be analogous. If the Oplontis atrium has a Roman pattern and theme, the remainder of the rooms may be interpreted accordingly. What Oplontis demonstrates is that Lehmann was essentially correct in her identification of the Boscoreale paintings as fictional views of a villa, and yet the grandeur of their designs far exceeds the utilitarian model she had in mind.[25] One thinks perhaps of the palaces of Hellenistic kings, but there are Roman possibilities closer at hand, and for these we may look again to our fullest source of information on late republican villas in Varro's book on farming.

In addition to its practical observations on agricultural method, *De re rustica* tells us much about several kinds of country houses and their surroundings. A running theme of banter among the speakers has to do with the limits to which luxurious accommodation in the country may be pressed without perverting the serious agricultural character of a farm. In the first two books, the sentiment for utilitarian simplicity prevails. The speakers agree upon a distinction between farms whose well-ordered cultivation is their main source of beauty and the ''regie polita aedificia'' of the rich (*Rust.* 1.2.10). A truly worthy villa is one whose visitors admire the *oporothecae,* or fruit rooms, and not, as in the villas of Lucullus, the *pinacothecae,* or picture galleries. By this allusion Varro indicates that class of pleasure villas built by the great fortune gatherers of the late republic for relaxation away from the heat and public business of Rome. It is a semimoral distinction that he draws, coloring it with an aesthetic utilitarianism that places his remarks within the Catonian tradition of personal dedication to agriculture.

In the third book, however, once the traditional crops and animals have been firmly established as the philosophical and economic basis of villa life, Varro gives his discourse a more playful and self-indulgent tone. The new topic introduced is that of making the most of the space of the farmstead. Although the speakers keep sight of the laudable Roman aims of productivity and profit, the crops and animals

they mention belong to a sphere of use quite different from common grain, grapes, and cattle. They are in fact the provisions of the refined table: rabbits, dormice, fowl of all kinds from doves to peahens, fish, and flowers for garlands. Such luxury products extend the purposes of farming beyond sober productivity and accordingly greater attention is given to a more elegant and complex kind of villa farm. Not only do we hear some defenses of fine interiors for villas but also more detailed mention of architecture of exterior landscaping (3.2.3–11). The keeping of small animals necessitates a variety of specialized buildings. Especially the breeding of birds contributes its own architecture of towers and dovecotes to the areas around the house. In her discussion of the Boscoreale paintings, Lehmann has cited some of Varro's descriptions, but one passage she omits seems pertinent to the buildings here. This is a lengthy, digressive account of an aviary that Varro locates on his own property in Casinum (3.8–17). In describing his own landscape architecture with obvious pride in its originality and ingenuity, Varro somewhat undermines his professed allegiance to the spare and utilitarian farm. His construction centers about a stream running through the grounds of the villa that he has bordered with a walk leading to a colonnade. Nets of hemp suspended between the columns keep the birds inside. At the far end is a round building with an exterior circle of stone columns and an interior circle of wooden ones—a version of course of the tholos, that ubiquitous building type that seems quite indiscriminately to have been used for temples, tombs, and even in such commercial contexts as the centers of the *macella* of Pompeii and Puteoli. A wood surrounds Varro's tholos, but is screened off from it to keep the birds from the interior of the enclosure. This space appears to serve as an open-air dining room with a platform surrounded by a balustrade and a duck pond.[26] All in all, it is a most elegantly extravagant piece of topographical construction, even to a planisphere inside the building.

The striking combination of tholos and colonnade is the very combination to be seen in the fictive courtyards of so many Pompeian walls. Varro himself supplies a point of reference in admitting that his buildings surpass the creations of Lucullus at Tusculum. Such elegant structures belong to the villas of the most prosperous Romans and are in all probability to be associated with one of the chief of Roman social rituals, that of dining. Among the Tusculan extravagances Plutarch attributes to the scandalously rich Lucullus, otherwise notorious for his fishponds and water channels at Baiae, are open-air dining rooms fronting upon great porticoes (*Luc.* 38). When Pompey questioned the practicality of these rooms, Lucullus answered that he, like the birds, could move his habitation with the seasons. The splendor of Lucullus' porticoes was doubtless no less than what is represented here—the models being the great parks of the Ptolemies and Eastern kings but the showmanship indigenously Roman. What we see then at Oplontis in the Boscoreale rooms, in the Casa del Labirinto, and in the Villa dei Misteri is, I propose, a Lucullan "porticus" style flamboyantly imitating the extravagance of boundless wealth as it displayed itself on Italian soil. The decorations of the Oplontis rooms, more palatial than those of Boscoreale, are of a piece with the atrium in their creation of an atmosphere far beyond the means and circumstances

of even this ample villa. Such fantasies of identification with a fabled stratum of society were, I believe, the commodity that one Campanian workshop of the mid first century B.C. sold to its middle-class patrons.

Whatever the level of Roman society, the ceremonies of hospitality and dining were of the greatest importance and understandably to be staged with great formality and show. Several subordinate motifs in these second-style rooms may also be explained by an association with dining. Most obvious are the bowls, baskets, or casually placed clusters of fruit on shelves or architraves. In explaining the handsome glass bowl on the rear wall of the New York Boscoreale room, scholars have referred to a passage in Vitruvius describing the Greek custom of sending *xenia,* or painted representations of items of uncooked food, to guests by way of an invitation (6.10).[27] While there is some argument for the logic of incorporating such symbols of hospitality into a cubiculum, there is still more for their inclusion among the decorations of a dining room (which, in accordance with the arguments of Richardson I have mentioned earlier, is the role that should be assigned to the Boscoreale room).[28] A very similar glass bowl of pomegranates in one of the rooms at Oplontis is among the details in which these two productions of one workshop are most similar. The room on the eastern side of the Oplontis atrium has not only the most abundantly filled basket of fruit in Campanian painting, but also a small table on which is a kind of sweetmeat that one of the custodians informs me is still prized in contemporary Italy, and it is surely only as a *xenium* that we can explain the vulgarly large fresh fish suspended on the half wall of the Naples panel. The persistence of fruit, fish, fowl, and such delicacies within the traditions of Pompeian painting up through the fourth style would seem to confirm their possessing a symbolism of their own quite independent of other changing fashions in the decoration of dining room walls.

Closely analogous to the *xenia* in their association with the rituals of Roman hospitality are, I believe, the masks which have often figured as evidence to support the stage decoration theory. In the greater number of second-style rooms these are satyr masks. As Agnes Allroggen-Bedel has shown in a recent study, there is little evidence for that kind of correspondence between the choice of tragic, comic, or satyr masks and the presence of doors, columns, balconies, grottos, and other such supposedly thematic motifs which one would have to expect were the stage decoration theory to be carried to its logical conclusion.[29] But in fact there is no reason why masks should be out of place in a Roman dining room decorated in any thematic mode, since the ritual of the dinner consisted not only in a leisurely service of formal courses but also in the host's planned after-dinner entertainment of a literary, musical, or theatrical nature. Augustus was well known for his provision in this line, giving very formal dinner parties enlivened, as Suetonius records, "with performances by musicians, actors or even men who gave turns at the circus, but most often by professional storytellers" (*Aug.* 74). Such entertainment ranged from a host's reading of his own writings (perhaps not always a pleasure) to troupes of trained actors, especially comic actors, or musicians. In this context the masks might well figure as a promise that the niceties of hospitality will be

maintained. Although the allusions cannot be pressed too far, the prevalence of satyr masks perhaps indicates a preference for lighter entertainment. In any event, the persistence of masks alongside the *xenia* in numerous rooms long after the disappearance of second-style megalography would seem to indicate that they too possess their own traditional symbolic value.

Thus I have disassociated this particular group of second-style paintings to which Oplontis belongs, both in motif and execution, from specific dependence upon the decorations of the theater only to restore theatricality to the walls as a metaphor. But such self-conscious dramatization, even beyond the provisions for formal entertainment, is also indigenously Roman. In literature we find more than one suggestion of the meal as a staged performance. Varro refers to his tholos-formed aviary as a *theatridion avium* (*Rust.* 3.5.13), ostensibly describing its rows of perches but possibly implying that the spectacles here offered by feathered performers are equal to shows of other kinds. In Hor. *Sat.* 2.8, Fundanius' snobbish account of the elaborate dinner given by the socially anxious Nasidienus is full of stage business, planned and unplanned, which culminates in the accident of a falling curtain—such a curtain, we may guess, as was frequently seen in painted dining rooms. Although the guests make their hasty excuses before the time for after-dinner entertainment, Horace's own comment on the spectacle seems thematic: "nullos his mallem ludos spectasse." Finally, Trimalchio's self-conscious hospitality complete with dancers, musicians, and a recital by the host is the ultimate in the ritual theatricality of dining.

Within this context, then, Roman dining rooms decorated with stage designs would scarcely be out of place, and in the fourth style they were recognizably a part of the fashion. Likewise I think they existed in the second-style period; it remains only to distinguish them from the "porticus" rooms I have identified. The mural designs of Carettoni's Palatine Ambiente delle Maschere are conspicuously unlike those of these Campanian rooms. Their architecture is not composed of monumental portals and gateways, but rather of wings and gables projecting forward in such a manner as to enclose, instead of open, the interior space of the room. The prospect of a colonnaded exterior courtyard is lacking; the architectonic structure seems rather to be built outwards from a solid wall while the gabled side pediments meet at the corners in a curiously unfinished angle (Figure 56).[30] Similar projecting structures appear in a series of adjoining rooms in the Casa del Criptoportico. The complex north wall of the frigidarium is double-storied, a projecting aedicula with columniated wings forming its lower level while a loggia is built into the upper tier. Although this room has apertures revealing glimpses of columns and balconies, they seem less like exterior prospects than backward extensions of the large ornamental structure itself. Unlike the "porticus" walls, these include human figures. The ones placed in alcoves flanking the aedicula on the first story are clearly statues while those above are ambiguous enough to be taken for real figures. The structure and ornamentation of this wall are far more complex than ones we see in the Ambiente delle Maschere, but a more recently discovered room in the Palatine excavation, still unpublished, shows the form of a

double-storied construction very similar to those of the Criptoportico walls.[31] Although equally elaborate in their patterns, walls of this type appear somewhat less opulent in their furnishings than those of Oplontis and Boscoreale. Their squared columns imitate painted wood instead of alabaster and marble. Here then we are likely to have our real imitations of the *scaenae frons*. Even so the designs are probably not, as Allroggen-Bedel has sensibly suggested, copies of full stages but rather abstractions from the common repertoire of stage motifs recombined at the painters' fancy.[32] Perhaps they are most reminiscent of the temporary sets used when wooden theaters were put up for their limited periods of Roman festival days. Thus they do not carry the house into the sphere of the theater, but rather reconstitute the theater within the house.

On the basis then of their compositional patterns and motifs, the most dramatically architectonic of second-style walls can be divided into two quite coherent groups. Since the masonry construction of late republican walls gives slim grounds for chronological distinction between these groups, there is no real evidence to argue against the possible contemporaneity or near contemporaneity of their two modes of design. Thus I propose that the stage pattern did not evolve out of the "porticus" pattern but that it existed in contradistinction to it, the dominant factor in the development of the period being the competition of workshops for patronage. Rooms were decorated in a manner thematically appropriate to their use, but each workshop had its own repertoire to offer. Some overlapping of details suggests that the workshops were not beyond borrowing from each other. There is, for instance, a tripod in the upper story of the Criptoportico frigidarium, and the *thymateria* that figure heavily in the Oplontis and Boscoreale decorations appear also in one room of the Criptoportico. These common details might also reflect such common grounds between the trappings of lavish houses and those of the stage as are suggested by accounts of the theater of Scaurus. Whatever their exact sources, the workshops must have been known by their repertoires. No matter whether the motifs were recorded in pattern books or merely in the minds of the painters, one may assume that the patron was able to choose the motif for which he contracted, the particular kind of illusion he wanted his house to display. The many variations among the houses belonging to the "porticus" group suggest that the painters did not copy their designs exactly, but rather adapted them freely to the nature of the spaces given them to fill. The illusionistically open walls of the Oplontis double-alcove room should thus appear as an experimental approach to the handling of areas rigidly defined by a conventional architecture, while the plenitude of motifs crowded into the New York Boscoreale room may simply betray a patron's wanting his money's worth in variety. With such possibilities of combination and recombination, I see little value in attempting to establish a relative chronology for the productions of this one workshop, since the determining factor in its execution of any design must have been the guidelines that patron and architect had laid down for the painter.[33]

Such impressive megalographics appear suited to the temper of the late republic with its still surviving concepts of personal power, its jostlings for influ-

ence and strong alliances of political interest. Still one wants to know the kinds of patrons these designs were created for, and again there is the chance that Oplontis may eventually provide an answer, although the evidence remains far from complete. To the best of our knowledge, the "porticus" style displayed here is restricted to Pompeii and its environs, and employed only in very large houses where we may assume its appropriateness to the pretensions of the owners. It does not automatically follow that these owners were members of the Roman aristocracy. As John D'Arms reminds us in a recent study of Vesuvian villas, there is not one piece of secure evidence to link any of the fifteen Romans whose proprietorship in the area is attested to by literary sources with a single one of our excavated houses.[34] Rather, D'Arms' analysis of the evidence for the economic function of the villas points to ownership by the prosperous commercial middle-class. Not only does the Villa Oplontis include its own extensive rustic quarter, but also it is located not far to the west of a large, rustic wine-producing establishment of late second- or early first-century date just now in the process of excavation. Quite possibly some definite association between the elegant residence and the commercial property will appear with time.[35] The Villa dei Misteri, if we accept Richardson's analysis of its history, was constructed in the mid first century as a fine residence with space and apparatus for producing large quantities of wine. Boscoreale was likewise a vineyard villa. The fortunes that built the Pompeian amphitheater and *odeon* in the Sullan period were made in wine;[36] one can scarcely believe that Roman aristocrats were alone in appreciating views of the sea. The probability of ownership by local citizens gives a rationale for the popularity of the "porticus" style in Pompeii. If not the most prized resort of the luxury-loving urban aristocracy, this fertile Vesuvian land which made its cultivators prosperous still lay in the shadow of the *crater delicatus,* the picturesque Baian region where Lucullus and his peers had built their fabled villas. To that region we may attribute either the original ideas or the patterns for decorations to lend elegance to the self-importance of provincial men. In Pompeii political competition and family alliances were always strong, and so must have been the accompanying rituals of hospitality. After the Roman domination of the Sullan period, the balance of power slowly adjusted itself by alliances among Roman and Campanian families.[37] When asked by a friend to procure a kinsman's entry into the Pompeian *ordo decurionum,* Cicero replied, "Romae, si vis habes; Pompeiis difficile est."[38]

That the rival style of *scaenae frons* decoration which Vitruvius knew should have been more widely disseminated is also not difficult to understand. Although the Roman and Campanian examples need scarcely be products of the same workshop, their general outlines are not dissimilar. Naturally, in the event that the attribution of the Palatine rooms to Augustus himself should ever be definitively proven,[39] we might find here Vitruvius' source and think also of the well-known love of the *princeps* for the stage; even so we would have to admit that the style of his decorations was not unique but represented only one of many commissions in a popular mode.

Within this general framework, explanations for other versions of the second style can be found. The contemporaneous use of orthostat walls and architectonic illusions within a single house would seem to confirm that there was never any step-by-step evolution of designs.[40] Among the variants I have not before mentioned is a paratactically ordered wall decorated with ornamental herm figures common to the Casa del Criptoportico and Casa di Caesio Blando,[41] whose factual prototype might be identified by a Lucretian reference to houses adorned with golden images holding lamps in their hands (2.23–26). Most significant among alternative patterns in its bearing upon the later history of painting is one unique to a small room off the peristyle of the Pompeian Casa degli Epigrammi—a room that gives the house its name (Figure 59).[42] Like the Oplontis atrium, this room lacks the spatial openness generally associated with the high second style, but the nature of its decoration is not hard to identify. The room is fitted out as a gallery for the display of pictures. Five separate figured panels comprise the chief furnishings: three closely juxtaposed on the rear wall and one centered on each side wall. These bordered panels are separated by a series of scale pattern columns in variegated colors set forward on a projecting dado. On the side walls the dado forms a podium beneath each panel while the columns continue above to support gabled aediculae framing each picture. On either side these aediculae are flanked by statues set upon small square pedestals within recessed niches. Above the niches the

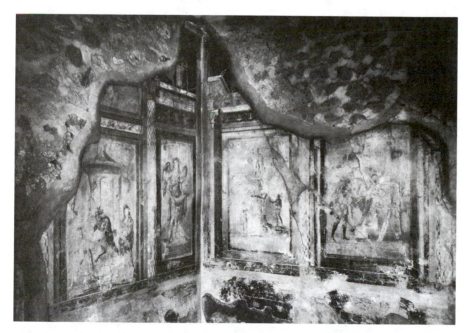

FIGURE 59 Casa degli Epigrammi, Pompeii *(Photo courtesy of the German Archaeological Institute, Rome, neg. no. 56.1218)* Pinacotheca

decoration continues with a molding in the egg-and-dart pattern and a series of figured friezes.

Neither motif nor technique leads me to place this room within the repertoires of the Oplontis or Casa del Criptoportico workshops, and yet I would venture to suggest that the background for these decorations lies within the same general context as that of the "porticus" style, for in fact the *pinacotheca* is the one kind of room prominently associated with the lavish establishments of the rich that second-style painters have not elsewhere imitated.[43] This Pompeian adaptation has a definite plan and theme. All five of its panels illustrate epigrams similar to Hellenistic epigrams of the Greek anthology. The room has an artistic unity as well. The three juxtaposed compositions on the rear wall resemble one another in their organization of graceful monuments and slender forms. Much smaller than any room previously mentioned, the room of the epigrams scarcely offers the space for comfortable dining, not even for the women, but its literary flavor suggests instead a small reading room so decorated as to exhibit its owner's cultivation and taste—such a room as Cicero in a letter to M. Fabius Gallus mentions wanting to decorate with pictures (Fam. 7.23.1–3).

When next we encounter a stately example of the *pinacotheca* mode in the Palatine Casa di Livia its appearance is quite changed from that of the diminutive Pompeian oecus (Figure 60).[44] The symmetrical centering traditional within Romano-Campanian wall schemes has taken over so that the picture panels are now framed within imposing central aediculae that dominate their walls. To these

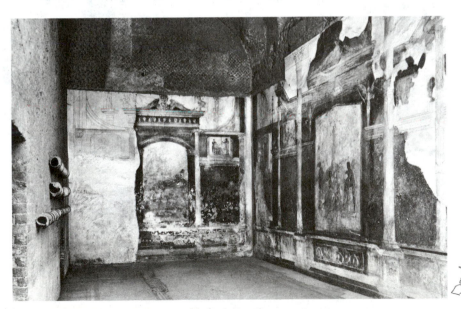

FIGURE 60 Casa di Livia, Palatine, Rome, Mythological Landscapes Room *(Photo courtesy of Alinari/Art Resource, neg. no. 2588Q1)*

have been added small shuttered boxes for the display of additional *pinakes*. Although the design of the wall contains elements akin to those of the second style—ornamental columns, elaborate architraves, molded cornices, brackets, and acroteria—the new room is at once less extravagantly showy and less firmly architectonic in character than second-style walls we have seen. It is in fact not a structured but a surface-ornamented wall whose purpose is to set off to advantage its mythological panels; on the short rear wall Polyphemus and Galatea, on the long wall a representation of the nymph Io, guarded by Argus as she sits beneath a statue of her rival Juno on a pedestal. That this panel is an adaptation from some earlier Greek composition is suggested both by parallel versions in Pompeii and by the iconography of Greek pottery, but the painter has certainly added touches of his own, especially in the landscape background.[45]

No clear intermediary steps link the small Pompeian gallery with this grand chamber. There is even reason to look to a different model or frame of reference for this new version of the *pinacotheca* mode. While private collections had been the chief repositories of works of art brought into Italy before the mid first century, later years saw the beginnings of the public museum in such showplaces as the Theater of Pompey with its great porticoes. Asinius Pollio is credited with establishing one of the first museums of the Augustan age in his library (Pliny *HN* 35.9), but soon afterward a great part of the propagandistic building program of Augustus and Agrippa took the form of "porticus" buildings furnished as galleries. To call attention to this munificence, as Pliny records (35.26–28), Agrippa delivered his famous oration recommending that collectors should not retain their imported statues and paintings for private delectation in their country villas but place them on public display. Naturally such an imitation of a *pinacotheca* as this of the Casa di Livia would be in accordance with Agrippa's recommendation (no matter whether its organization resembled that of a private or of a public gallery), but the corollary notion that it might represent a compensatory kind of picture room invented within the bosom of the Augustan family is probably no more than a pretty fantasy. What seems likely is that the development of public displays of art made the imitative *pinacotheca* popular as house owners began to discover that such creations lay within their painters' illusionary skills. A more certain feature of the decoration is its incorporation of those unreal structures and improbable ornaments deplored by Vitruvius which, however fantastic they may sound in the abstract, explain themselves perfectly in context as the elements of an appropriately rich setting for the display of pictures.

Such elements are even more notable among the smaller scale furnishings of another room of the same species painted perhaps ten years later that displays the style at its most elegant. Here along with the central paintings in their ornamental frames are heavy candelabra shaped to represent Diana as *potnia theron* and the goddess Fortuna that may be counted as works of art in their own right (Figure 61).[46] *Pinakes* again appear in subordinate positions at the sides of the central panels while the representation on the rear wall of Dionysus and his nurses in a landscape setting is flanked by statues of figures supporting small line drawings

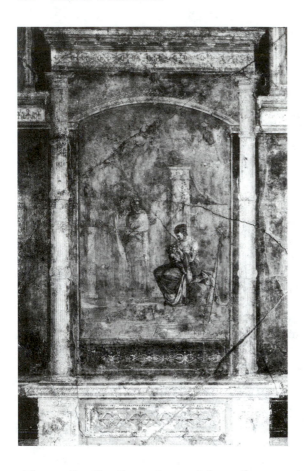

FIGURE 61 Villa alla Farnesina, Museo Nazionale Romano, Rome, Cubiculum B, Rear Wall *(Photo courtesy of German Archaeological Institute, Rome, neg. no. 32.148)*

(Figure 62). The flat surfaces of the walls are varied by elegant panels imitating patterns inlaid in stone whose fine detail is carried out with meticulous brushwork. A fine line drawing of a seated Aphrodite must have a fifth-century Greek painting for its original; both in style and in execution it differs from the Dionysus landscape. Unlike the Livia room, this is not a thematically organized gallery but rather an eclectic gathering of works to display the organizer's personal taste.

The question of taste brings us back to the specifics of patronage and its role in historical Rome. In interpreters' attempts to forge links between the private world of painting and the facts and Roman personalities we know, these rooms from the Villa alla Farnesina have been of great interest since Beyen, on the basis of the villa's location by the Tiber just above the Pons Agrippae, assigned its ownership to Julia and Marcus Agrippa.[47] But the ownership of these choice pieces of Tiber property is by no means certain, and the area deserves another look. In a recent article reinvestigating the course of the Agrippan Aqua Virgo and Euripus, Robert Lloyd has called attention to the *sepulchrum C. Platorini* of late Augustan date which was located on the right bank by the terminal of the Pons.[48]

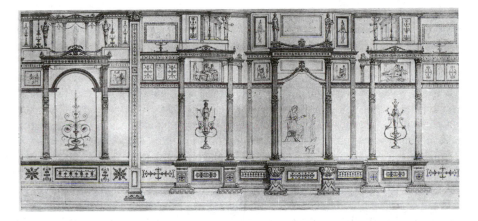

FIGURE 62 Villa alla Farnese, Museo Nazionale Romano, Rome, Cubiculum B, Drawing of the Side Wall *(Photo courtesy of the German Archaeological Institute, Rome, neg. no. 56.318)*

He suggests that the A. Crispinus Caepio also buried in the tomb was the first proprietor of the *Figlinae Caepionis* whose bricks bear the stamp *ab euripo,* a factory that under imperial patronage flourished for well over two centuries. Although we are again in the realm of speculation, the presence of this tomb, no doubt located on family property, in the area of the Tiber villa suggests the perfect kind of commissioner for the paintings: a prosperous patron of the equestrian order eager to display at an affordable cost his ability to share in a contemporary enthusiasm for art or in the cultivated tastes of great aristocratic collectors.

Like the "porticus" pattern of the second style, the Augustan *pinacotheca* bears, I believe, the mark of middle-class imitation of the creations of wealth and power. Its emphases are nonetheless quite different from those of the flamboyant republican style. Instead of the social importance of the house owner, the interconnection of his public and his domestic life, or the extravagance of his hospitality, the picture gallery style attests the refinement and comfortable well-being of the private man. The fantastic elements that ornament the gallery wall (and it is strange that Vitruvius did not allow it) are the fantasies created by the decorative arts, while their sudden popularity, for which Vitruvius may give us quite accurate witness, is a consequence of their belonging to a new mode that offered each patron the opportunity to place a personal stamp on his environment through his selection of pictures or myths. With their delicately executed details, many of which are imperceptible to the spectator at a distance, these are designs to be looked at carefully and at leisure within the framework of that comfortable materialistic world inhabited by so many of the addresses of Horace's second book of *Odes.* In the subtle tone of the early third style we may see reflected the changed temper of the Augustan world where the *princeps* championed the virtues of solid citizens in whose lives quiet prosperity and dutiful service had replaced the republican passions for honor and display.

The accidents of survival that direct our attention from Pompeii to Rome for the first fully formed example of the *pinacotheca* style cause us to look back again to Pompeii for its further development. It is perhaps scarcely coincidental that Augustan associations were growing strong in the *municipium* in company with Augustan middle-class prosperity.[49] Once the picture gallery had come into vogue here, it was scarcely displaced over the next sixty years. During that time it survived the mutations of the background wall from third-style solidity to the stagy architectural fantasies of the fourth style and was challenged only in the final, Vespasianic years of the city by a new and far more literal rendering of the *scaenae frons* in full dress with actors standing in place to play their roles. The reason for the dominance of the *pinacotheca* appears to me quite simply the equality of its appeal to painters and patrons.

To the painter the picture gallery must have offered a format easily adaptable to the proportions of any given space; there is no more of the occasional crowding of designs found in second-style rooms. As the pictures themselves become the focal points of mural composition, the marks of the workshop grow less evident. No two of the third-style *pinacothecae* in Pompeii are identical, nor do even the banded columns that frame the central aediculae show identical patterns of detail. Colors repeated between the ornamental members and the picture panels create harmonious unities within each room. Above all, the style offered the painters new opportunities to put their hands to the adaptation of mythological pictures. Very few it appears were content to copy exactly from sources or models, and their free disposition both of setting and of figures brought about a genuinely Roman brand of painting whose substance was the integration of landscape and myth.

To the house owners likewise *pinacothecae* must have offered new opportunities for individualism. With its format so easily adaptable to large or small spaces, the style was one that cut across the boundaries of prosperity, and many a modest house, not to mention commercial establishment, has its picture gallery rooms. Unlike the eclectic Farnesina rooms, the mythological orientation of Pompeian *pinacothecae* may well place emphasis upon the display of acquired learning rather than the taste of the connoisseur collector. As there are many levels of prosperity in houses, or of quality in painting, so also we see hints of varied levels of learning from houses that seem to announce an intimate familiarity with Greek or Latin literature to those whose standard, endlessly repetitive subjects may show simple pride in the acquisition of any culture at all. From among the ranks of such citizens we acquire our best literary portrait of a patron, one whose taste is never quite paralleled in Pompeii and yet is perhaps only slightly exaggerated.[50] As we enter Trimalchio's *vestibulum*, we see illustrations of the *Iliad*, the *Odyssey*, and a local gladiatorial contest. Where else in the ancient world do art and literature join more closely with life? What better testimony is found of the patron's wish to reflect his personality in his surroundings and of the painter's compliance in executing his desire?

NOTES

1. The greater part of the research on which this essay is based was made possible by a fellowship awarded by the John Simon Guggenheim Memorial Foundation in 1976. I wish to acknowledge the kindness of the several scholars who granted me permissions for my work: Professor Alfonso de Franciscis, Dottore Fausto Zevi, Soprintendente delle Antichità delle Province di Napoli e Caserta, Dottoressa Giuseppina Cerulli-Irelli, Professore Adriano La Regina, Soprintendente delle Antichità di Roma, and Herr Professor Doktor Hellmut Sichtermann of the Deutsches Archäologisches Institut, who has allowed me to publish the following photographs: D.A.I. negatives 56.937, 74.2692, 56.318, 59.1973, 56.1235, 56.1218, 74.2689, 66.1845.

2. E. Gjerstadt, *Early Rome*, vol. 4:2, p. 406.

3. M. Borda, *La pittura romana*, pp. 145–63, discusses the written and visual evidence.

4. The somewhat self-contradictory nature of Pliny's several remarks pertinent to patronage betrays this point. In praising the Augustan "inventor" of mural landscapes who might seem to have offered patrons some opportunities for choice in painting "qualia quis optaret," he takes occasion to remark on the superiority of *tabulae* over mural paintings and romanticizes the civic currency of Greek paintings (HN 35.117–18). Consistent with this prejudice is his selection of Fabius Pictor and Pacuvius, who worked in temples probably without the support or dictates of patronage, as the most honorable of Roman painters (35.18–19), but we cannot be certain that these artists did not paint directly on walls. Following this mention (35.22) Pliny adds that the importance of painting in Rome gained much from a series of painters (unnamed) who created narrative battle posters for triumphing generals. While we can be sure that these took directions from patrons, one cannot imagine that their productions were of the highest quality.

5. Such an approach is exemplified by the discussion of M.-Th. Picard Schmitter, "Bétyles hellenistiques," *Mon. Piot.* 57 (1971): 43–88, who constructs an Augustan iconography for the second-style paintings of the Palatine Ambiente delle Maschere from the evidence of coins and monuments.

6. O. J. Brendel, *Prolegomena to the Study of Roman Art* (expanded from "Prolegomena to a Book on Roman Art" with a foreword by J. J. Pollitt), pp. 153–56.

7. Interpreters of the Ara Pacis reliefs are accustomed to invoke Augustan literature: the *Aeneid* for the sacrifice panel; the *Georgics* and Horace's *Carmen saeculare* for the "Tellus" (e.g., E. Simon, *Ara Pacis Augustae*, pp. 23–24, 26–29), while observing that the handling of the natural elements owes its form to the conventions of Hellenistic art. Comparisons between the altar and Augustan landscape painting are thus most frequently made by scholars who, unlike Brendel, attribute the character of all Augustan public and private art to Hellenistic influence, e.g., R. Bianchi Bandinelli, *Rome: The Center of Power, 500 B.C. to A.D. 200*, trans. P. Green, pp. 189–93, and R. Brilliant, *Roman Art from the Republic to Constantine*, pp. 239–40.

8. In discussing such problems for the "Tellus" panel, G. K. Galinsky, *Aeneas, Sicily, and Rome*, pp. 191–241, very appropriately stresses the compositional structure of the design as the basis on which its symbols should be interpreted.

9. P. H. von Blanckenhagen, *The Paintings from Boscotrecase, MDAI(R)* Suppl. 6, 30–35, uses his observations on the "unreal" perspective of the landscape to argue for the latter point of view.

10. A. Mau, *Pompeii: Its Life and Art*, trans. F. W. Kelset, pp. 456–84.

11. A complete and chronologically categorized presentation of the corpus up until the discoveries of the past two decades is provided by H. G. Beyen, *Die pompejanische Wanddekoration von zweiten bis zum vierten Stil*, vols. 1 and 2.

12. A history of scholarship on this point is provided by P. W. Lehmann, *Roman Wall Paintings from Boscoreale in the Metropolitan Museum of Art in New York*, p. 91 n. 23, and is updated by G. C. Picard, "Origine et signification des fresques architectoniques dites de Second Style," *RA* (1977): 231–52.

13. Beyen, *Wanddekoration*, vol. 1, illustrations 28–33, 51–55, 59, 70–71b, 74–76.

14. G. Carettoni, "Due nuovi ambienti dipinti sul Palatino," *BA* 46 (1961): 189–99. V. Spinazzola, *Pompei alla luce degli scavi nuovi de Via dell'Abbondanza (Anni 1910–1923)*, vol. 1, pp. 462–88.

15. Lehmann, *Paintings from Boscoreale,* pp. 82–131.

16. Especially important for its modification of Lehmann's theories is the study by J. Engemann, *Architekturdarstellungen des frühen zweiten Stils: illusionistiche römische Wandmalerei der ersten Phase und ihre Vorbilder in der realen Architektur, MDAI(R)* Suppl. 12, which argues that the paintings were of a wholly indigenous origin developing step by step in company with the painters' mastery of the perspective techniques necessary to represent possible interior extensions of the house. Picard, "Fresques architectoniques," pp. 234–40, emphasizes the importance of Engemann's contribution to arguments against the *scaenae frons* theory, but while he himself rejects this theory as too narrow to encompass the entire meaning of the second style, he still argues that the whole corpus must have a single theme: to his mind, a religious one.

17. A. de Franciscis, "La villa romana di Oplontis," in *Neue Forschungen in Pompeii,* ed. B. Andreae and H. Kyrieleis, pp. 7–38. Aside from de Franciscis' initial statement, the one specific attempt to give the paintings a date and a place in second-style chronology is that of K. Schefold, "Zur Geschichte der Wandmalerei Campaniens," *Antike Kunst,* 19 (1976): 118, who has assigned them to the years 40–30 B.C., placing them after Boscoreale but still before the Casa del Criptoportico, and at the high point of the second style.

18. See the discussion in A. G. McKay, *Houses, Villas, and Palaces in the Roman World,* pp. 32–34.

19. A somewhat analogous situation appears in the atrium of the Villa dei Misteri where the two pair of blocked doors on either side of the room were apparently covered by wooden or painted facsimiles. The place of these mock doors in the decorative scheme is discussed by K. Fittschen, "Zur Herkunft und Entstehung des 2. Stils," in *Hellenismus in Mittelitalien: Kolloquium in Göttingen 1974,* ed. P. Zanker, pp. 539–57, who holds to the common opinion that the doors, originally functional, were blocked when the room received a second-style decoration.

20. Fittschen, "Herkunft und Entstehung," p. 548, attributes this lack of symmetry to the painter's having worked with a pattern that did not fit the wall, but this is to overlook the marked differences between the two sides of the door and the deliberate positioning of the corridor that leads off behind. One may notice that the *imagines clipeati* (shield portraits) hung in the alcove of the first door are thematically appropriate to the decoration of an atrium in their double association with the public and private life. Pliny (*HN* 35.13) records that M. Aemilius Lepidus (consul 78 B.C.) set up such portraits both in the basilica Aemilia and in his own house.

21. Fittschen, "Herkunft und Entstehung," pp. 549–56, provides a detailed analysis of such imitations both at Oplontis and in other second-style paintings. Although he reviews the evidence for the employment of luxurious building materials in Roman houses, he attributes their appearance in the paintings wholly to a Hellenistic background. P. Zanker, "Die Villa als Vorbild des späten pompejanischen Wohngeschmacks," *Jahrbuch des Deutschen Archäologischen Instituts* 94 (1979): 460–523, follows Fittschen in attributing the architectonic character of second-style painting to Hellenistic sources, finding evidence for indigenous influence only in later periods.

22. This theory which I owe to discussions with Lawrence Richardson, Jr., will be published by him in a forthcoming issue of *Chronache Pompeiane.*

23. De Franciscis, "Villa di Oplontis," p. 11, fig. 1. The room numbered 12 on the plan is connected with room 11 by a door cut through the rear wall of the left hand alcove. It is a somewhat larger room which has been redecorated in the third style.

24. De Franciscis, "Villa di Oplontis," pls. 14–16.

25. Lehmann herself, *Paintings from Boscoreale,* pp. 157–61, does not identify all the details of the paintings from Roman sources but attributes several to Hellenistic prototypes (and these the most luxurious), referring especially to Athenaeus' accounts of the pavilion of Ptolemy II and the boats of Ptolemy IV and Hieron. K. Schefold, "Der zweite Stil als Zeugnis alexandrinischer Architektur," in *Neue Forschungen in Pompeii,* ed. B. Andreae and H. Kyrieleis, pp. 53–60, believes that the paintings came directly from Hellenistic patterns, as does Fittschen, "Herkunft und Entstehung," pp. 549–56, but Zanker, "Die Villa als Vorbild," pp. 462–68, while again stressing the significance of villas themselves as a symptom of Roman response to the attractions of Hellenistic culture, does interpose a mention of the luxury villas in Italy as a reason for the popularity of the "porticus" designs.

26. For a discussion and hypothetical plan of the aviary, see G. Fuchs, "Varros Vogelhaus bei Casinum," *MDAI(R)* 69 (1962): 96–105.

27. Vitr. 6.7.4. Beyen, *Wanddekoration,* vol. 1, p. 315; Lehmann, *Paintings from Boscoreale,* p. 159. The background and use of *xenia* are discussed by J. M. Croisille, *Les natures mortes campaniennes, Collection Latomus 76,* pp. 11–16. Since Lehmann's discussion is based upon the assumption that the cubiculum was that of the master's personal use, the *xenium* is only marginally appropriate in context.

28. In the first full publication of the villa, F. Barnabei, *La villa pompeiana di P. Fannio Sinistore scoperto presso Boscoreale,* pp. 77 ff., did identify the room as a triclinium, but Beyen, *Wanddekoration,* vol. 1, p. 141, sees the division into anteroom, or "procoeton," and alcove as that of a cubiculum, although admitting (n. 2) that this pattern came to be seen as better suited to triclinia. Lehmann, *Paintings from Boscoreale,* p. 15 n. 39, completely dismisses the possibility of its being a triclinium, and says the same of the contiguous second-style room *N,* but the juxtaposition of these two rooms of different sizes is quite in accordance with Richardson's observations on triclinia in pairs.

29. A. Allroggen-Bedel, *Maskendarstellungen in der römische-kampanische Wandmalerei,* pp. 28–30. She finds the closest apparent link in the Boscoreale summer triclinium where tragic masks might seem to accompany a decoration of doors and columns *tragico more* on the Naples wall, but the Mariemont wall is only a simpler version of this one and yet has comic masks. Her emphasis upon the importance of understanding the place and function of the masks within the total context of their decorative surroundings is well taken, but her ultimate conclusion (pp. 68–72) that masks exist as symbols of the *mimus vitae* is broader than it need be.

30. Carettoni, "Due nuovi ambienti," pp. 191–94, first characterized these as representations of wooden stage decorations, incomplete for want of space, on the rear wall. One should notice a strong similarity between the architecture of this construction and that of the rear wall of Room 23 of the Oplontis Villa, de Franciscis, "Villa di Oplontis," p. 24, pl. 13. In contrast with the variations in the "porticus" rooms, we seem here to be dealing with a standard pattern that the painters reproduced in its exact lineaments, altering only the superficial ornamentation to their taste. My own explanation for the parallel is that Room 23 at Oplontis was painted later than the rooms in the west wing, perhaps in the attempt to bring the decoration of the house up to date by inclusion of a new style of theatrical room.

31. I wish to thank Gianfilippo Carettoni for his kindness in showing and discussing these newly excavated rooms in October 1976.

32. Allroggen-Bedel, *Maskendarstellungen,* p. 33. The possible link with temporary stage sets was suggested to me by Lawrence Richardson. Like the "porticus" paintings, the "theatrical" walls of the Casa del Criptoportico include colonnades in receding perspective. They do not, however, extend backwards so deeply, nor do they define an enclosed space beyond the wall. A theatrical explanation may be available for these structures if we consider a passage where Vitruvius (5.9.1) mentions the need for *porticus* behind the *scaena* to offer playgoers shelter from a sudden rain as well as space for preparing the apparatus of the stage. Although the view of these spaces was in the real theater presumably blocked by the *scaena,* there is no reason why the painters of fictional stages should not have chosen to open these prospects to give depth to their designs since the illusion of depth was clearly one of the attractive features of the rival "porticus" style.

33. I cannot in any case agree with Schefold, "Geschichte," p. 118, that Oplontis follows after Boscoreale, if only because the grotto motif in Room 11 is so much less fully developed than that in the New York room. As for the Villa dei Misteri, even though its scheme of predominantly orthostat walls has led scholars to assign it an early place in their evolutionary chronologies, its full complement of second-style decoration may have included at least one illusionistically open wall. The *L*-shaped triclinium at the northwest corner, whose second-style paintings were destroyed by a later remodeling, still shows remnants of a grandiose second-style pediment comparable to one in the Casa del Labirinto above the cornice line of a false vault constructed when the shape of the room was changed.

34. J. H. D'Arms, "Ville rustiche e ville d'*otium,*" in *Pompeii 79,* ed. F. Zevi, pp. 78–79.

35. D'Arms, ibid., p. 76. A locational map showing the two excavation sites now appears in W. Jashemski, *The Gardens of Pompeii,* p. 322, fig. 497.

36. P. Castrén, "*Ordo Populusque Pompeianus*": *Polity and Society in Roman Pompeii,* pp. 88–91.

37. Castrén, ibid., p. 85.

38. Macrob. *Sat.* 2.3.12; cited by Castrén, "*Ordo Populusque,*" p. 62.

39. Carettoni's arguments on the basis of a location close to the Temple of Apollo are in *London Illustrated News,* September 20, 1969, pp. 24 ff. The painted terracotta metope plaques which he considers the best evidence to confirm the identification of the temple site are in "Nuova serie di grandi 'lastre fittili' campana," *BA* 58 (1973):75–87, and "Terracotte 'campana' dallo scavo del Tempio di Apollo Palatino," *RPAA* 44 (1971–72): 123 ff.

40. Remarking on the coincidence of illusionistic and paratactic orthostat walls within the same houses, Fittschen, "Herkunft und Entstehung," pp. 543–44, reaches the conclusion that architectural illusion and the opening of space need not be considered the primary aims of the second style.

41. Spinazzola, *Via dell' Abbondanza,* pp. 488–503.

42. C. Dilthey, "Dipinti pompeiani accompagnati d'epigrammi greci," *Ann. Inst.* 48 (1876): 294–314, describes the paintings and provides a text of the inscribed epigrams, none of which is exactly identical with its counterpart in the *Anthology.* Allroggen-Bedel, *Maskendarstellungen,* pp. 24–25, dates this room later than the Casa del Criptoportico on account of the "vegetative" nature of the columns, which she sees as forerunners of the candelabra style.

43. A. W. van Buren, "*Pinacothecae* with Especial Reference to Pompeii," *MAAR* 15 (1938): 70–81, deals with forms of *pinakes* and with *pinacothecae* as a class, but follows Vitr. 6.5.2 in regarding them as gallery rooms existing solely for their picture displays and not as rooms whose primary purpose might have been utilitarian. He quite rightly identifies the large oecus in the Casa di Obellio Firmo as one of this mode (for which see Allroggen-Bedel, *Maskendarstellungen,* pp. 26–28). This room in fact combines elements of the "porticus" and "pinacotheca" styles, and the unusual nature of its brushwork which defines almost all details by the use of single lines might suggest that it is the product of still a different workshop. K. Schefold, *La peinture pompéienne: essai sur l'évolution et de sa signification,* pp. 50–52, discusses *pinacothecae* in the third and fourth style but finds none in the second, identifying "cubiculum B" of the Villa alla Farnesina as the earliest example.

44. G. E. Rizzo, *Monumenti della pittura antica scoperti in Italia III.3: Le pitture della Casa di Livia.*

45. J. M. Moret, *L'Ilioupersis dans la céramique italiote: Les mythes et leur expression figurée au IV Siecle,* p. 285, mentions two south Italian vases that have the same iconography but depict a different moment in the unfolding of the action.

46. J. Lessing and A. Mau, *Wand und Deckenschmuck eines römischen Hauses aus der Zeit des Augustus.*

47. H. G. Beyen, "Les domini de la Villa de la Farnésine," *Studia varia Carolo Guilielmo Vollgraf a discipulis oblata* (1948): 3–21.

48. R. B. Lloyd, "The Aqua Virgo, Euripus, and Pons Agrippa," *AJA* 83 (1979): 193–204.

49. Castrén, "*Ordo Populusque,*" pp. 92–103. In this context one should take account of D'Arms' questioning, pp. 66–67, of the evidence for imperial proprietorship of the "first" notable Campanian third-style villa, commonly called the Villa of Agrippa Postumus, at Boscotrecase, which is famed for the high quality of its mythological panels. The excavations, as D'Arms points out, were interrupted by the Vesuvian eruption of 1906; there is no evidence that this was strictly a resort villa, and much argument from the size of its slave quarters and from the terrain itself, that it was not.

50. A gladiatorial scene in the *fauces* of the Casa di Fabio Amando is shown and described by Borda, *Pittura romana,* p. 159, who attributes the taste to the Samnite strain in Pompeian culture. Pliny (*HN* 35.52) makes mention of the first gladiatorial painting displayed in Rome in the mid second century, but the piece was commissioned by the sponsor of the games rather than by a fan.

Copying in Roman Sculpture: The Replica Series

MIRANDA MARVIN

Roman sculpture today is chiefly esteemed for the splendor of its portraits and the power of its historical reliefs. In its mythological/decorative statuary (what the Germans call *Idealplastik*), however, a certain lack of originality is conspicuous. The same images of major and minor gods, athletes, personifications, and culture heroes are reproduced century after century from one end of the Mediterranean to the other. All these "ideal" works, moreover, are Greek in style.

This repetition is explained as a peculiarity of Roman patronage. Since the Romans were unstinting in their admiration for Greek sculpture, and in particular for the works of a handful of fifth- and fourth-century artists recognized as supreme masters, Roman purchasers are thought to have wanted to decorate their private dwellings and public places not with original contemporary sculptures but with the closest possible replicas of the works of those Greek artists most admired by Roman writers. To own an acknowledged masterpiece, even in a surrogate version, is thought to have been the goal of most Romans when buying sculpture.[1]

There is little direct information about the intentions of Roman patrons. On the whole, their goals must be deduced from their purchases. The one exception is that prolific correspondent, M. Tullius Cicero. In his letters a wealthy Roman can be observed in the process of buying statuary for a villa. The picture of a Roman

"Copying in Roman Sculpture: The Replica Series" from *Retaining the Original. Multiple Originals, Copies, and Reproductions, vol. 20, Studies in the History of Art* (National Gallery of Art, Washington, D.C., 1989).

patron that emerges from these letters is strikingly unlike the one posited for Roman purchasers in traditional theory. It is, however, completely congruent with the discoveries about Roman art and its relationship to the Greek past made by recent scholars.[2] Following their lead, it becomes possible, starting with Cicero, to develop a new explanatory hypothesis for the presence in Roman contexts of so many replicas of familiar works. Accepting this hypothesis leads in turn to consideration of the terms used to describe Roman sculptors and to a realization that the nature of Roman ideal sculpture needs to be redefined.

In a series of ten early letters to T. Pomponius Atticus, his intimate friend who lived much of the time in Athens, and a much later letter to another correspondent, Cicero discusses in some detail the sculptures he is buying for his villa in Tusculum.[3] This correspondence is the best testimony available for the frame of mind with which at least one Roman buyer approached the purchase of works of art. The letters to Atticus dating between November 68 B.C. and the early summer of 65 B.C. (in the arrangement of D. R. Shackleton Bailey) are the earliest to survive from their long correspondence. Some earlier letters are clearly lost since the first to survive refers to a project already in motion by which Atticus in Athens is to buy sculptures for the villa Cicero recently purchased in Tusculum. As the correspondence proceeds, it gradually becomes clear what sort of sculptures Cicero wants and where he intends to put them.

Two things are notable in the first letter (see Appendix). There is, to begin with, the loose definition of Atticus' assignment. He is to provide for the Tusculan villa not just the works Cicero had specified but whatever he recognizes as suitable for the place. Cicero's confidence in Atticus' ability to choose correctly is absolute. Second, there is the immediate association made between the purchases and the villa as the place where Cicero can "rest from all troubles and toils."

The second letter introduces the Greek term that will be the closest Cicero will come to defining just what sort of sculptures he has in mind. He wants decorations (*ornamenta*) that will be *gymnasiode,* or "appropriate for a *gymnasium.*"[4] Gymnasia, beginning as places where athletes trained, by Cicero's day had become known equally well as places where young men went to study philosophy.[5] Wealthy Romans, moreover, following Hellenistic precedents, delighted in naming parts of their extensive gardens after Greek building types. Gymnasia (interchangeably called *palaestrae* by the Romans) were especially popular, thanks to their philosophical and aristocratic associations. Most of the Roman versions seem to have been peristyle gardens.[6] In the villa at Tusculum Cicero had two "gymnasia," and to each he gave a specific name. One he called the Lyceum and the other the Academy after the two gymnasia in Athens, where, respectively, Aristotle and Plato had taught.[7]

The Lyceum in Athens has not been excavated, but the Academy has, and although the building has been robbed down to its foundations, the plan is recoverable (Figure 63).[8] The design is characteristic of most Greek gymnasia: a large rectangular open area (once filled with shade trees) surrounded by porticoes with a set of rooms on one side, originally containing the athletes' bath complex, dress-

FIGURE 63 Plan of the Gymnasium at the Academy, Athens *(After John Travlos, Pictorial Dictionary of Ancient Athens)*

ing rooms, equipment storage, and other necessary facilities. By Cicero's day the structure was given over to students of philosophy, who, as was the ancient practice, strolled up and down in their earnest debates.

Cicero himself in his twenties studied philosophy in Athens where he spent a good deal of time with Atticus who was already living there.[9] Cicero's philosophical dialogues often reflect a nostalgia for those golden months. One of his most evocative references is specifically to the Academy. For the setting of the *De Finibus,* he imagines or remembers walking out there with Atticus and a group of other friends one afternoon and finding that the place itself, deserted at that time of day, brought Plato more vividly to their minds than did simply reading or hearing about him and made them realize the power of places to stir the imagination.[10] Cicero's nostalgia was deep, and his affection genuine. Rather touchingly he writes much later to Atticus (*Att.* 115.26) that he hears Appius Claudius Pulcher is building a propylon for the sanctuary of Demeter at Eleusis, and he wonders if "it would be out of the way if I did the same for the Academy? . . . I am really very fond of Athens, the actual city. I want to have some memorial there."[11]

Whether Cicero's Tusculan Academy looked like the Athenian Academy is not known since Cicero's villa has not been excavated. Cicero's writings, however, make it clear that he liked to think of himself as using his gymnasia as their

prototypes were used, as the sites for philosophical discussions.[12] He sets one of his dialogues in his Lyceum, for example, telling the reader that the discussion took place when he and his brother had gone there "for a stroll" (*ambulandi causa*).[13] The Academy was the place where, he would have us believe, he and his friends spent every afternoon walking up and down discussing philosophy.[14] The likelihood is, therefore, very great that Cicero's gymnasia too consisted of long porticoes surrounding tree-shaded areas dotted with seats to drop into when the conversation became intense.[15]

As letter two continues, Cicero associates the villa again with happiness and peace of mind, as he does in the third letter, of February 67 B.C. Here he introduces a new theme: the purchase of a library. Apparently, this too had been promised by Atticus, who has, it would seem for the first time, actually made some purchases for Cicero. It is not until the fourth letter, however, that it is clear that these were Megarian statues and cost HS 20,400.

The fourth letter contains a rather perplexing reference. Since Cicero describes the herms with bronze heads that Atticus had bought him (from letter six it is clear that they were Herakles heads) as Pentelic, it would be reasonable to suppose that the "Megarian" statues were made of Megarian marble. Megara, however, was never famous for statuary marble and was little known as a center of sculpture production.[16] The city is, however, very close to Athens, and Kim Hartswick and John Pollini have suggested that perhaps the statues were not newly made but were purchased by Atticus in Megara as antiques.[17] The price is very high, but since we do not know how many statues were bought, the sum is useful only as a reminder of how much Cicero was prepared to spend on works of art.[18]

The fourth letter positively bubbles with enthusiasm as Cicero again urges Atticus not to stop at the Megarian statues and the herms but to buy more ornaments, "as many and as soon as possible," objects that would be "suitable to a gymnasium and xystus" (*gymnasi xystique*). The term *xystus,* which originally meant a running track, was in Roman usage employed for an open-air garden.[19] Here, no doubt, it is to be distinguished from the covered porticoes of the gymnasium. The two were often paired in garden planning.

As he waits impatiently for the opening of the spring sailing season, Cicero is at last in letter five explicit about where he plans to put the sculptures—in his Academy.[20] The instructions to Atticus remain the same, to spare no expense but to send anything "suitable for the Academy." Works that are *gymnasiode* are what he wants.

Cicero writes the sixth letter, he reports, sitting in the Academy itself, so that the very place reminds him of its need for sculptures. Being in Tusculum (this is the first letter from there) seems to provoke new ideas about decorating the villa, and Cicero requests some reliefs for the walls of the "little atrium" ("in tectorio atrioli") and two well heads decorated with reliefs ("putealia sigillata duo").[21] These are the only references in this group of letters to sculptures for any place other than the Academy. He mentions again the library first brought up in letter three.

The seventh letter is written from Rome and is infused with his affection for Tusculum. He once more immediately associates the Academy with the books he plans to buy, a pattern suggesting that he might be intending to house them there. Elsewhere he refers, however, to a library in the Lyceum.[22] Either he plans two libraries for the villa or perhaps the two gymnasia were parts of the same complex.

The two following letters let us know that the works have finally arrived safely, although Cicero has been unable to see them, and that Atticus has made one further purchase for the villa, a herm of Athena.

Cicero's satisfaction with the Minerva (Athena) herm is usually taken to refer to Cicero's own inclinations. Shackleton Bailey's note puts it deftly "as a giver of wit and wisdom Minerva was the natural protectress of Cicero's Academy and of Cicero himself."[23] In this case, however, more than such a general suitability seems to be meant. Cicero and Atticus, both familiar with the Academy in Athens, knew that it contained a sanctuary of Athena, who was one of the tutelary deities of the place. It is this association that makes the Athena herm so appropriate and explains the allusion in the tenth and final letter of the series, which notes that the Athena has been so nicely placed that the whole gymnasium appears like a votive offering to her.[24]

After a brief note telling Atticus of the birth of a son, the correspondence ceases for almost four years, since Atticus comes to Rome. We never hear Cicero's reaction, therefore, to the rest of the sculpture that Atticus bought for him nor how the decoration of the villa continued.

Nevertheless, there is enough information in these ten letters to give some sense of Cicero as a purchaser.[25] Cicero tells Atticus what sort of sculpture to buy, not by describing the artist or the style or the scale or the material or the subjects that he wants him to look for, but by describing the location where the works are to be placed. Atticus knows the villa, knows what Cicero uses it for, knows the mood Cicero wants to evoke there—or rather, as Cicero says in letter six, what the place itself reminds him that it needs ("me locus ipse admoneret")—and does not require any further information to make an appropriate purchase except the welcome assurance that money is no object.[26] That additional letters giving more specific instructions are not missing is clear from Cicero's delight that the new herm Atticus had found should have turned out to be an Athena—the perfect choice—but not one that Cicero had anticipated.

It is interesting that Cicero mentions nothing about the Athena herm except its subject. Atticus has either not told him anything about the style or the material or the artist or Cicero is not interested enough in that information to mention it. Even after the work has arrived and been set in place, Cicero's thanks include nothing about the quality or appearance of the work, only its effect on the architecture around it. Perhaps this is simply Cicero patting himself on the back. (Who, after all, chose that judicious placement?) Perhaps it is his good manners concealing a disappointment with Atticus' selection. It seems most likely, however, to be a straightforward reflection of what was important to Cicero when he bought art. This supposition is confirmed in a much later letter to a different correspondent.

In 46 B.C. Cicero writes to M. Fabius Gallus about some sculptures that Gallus had bought for him, which were not as welcome as those Atticus had acquired. In this rather testy letter good manners and tact are clearly not responsible for Cicero's failure to discuss the works' quality, material, scale, style, or artist. His principal objection is to the cost of the statues. His irritation is intensified, however, by being asked to pay so much for works that he would not have chosen at any price. Not knowing where Cicero intended to put the statues, Gallus has bought works that are not *gymnasiode*. Their subjects are, in fact, so contrary to Cicero's image of himself that he can think of no suitable place anywhere on his property for them (''Bacchis vero ubi est apud me locus?'') and wants only to find someone to take them off his hands. He claims to have seen the Maenads (Bacchantes), to know them well (''novi optime et saepe vidi''), and to think them pretty (*pulchellae*).[27] This does not make him like them any better, and he irritably points out that he would have asked for specific works if he had wanted them. What he does want yet again are works he can use to decorate ''a place in my palaestralike gymnasia.'' Here the language strengthens the supposition that his two gymnasia are part of one complex (*locum*). It is noteworthy that Cicero claims he would have objected less to the group of Muses that Gallus had mentioned since they at least could find a home in his library.

Cicero's interest, in other words, is still exclusively in the role that statuary can play in creating a special kind of atmosphere.[28] In these particular letters he is interested specifically in using it to evoke Plato's Academy.[29] He has no desire for an exact replica of the place, however. He had, after all, spent six months in Athens and knew it well. Atticus lived in Athens and could go to the Academy every day. It would have been possible for him to reproduce its architecture and sculpture point for point. In the case of the architecture we have no evidence of what he may have done, but we do know that he did not attempt to copy the sculptures exactly. The Athenian Academy contained quite a number of statues, and we know what some of them were. There was a portrait of Plato, for instance, and statues of the Graces, which stood in a sanctuary of the Muses dedicated by Plato.[30] In addition to the sanctuaries of Athena and of the Muses there were altars (some at least with images) to Eros, Prometheus, Hermes, Zeus, and Herakles as well as a memorial of the hero Akademos after whom the Academy was named.[31] The excavations there also produced many fragments of sculptures.[32]

Cicero did not ask for replicas of specific works, only for the ''generic brand'' of gymnasium statuary.[33] He sought to create not a literal copy of Plato's Academy but what he saw as its essential character as a place of philosophic discussion—what he remembered from his student days—the long porticoes, the walking up and down, the earnest conversation, and a marble blur of statuary as they passed. The sculptures played their part not by exactly duplicating any particular work but by awakening the associations Cicero thought proper. It was not the appearance of the Academy that he wanted to reproduce but his feelings about it. The sculptures, therefore, had to be agreeable to a mood of philosophic tran-

quillity and suggest only the prime use of the space in which they were set. Plato may have erected a shrine of the Muses in the Academy, but Cicero could imagine placing statues of Muses only in a library, where their function was comfortingly predictable. Sculptures evoking the wrong associations (Mars, Maenads) were manifestly impossible, handsome though they might be. What emerges strongly in these letters is Cicero's sense of the power of sculpture to affect the meaning of the architecture around it. Admitting statues of Maenads into his villa might turn his philosophic retreat into a Dionysiac garden, and the Athena herm, after all, redefines the space in which it is placed so that "the whole gymnasium appears to be its votive offering."[34]

An analogy is sometimes drawn between Cicero's acquisition of sculpture for Tusculum and the filling of English country houses in the eighteenth century with classical statuary.[35] Cicero's willingness to let Atticus make decisions for him is not unlike the dependence of these English patrons on the discretion of the Roman dealers who supplied them with marbles. Their use of statuary, however, was very different.[36]

One of the finest of the neoclassical country houses, Syon House, remodeled in 1762 by Robert Adam for Sir Hugh Smithson, is typical. It contains in its entrance hall a collection of replicas after the antique. These are dominated by the Dying Gaul at one end of the room and the Apollo Belvedere in the other. The walls between are lined with a heterogeneous mix of figures.

In two notable ways this assemblage differs from anything thought desirable by Cicero. There is, first, the juxtaposition of incongruous subjects. What has Apollo to do with a dying Gaul (or gladiator as it was known in the eighteenth century)? What is a dying barbarian doing in the country estate of an English landed proprietor anyway or what are pagan gods doing in the house of a Christian gentleman? (Cicero's tones of outrage are audible even today.) Smithson and Adam's use of these classical replicas depend on their being considered exclusively as works of art, as two of the canonical antiquities admired by every person of taste. Their significance is reduced to general notions of "the antique," "the sublime," and "the noble."

The ability thus to trivialize the content of representational works depends on the viewer's feeling distant from the culture that produced them. Such uses of classical sculpture occur in Roman contexts but only in later periods when the world Cicero lived in and the values he cherished were remote.[37]

Second, these sculptures do not define the function of the space around them. The hall stands at the entrance to Syon House. It is the place where as they came in visitors handed their overcoats to the footman. The statues here, if anything, attempt to disguise the rather mundane use of the room, to suggest that it is instead what Cicero's villa is often quite wrongly said to be, a museum.[38]

In one way Smithson is very comparable to Cicero. He clearly shares Cicero's concern that sculptures reflect their owner. Smithson was known as a man of "perfect taste" and wanted his visitors to know that the minute they walked in his

door. Reducing the content of his works to generalities, however, limited the meaning they conveyed. They no longer functioned in the sharply programmatic way that Cicero's did, a way that was typically Roman.

Writing in the first century B.C., Cicero is a very early example of a Roman purchaser. The attitudes of later, Imperial, patrons and of Republican patrons other than Cicero must be deduced from brief written references and from modern reconstructions of excavated material. From this evidence it is clear that Cicero's creation of evocative spaces in the grounds of his villa was typical. It is also clear that the patrons and architects who laid out the private domains of the rich indulged in personal taste and took pride in learned interests. Cicero's visitors were clearly assumed to be well-educated, well-traveled, cultured men capable of making sophisticated associations—an image of Athena—Cicero's Academy—Plato's Academy. Not every wealthy patron, however, shared Cicero's conservatism and conventionality. The unfortunate Gallus clearly had notions vastly different from Cicero's of what sort of sculpture might appropriately decorate his villa. Pliny's account shows that the taste and interests of Asinius Pollio, to cite a famous contemporary of Cicero, resulted in a very different display of statuary.[39]

The same principle of laying out the grounds of villas as clearly defined units redolent with specific meanings continued into the empire.[40] The finds from the Villa of the Papyri, for example, suggest that its owner chose and arranged his sculptures in agreement with the Epicureanism demonstrable in his library.[41] The transformation of a grotto at Sperlonga into a landscape of heroic mythology is even better known.[42] The sculptures from the largest and most elaborate villa of all, the Villa of Hadrian at Tivoli, have recently been published and show that the principle of using sculpture in an architectural and landscape setting to make a special world for the visitor is retained in the second century A.D.[43] In the spreading acreage of Tivoli the emperor and his guests could apparently wander from rustic shrines to evocations of a Hellenistic hunting park to a romantic Egyptian dreamland. It was the sculptures that helped to give each setting its distinctive identity.

The same guiding principle, that the function of sculpture is to suggest the character of the space in which it is set, dominates public as well as private displays of statuary. Vitruvius makes this plain in a comic anecdote about the people of Alabanda, who

> were considered bright enough in all matters of politics, but that on account of one slight defect, the lack of a sense of propriety, they were believed to be unintelligent. In their gymnasium the statues are all pleading causes, in their forum, throwing the discus, running, or playing ball. This disregard of propriety in the interchange of statues appropriate to different places has brought the state as a whole into disrepute.[44]

Analysis of the sculptural programs of Roman public buildings is just beginning, but it is already clear that most cities tried to maintain a "sense of propriety."[45] Even the plundered Greek works displayed in public places in Rome itself

are now seen to have been chosen more with a view to the propaganda messages they could convey than to the names of the artists associated with them.[46]

Most users of these public buildings were uneducated, untraveled, familiar with very few works of art, and capable of making no arcane associations. Yet since it was the function of the sculpture to help define the character of the space around it, here too patrons had instantly to be made to recognize the special nature of the space they were in, whether it was a bath, forum, theater, basilica, or hippodrome. All public buildings were enriched with statues and depended in part on them to convey the messages of the place to the user. By necessity the designers of such buildings confined themselves to works whose associations were familiar, unambiguous, and immediately recognizable. They came to rely on a handful of works whose meaning was instantly clear to everyone, the visual equivalent of clichés.

In this requirement perhaps lies the explanation for that curiosity of Roman sculpture, the absolute dominance in the production of "ideal" statuary of a few familiar types, endlessly repeated. What is known as the "replica series"—a set of replicas that, although differing in material, scale, quality, and iconographic detail, can be seen as deriving from a common type—accounts for most of the market in these statues.

The designers of Roman buildings needed instantly recognizable sculptures, and for public places they needed them in quantity. It is no coincidence that the great age of replica production coincided with the spread throughout the empire of what has been called the Marble Style in architecture.[47] The most imposing feature of this style, apart from the glittering material that gives it its name, was the erection of elaborate facades decorated with superimposed recesses and projections framed by columns supporting continuous architraves or little individual triangular or arcuated pediments. Once thought to be a second-century phenomenon, recent finds from Aphrodisias demonstrate that in Asia Minor, the heartland of the style, these columned facades appear in a building that may be Julio-Claudian.[48] The varieties of design were many, but the general effect was uniform: ascending rows of pavilions framing statues. These are almost all lost today, but often empty bases testify to where they once stood. Such facades characterized buildings of the most diverse types, the *scaenae frontes* of theaters, temple precincts, swimming pools in baths, public libraries, city gates, fountains, and palaces; by the mid-second century and into the early third the style had become almost inevitable for certain types of pretentious civic structures (Figures 64–68).[49]

This similarity of appearance among buildings of such different functions is one of the puzzles of the Marble Style. For architects to whom the idea of appropriateness was as important as it was to the Romans, it looks like an anomaly. When their sculptural decoration was in place, however, these facades must have seemed less uniform as the choice of subjects suitable for each place would have more clearly differentiated them from each other than is now apparent.[50]

It was, of course, not merely the facades of these buildings that were filled with sculpture. Standing on the floors or set in niches in the walls, statues

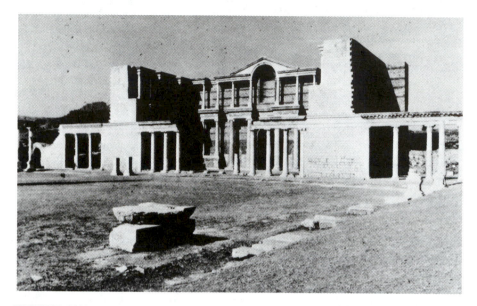

FIGURE 64 The "Marble Court," or Entrance to the Bath-Gymnasium Complex, Sardis

abounded in the public buildings of the empire.[51] When to these massed displays is added the great bulk of statues used in smaller numbers in private contexts and less flashy public buildings, the effect of "mass production" given by the most popular statuary types is understandable.

The explanation suggested for a large replica series is that it represents a tribute to the usefulness of the type in a variety of Roman sculptural programs.[52] Figures such as, for example, Aphrodite or Herakles, who have a role both in the life of the state and in popular affection and who find themselves at home in a number of contexts, are the subjects that survive today in the greatest numbers. The particular sculptural types chosen were those capable of conveying the desired meaning most clearly, those everybody knew.

How certain images of favorite subjects came to represent those subjects to the popular imagination is an important and difficult question. In many cases the types were replicas of well-known statues by the great Greek artists of the past, and it was the fame of the original work that inspired the copies. The best example of this phenomenon is perhaps the Aphrodite of Knidos, of which Pliny says that "with that statue Praxiteles made Knidos famous" (Figure 69).[53] In 1933 Christian Blinkenberg counted fifty-one replicas, and more have appeared since.[54] More interesting is the large number of adaptations and variations on the Knidia that appeared after Praxiteles. The two best known today are the Medici and Capitoline Venus types (Figures 70 and 71). Replica lists for these were assembled in 1951. Thirty-three versions of the Medici were recorded, and 101 of the Capitoline.[55] The dates when these types were created are fiercely debated; no artists'

FIGURE 65 "Septizodium," Rome

names can be plausibly associated with them.[56] They state richly and unequivo-
cally, however, the Venus Pudica theme, which had, thanks to Praxiteles, come to
represent the goddess at her most characteristic.[57] They were as satisfactory a
depiction of that theme as was a copy of the Knidia herself and were equally, or
in the case of the Capitoline possibly even more, acceptable to Roman purchasers
looking for a traditional image of Aphrodite.[58] The meaning of the figure could
hardly escape the most inattentive or ignorant viewer.

 Other popular works are difficult to connect even at secondhand with a
famous original. The Crouching Aphrodite, for example, is another very familiar
image of the goddess (Figure 72). Now that doubts have been cast on the attribu-
tion to Doidalsas, she has become a foundling, dumped by the Romans' affection
for her on the doorstep of art history.[59] The failure to establish secure connections
for the type with known schools or artists may simply be a failure of modern
scholarship that time will correct. It is not, however, absolutely necessary for a
work to be connected with a great artist for it to become famous.

 A modern analogy comes to mind. Undoubtedly the most famous American
painting of the nineteenth century is the work universally known as Whistler's
Mother. Painted in 1871, the work had become so famous by the 1930s that it was
used, untitled, as a Mother's Day commemorative stamp. Although the Romans
had neither Mother's Day nor postage stamps, there are nevertheless aspects to the

FIGURE 66 Theater, Sabratha

fame of this work that are not irrelevant to the problem of the replica series. First, although the name of the artist is locked into the title by which the work is popularly known, its celebrity is independent of the reputation of his other works or even of his personal notoriety. Second, greater and more famous artists, even including Rembrandt, have painted better portraits of their mothers, which have no fame outside the world of art. In the case of Rembrandt this is particularly striking since his is one of the names that resonates to the modern public as Pheidias or Praxiteles did to the Romans. Finally, there is almost nothing in this painting that suggests the feelings the Post Office would reasonably be expected to associate with Mother's Day. Mrs. Whistler sits isolated and withdrawn, exuding neither warmth, nor nurturance, nor selfless, maternal love. Hers is not a lap to snuggle in. It is, in fact, hard to imagine any quality other than fame that could have made this work a symbol of motherhood.

The point is that the process that turns works of art into clichés takes place for many different reasons, not all of which are immediately apparent. Once, how-

FIGURE 67 Library of Celsus, Ephesus

ever, a work becomes familiar, then it will be reproduced again and again simply on the strength of its notoriety. Works of art, like human celebrities, can be famous for being famous.

The moral to be drawn for Roman art from this digression into the anomalies of fame in the twentieth century is that it is no easier to predict what factors made a work successful in the Roman art market than in the modern one. Works brought from Greece, for instance, may have become popular after they arrived in Rome, perhaps because they were set up in a particularly conspicuous place.[60] Others may have achieved notoriety through association with famous donors or because they played a role in Roman religious life.[61] Still others of the many replica series that survive today may not refer to any Greek original at all but may simply be the version of the, say, Venus Pudica produced by a popular workshop, which was then imitated by other workshops and entered the repertory of well-known types.

Works of art may also have symbolic meanings that are not visually obvious. As Mrs. Whistler could represent motherhood, so surprising works could symbolize Roman values. Joachim Raeder has suggested, for example, that the wounded Amazons from the Euripus at Hadrian's villa symbolize Virtus (valor), pointing out how close the standard Virtus iconography is to representations of Amazons,

FIGURE 68 North Agora Gate, Miletos

despite the connection of the word with "manliness" (Figure 73).[62] If he is right and if that is what those particular Amazons could mean to the Romans, then the popularity of the types can be understood independently of their connections to particular fifth-century Greek artists.[63]

This explanation for the preponderance of the replica series in Roman sculptural production is not commonly offered. A large replica series is usually considered to indicate that a major work by a famous Greek artist must lie behind it. Gisela Richter put it clearly in *The Sculpture and Sculptors of the Greeks* (1970), saying of the Herakles Farnese that "the original . . . must have been an important work, to judge by the number of extant copies."[64] Accounting for large replica series in this way is, of course, only one aspect of a theory of Roman copying developed in the nineteenth century and most characteristically expressed at its end by Adolf Furtwängler. Speaking of the sculptures that emerged in such numbers from the great excavations of that century, he wrote:

> The original sculptures from Greece are . . . works of the second or even inferior rank. The Roman copies, on the other hand, have preserved that pick from the masterpieces of the classical epoch which pleased ancient taste and connoisseurship in the times of highest culture. It is the pick of the best and the most famous that antiquity possessed.[65]

FIGURE 69 Copy of the Aphrodite from Knidos by Praxiteles *(Vatican Museums, Rome)*

Furtwängler's enthusiastic belief that from Roman works he could trace the careers not merely of Pheidias, Myron, Polykleitos, and Praxiteles but of figures like Kresilas and Euphranor as well is now seen as overly optimistic; and many of the works he thought of as copies are recognized as Roman classicizing creations. Nevertheless, the fundamental principles he articulated still dominate contemporary surveys of classical art.[66] The Romans are still thought to have copied the works they most admired because they judged them to be "the best and the most famous that antiquity possessed."

One possibility that must be considered, however, is that in making the assumption that the Romans' undoubted love of Greek art led them also systematically to copy the greatest works of the greatest artists, scholars are throwing back on the Romans a point of view that properly belongs to modern art history. Contemporary art historians, conditioned by a discipline devoted to a chain of infinite regress in formal development and to the methodical sorting out of the influence of one artist on another, are naturally eager to know just what the great works of Pheidias, Praxiteles, Lysippos really looked like. We expect, as it were, to read our Pliny with illustrations. It is only modern technologies of reproduction (particularly the camera) that make these methodologies possible and expectations reasonable.[67] The expectations of the Romans, however, are the issue, and it is not entirely clear that an accurate knowledge of works of art they had never seen was one of them.

FIGURE 70 "Medici Venus,"
(Galleria degli Uffizi, Florence)

In yet another sense Furtwängler's view can be seen as a historical artifact. It is not surprising that it emerged from the nineteenth century, the great age of sculptural reproduction, the heyday of the plaster cast. The taste for surrounding oneself with replicas of great works, aristocratic in eighteenth-century England, came to be universal a century later. In an illuminating study of mid-Victorian taste in America, Michelle Bogart has demonstrated how owning reproductions of esteemed works lent status and refinement to the household displaying them. She quotes Clarence Cook in *House Beautiful* (1878):

> All is, to choose something for the living room mantel piece that shall be worth living with; it ought to be something that is good alike for young and old . . . there is hardly anything that better rewards trouble than a fine cast of a really noble or lovely piece of sculpture. Who would ever get tired of seeing on the wall, over his mantel piece, as he sat with his wife or friend before his sea coal fire, the mask of either one of Michelangelo's captives on one side, and the Naples Psyche on the other.[68]

In such an environment, in which a heterogeneous mixture of "noble or lovely" works distinguishes not just the formal spaces of the rich but the parlors

FIGURE 71 "Capitoline Aphrodite," *(Capitoline Museum, Rome)*

of the middle class, it becomes easy to understand how the Romans could be thought to have desired replicas in the same way if not for the mantelpiece, at least for the garden.[69]

In recent years, principally among scholars in Germany and Italy, and in this country most notably by Brunilde S. Ridgway, a reexamination of the evidence for the Romans' attitude toward Greek sculpture has confirmed their enthusiasm for it, but has suggested that they collected, copied, and imitated it for reasons of their own.[70] This revised view compels a comprehensive reexamination of the problem, from the Romans' motives for choosing Greek works as war booty to careful formal analyses of period styles in classicistic works.[71] The increased emphasis on the Roman contexts in which sculptures are found and the meaning of the sculptures to Roman viewers is one part of this development.

To understand the specific issue of the replica series it is helpful to state the problem in a form borrowed from the philosophy of science. Two hypotheses have been put forward to explain the replica series. One could be called the "copy" and the other the "programmatic" hypothesis. The traditional or copy hypothesis holds that behind every large Roman replica series stands an important Greek original, copied by the Romans as a tribute to that original and a sign of their desire to own literal reproductions of acknowledged masterpieces. Recent studies can be seen as tests of that hypothesis that have demonstrated its weakness.

The alternative or programmatic hypothesis put forth here explains the existence of the replica series as a tribute to the usefulness of its base type in Roman contexts and its dependence on an original Greek work as true for some series but

FIGURE 72 Crouching
Aphrodite *(Museo Nazionale
Romano, Rome)*

not for all. The letters of Cicero can be seen as a test strongly supporting that hypothesis since one Roman purchaser at least can be clearly shown to have been interested in sculptures appropriate for specific settings but to have left no evidence of wanting copies of particular Greek originals.

Certain logical consequences must be admitted to flow from accepting the new hypothesis as a model for Roman sculptural practice. If a direct connection to a specific work by a Greek artist is not needed to account for the popularity of a type, then the possibility that original Roman works also could generate replica series becomes not remote but likely. In fact, the principle of Occam's Razor would seem to dictate that a Greek original should be posited for a Roman sculpture only when there is external evidence to suggest that the type was in existence before the date of the earliest Roman replica.

A second consequence must be a rise in the perceived status of many Roman sculptors. The traditional approach admits the makers of portraits and historical reliefs to be artists but degrades the makers of ideal types to "copyists." The term is properly functional, belonging to any sculptor at work on a copy. When the work is not a mechanical reproduction but an imitation or adaptation, a work "after the antique," its maker is better described as a neoclassical sculptor, and Roman ideal sculpture should be recognized for what it is, the first neoclassicism.

Fundamentally different from their European successors in most respects, Roman neoclassical artists and patrons were like them in the way they unreservedly admired antique art and diligently set themselves to imitate it.[72] Like them,

FIGURE 73 Villa of Hadrian, Tivoli

they intertwined practice and theory. Like them also, they created original works from the raw material of a classical art. Modern art historians, however, have to struggle to recognize these Roman originals.

It is easy to separate the relationship to ancient statues found in Canova's *Venus Italica* from that of his *Three Graces* or *Perseus,* because his models are extant.[73] It is much more difficult to sort out whether a Roman work is, like the *Venus,* a close imitation of a single work, or, like the *Graces,* a freer adaptation, or, like the *Perseus,* a novel creation drawing on a variety of sources, when the only evidence for those sources is the appearance of the derivative work.[74]

The current willingness to make the effort and interest in looking directly at these Roman sculptures in Greek style as works of art in themselves rather than through them for evidence of their putative originals are signs that the programmatic hypothesis too is a historical artifact. In the later twentieth century neoclassical sculpture is again admired. Signaled by the Council of Europe's mammoth exhibition of 1972 (whose catalogue covers are front and rear views of Canova's *Three Graces*), the revival of neoclassicism has become an established fact of the contemporary art market.[75] The tastes and interests of our own time are making it possible to give Roman neoclassicism the attention and respect it has been for so long lacking.

APPENDIX

Selections from Cicero's Letters

The letters to Atticus are from D. R. Shackleton Bailey, *Cicero's Letters to Atticus,* vol. 1 (Cambridge 1965). The letter to Gallus is from D. R. Shackleton Bailey, *Cicero: Epistulae ad familiares,* 2 vols. (Cambridge 1977). Translations of the letters to Atticus from *Cicero's Letters to Atticus* and of the letter to Gallus from *Cicero's Letters to His Friends* (Harmondsworth 1978) are also Shackleton Bailey's.

1. To Atticus
Letter One
1.7. November 68 B.C.

Epiroticam emptionem gaudeo tibi placere. quae tibi mandavi et quae tu intelleges convenire nostro Tusculano velim, ut scribis, cures, quod sine molestia tua facere poteris. nam nos ex omnibus molestiis et laboribus uno illo in loco conquiescimus.

I am glad you are pleased with your purchase in Epirus. Yes, do please look after my commissions and anything else that may strike you as suitable to my place in Tusculum, so far as you can without putting yourself to too much trouble. It is the one place where I rest from all troubles and toils.

Letter Two
2.2. November 68 B.C.

Haec habebam fere quae te scire vellem. tu velim, si qua ornamenta γυμνασιώδη reperire poteris quae loci sint eius quem tu non ignoras, ne praetermittas. nos Tuscu-lano ita delectamur ut nobismet ipsis tum denique cum illo venimus placeamus. quid agas omnibus de rebus et quid acturus sis fac nos quam diligentissime certiores.

That is about all I have to tell you. If you succeed in finding any *objets d'art* suit-able for a lecture hall, which would do for you know where, I hope you won't let them slip. I am delighted with my place at Tusculum, so much so that I feel con-tent with myself when, and only when, I get there. Let me know in full detail about everything you are doing and intending to do.

Letter Three
3. February 67 B.C.

Apud matrem recte est eaque nobis curae est. L. Cincio HS x̄x̄CD constitui me curaturum Id. Febr. tu velim ea quae nobis emisse ⟨te⟩ et parasse scribis des operam ut quam primum habeamus. et velim cogites, id quod mihi pollicitus es, quem ad modum bibliothecam nobis conficere possis. omnem spem delectationis nostrae, quam cum in otium venerimus habere volumus, in tua humanitate posi-tam habemus.

All is in order at your mother's and I am not forgetting her. I have arranged to pay L. Cincius HS 20,400 on the Ides of February. I should be grateful if you would see that I get the articles which you say you have bought and have ready for me as soon as possible. And please give some thought to how you are to procure a library for me as you have promised. All my hopes of enjoying myself as I want to do when I get some leisure depend upon your kindness.

Letter Four
4.2. February 67 B.C.

L. Cincio HS ꟲꟾꟷ ꟲꟾꟷ cccc pro signis Megaricis, ut tu ad me scripseras, curavi. Hermae tui Pentelici cum capitibus aëneis, de quibus ad me scripsisti, iam nunc me admodum delectant. qua re velim et eos et signa et cetera quae tibi eius loci et nostri studi et tuae elegantiae esse videbuntur quam plurima quam primumque mittas, et maxime quae tibi gymnasi xystique vedebuntur esse. name in eo genere sic studio efferimur, ut abs te adiuvandi, ab aliis prope reprehendendi simus. si Lentuli navis non erit, quo tibi placebit imponito.

I have paid L. Cincius the HS 20,400 for the Megarian statues in accordance with your earlier letter. I am already quite enchanted with your Pentelic herms with the bronze heads, about which you write to me, so please send them and the statues and any other things you think would do credit to the place in question and to my enthusiasm and to your good taste, as many and as soon as possible, especially any you think suitable to a lecture hall and colonnade. I am so carried away by my enthusiasm for this sort of thing that it's your duty to help me—and other people's perhaps to scold me. If a ship of Lentulus' is not available, put them aboard any you think fit.

Letter Five
5.2. March or April 67 B.C.

Signa Megarica et Hermas de quibus ad me scripsisti vehementer exspecto. quicquid eiusdem generis habebis dignum Academia tibi quod videbitur, ne dubitaris mittere et arcae nostrae confidito. genus hoc est voluptatis meae. quae γυμνασιώδη maxime sunt, ea quaero. Lentulus navis suas pollicetur. peto abs te ut haec cures diligenter.

I am eagerly expecting the Megarian statues and the herms you wrote to me about. Anything you may have of the same sort which you think suitable for the Academy, don't hesitate to send it and trust my purse. This is how my fancy takes me. Things that are specially suitable for a lecture hall are what I want. Lentulus promises his ships. Please attend to this carefully.

Letter Six
6.3–4. c. May 67 B.C.

Signa nostra et Hermeraclas, ut scribis, cum commodissime poteris, velim impo-
nas, et si quid aliud οἰκεῖον eius loci quem non ignoras reperies, et maxime quae
tibi palaestrae gymnasique videbuntur esse. etenim ibi sedens haec ad te scribe-
bam, ut me locus ipse admoneret. praeterea typos tibi mando quos in tectorio atri-
oli possim includere et putealia sigillata duo. bibliothecam tuam cave cuiquam
despondeas, quamvis acrem amatorem inveneris; nam ego omnis meas vindemio-
las eo reservo, ut illud subsidium senectuti parem.

Yes, I should be grateful if you would ship when you most conveniently can my
statues and Heracles herms and anything else you may discover that would be
convenable you know where, especially things you think suitable to a palaestra and
lecture hall. In fact I am sitting there now as I write, so that the place itself is a
reminder. Further please get me some bas-reliefs which I can lay in the stucco of
the small entrance hall and two figured puteals. Mind you don't engage your
library to anyone, no matter how ardent a wooer you may find. I am putting all
my little gleanings aside to pay for this stand-by for my old age.

Letter Seven
7.3. August 67 B.C.

Tu velim quae nostrae Academiae parasti quam primum mittas. mire quam illius
loci non modo usus sed etiam cogitatio delectat. libros vero tuos cave cuiquam
tradas; nobis eas, quem ad modum scribis, conserva. summum me eorum studium
tenet, sicut odium iam ceterarum rerum; quas tu incredibile est quam brevi tem-
pore quanto deteriores offensurus sis quam reliquisti.

Please send the things you have got for my Academy as soon as possible. The very
thought of the place, let alone the actual use of it, gives me enormous pleasure.
Mind you don't hand over your books to anybody. Keep them for me, as you say
you will. I am consumed with enthusiasm for them, as with disgust for all things
else. It's unbelievable in so short a time how much worse you will find them than
you left them.

Letter Eight
8.2. End of 67 B.C.

Signa quae nobis curasti, ea sunt ad Caietam exposita. nos ea non vidimus; neque
enim exeundi Roma potestas nobis fuit. misimus qui pro vectura solveret. te mul-
tum amamus quod ea abs te diligenter parvoque curata sunt.

The statues you acquired for me have been disembarked at Caieta. I have not seen
them, not having had an opportunity of leaving Rome. I have sent a man to pay
the freight. I am most grateful to you for taking so much trouble and getting them
cheaply.

Letter Nine
9.3. First half 66 B.C.

Quod ad me de Hermathena scribis per mihi gratum est. est ornamentum Academiae proprium meae, quod et Hermes commune est omnium et Minerva singulare est insigne eius gymnasi. qua re velim, ut scribis, ceteris quoque rebus quam plurimis eum locum ornes. quae mihi antea signa misisti, ea nondum vidi; in Formiano sunt, quo ego nunc proficisci cogitabam. illa omnia in Tusculanum deportabo. Caietam, si quando abundare coepero, ornabo. libros tuos conserva et noli desperare eos ⟨me⟩ meos facere posse. quod si adsequor, supero Crassum divitiis atque omnium vicos et prata contemno.

I am very grateful for what you say about the Hermathena. It's an appropriate ornament for my Academy, since Hermes is the common emblem of all such places and Minerva special to that one. So please beautify it with other pieces, as you promise, as many as possible. I have not yet seen the statues you sent me earlier. They are in my house at Formiae, which I am now preparing to visit. I shall take them all up to Tusculum, and decorate Caieta if and when I begin to have a surplus. Hold on to your books and don't despair of my being able to make them mine. If I manage that, I am richer than Crassus and can afford to despise any man's manors and meadows.

Letter Ten
10.5. Shortly before 17 July 65 B.C.

Hermathena tua valde me delectat et posita ita belle est ut totum gymnasium eius ἀνάθημα videatur. multum te amamus.

I am quite delighted with your Hermathena. It's so judiciously placed that the whole hall is like an offering at its feet. Many thanks.

2. To Gallus
To M. Fabius Gallus. December 46 B.C.
(Shackleton Bailey 1977, no. 209)

sed essent, mi Galle, omnia facilia si et ea mercatus esses quae ego desiderabam et ad eam summam quam volueram. ac tamen ista ipsa quae te emisse scribis non solum rata mihi erunt sed etiam grata. plane enim intellego te non modo studio sed etiam amore usum quae te delectarint, hominem, ut ego semper iudicavi, in omni iudicio elegantissimum, quae me digna putaris, coemisse. sed velim maneat Damasippus in sententia; prorsus enim ex istis emptionibus nullam desidero. tu autem, ignarus instituti mei, quanti ego genus omnino signorum omnium non aestimo tanti ista quattuor aut quinque sumpsisti. Bacchas istas cum Musis Metelli comparas. quid simile? primum ipsas ego Musas numquam tanti putassem atque id fecissem Musis omnibus approbantibus, sed tamen erat aptum bibliothecae studiisque nostris congruens; Bacchis vero ubi est apud me locus? at pulchellae sunt. novi optime

et saepe vidi. nominatim tibi signa mihi nota mandassem si probassem. ea enim signa ego emere soleo quae ad similitudinem gymnasiorum exornent mihi in palaestra locum. Martis vero signum quo mihi pacis auctori? . . .

Ista quidem summa ne ego multo libentius emerium deversorium Tarracinae, ne semper hospiti molestus sim. omnino liberti mei video esse culpam, cui plane res certas mandaram, itemque Iuni, quem puto tibi notum esse, Aviani familiarem. exhedria quaedam mihi nova sunt instituta in porticula Tusculani. ea volebam tabellis ornare. etenim, si quid generis istius modi me delectat, pictura delectat.

But everything would be straightforward, my dear Gallus, if you had bought what I needed and within the price I had wished to pay. Not but what I stand by these purchases you say you have made, indeed I am grateful. I fully understand that you acted out of good-will, affection indeed, in buying the pieces which pleased you (I have always regarded you as a very fine judge in any matter of taste), and which you considered worthy of me. But I hope Damasippus doesn't change his mind, for, frankly, I don't need any of these purchases of yours. Not being acquainted with my regular practice you have taken these four or five pieces at a price I should consider excessive for all the statuary in creation. You compare these Bacchantes with Metellus' Muses. Where's the likeness? To begin with, I should never have reckoned the Muses themselves worth such a sum—and all Nine would have approved my judgement! Still, that would have made a suitable acquisition for a library, and one appropriate to my interests. But where am I going to put Bacchantes? Pretty little things, you may say. I know them well, I've seen them often. I should have given you a specific commission about statues which I know, if I had cared for them. My habit is to buy pieces which I can use to decorate a place in my palaestra, in imitation of lecture-halls. But a statue of Mars! What can I, as an advocate of peace, do with that? . . .

For the sum you have spent I should really have much preferred to buy a lodge at Tarracina, so as not to be continually imposing on hospitality. To be sure, I realize that my freedman is to blame (I had given him quite definite commissions), and Junius too—I think you know him, Avianius' friend. I am making some new alcoves in the little gallery of my house at Tusculum, and I wanted some pictures for their decoration—indeed, if anything in this way appeals to me, it is painting.

NOTES

I wish to thank the American Academy in Rome for its hospitality as I prepared this manuscript, George Heard Hamilton for his peerless knowledge of Whistler and of postage stamps, my colleague Katherine Geffcken for erudite aid, and Brunilde S. Ridgway for the joy of invigorating discussions.

1. See Brunilde S. Ridgway, "The State of Research on Ancient Art," *Art Bulletin* 68 (1986): 22.

2. Ridgway 1986 reviews recent literature (see her 9–15 and notes therein).

3. See Appendix for texts and translations of the relevant passages in the letters. Unless otherwise noted, all references to Cicero's letters are from the editions of D. R. Shackleton Bailey cited in the Appendix.

4. Paul Zanker, "Zur Funktion und Bedeutung griechischer Skulptur in der Römerzeit," *Entretiens Hardt* 25 (1978), suggests that the term *gymnasiode* refers to a standard "line" available in contemporary workshops. These letters alone cannot support such a hypothesis. Shackleton Bailey consistently translates *gymnasium* as "lecture hall" and *gymnasiode* as "suitable to a lecture hall" (Appendix, letters 2, 4–6). As will become clear, Cicero refers to a peristyle in his garden, not an auditorium. I have, therefore, kept the word *gymnasium*, finding no easy English equivalent.

5. The most comprehensive study of gymnasia is Jean Delorme, *Gymnasion* (Paris 1960).

6. Some examples: a villa of Crassus in Tusculum (*De Or.* 1.98) and Bauli (*Acad.* 2.9). The fundamental study remains Pierre Grimal, *Les jardins romains*, 2d ed. (Paris 1969). See Paul Zanker, "Die Villa als Vorbild des späten pompejanischen Wohngeschmacks," *Jahrbuch des Deutschen Archäologischen Instituts* 94 (1979): 460–523.

7. *Div.* 1.8 (on the Lyceum). See Appendix for the Academy.

8. See John Travlos, *Pictorial Dictionary of Ancient Athens* (New York 1971), s.v. "Akademia." See also Pausanias 1, 30: 1–2; *Real-Encyclopädie*, 1, 1132–34, "Akademia" (Wachsmuth).

9. D. R. Shackleton Bailey, *Cicero's Letters to Atticus* (Cambridge 1965), p. 4.

10. *De Finibus* 5.1.1–2 and 5.2.4.

11. The translation is Shackleton Bailey's.

12. See Michael Ruch, *Le préambule dans les oeuvres philosophiques de Cicéron* (Paris 1958), pp. 81–82. See also Filippo Coarelli, "Discussione," *Dialoghi di archeologia*, 3d ser., 2 (1984), 152–53. I wish to thank Professor William Harris for calling this reference to my attention.

13. *Div.* 1.8.

14. *Tusc.* 2.9, 3.7.

15. Cicero, *Brutus*, ed. A. E. Douglas (Oxford 1966), p. 17, notes that the word *consedimus* is "the customary indication in a Ciceronian dialogue that the main discussion is about to begin" (*Brut.* 24).

16. Ronald P. Legon, *Megara* (Ithaca 1981), 25; Pausanias 1, 40:4; H. Stuart Jones, *Select Passages from Ancient Writers . . . Greek Sculpture*, rev. ed. A. N. Oikonomides (Chicago 1966), p. 142; Alfred Philippson, *Die griechischen Landschaften* (Frankfurt 1952), p. 1, pt. 3: 940–964; Emanuel Loewy, *Inschriften griechischer Bildhauer* (Leipzig 1885), pp. 78–79, no. 99, and 107, no. 140.

17. This suggestion was made in discussion at the symposium "Retaining the Original" held at the Center for Advanced Study of the Visual Arts, National Gallery of Art, Washington, March 8, 1985, when this material was originally presented.

18. To give a general sense of the worth of HS 20,400: Varro claims that a farm of 200 *iugera* (about 130 acres) should produce an annual income of about HS 30,000 (Varro *Rust.* 3.2.15). See also Patrizio Pensabene, "Osservazioni sulla diffusione dei marmi e sul loro prezzo," *Dialoghi di archeologia*, 3d ser., 1 (1983), 55–63.

19. Vitruvius explains the difference between the Greek and Roman xystus, 5.11.4 and 6.7.5. Shackleton Bailey translates *xystus* as "colonnade," following the Greek usage. Since Cicero differentiates it from *gymnasium*, which was a peristyle colonnade, he clearly intended its Latin meaning.

20. Some of the urgency in the letters can be explained by the closing of the Mediterranean shipping routes in the winter. The period 27 May to 14 September was considered the best time to transport goods by sea. The dates could be extended to between 10 March and 10 November but no further with safety (Lionel Casson, *Ships and Seamanship in the Ancient World* [Princeton 1971], p. 270).

21. These are Shackleton Bailey's "bas-reliefs which I can lay in the stucco of the small entrance hall and two figured puteals."

22. *Div.* 2.8.

23. Shackleton Bailey 1965, 1, 288 *ad.* 3: *singulare*.

24. Shackleton Bailey 1965, 1, 296, discusses the textual difficulties with 5.2, *eius* ἀ νάθημα.

25. The basic studies of Cicero as a purchaser of works of art are Giovanni Becatti, *Arte e gusto negli scrittori latini* (Florence 1951), especially pp. 89–92, and Hans Jucker, *Vom Verhältnis der Römer zur bildenden Kunst der Griechen* (Frankfurt 1950), especially pp. 37–45. More recently see Andrew Stewart, "Sculpture in a Classical Landscape," in Mario del Chiaro, *Classical Art:*

Sculpture [exh. cat., Santa Barbara Museum of Art] (Santa Barbara 1984), pp. 86–94, especially 92; Filippo Coarelli, "Il commercio delle opere d'arte in età tardo-repubblicana," *Dialoghi di archeologia*, 3d ser., 1 (1983), 45–53 (principally about the practicalities of shipment); Zanker 1978, 284–85; Grimal 1969, 357–62; Delorme 1960, 223. For bibliography on Cicero's view on art see Magrit Pape, *Griechische Kunstwerke aus Kriegsbeute* (Hamburg 1975), p. 101 n. 3c.

26. See, however, letter eight and the letter to Gallus.

27. In this case the statues seem very clearly to have been "previously owned" (as Kim Hartswick and John Pollini propose for the Megarian statues bought twenty years earlier).

28. I consider Cicero's final comments about painting in his letter to Gallus to be more a function of his momentary bad temper than a considered aesthetic judgment.

29. The use of the word *palaestra* leads Shackleton Bailey (*Cicero: Epistulae ad familiares*, 2 vols. [Cambridge 1977], 2:372) to suppose that the letter refers to Cicero's house on the Palatine, in which he had a *palaestra* (*Att.* 24.7). Vitruvius, however, simply uses *palaestra* as a term for spacious peristyle gardens (6.5.3), and Cicero interchangeably uses it with gymnasium (*De Or.* 1.98). The reference to Tusculum later in the letter, therefore, must be allowed to keep its natural meaning and identify the place for which Cicero intended the decorations.

30. Diog. Laert. 3.25, 4.1; Cicero owned a portrait of Plato (*Brut.* 24). The setting of the *Brutus* is vague, but it was not in Tusculum (*Brut.* 20,300). The portrait of Plato, therefore, was in one of his other properties.

31. Pausanias 1, 30: 1–2; Schol. O.C. 56 (=FGrH. 244 frag. 147); Ath. 13.609d.

32. Travlos 1971. These sculptures remain mostly unpublished, and so it is not clear which ones may have been there in Cicero's day.

33. This could be an alternative explanation for the plural gymnasia in the letter to Gallus. Cicero could be indicating that he wants to decorate his Academy with sculptures as gymnasia generally were decorated. His interest in re-creating the Athenian Academy might have lessened over the years.

34. Shackleton Bailey's translation (Appendix, letter 10) makes Cicero appear to believe that Herms had feet. The Latin text implies nothing of the kind.

35. Cornelius C. Vermeule, *Greek Sculpture and Roman Taste* (Ann Arbor 1976), p. 6.

36. On, for example, Matthew Brettingham's purchase for English patrons, see Seymour Howard, *Bartolomeo Cavaceppi* (New York and London 1982), pp. 32–49. On the dependence of the Marquis of Landsdowne on Gavin Hamilton see Adolf Michaelis, *Ancient Marbles in Great Britain* (Cambridge 1882), pp. 104–6.

37. Miranda Marvin, "Freestanding Sculpture from the Baths of Caracalla," *American Journal of Archaeology* 87 (1983): 371–72.

38. See Delorme 1960, 223; Ruch 1958, 82.

39. Giovanni Becatti, "Letture pliniane," in *Studi in onore di A. Calderini e R. Paribene*, 3 vols. (Milan 1956), 3: 199–210.

40. See note 6 above; Henner von Hesberg, "Einige Statuen mit bukolischer Bedeutung." *Mitteilungen des Deutschen Archäologischen Instituts, Römische Abteilung* 86 (1979): 297–317; Joachim Raeder, *Die statuarische Ausstattung der Villa Hadriana bei Tivoli* (Frankfurt 1983).

41. Dimitrios Pandermalis, "Zum Programm der Statuenausstatung in der Villa dei Papiri," *Mitteilungen des Deutschen Archäologischen Instituts, Athenische Abteilung* 86 (1971): 173–209.

42. Two recent studies include earlier bibliography: Andrew Stewart, "To Entertain an Emperor," *Journal of Roman Studies* 67 (1977): 76–90; Manfred Leppert, "Domina Nympha," *Archäologischer Anzeiger* 93 (1978): 554–73.

43. Raeder 1983, 287–315.

44. Vitruvius 7.5.6 in *Vitruvius*, trans. Morris Hicky Morgan (Cambridge, Mass. 1914), p. 212.

45. Some studies of Roman public buildings: Marvin 1983, 347–84; Hubertus Manderscheid, *Die Skulpturenausstattung der kaiserzeitlichen Thermenanlagen* (Berlin 1981); Giorgio Bejor, "La decorazione scultorea dei teatri romani nelle provincie africane," *Prospettiva* 17 (1979): 37–46; Filippo Coarelli, "Il complesso pompeiano," *Rendiconti della Pontificia accademia romana* 44 (1971–1972): 99–122. Nymphaea are well documented. The basic study is Balázs Kapossy, *Brunnenfiguren der hellenistischen und römischen Zeit* (Zurich 1969). See also A. Schmidt-

Colinet, "Skulpturen aus dem Nymphäum von Apamea/Syrien," *Archäologischer Anzeiger* (1985): 119–33. A fine study of an alternative type of program is Renate Bol, *Das Statuenprogramm des Herodes-Atticus-Nymphäums,* Olympische Forschungen, 15 (Berlin 1984), pp. 83–97. Note the different sculptural programs that were thought to be appropriate for this single building type. Additional references in Ridgway 1986.

46. If it is an original Greek work, a fine new example would be the sculpture from the Temple of Apollo Sosianus (Eugenio La Rocca, *Amazzonomachia* [Rome 1985], pp. 89–90). The statues in the Temple of Apollo on the Palatine are discussed in Barbara Kellum, "The Temple of Apollo on the Palatine," in *The Age of Augustus: The Rise of Imperial Ideology* (in press).

47. Compare J. B. Ward-Perkins, *Roman Imperial Architecture* (Harmondsworth 1981), p. 391. The phenomenon has been often noted; see, for example, Zanker 1978, 293–95.

48. Kenan Erim, "Aphrodisias 1982," *Anatolian Studies* 33 (1983): 231–32; "Aphrodisias Excavations," *New York University Bulletin* 84/5–1 (April 1985): 3.

49. Visible at a glance in the illustrations to Ward-Perkins 1981. For example, figs. 66 (Rome, screen wall), 164 (Stobi, theater), 189 (Ephesus, library), 191 (Ephesus, bath), 192 (Miletus, nymphaeum), 204–5 (Baalbek, temple), 213 (Petra, rock-cut sandstone tomb), 249 (Sabratha, theater), 260 (Lepcis Magna, nymphaeum). For further illustrations and examples see Margaret Lyttelton. *Baroque Architecture in Classical Antiquity* (London 1974).

50. In the newly discovered Julio-Claudian "precinct of Aphrodite Prometer" at Aphrodisias (Erim 1985, 3), for example, the inscribed bases include the names of Gaius, Lucius, Drusus (son of Tiberius), Aeneas, and Aphrodite Prometer (*Anatolian Studies* 33 [1983]: 231–32). Other finds include an inscription mentioning Valerian and Gallienus. The difficulty of guaranteeing that the excavated sculptures represent the original program is characteristic for these structures, which were objects of civic pride, long maintained and often remodeled.

51. Baths were particularly rich in sculpture. See Marvin 1983 and Manderscheid 1981.

52. I am speaking of large-scale replicas. Figurines, statuettes, and other small statuary represent a separate issue, for which see Elizabeth Bartman, "Miniature Copies" (unpublished Ph.D. diss., Columbia University, 1984).

53. Pliny *Natural History* 36.21.

54. Christian Blinkenberg, *Knidia* (Copenhagen 1933), pp. 230–32; Barbara Vierneisel-Schlörb, *Klassische Skulpturen,* vol. 2 of Glyptothek münchen Katalog der Skulpturen (Munich 1979), pp. 333–48.

55. B. M. Felletti Maj, "Aphrodite Pudica," *Archeologia classica* 3 (1951): 61–65. (These lists include some statuettes.)

56. For a summary of much earlier literature see Dericksen M. Brinkerhoff, "Figures of Venus, Creative and Derivative," in *Studies Presented to George M. A. Hanfmann,* ed. D. G. Mitten, J. G. Pedley, J. A. Scott (Mainz 1971), pp. 9–16.

57. "Cypris [Venus], seeing Cypris in Cnidus, said 'Alas! Alas! Where did Praxiteles see me naked?' " in *The Greek Anthology,* trans. W. R. Paton, 5 vols. (London and New York 1926), 5: 255 (16.162).

58. The numbers in the replica counts are of absolutely no statistical value beyond indicating in a general way that these types were extremely popular.

59. A. Linfert, "Der Meister der 'kauernden Aphrodite,' " *Mitteilungen des Deutschen Archäologischen Instituts, Athenische Abteilung* 84 (1969): 158–64. See also Dericksen M. Brinkerhoff, "Hypotheses on the History of the Crouching Aphrodite Type in Antiquity," *Getty Museum Journal* 6–7 (1978–1979): 83–96.

60. Pape 1975, Appendix 1 (143–93), lists the buildings in Rome in which Greek works of art were kept. They included major temples, the Area Capitolina, the Horti Luculliani and Serviliani, colonnades, baths, and other frequented places. See also Zanker 1978, 291–92.

61. Pape 1975, Appendix 2 (194–208), lists donors; her list of sites (143–93) includes twenty-three temples.

62. Raeder 1983, 309.

63. For examples of the variety of meanings a single type could assume, depending on its context, see Zanker 1978, 295–96. Martha Weber, "Die Amazonen von Ephesos II," *Jahrbuch des Deutschen*

Archäologischen Instituts 99 (1984): 75–126, cites the extensive earlier bibliography on these disputed figures. Brunilde S. Ridgway, *Roman Copies of Greek Sculpture: The Problem of the Originals* (Ann Arbor 1984), pp. 99–100, still doubts a Greek origin for any of them.

64. Gisela M. A. Richter, *The Sculpture and Sculptors of the Greeks,* 4th ed. (New Haven and London 1970), p. 226.

65. Adolf Furtwängler, *Masterpieces of Greek Sculpture,* ed. Eugénie Sellers (London 1895), p. viii.

66. Most recently in English, Martin Robertson, *A History of Greek Art* (Cambridge 1975), pp. xiv–xv.

67. Compare Walter Benjamin, "The Work of Art in the Age of Mechanical Reproduction (1936)," in *Illuminations,* trans. Harry Zohn, ed. Hannah Arendt (New York 1969), pp. 218–22. I wish to thank Professor Zirka Filipczak for reminding me of the relevance of this passage.

68. Cited in Michelle Bogart, "Attitudes toward Sculpture Reproduction in America, 1850–1880" (unpublished Ph.D. diss., University of Chicago, 1979), p. 72.

69. Some variation on this approach may well have governed the collection, presumably of replicas, described in Lucian *Philopseudes* 18.

70. The most succinct statement of the new position is Zanker 1978. Ridgway 1984 contains not only her own stimulating and controversial views but a thorough bibliography of earlier literature.

71. Pape 1975; Paul Zanker, *Klassizistische Statuen: Studien zur Veränderung des Kunstgeschmacks in der römischen Kaiserzeit* (Mainz 1974).

72. Compare Felix Preisshofen and Paul Zanker, "Reflex einer eklektischen Kunstanschauung beim Auctor ad Herennium," *Dialoghi di archeologia* 4–5 (1970–1971): 100–119; R. Wünsche, "Der Jüngling von Magdalensberg," *Festschrift für Luitpold Dussler* (Munich 1972).

73. David Finn and Fred Licht, *Canova* (New York 1983), color pls. 32 (*Perseus*), 42 (*Venus Italica*), 43 (*Three Graces*).

74. See the poignant comments of Ridgway 1986, 11 n. 28.

75. *The Age of Neo-Classicism* [exh. cat., Council of Europe] (London and Harlow 1972).

The City Gate
of Plancia Magna in Perge[1]

MARY T. BOATWRIGHT

Around A.D. 121, Plancia Magna completely rebuilt the main gate in her native city Perge, in Turkey, adding a monumental arch and statues to the internal courtyard she had reshaped and embellished.[2] Enough of her programmatic and opulent installation has been identified in the numerous inscriptions, structural remains, and fragments of sculpture and architectural decoration for us to comprehend the form and message of her restoration. Similar in some ways to buildings elsewhere in the Roman empire, the city gate in provincial Perge also manifests an aesthetic and ideological program that glorifies the history of both Perge and Plancia Magna. The analysis, therefore, points out both the wide diffusion of architectural types throughout the Roman empire and the regional elements distinguishing Plancia Magna's monument. Unusually rich epigraphic evidence assists in the reconstruction of the architecture at the same time as it documents an elite Roman woman's political roles and social clout. Plancia Magna's edifice is an example of civic architecture in the eastern provinces that displays traditional forms and the individual ambition and vision of its patron, in this case, an influential woman.

Perge thrived on the coast of southern Asia Minor during the Hellenistic and Roman periods, flourishing brilliantly after the Romans incorporated the area as the province of Lycia and Pamphylia (in modern Turkey) in 25 B.C. (Figure 74).[3]

This essay is a substantially revised version of the author's "Plancia Magna of Perge: Women's Roles and Status in Roman Asia Minor," in *Women's History and Ancient History,* ed. S. B. Pomeroy (Chapel Hill and London: The University of North Carolina Press, 1991), pp. 249–72.

FIGURE 74 Map of Southern Turkey *(Ancient Pamphylia, after A.M. Mansel, Dic Ruinen von Side)*

The ancient city lies in ruins near the modern village of Murtuna, about 18 to 20 kilometers from the sites of other Roman towns and cities. Such close proximity enhanced the intense competition characteristic of the cities of provincial Roman Asia Minor. Twelve kilometers inland, Perge is far enough from the sea for protection against pirates and marauders. Yet the city's communication with the sea and trade was assured by the Kestros river (the modern Aksu), which runs through Perge's territory and was navigable in antiquity up to seven kilometers east of the city where there apparently was a port installation. The alluvial plain supported Perge's abundant agriculture, and the river's tributaries furnished routes to the interior, the highlands with which Perge and the coast maintained stable relationships from the first century B.C. at the latest.[4]

Perge is typical of cities in this part of the Roman empire, called the Greek East in recognition of its deep-rooted Hellenization. The city's boast of a foundation by the Greek heroes Amphilochos, Kalchas, Mopsos, and other wanderers from the Trojan War (Hdt. 2.91; Strab. 668) was a source of pride,[5] and was reaf-

firmed by Plancia Magna when she erected statues to these and other "city-founders" in her courtyard. Like other cities in the region, Perge fell under the sway of larger powers in the eastern Mediterranean from the fifth century B.C., and prospered through its contact with the wider world.[6] By the third century B.C., urban Perge had spread from its site on the steep acropolis to the southern plain enclosed by low hills and fortification walls below (Figure 75). The major entrance of the city, equipped with twin round towers each 11.70 m. in diameter within 2.20 m. thick walls, opened south towards the sea. Its remains under Plancia Magna's reconstruction (Figure 77, on page 194) indicate that this third-century Hellenistic city gate was a strictly defensive one, similar to other such gateways in mainland Greece and Asia Minor.[7]

Also by the third century, Perge's greatest tutelary deity, Artemis Pergaia (Diana Pergensis or Diana of Perge), was renowned throughout the Mediterranean. The famous temple of Artemis Pergaia attracted rich offerings and visitors from far away, sponsored prize-awarding games catering to a pan-Hellenic crowd, and seems to have sent out itinerant priests. Unfortunately, the celebrated temple has never been located.[8] After Pompey's successful campaign against the pirates in 67 B.C., the newfound security encouraged wider trading contacts, originally initiated by Perge's choice location. Inscriptions indicate that in the last half of the first century B.C., Roman *negotiatores* (traders), probably including Plancia Magna's ancestors, came to Perge.[9] The Augustan peace ushered in even greater prosperity, to last three centuries or more.

The remains of ancient Perge proclaim its wealth during the Roman Empire, when most of the extant structures were built or renovated (Figure 75).[10] Two

FIGURE 75 Excavated Perge *(After A.M. Mansel, AA 1975, ill. 10)*

intersecting broad streets, the north-south one ending near Plancia Magna's gate but built later than it, divided the city into four unequal parts. As in other Roman cities of Asia Minor, these main arteries were colonnaded; here a special note of luxury was added by a water channel running down the centers. Other urban amenities included baths, fountains, a gymnasium, an agora, a stadium, and a theater. The structures were lavish, almost certainly aimed at accommodating and impressing the city's visitors as well as its residents. For example, the theater seated 13,000 to 14,000 spectators, more than the inhabitants of the city and its territory. It must have been used in the games associated with Artemis Pergaia and in others the city produced, such as the Varian games apparently endowed by Plancia Magna's father, M. Plancius Varus.[11]

Most public buildings were donated by Pergaians in a phenomenon known as evergetism.[12] In the practice of evergetism, which can be defined as a tight nexus of wealth, largesse, and status, the elite of a city employed their wealth to benefit their fellow citizens. At times the occasion was the tenure of political office or a priesthood, or the assumption of a liturgy (the responsibility to oversee and pay for urban amenities like games). Sometimes no particular cause triggered the generosity: the rich and powerful donated buildings, public meals, olive oil for the gymnasium, and other public goods simply as a means to show off their wealth and reaffirm their status. In return came reinforcement and vociferous celebration of the political and social eminence of these donors, even if merely through public recognition of the gift by an inscription. For instance, at least four inscriptions commemorate the donation in Nero's honor of a gymnasium in Perge by the Iulii Cornuti, the family of Plancia Magna's husband.[13] Evergetism was typical of the Greek and Roman world, and particularly marked in Hellenistic and Roman Asia Minor. Plancia Magna's city gate fits this general context.

In the mid-1950s and late 1960s excavations around the major southern entrance of Perge revealed the complexity of this entry into the city, and we now know that the third-century B.C. Hellenistic city gate was reconstructed, and its function completely changed, in the early second century A.C. (see Figures 76 and 77).[14] The exterior, southern entrance of the Hellenistic portal was narrowed (to 5.5 m. wide, 3.7 m. deep) by the addition of rectangular piers between the towers, thus focusing attention on the interior. The walls of a paved and originally oval courtyard were rebuilt on a different plan with altered dimensions (now measuring less than 2 m. thick) to form a horseshoe shaped courtyard (20.35 m. deep, 17.80 m. at its widest point). The perimeter walls now stand to a height of 11 meters, but were higher in antiquity (Figure 78). Each wall was decorated internally by two levels of seven niches, making a total of twenty-eight niches slightly less than one meter deep each. The irregularly-formed niches closest to the round towers resulted from the integration of the new construction with the old. Apart from these anomalies, the niches on the lower level were rectangular in section yet round-headed, and the niches above alternated between straight and arched lintels in a characteristically Roman architectural scheme. A new monumental triple arch, opposite the exterior entrance into the city and constructed approximately 22

FIGURE 76 Plan of Renovated
Gate *(Photo courtesy of the
Fototeca Unione, Rome, neg. no.
27361)*

meters from it, visually closed the courtyard towards the city, contributing to the
unified, articulated space Plancia Magna built as the main entry to Perge.

The walls and niches of the courtyard walls were once revetted in marble. In
front of them a marble two-storied Corinthian columnar facade rose from two
steps, with the pedestals that supported the columns attached to the walls behind
(Figure 79). The details of the facade are still unclear: We do not know, for
instance, if small pediments were a part of the decorative system. In any case, the
finely carved architectural decoration is characteristic of J. B. Ward-Perkins's
"Marble Style," and created the impression of a *scaenae frons,* the elaborate
facade of a Roman stage building that symbolized wealth and taste throughout the
Roman empire in the second century A.C.[15] This type of ornamentation was
repeated, for example, in a late second-century reconstruction of the city gate at
Side, about 50 kilometers east of Perge (see Figure 86, on page 202).[16] The sump-
tuousness of Perge's Corinthian facade was heightened by the statues once stand-
ing in the niches, of which numerous fragments and bases survive. These formed
an elaborate exhibit of gods and heroes, to which corresponded a display of impe-
rial and other statues on the triple arch, also revealed to us by their bases. As cus-
tomary in the Greek East, the inscriptions of the courtyard celebrate in Greek the
local heroes and gods they identify; those of the triple arch commemorate in Greek

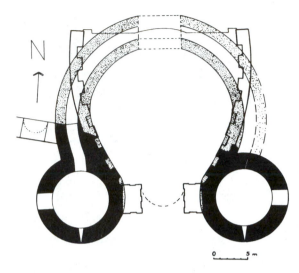

FIGURE 77 Plan of Hellenistic Gate: the Hellenistic walls are in black, the walls of the Hellenistic courtyard are stippled, and the reconstruction is in simple outline *(After H. Lauter, BJh 172, 1972, ill. 7)*

and Latin the members of the imperial house and the most important civic deities. These statue bases establish Plancia Magna as the donor of the renovation.

In the lower niches of the courtyard walls stood the gods, greater than life-size.[17] Statue fragments of eight major and minor Olympian deities are extant: Hermes, Apollo, Aphrodite, the two Dioscuri (Figure 80), Pan, Heracles, and an unidentified young male. In the upper niches bases supported statues of the city's Greek mythological founders and more historical benefactors, equally and grandiloquently called "city-founders" (*ktistai*, sing. *ktistes*).[18] Bases have been found for statues of Mopsos the Delphian, son of Apollo; Kalchas the Argive, son of Thestor; the Lapith Leonteus, son of Koronos; Machaon the Thessalian, son of Asklepios; (Mi)nyas the Orchomenian, son of Ialmenos, son of Ares; Labos the Delphian, son of Dae—; and Rixos the Athenian, son of Lykos, son of Pandeion. Many more heroes appear here than are mentioned by Strabo and Herodotus as participants in Perge's foundation, although a statue base to Amphilochus, named as a founder in both literary sources, has not yet been found. Some of these founders are unknown otherwise, such as Rixos and Labos, and at least some had ancient cults in Perge, to judge from the "foot of Rixos"—apparently a reliquary—cited in this hero's inscription.[19] Also in the upper tier of niches stood the statues of M. Plancius Varus and C. Plancius Varus, with the inscriptions: "City-founder, M. Plancius Varus the Pergaian, father of Plancia Magna," and "City-founder, C. Plancius Varus the Pergaian, brother of Plancia Magna."[20] The inclusion of these two and their unusual identification through their relationships to Plancia, rather than the traditional identification of Plancia Magna and C. Plancius Varus through their father, are a sure sign that Plancia Magna played an important role in designing the courtyard. This is supported by evidence from the arch.

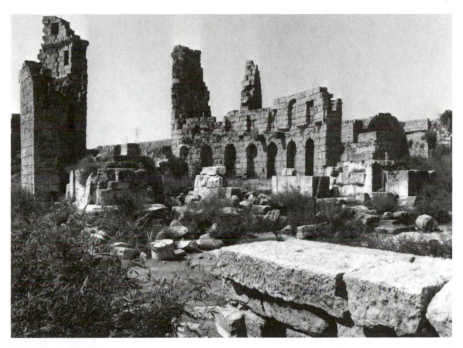

FIGURE 78 Interior of the Courtyard *(Photo courtesy of the Fototeca Unione, Rome, neg. no. 22034)*

This massive triple arch was built in the second and third decades of the second century (Figure 81).[21] Its length of 20 meters exceeds the width of the courtyard (17.80 m.), and almost equals the courtyard's depth (20.35 m.). Its position so close to the city gate is surprising but brilliant in design: as an architectural element of transition opening towards the street and city, it must have framed the view and passage of those entering Perge.[22] With a width of 9.10 meters, it rose from two thick lateral piers and two thinner internal ones to form a broad middle arch (3.40 m. wide) flanked by two smaller side arches (2.50 m. wide), all apparently decorated with marble coffering. Fragments of decoration and the footings of the arch are extant (Figures 82 and 83). The arch, four steps above the paved courtyard, was made from the local limestone revetted with imported marble. The lateral piers displayed on their primary faces *aediculae* (shrines) above a high molding, and on their sides semi-circular and rectangular niches. In front of the two middle piers rose columns on freestanding pedestals. Fragments of architectural decoration were found in two sizes; this, and the magnitude of the lateral piers and overall plan, indicate that the arch was two-storied. A Nike carrying a trophy crowned the arch. The plan of freestanding pedestals and columns adorning the arch is noteworthy, but has parallels in the Arch of Hadrian in neighboring Attaleia (modern Antalya), and in the Arch of Hadrian in Athens.[23]

FIGURE 79 Courtyard, Detail *(Photo courtesy of the Fototeca Unione, Rome, neg. no. 21992)*

Both primary facades of Perge's arch once carried honorary inscriptions in Latin and in Greek, which have never been published. These proclaimed that Plancia Magna dedicated the arch to her city (Latin, *patriae;* Greek, *patridi*).[24] They complement inscribed statue bases found near the arch. These latter memorialize Plancia Magna's dedication of statues to Artemis Pergaia (Figure 84) and to the tutelary spirit of the state (the city's Genius: Latin, *genius civitatis;* in Greek, *tyche tes polios*), as well as to members of the imperial house. Inscriptions name emperors, empresses, and their relatives: Divus (the deified) Nerva, Divus Traianus, Hadrian, Plotina Augusta, Diva Marciana (Trajan's sister, the mother of Matidia), Diva Matidia (Marciana's daughter, the mother of Hadrian's wife Sabina), and Sabina Augusta.[25] Hadrian's statue base is dated to 121, and the nomenclature of Plotina and Matidia indicates a date from 119 to 122.[26] The completion of Plancia Magna's renovation of Perge's city gate can thus plausibly be dated to A.D. 121.

Plancia Magna's transformation of the city entrance was thorough and extravagant, and the impression of individuals entering Perge from the south was now completely changed from what it had been for more than three centuries. The

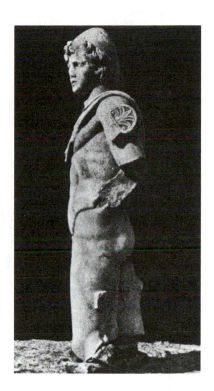

FIGURE 80 Statue of one of
the Dioscuri, from the Court-
yard *(After A.M. Mansel,* AA
1956, ill. 58)

piers added between the two Hellenistic towers, the reconstruction of the walls of
the courtyard in a different plan and decorative scheme, and the new juxtaposed
arch changed this city entrance from a defensive gate into an elaborate courtyard
in which visitors to Perge had to pause. The decoration was quite costly: every-
thing was sheathed in marble, which the region began importing in quantity only
at the end of Trajan's reign (A.D. 117), and both the architectural ornament and
sculpture were of very high quality.[27] Moreover, the identification of the statues
argues that the courtyard was programmatic. In the niches of the courtyard's lower
walls were the "Olympian" gods, the Greek gods with cults in Perge. Above them
the mythical founders of Perge were arrayed together with Plancia Magna's father
and brother, similarly called "city-founders." The triple two-storied arch was
adorned with statues of Artemis Pergaia, the celebrated deity of the city, the
Genius of the city, and the imperial family. Here the bases assert Plancia Magna's
patronage, as does her dedication of the arch to her city that is repeated on the two
major facades of the arch.

Plancia Magna's patronage is not unique in the second century A.C. in
impressively combining architecture and sculpture: there are other second-century
examples of lavish benefactions from private individuals that display statues of
deities, the imperial family, and the family of the donor, including female mem-
bers, often in a *scaenae frons* schema. R. Bol has recently discussed this type of

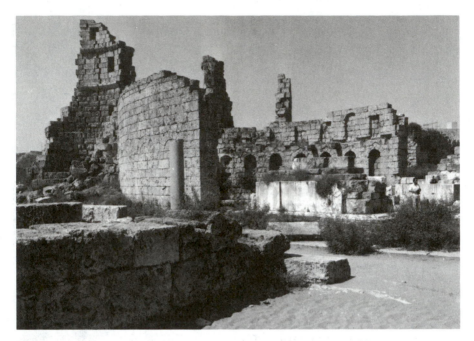

FIGURE 81 Renovated Gate with Remains of Arch *(Photo courtesy of the Fototeca Unione, Rome, neg. no. 22024)*

monument in Greece in his monograph on the Nymphaeum of Herodes Atticus in Olympia, which Herodes Atticus's wife Regilla, a priestess of Demeter, dedicated to Zeus in A.D. 149–153. Bol identifies the sculptures adorning the lower level of Herodes's Nymphaeum (Figure 85) as representing imperial personages such as Antoninus Pius, Hadrian, Sabina, Marcus Aurelius, and Faustina the Younger; the statues on the upper level depicted family members of Regilla and Herodes.[28]

As comparanda to the Nymphaeum of Herodes Atticus, Bol's list includes Plancia Magna's gate, the mid- to late second-century A.C. renovation of the main city gate of Side (Figure 86); the Library of Celsus in Ephesus, and the "Marmorsaal" of the Baths of the Vedii there.[29] Although most of the known examples date to Plancia Magna's time or later, the inspiration for such eclectic sculptural programs ultimately may be the Forum of Augustus, whose exedra walls displayed Rome's founding deities and historical personages, and emphasized the lineage of Augustus.[30] There must have been many other examples whose components are no longer extant, making it impossible to determine the character of such lavish and programmatic installations. The widespread phenomenon of evergetism throughout the Roman world and the concentration of wealth in the hands of the municipal land-owning elite help explain such costly gifts.

Yet some aspects of Plancia Magna's city gate seem unique to Perge and are especially striking. Plancia Magna's building as a whole succinctly expresses the essence of the Greek cities in this affluent province in Roman Turkey. Its function

FIGURE 82 Remains of Arch *(Photo courtesy of the Fototeca Unione, Rome, neg. no. 22036)*

was to impress, not to stand on the defensive. Juxtaposing in its sculptural program Perge's Olympian gods and civic deities, city-founders, and imperial personages, Plancia Magna's city gate manifests the tenacity of the Greek foundation of Perge and local pride in Perge's own heritage. The regional aspect of Plancia Magna's gate is underscored by her dedication of the arch to her city rather than to the ruling emperor, the customary recipient of honorary arches.[31]

Furthermore, as far as we now know, the triple arch displays proportionally more statues of women of the imperial house than of men. Although the second century witnessed a rise in the number of women prominent in the imperial house,[32] the predominance of females on Plancia Magna's arch is noteworthy in that the patron was herself a woman. And she was an exceptional woman, to judge from all the evidence that indicates her background of wealth and power in Asia Minor, service and honors in Perge and Rome, and cultural aspirations and benefactions.[33] Moreover, Plancia Magna's personal history gives further insight into her architectural patronage.

The inscriptions from her renovated city gate, discussed previously, reveal Plancia Magna's own wealth[34]—for she dedicated the arch to her city in her name

FIGURE 83 Architectural Decoration, Probably from Arch *(Photo courtesy of the Fototeca Unione, Rome, neg. no. 22042)*

alone and not in tandem with a husband or other male relative—and her assertiveness, demonstrated in the unusual identification of her father and her brother through their relationships to her. Elsewhere in Perge, two similarly inscribed statue bases were dedicated to her, respectively, by Perge's council and assembly (*boule* and *demos*) and by Perge's council of elders (*geraioi*).[35] On these Plancia Magna is identified as the daughter of M. Plancius Varus and the ''daughter of the city,'' an honorary epithet frequently found for prominent women in the Greek East.[36] She is also identified as *demiourgos* (the most important and annual eponymous magistrate of the city, whose name was used for dating purposes); the priestess of Artemis [Pergaia]; the first and only priestess of the Mother of the Gods, for life; and pious and loving of her city. A fragmentary unpublished inscription from Plancia Magna's tomb south of the city similarly gives her patronymic and calls her ''daughter of the city,''[37] and another broken inscription on an architrave from Perge commemorates Plancia Magna, the ''daughter of the city,'' together with Coccaeia Ti—, a *demiourgos* and gymnasiarch (director of the gymnasium, the physical and intellectual school for young men, and producer of

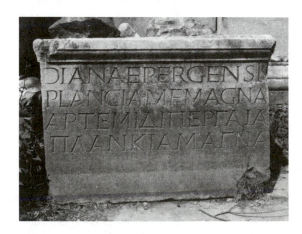

FIGURE 84 Inscription on Statue Base from the Arch, Dedicated by Plancia Magna to Artemis Pergaia *(Photo courtesy of the Fototeca Unione, Rome, neg. no. 22059)*

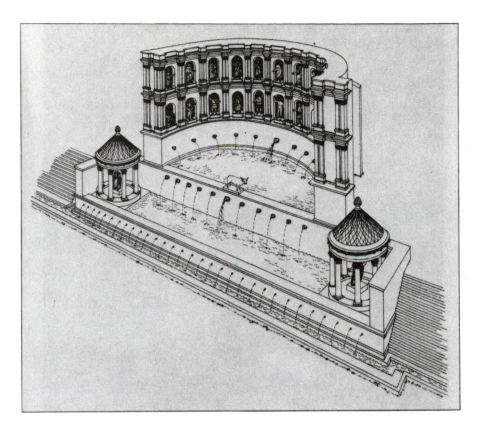

FIGURE 85 Reconstruction of the Nymphaeum of Herodes Atticus *(after R. Bol, Das Statuenprogramm des Herodes-Atticus-Nymphäums in Olympia, insert 5)*

gymnastic festivals).[38] As yet unedited inscriptions, only recently disclosed, witness that Plancia Magna was the wife of C. Iulius Cornutus Tertullus and the mother of C. Iulius Plancius Varus Cornutus, two men of significance at home in Perge and abroad in the service of Rome.[39]

Further, a statue of Plancia Magna and twin inscriptions dedicated to her, still unpublished, were found just south of her renovated gate. Here excavators unearthed what seems to have been a display wall running about ten meters in a southernly direction from the gate's western tower (Figure 87).[40] The wall had three niches revetted with marble, all 1.10 meters deep but varying in width from 1.25–2.15 meters. A base surmounted by a statue originally stood in each niche. The central niche held an unidentified male statue (1.87 m. high and now headless; perhaps Apollo or Musikos). This was apparently flanked by two statues of Plancia Magna, since both bases in the outer niches were inscribed with dedications to her, the southern one by M. Plancius Pius to his patroness (*patronissa*) and the northern by M. Plancius Alexandros. In addition to listing the positions known

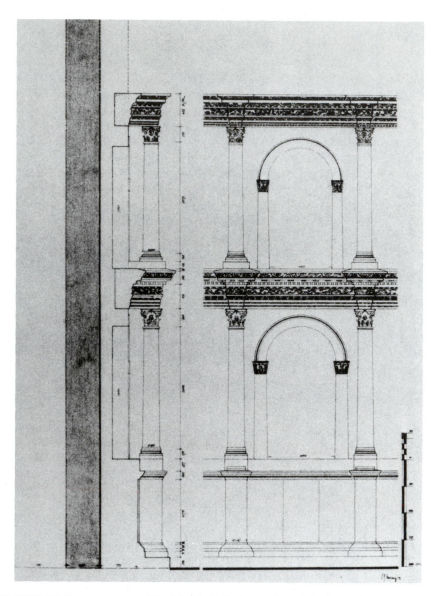

FIGURE 86 Reconstruction of the Marble Style Decoration of the Gate of Side, Renovated in the Second Half of the Second Century *(After A.M. Mansel,* Die Ruinen von Side, *ill. 22)*

from other inscriptions, these two inscriptions hail Plancia Magna as a priestess of the imperial cult.[41] The well-preserved statue (2.03 m. H.; Figure 88) from the southern niche must be identified as that of Plancia Magna.[42] This depicts a woman, perhaps in her 30s, wearing a chiton and himation in the style of the statue type known as that of the large Herculaneum woman, with the himation pulled

FIGURE 87 Reconstruction of the Display Wall with Statue Niches, South of the Gate, Including a Statue of Plancia Magna to the Left *(After A.M. Mansel, AA, 1975, ill. 35)*

over her head in a sacral gesture. Her priestly diadem, now chipped, was once adorned with four imperial busts, thus marking her as a priestess of the imperial cult as indicated in the inscription on the statue's base. The statue strongly resembles one of Sabina found in the vicinity of the gate, and perhaps originally belonging to the decoration on Plancia Magna's arch.[43] The other female statue (1.61 m. H.) from the display wall, attired differently and now missing its head, probably also portrayed Plancia Magna in a different role; two statues of the same person in

FIGURE 88 Statue of Plancia Magna *(After A.M. Mansel, AA, 1975, ill. 37a)*

such close proximity would probably not be identical. The honors ascribed to Plancia Magna represented in this sculptural display complement the gate itself, of which Plancia Magna was the donor. Although we have no conclusive evidence, it may be that Plancia Magna bestowed her renovation to Perge on the occasion of becoming high priestess of the imperial cult in her city.

Plancia Magna held the most important civic and religious positions in Perge, as *demiourgos,* the priestess of Artemis Pergaia, the first and only priestess of the Mother of the Gods with tenure for life, and high priestess of the imperial cult. She gave magnificently and ostentatiously to her city in the form of the renovation of Perge's main entrance, and she was honored prominently by the city and individuals she served and patronized. Her public visibility belies the ancient legal and literary paradigm of retiring, submissive women. Roman jurists repeatedly state that, "due to the weakness of their sex," women do not hold civil offices and cannot give testimony, nor can they hold magistracies at Rome, bring suit on behalf of others, involve themselves in others' cases, or undertake the functions of men (*Dig.* 5.1.12.2, 3.1.1.5, cf. 50.17.2 and Gai. *Inst.* 1.144, 1.190; early third and second centuries A.C.).[44] In the Greek East, the prevalent images were provided by the well-known relegation of Athenian women to the domestic sphere, except for sacral functions, and by their lack of control over property.[45] At the end of the first and the beginning of the second centuries A.C., Stoic philosophers and other intellectuals reemphasized the domestic roles of women.[46] The veiling of some women in the Greek East and Roman North Africa corresponds to the preoccupation among the elite with the virtuous and modest wife, the pious and silent woman, whose main task was to care for her husband and children.[47]

Contradicting this paradigm, however, are hundreds of inscriptions and coins from Greece and Asia Minor, and elsewhere in the Roman Empire, that attest to prominent individual women such as Plancia Magna, who were unremarked in the literary sources.[48] These women were priestesses, gymnasiarchs, theatrical game producers, and other officials, although women as magistrates are attested only in the Roman imperial period. Many of the inscriptions commemorate benefactresses like Plancia Magna; at least one woman, Melia Anniana from Zara (Dalmatia), similarly donated an arch with statues in conjunction with the paving of an emporium (*ILS* 5598). For the most part, the buildings these women built have disappeared. The evidence of Plancia Magna's city gate is exceptional.

The variety and wealth of the remains of Plancia Magna's city gate provide a tantalizing glimpse into the preoccupations of its donor, just as Plancia Magna's personal history helps illuminate the city gate itself. Plancia Magna was devoted to her city, which was the only place in which she could gain real prominence: in Rome, she would have been overshadowed by the imperial court and the senatorial elite running the empire. She knew her city's history intimately, to judge from the recondite identifications of Perge's numerous founders she honored. Just as her local eminence rested on her tenure of Perge's magistracies and priesthoods and on her association with the imperial cult, the sculptural program of her gate celebrated Perge's history as a city, ennobled by its gods and its ties to the imperial house.

Plancia Magna's riches and close family bonds are manifested in the expense and quality of the architectural decoration and sculpture, and in the statues to her father and brother as city-founders.[49] Finally, her gender, and perhaps even a certain pride in her accomplishments as a woman, may have moved Plancia Magna to honor so many imperial women on the arch she had built *ex novo* as the culmination of her renovated entrance to Perge.

NOTES

1. This article is a very different version of my "Plancia Magna of Perge: Women's Roles and Status in Roman Asia Minor," in *Women's History and Ancient History*, ed. S. B. Pomeroy (Chapel Hill and London: University of North Carolina Press 1991), pp. 249–72, and I thank both the editor and publisher for allowing me to develop here the implications of Plancia Magna's contribution to architectural history. As the title suggests, the earlier article discusses at length Plancia Magna and the public roles and benefactions of women in this part of the Roman world. In the following, I have used Latin, rather than transliterated Greek, for most Roman names: i.e., "Plancia Magna" rather than "Plankia Magne." Thanks are also due to Eve D'Ambra and to Darryl A. Phillips for advice on this version; what errors and infelicities remain are my own.

2. I have detailed Plancia Magna's family, positions, and benefactions in the article mentioned above; see also M.-T. Raepsaet-Charlier, *Prosopographie des femmes de l'ordre sénatorial (Ier–IIe siècles)* (Louvain: Peeters 1987) no. 609, pp. 494–95; H. Halfmann, *Die Senatoren aus dem östlichen Teil des Imperium Romanum* (Göttingen: Vandenhoeck and Ruprecht 1979) no. 31, pp. 128–29. R. Merkelbach and S. Sahin, "Die publizierten Inschriften von Perge," *Epigraphica Anatolica* 11 (1988): 97–170, have published most of the inscriptions of Perge, which will hereafter be referred to as M&S, no., whenever possible. Sahin is to publish an article devoted to the family connections of the Plancii and the Cornuti.

3. G. E. Bean, *Turkey's Southern Shore. An Archaeological Guide* (New York and Washington, D.C.: Frederick A. Praeger, 1968) pp. 45–58; S. Jameson, *RE,* Suppl. 14 (1974): 375–83, s.v. Perge.

4. The city's territory was about 61 hectares, which, although small in comparison to most modern towns, made Perge the second largest of the five great coastal cities of Pamphylia.

5. W. Ruge, *RE* 18.3 (1949): 361, s.v. Pamphylia.

6. Bean, *TSS* (above, n. 3) 45–47; W. Ruge, *RE* 19.1 (1937): 696–97, s.v. Perge, no. 2.

7. H. Lauter, "Das hellenistische Südtor von Perge," *BJh* 172 (1972): 1–11; K. Lanckorowski, *Städte Pamphyliens und Pisidiens,* I (Vienna: P. Tempsky 1890), p. 61.

8. A. Akarca, "Investigations in Search of the Temple of Artemis at Perge," in *Excavations and Researches at Perge*, A. M. Mansel and A. Akarca (Ankara: Türk Tahîh Kurumu Basimevî 1949) pp. 62–64; cf. A. M. Mansel, "Bericht über Ausgrabungen und Untersuchungen in Pamphylién in den Jahren 1957–1972," *AA* (1975): 96.

9. S. Jameson, "Cornutus Tertullus and the Plancii of Perge," *JRS* 55 (1965): 54–55.

10. In addition to Bean, *TSS* (above, n. 3), see A. M. Mansel, "Bericht über Ausgrabungen und Untersuchungen in Pamphylien in den Jahren 1946–1955," *AA* (1956): 99–120, and Mansel, *AA* (1975): 57–96. The colonnaded streets have not yet been thoroughly published. The north-south one, however, most likely postdates Plancia Magna's installation, and did not connect with it physically or visually: see Mansel, *AA* (1975): 61, ill. 14.

11. These games are known from an inscription honoring C. Iulius Plancius Varus Cornutus, the son of Plancia Magna and C. Iulius Cornutus Tertullus, as "patron, benefactor, and victor in all the contests of the Varian games": M&S no. 57, pp. 132–33 = *AE*, 1965: no. 208.

12. See P. Veyne, *Le Pain et le cirque* (Paris: Éditions du Seuil, 1976); R. Van Bremen, "Women and Wealth," in *Images of Women in Antiquity*, ed. A. Cameron and A. Kuhrt (Detroit: Wayne State University Press, 1983), pp. 223–42; and P. Garnsey and R. Saller, *The Roman Empire. Economy, Society and Culture* (Berkeley and Los Angeles: University of California Press, 1987), pp. 33–34, 38, 101–2, 198.

13. The inscriptions naming the donors, C. Iulius Cornutus, his unidentified wife, and perhaps their children, are now fragmentary: M&S nos. 18–21, pp. 113–15 = *IGR* III 792, *CIL* III 6734, *IGR* III 789. C. Iulius P. f. Hor. Cornutus Tertullus, the future husband of Plancia Magna, was probably the adopted son of this C. Iulius Cornutus (Jameson, "Tertullus and the Plancii" [above, n. 9], 54).

14. See notes 7 and 10 above.

15. J. B. Ward-Perkins, *Roman Imperial Architecture* (New York: Penguin Books, 1981) pp. 300–302.

16. Mansel, *AA* (1956): 105–6.

17. Mansel, *AA* (1956): 106–9, with illustrations.

18. Mansel, *AA* (1956): 109; M&S nos. 24–27, pp. 117–19. For the meanings of *ktistes,* an honorary appellation bestowed on eminent individuals for having brought to a city imperial favor or other far-reaching benefits, see L. Robert, *Hellenica* IV (Paris: Librairie d'Amérique et d'Orient, 1948), p. 116.

19. M&S no. 27a, 119; Mansel, *AA* (1956): 109–10 n.79.

20. M&S nos. 28 a–b, pp. 119–20; no. 28 b incorrectly gives "adephos" for "adelphos" (cp. *Türk Arkeoloji Dergisi* 6 [1956], Plate VI, fig. 20; Jameson, "Tertullus and the Plancii" [above, n. 9], 56).

21. Mansel, *AA* (1956): 112.

22. A possible parallel to this positioning may be seen in the placement of a tetrakionion in the middle of Palmyra's oval courtyard: W. L. MacDonald, *The Architecture of the Roman Empire.* II: *An Urban Appraisal* (New Haven and London: Yale University Press, 1986), pp. 20–21, ills. 16–17; Ward-Perkins, *RIA* (above, n. 15), 359.

23. Ward-Perkins, *RIA* (above, n. 15), 485 n.49; D. Willers, *Hadrians panhellenisches Programm. Archäologische Beiträge zur Neugestaltung Athens durch Hadrian* (Basel: Vereinigung der Freunde antiker Kunst, 1990), p. 75. The scheme becomes much more common in the second century.

24. Mansel, *AA* (1956): 117–18 (not in M&S): the inscriptions were in bronze letters within tabulae ansatae.

25. M&S nos. 29–34, pp. 120–22, referring to unedited statue bases as well as the ones they publish, and mentioning one purportedly to [?Divus] Augustus, for which I have encountered no other reference and find implausible. H. J. Kruse, *Römische weibliche Gewandstatuen des 2.Jhs. n. Chr.* (Göttingen: Bönecke Druck, 1975), pp. 281–83, argues against matching these bases with fragmentary cuirassed and draped statues also found in the general proximity, but see the cogent discussion of J. Inan and E. Rosenbaum, *Roman and Early Byzantine Portrait Sculpture in Asia Minor* (London: The British Academy, 1966), pp. 72–73, no. 36.

26. Hadrian's base is dated by the number of his years with tribunician power inscribed on it. Although it had been assumed from Sabina's epithet "Augusta" that Sabina's statue was erected not before 128, when she received that title officially (e.g., Jameson, "Tertullus and the Plancii" [above, n. 9], 56), W. Eck has now established that she was called Augusta probably as early as after Matidia's death in 119 (*Romanitas-Christianitas,* ed. G. Wirth et al. [Berlin and New York: W. de Gruyter, 1982], pp. 226–28).

27. Ward-Perkins, *RIA* (above, n. 15), 299–300; Inan and Rosenbaum, *Portrait Sculpture* (above, n. 25), p. 35.

28. R. Bol, *Das Statuenprogramm des Herodes-Atticus-Nymphäums in Olympia* (Berlin: W. de Gruyter, 1984), pp. 22–31, and his insert 4. For the date of Herodes Atticus's nymphaeum, ibid., pp. 98–100.

29. Bol, *Herodes-Atticus* (above, n. 28), pp. 83–95, 108.

30. For the Forum of Augustus, see (most recently) P. Zanker, *The Power of Images in the Age of Augustus,* trans. A. Shapiro (Ann Arbor: University of Michigan, 1988), pp. 210–14.

31. See Mansel, *AA* (1956): 117 n. 83.

32. See, for example, the numerous dedications to Plotina, Marciana, Matidia the Elder, and even (Aelia) Domitia Paulina (Hadrian's sister), at Lyttos, Crete (*IGR* I 992–99, 1004). In Lyttos, however, as in almost all other such installations, the dedications are made publicly, and representations of imperial men outnumber those of imperial women. See T. Pekary, *Das römische Kaiserbildnis in Staat, Kult und Gesellschaft, dargestellt anhand der Schriftquellen* (Berlin: Mann Verlag, 1985), pp. 90–96, 101–5; and my "The Imperial Women of the Second Century A.C.," *AJP* 112 (1991).

33. For the Plancii and the Cornuti, see my "Plancia Magna of Perge: Women's Roles and Status in Roman Asia Minor" (above, n. 1), and Sahin's forthcoming article (above, n. 2).

34. For Roman women's control of wealth, see J. F. Gardner, *Women in Roman Law and Society* (Bloomington and Indianapolis: Indiana University Press, 1986), pp. 68–71, 97–116, 170–79; R. P. Saller, "Roman Dowry and the Devolution of Property in the Principate," *CQ* n.s. 34 (1984): 196–202; and J. A. Crook, "Women in Roman Succession," in *The Family in Ancient Rome. New Perspectives,* ed. B. Rawson (Ithaca, N.Y.: Cornell University Press, 1986), pp. 58–82.

35. M&S no. 36, pp. 122–23 = *AE,* 1958: no. 78 = *AE,* 1965: no. 209; M&S no. 37, p. 123, correcting *BSA* 17 (1910–11): 245–46, no. 31.

36. L. Robert, in *Laodicée du Lycos: Le Nymphée. Campagnes 1961–63* (Quebec and Paris: Presses de l'Université Laval, 1969), pp. 317–27.

37. Mansel, *AA* (1956): 120 n. 87 (not in M&S).

38. M&S no. 35, p. 122 = *IGR* III 794. The edition by Merkelbach and Sahin puts *demiourgos kai gymnasiarchos* in apposition to Plancia Magna rather than to Coccaeia Ti—, as earlier editions. Yet this restoration of the fragments is unlikely, since Plancia's supposed gymnasiarchy occurs on no other inscription for her.

39. Her marriage to Cornutus Tertullus is mentioned in the commentary on M&S no. 18, p. 114; her parentage of Plancius Varus Cornutus at M&S nos. 28 and 57, pp. 120 and 133, and see M&S no. 29, p. 120. These brief notices give no particulars such as dates, so that (e.g.) we have as yet no way of knowing if she was a widow at the time of her donations to Perge.

40. Mansel, *AA* (1975): 74–75.

41. See Mansel, *AA* (1975): 75 (not in M&S). For this religious position, see R. A. Kearsley, "Asiarchs, Archiereis, and the Archiereiai of Asia," *GRBS* 27 (1986): 183–92.

42. In addition to Mansel, *AA* (1975): 74–75, see J. Inan, "Neue Porträtstatuen aus Perge," in *Mélanges Mansel* II (Ankara: Türk Türk Tahîh Kurumu Basimevî, 1974), pp. 648–49, and plates 195–197. Despite numerous statue bases dedicated to Plancia Magna, this is the only statue preserved with its head: Mansel, *AA* (1975): 74 n. 39.

43. Inan and Rosenbaum, *Portrait Sculpture* (above, n. 25), pp. 72–73, no. 36, and plates xix.3 and xxii.

44. On these and similar texts, see J. A. Crook, "Feminine Inadequacy and the Senatus Consultum Velleianum," in *The Family in Ancient Rome* (above, n. 34), pp. 85–92, and S. Dixon, "*Infirmitas sexus:* Womanly Weakness in Roman Law," *Tijdschrift voor Rechtsgeschiedenis* 52 (1984): 356–71.

45. S. B. Pomeroy, *Goddesses, Whores, Wives, and Slaves: Women in Classical Antiquity* (New York: Schocken Books, 1975), pp. 57–119; J. Gould, "Law, Custom and Myth: Aspects of the Social Position of Women in Classical Athens," *JHS* 100 (1980): 38–59. D. M. Schaps, *The Economic Rights of Women in Ancient Greece* (Edinburgh: Edinburgh University Press, 1979), modifies somewhat the conventional picture of women and wealth.

46. For example, in Plancia Magna's day Plutarch wrote that "the speech [of a virtuous woman] ought not to be for the public, and she ought to be modest and guarded about saying anything in the hearing of outsiders . . . ," and stressed that wives be their husbands' helpmates throughout life (*Moralia* 138C; 139D, F; 140A, D–F, 141A, 142C–D, 145A). See M. Foucault, *The Care of the Self* (New York: Vintage Books, 1986), pp. 147–85, and my article, "Imperial Women of the Early Second Century c.e." (above, n. 32).

47. Van Bremen, "Women and Wealth" (above, n. 12) 234; L. Robert, *Hellenica* V (Paris: Librarie d'Amérique et d'Orient, 1948), pp. 66–69.

48. For women's benefactions of all types, see Van Bremen, "Women and Wealth" (above, n. 12) 223–42; R. MacMullen, "Women in Public in the Roman Empire," *Historia* 29 (1980): 208–18; H. W. Pleket, "The Social Position of Women in the Greco-Roman World," in *Epigraphica* II. *Texts on the Social History of the Greek World* (Leiden: E. J. Brill, 1969), pp. 10–41; my article cited in n. 1 above (all concentrating on the Greek East); and E. P. Forbis, "Women's Public Image in Italian Honorary Inscriptions," *AJP* 111 (1990): 493–512.

49. That the Cornuti are not mentioned is a puzzle, for which see my "Plancia Magna of Perge: Women's Roles and Status in Roman Asia Minor" (above, n. 1).

Some Theoretical Considerations

YVON THÉBERT

What can we learn about private life from the study of domestic architecture? In attempting to answer this question, I shall restrict myself to a well-defined class of dwellings in Roman Africa: the urban homes of the ruling class. Given the current state of our knowledge and my desire to avoid repeating generalities, these limits are necessary. Roman Africa is a fruitful area for study, since it was one of the most important provinces of the Empire. By concentrating on a precise geographical area I hope to elucidate general principles valid for the Empire as a whole, as well as regional peculiarities, of lesser importance perhaps but useful for gaining a better idea of everyday life.

My aim is not just to understand private life by studying the place in which much of it took place. Architectural investigation offers a method of inquiry, not a theory of private life. Yet we cannot dispense with such a theory if we wish to understand what the ruins have to tell us. Domestic architecture was not static; it evolved over time. The architecture and decoration of private dwellings in the classical Greek city were quite modest. Majesty and luxury were qualities the Greeks considered appropriate only to the public sector, the city, which involved both individual and community, private and public. Here the individual owed

Reprinted by permission of the publishers from *A History of Private Life*, vol. 1, *From Pagan Rome to Byzantium*, Philippe Aries and Georges Duby, General Editors. Cambridge, Mass.: Harvard University Press, copyright © 1987 by the President and Fellows of Harvard College.

everything, including his status as a Roman subject entitled to lead a private life, to membership in the political community. In the Hellenistic era the classical city emerged from a crisis changed in ways that can easily be interpreted as the result of a remarkable extension of the private sphere at the expense of the public. Along with other changes, homes became increasingly luxurious, and people began to amass private collections of art, a development that paralleled the transformation of the work of art into a commodity.

How are we to interpret these changes? Should we opt for an evolutionary view, according to which what we are witnessing is the emergence of private life as such? To adopt such a view would be to argue that the Hellenistic era marked a key moment in a lengthy historical process: the slow development of the private vis-à-vis the public sphere. The ebb and flow of this process could be traced over many centuries. The problem is not quantitative but qualitative, the question being not to measure the relative importance of public versus private but to describe how the spheres were related, how each defined the other. It is not true that the private sphere had to struggle for its very existence against public constraints, but it is true that society determines what private life will be like. Private life is a product of social relations and a defining feature of every social formation. Hence private life is subject, from time to time, to radical redefinition; to attempt to trace its history as a matter of continuous evolution, independent of sharp discontinuities in other areas of social life, would be misleading. It is particularly risky to take our current conception of private life as a starting point and to trace its genealogy by interpreting the past in the light of what we now believe. If we adopted such an approach, we would very likely find that "private life" did not begin until quite recently. But this "finding" would be anachronistic, the result of misapplying modern bourgeois notions to the past.

Nor is a strictly psychological approach adequate. By "psychological approach" I mean one that begins with the assumption that every individual has an "identity" that can be characterized in terms of his "strategies" toward the outside world. In this way of looking at things, the public/private dichotomy is replaced by two other dichotomies: individual/society and internal/external. The result is that the social determinants of individual psychology are not taken into consideration. My own view has much in common with the approach taken by sociologists such as Erving Goffman, who deny that internal psychological states are the decisive determinants, and who emphasize the interaction between public and private, which can be elucidated through the study of "practices."

These theoretical considerations have had an important impact on my work. I hold that the organization of domestic space is not determined by autonomous private needs but is, rather, a social product. This same view is present in the only comprehensive meditation on architecture that antiquity has left us, that of Vitruvius. Vitruvius asserts that there is a connection between the floor plan of a house and the social status of its owner. Even more significant, he states that the house came into being not in response to individual needs but as a consequence of social

organization. When men finally learned to tame fire and gathered together around its warmth, they collectively invented both language and the art of building shelters.

A further consequence of the foregoing theoretical remarks is that domestic space is intrinsically unified. The Roman household was the scene of extremely diverse activity (diverse in appearance at any rate), some of which strikes us as eminently public in nature rather than private. The master of the house, for example, received large numbers of clients every day. Vitruvius himself uses the expression "public places" in referring to those parts of the dwelling open to outsiders; it will be convenient, when it comes time to discuss the various parts that went to make up a house, to use "public" and "private" in describing the various rooms. Different parts of any house are of course always "visible" to the public to a greater or lesser degree, but in the Roman house this difference of degree comes close to being a difference of kind. Yet it would be a mistake to suppose that a Roman house was an incoherent juxtaposition of two distinct areas, one essentially private, the other essentially public. That a place was made in the home for what came from "outside" was neither contradictory nor irrational. Indeed, architecture gives us a way of grasping the rather distended definition of private life current among the Roman ruling class. This distension explains why certain obviously social activities naturally took place inside private dwellings. The Romans behaved as they did because this was their way, not because they had no alternative or because private citizens usurped power that rightfully belonged to the public authorities.

The homes of African notables, like those of notables elsewhere in the Empire, sheltered several levels, several modalities, of private life. They were, as homes usually are, places to which the individual could withdraw, homes for the "family" in the narrow, modern sense of the term: the master of the house, his wife (who, in marrying, *convenit in manum,* that is, came under the paternal power of her husband), and their children. The basic family structure showed a remarkable capacity to expand; even though paternal authority was considerably weakened by changing ways of life, the paterfamilias remained theoretically in charge of the many disparate elements that made up the household. Besides the master's wife, and possibly other relatives, there were servants and slaves, described as the *familia,* among whom one carefully distinguished the *vernaculi,* those born in the house. The vocabulary reveals how the family subsumed social relations that would have been regarded as extrafamilial in other periods. The same phenomenon is evident in relations between patrons and clients, which were closely modeled on relations between a father and his children, as well as in religious attitudes. Pagan priests were in fact compared with parents and disciples with children (Apuleius, *Metamorphoses,* XI, 21). The Christian sect, also modeled on the family, simply carried on a long tradition. In all of this we see the central role of the private sphere in Roman society from the final centuries of the Republic onward. Political life was concentrated in the home of Caesar or Pompey as much as, or

more than, in the Senate. The wealth of activities in the home is explicable only in terms of the nature of the society. We see here a reflection of the new relations between public and private typical of the Roman world (where Senators were, after all, *patres*). These relations, which reflected the evolution of the Mediterranean world in general, became established in the late Republic and endured, in one form or another, to the end of the Empire.

In describing how the examination of domestic architecture can help explain the private life of African elites, and of imperial elites generally, I shall consider not only rich urban remains but also African literature, less abundant than Italian literature but also less exploited, at least from this point of view. I shall assume from the outset that African literary and African archaeological sources complement each other. This requires us to begin with the archaeological remains (Figures 89 and 90), the vestiges of the *domus,* that is, with the scattered and incomplete material record. In order to distinguish what is of general significance from what is unique, classification and comparison are essential. I shall look first at the concrete archaeological data before moving on to literary texts and comparisons with other provinces or even other periods. This approach has the advantage of confronting the facts directly, whereas the literary sources interpret private life as much as they describe it. I shall turn for corroboration to the work of numerous researchers whose experience in the field has contributed to a revision of earlier views of ancient society. Because these views were based too exclusively on literary sources and idealizations, every object was transformed into a work of art and treated as if laden with symbolic significance. This "demythification" of the past,

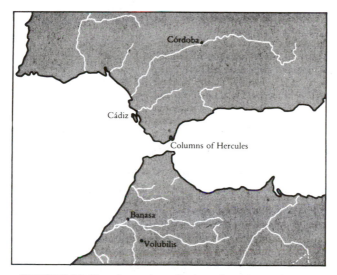

FIGURE 89 Sites in southern Spain and northern Morocco
(After Thébert)

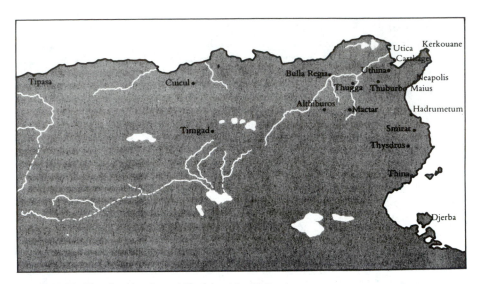

FIGURE 90 Sites in Algeria and Tunisia *(After Thébert)*

though salutary, is not without risks. It sometimes engenders hypercritical attitudes and can make scholars overly cautious in interpreting the quality and significance of elite dwellings. In studying domestic spaces I shall try to come to grips with their true nature. To do this I must say something about how owners shaped the designs of their homes. In this regard ruins can be quite instructive.

Private and Public Spaces:
The Components of the Domus

YVON THÉBERT

All the interior spaces of the domus belonged to the sphere of private life. Individuals could dwell in a house in many different ways, however, ranging from isolation to the receiving of large numbers of visitors with whom the owner was not on intimate terms. Living space varied, with some parts closed to the outside world, others not. It is therefore convenient, if not strictly accurate, to use the terms "public" and "private" in characterizing different parts of the domus.

How did the house communicate with the street? Many larger houses had several entryways, but there was always a main entrance, symbolically and concretely the point of transition from outside to inside. It was here that Trimalchio posted the sign stating, "any slave who leaves without orders of the master will receive one hundred lashes." The sources attach many meanings to the main entrance. A plaintiff attacking the behavior of one family charged that songs were shouted beneath the windows of their house and the door was often kicked open; the fact that the home was not respected proved it was nothing but a hovel (Apuleius, *Apol.*, LXXV). In the many thefts recounted in *Metamorphoses,* the entrance gate determines success or failure. Once this barrier was surmounted, there was no way, short of mobilizing the neighborhood, to prevent thieves from pillaging a home. The gate protected property as it protected morality.

Reprinted by permission of the publishers from *A History of Private Life,* vol. 1, *From Pagan Rome to Byzantium,* Philippe Aries and Georges Duby, General Editors. Cambridge, Mass.: Harvard University Press, copyright © 1987 by the President and Fellows of Harvard College.

Builders took particular care with this strategic point. The importance of the main entrance was usually emphasized by the construction of a porch consisting of a roof supported by two columns. This created an ambiguous space, often projecting into the street, that was not really a part of the house's interior. The true dividing line was marked by the door or gate, and the transition from street to house was often arranged in a complex manner. Usually there was not one gate but two or even three, with a clear hierarchy. A vast central bay was closed by a double gate, flanked by one or two smaller gates. But we must not assume that the large gate was for carriages and the smaller ones for pedestrians. The pattern of wear on the threshold and the organization of the rooms inside refute the notion that any vehicle ever passed through the main gate. The use of this entryway varied from time to time. As a rule, only one of the smaller gates was used, the small size of the entrance underscoring the division between the outside world and the house proper. At certain times, however, the main entrance was opened wide—probably when the owner gave a reception of some importance, and perhaps also in the morning, to indicate the moment when he was ready to receive his clients' homage.

The functions of the entrance were complex. Symbols of the owner's ambitions, entrances were the focus of much architectural attention. Many who never actually entered wealthy houses were aware of their owners' opulence from the magnificence of their entrances. In a well-to-do section like the northeastern quarter of Volubilis, splendid entrances were the rule. Two embedded small columns frame the secondary entrance of the House of Hercules' Labors. The entire composition is framed by moldings. The main entrance is flanked on either side by twin embedded columns. The design informs the passerby that this is a wealthy home and, depending on the time of day and the positioning of the gates, tells the person about to enter how he must present himself.

After passing through the main entrance, the visitor finds himself in the vestibule. This transitional space, although part of the house proper, is one in which the visitor is still subject to scrutiny. His view of the house is limited, and the vestibule is under the watchful eye of a guard: the *ianitor* is often mentioned in the texts, and many ruins include a small room, directly off the vestibule, which is clearly where the slave posted as guard watched those who came and went. The vestibule was a transitional space in another sense: it was supposed to herald the sumptuousness in store for the visitor. When Apuleius describes the Palace of Psyche (an imaginary palace, but nonetheless valuable for our purposes), he states that its divine nature strikes the eye as soon as one enters (*Metamorphoses*, V, I). The magnificence of a house was supposed to be on display from the moment one crossed the threshold. Vitruvius numbers the vestibule among those rooms that should be spacious and magnificent, and the remains of wealthy homes fully bear out this precept. In most great homes in fact the vestibule is one of the largest rooms. Frequently it opens onto the peristyle via a spacious triple bay that reflects the threefold entryway. Sometimes the nobility of the vestibule is enhanced by a small colonnade, as in the House of Castorius at Cuicul or that of Sertius at Tim-

gad (Figure 91). One of the most striking of all such entrances is found at Althiburos, in the House of the Asclepiae. Behind a gallery nearly 70 feet long, set between two projecting front rooms, are three vestibules, one for each of the three entries. The main vestibule leads into the central hall, located on the building's axis of symmetry. Covering nearly 700 square feet, it is the largest covered room in the building. The care taken in its decoration is in keeping with its magnificence. The walls are decorated with marble panels, and the floor is covered with a mosaic featuring a large marine composition, whose quality and complexity attest to the room's importance. The two side vestibules are actually annexes to the main vestibule. Each incorporates an uncovered pool between it and the central vestibule and amounts to little more than a walkway offering access to side rooms at either of the building's extremes. This symmetrical composition extends over the building's entire width.

In discussing the relation of exterior to interior, it is not enough just to call attention to the care taken in designing the place where the transition from one to the other was effected. For within the domus itself there were enclaves, often including an area, accessible by wagons, used for the owner's business activities. Household provisions were unloaded here (see Figure 92). Many houses also had shops along their outside walls. These could be used by the owner of the house to sell his own products, as is clear in cases where shops communicated directly with the domus, or rented to outsiders (see Figures 92 and 93). They are architecturally complex: integrated into the building (especially where symmetrically arrayed on either side of the entry vestibule), they nevertheless functioned independently. Often they served both as shops open to the public and as private residences for the shopkeeper and his family.

There was another type of enclave inside the domus: apartments rented to people who were not members of the owner's household. This practice is often mentioned in Roman sources and well attested in Africa. Apuleius was accused of making nocturnal sacrifices in a domus where one of his friends rented an apartment (*Apol.*, LVII). In practice, it is difficult to recognize from the remains of buildings which parts were rented to tenants. Texts and inscriptions suggest that apartments were usually located in upper stories, so the presence of stairways easily accessible from the street suggests that a building may have contained independent rooms suitable for renting. When the upper stories have been destroyed, however, this hypothesis is difficult to verify. What, for example, was the purpose of the staircase that led up from the southeastern corner of the House of the Hunt at Bulla Regia (Figure 94)? Did it lead to terraces? Or to separate apartments? Its location, close to both the vestibule and the wagon entrance, meant that it would have been accessible to tenants without affecting the owner's privacy; but this argument is hardly convincing. On the other hand, we can say with some confidence that rooms in the northeastern corner of the House of the Gold Coins at Volubilis (Figure 93) were intended for rental. This vast building occupied an entire insula, and the small apartment in question was almost surely part of it. It was set up for independent access from the street to the north via corridor 36, which served

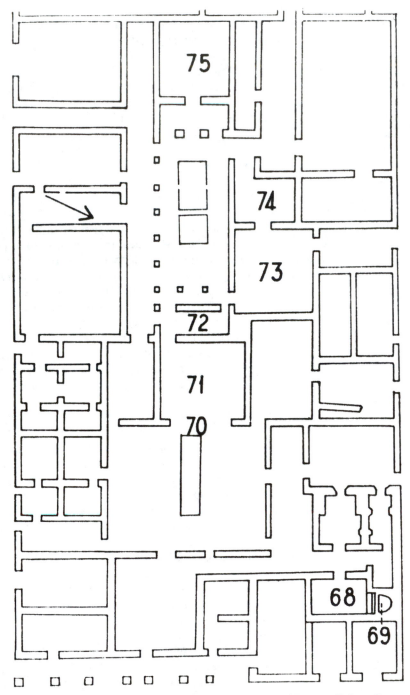

FIGURE 91 Timgad, House of Sertius *(Photo courtesy of Fototeca Unione, Rome, neg. no. 27995)*

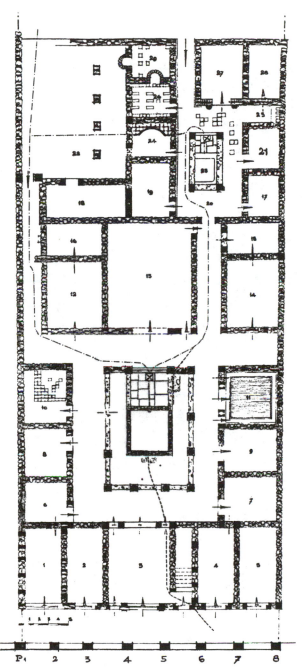

FIGURE 92 Volubilis, House to the West of the Governor's Palace; shops: rooms 1, 2, 4, and 5; courtyard for wagons: room 22 *(Photo courtesy of Fototeca Unione, Rome, neg. no. 27388)*

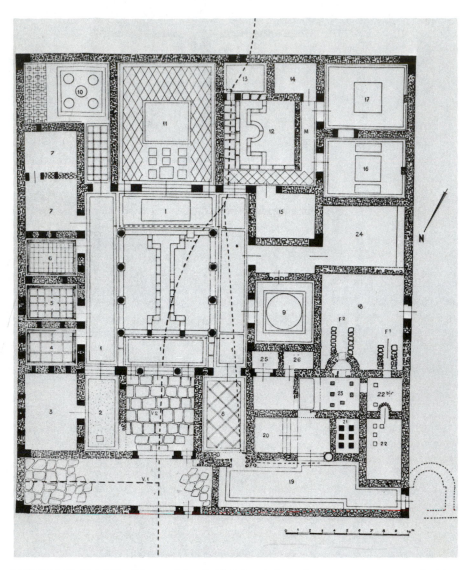

FIGURE 93 Volubilis, House of the Gold Coins; independent apartments: rooms 1, 15 and 16; shops communicating with house: rooms 2, 3 and 5; independent shops: rooms 6–11 *(Photo courtesy of Fototeca Unione, Rome, neg. no. 27391)*

rooms 1 and 16, the first of which had a window opening onto the street. Room 15 seems to have contained a staircase offering direct access to the street east of the building. Two ground-floor rooms and three upper-story rooms were thus available for rental. Also in Volubilis, next to the vestibule of the house to the west of the governor's palace, a staircase leads to the street through one of the three

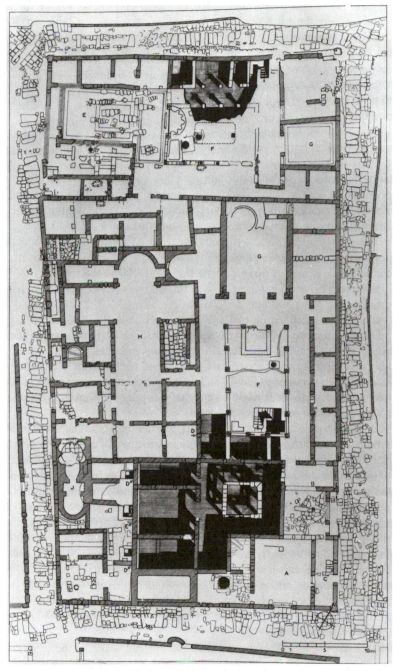

FIGURE 94 Bulla Regia, Insula of the Hunt; stairway to upper stories: C; triclinium: E; exedra: G *(Photo courtesy of Fototeca Unione, Rome, neg. no. 27582)*

doors (Figure 92). In all probability it led to rental apartments above the shops which, together with the entry vestibule, formed the facade of the building. Rooms of very different status often stood cheek by jowl. The house was in contact with the street only through its vestibule, which like an antenna probed the outside world, completely surrounded by rooms to let. We can only assume that the corridor that served the upper-story rooms, which must have been situated above the southern portico, was lighted by high, narrow windows so as to protect the privacy of the courtyard below.

The peristyle was the heart of every wealthy residence. The central court, open to the sky, allowed air and light into neighboring rooms, but it was the colonnade surrounding the courtyard that made the peristyle the ideal place for developing architectural ideas of some magnitude. Where space was lacking, an owner might have to settle for an incomplete peristyle, eliminating one or two porticoes. Usually, though, owners preferred to allocate as much of the available space as possible to the peristyle. In the most ambitious houses the peristyle attained vast dimensions: more than 3,500 square feet in the House of the Asclepiae at Althiburos or the Peacock House at Thysdrus, more than 5,000 square feet in the House of the Fisherman at Bulla Regia, and around 6,000 square feet in the House of the Laberii at Uthina.

Analysis of the peristyle turns out to be a more exacting task than it appears at first glance. It is customary today to maintain that the peristyle was the heart of the public portion of the house, that this spacious area was where visitors were received. This claim is corroborated by house plans, for the peristyle is frequently accessible directly from the vestibule, and most of the reception rooms are arrayed around its boundary. Hence it would seem that this space served as a complement to the rooms in which guests were received.

Such an interpretation suggests a sharp contrast between the African house, with its peristyle used for receiving guests, and the type of house found in Pompeii, with the traditional atrium on the facade used for the same purpose and the peristyle located at the other end of the building, ostensibly serving mainly to enhance the beauty of the house's private portions. This contrast is, I think, too stark. A distinction must be drawn between two types of visitors: ordinary clients who came to pay respects and receive their sportulae (distributions of food and other gifts), and other guests who were received privately by the master. Although the atrium of the Pompeiian house was well suited to receive clients, it was not useful for receiving distinguished visitors, who would have been entertained in one of the dining rooms or salons off the peristyle. It is therefore wrong to draw a sharp contrast between the atrium and the peristyle of the Pompeiian house on the grounds that the former belonged to the "public" portion of the house and the latter to the "private" portion.

Did the absence of an atrium in the African house make the peristyle a much more public space? If so, clients would have been received there; but there is no evidence for this either in the texts or in the arrangement of space, which would

scarcely have lent itself to such assemblies. The functions of the atrium were filled in the African house by other rooms: by the private basilica, about which I shall have more to say presently, and by the vestibule. We have seen that the vestibule was generally an ample room. It is likely that it inherited at least some of the functions of the atrium, although there is no persuasive proof of this assertion. A glance at the plans of many of these houses shows that their vestibules would have been suitable as sites for the salutation ceremony. In the House of the Ass at Cuicul the long vestibule ends in a sort of exedra marked off by two columns, behind which stood two rooms that might have served as storerooms for food handed out to clients. Vestibules were especially large in houses built on plots formed by combining a number of smaller lots. Rather than gain additional space by staying with a single entry, several entrances were kept in these houses. Some of the vestibules seem far too large to have served as mere anterooms. How else can we explain in the House of Europa at Cuicul the large southern vestibule, far from the central part of the building and not linked to the peristyle in any straight-forward way (Figure 95)? Despite the tiled floor, it cannot have been an uncov-ered room. The size of the triple doors and the fine molding around the bays show that it was an important place. Although the building has not been studied in suf-ficient detail to warrant any firm opinion, it seems likely that this was not an ear-lier building's original entrance, retained when two neighboring houses were combined, but an entrance constructed when the joining of the properties made space available. This vestibule apparently served as a waiting room for clients; it has all the necessary appurtenances, and the stairs that face the door could have served as a dais on which the master might have stood or made his formal entrance. It would be helpful if we knew more about the room located just north of this vestibule, which communicated with the street through two entries. (The portico in front of it rules out the possibility that the larger of the gates was a car-riage entrance.) The fact that the floor was tiled does not prove that this room was open to the elements. The space communicates with an inner room from which it is separated by nothing more than a row of stone vessels. These troughs, which were kept covered, would have been suitable for a room used for distribution of sportulae. If this hypothesis is correct, then the whole southwestern portion of the building, which included shops (Figure 95), would have been given over to "pub-lic" functions.

Thus, the African house was not without rooms located close to the street and, like the atrium, suitable for receiving certain visitors without disturbing the privacy of the rest of the house. The usual way of stating the contrast between the African and the traditional Italic house is therefore fundamentally wrong, since, on the one hand, the peristyle in the Pompeiian house was not used only by residents and, on the other hand, the African peristyle need not have been used to receive all visitors despite the absence of an atrium. This impression is confirmed by study of the rooms bordering the courtyard. Reception rooms are next to rooms used for completely different purposes, proof that the peristyle was not used solely as a public space.

Dais

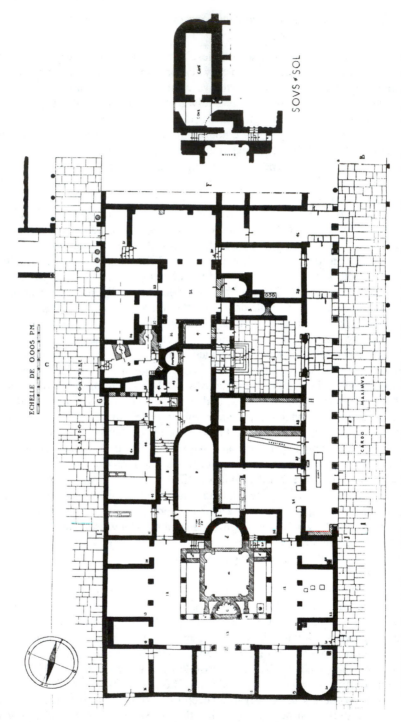

FIGURE 95 Cuicul, House of Europa; peristyle with courtyard filled with pools (a, b, c): room 12; vestibule: room 1; shops: rooms 27–28 (*Photo courtesy of Fototeca Unione, Rome, neg. no. 27355*)

The bedrooms, among the most private rooms in the house, are easily identifiable. The bed was often installed on a dais, raised slightly above the rest of the room; another device was the use of two different kinds of tile, with the simpler motif indicating the placement of the bed. Hence it is easy to see where reception rooms and bedrooms were juxtaposed. Such an arrangement was commonplace. The Sollertiana domus in Hadrumetum has two bedrooms that occupy an entire wing of the peristyle. At Acholla, in the House of Neptune, a suite of rooms occupies the northeastern corner of the peristyle, between two dining rooms. Three of the rooms in the suite are probably bedrooms, as is suggested by the use of two motifs in the mosaic tiling. The House of the Hunt at Bulla Regia provides a striking instance of this interspersing of public and private rooms (see Figure 94). The building contains two *triclinia*, one on the ground floor, the other immediately below it on the basement floor. Both rooms, which open onto the building's second peristyle, are flanked by bedrooms.

The complexity of the peristyle is highlighted by the placement of rooms serving such different purposes around its periphery. The peristyle cannot, therefore, be characterized as a reception area. It was the scene of such diverse activities that one is forced to ask how they could have coexisted. I shall return to this question when we consider how the various parts of the house were related.

The ambiguity of the peristyle is evident, too, in the way it was built. Construction sometimes highlighted the utilitarian aspect. Some courtyards were made of packed earth, and often there was a well and holes for cisterns. The House of the New Hunt at Bulla Regia demonstrates such utilitarian construction. Usually, however, the colonnaded space was decorated, often with plants, suggesting a domestication of nature. There were many different approaches. Some courtyards were entirely paved with mosaics. This emphasized the architecture and deemphasized the plants, which were here limited to the potted variety. Still, water and vegetation were constant, and complementary, themes of decoration, sometimes to such a degree that the peristyle was transformed into a garden with fountains and pools.

Practically every peristyle of any size was embellished with fountains. One of the most common and simple devices was to place next to one of the porticoes a semicircular basin with holes pierced through its lip. These were not pressurized fountains, merely pools of water a few inches deep. There were probably fixtures for inserting a frame to support a trellis, which made for an intimate association of water and vegetation on a small scale.

The same theme was carried to much greater lengths, and many courts were filled with basins and pools. In the House of Europa at Cuicul three complex basins are complemented by two jardinieres (Figure 95). In the House of Castorius, four semicircular basins flank the porticoes, while the central space of the courtyard is occupied by a rectangular pool. In this arrangement the space left open for passage appears to have been quite limited. A more radical approach was to give the court entirely over to water. Consider the House of the Fisherman at Bulla Regia.[1] In an immense peristyle, covering some 5,300 square feet, the court per

se occupies some 2,700 square feet. This entire area (apart from a few places left open to allow air and light to penetrate to the floor below) is filled with basins separated by low walls, in which holes have been left to allow water to circulate. On top of these walls there are traces of the fixtures used to support wooden studs or small stone columns, some of which are still in place. It is easy to imagine these devices supporting a light framework decorated with hanging plants.

When it came to bringing water and plants into the heart of the house, the owner had a wide range of possibilities. He might opt for a single basin and a few potted plants, or he might turn his entire courtyard into a garden with fountains or even a watery fantasy upon which one gazed but did not enter. Even the decor emphasized the "natural" aspect of the peristyle. In the House of the Fisherman vestiges of paintings depict birds and plants, while a basin with several lobes to catch the overflow was decorated with a mosaic of fish. In the Villa of the Aviary in Carthage the mosaic of the porticoes depicts various animals among the flowers and fruits. Frequent remodeling reveals changes in taste, but there are too few detailed studies to warrant the conclusion that owners devoted increasing amounts of space to such artificial natural decor. However that may be, no African house was without a peristyle decorated in this manner.

The charm of the peristyle obviously would have enhanced the private lives of the residents; its magnificent decor was just as obviously intended for the eyes of visitors. Evidence for the latter assertion lies in the way in which the decorative elements of the court were arranged. Usually the basins were placed along the axis of the reception hall. In the House of Castorius at Cuicul three basins correspond to each of the three bays of the main reception hall. Sometimes the connection between the architecture of the peristyle and that of the large adjoining halls is closer still. The rhythm of the colonnade in the House of the Trefoil Basin in Volubilis was altered so that the columns would line up with the three bays of the large hall. This extreme case, in which the entire peristyle is subjected to the ceremonial necessities of reception, merely confirms an obvious fact: this space was intended to convey to visitors the owner's high status.

The peristyle was the perfect embodiment of the complexity of the private sphere. Embellished by a combination of architectural and natural effects, it was a space in which a variety of activities took place, from solitary pursuits to great receptions befitting the master's high social station—to say nothing of the work of the servants, for whom the peristyle served as passageway, work space, and water supply. Whenever domestic chapels have been located in African houses, they have been found either in or close to the peristyle. In the House with Four Pillars, at Banasa in Morocco, the altar stood in a room just off the peristyle. In Libya, in the insula of Jason Magnus of Cyrene as well as in Ptolemais' House (with its D-shaped peristyle), a small chapel stands in the courtyard. An altar dedicated to the genius of the domus sat under one of the porticoes of the Wild Animal House at Volubilis, as well as the House of Flavius Germanus. The presence of a chapel did not "privatize" the use of the peristyle, however. In the House of Asinius Rufus at Acholla a cippus was dedicated by *cultores domus,* clients who partici-

pated in the domestic cult of the Asinii, the family that owned the house. The private cults were not limited to the family in the strict sense but included other "dependents." Hence it was entirely appropriate to place these altars in the peristyle, whose many functions reflected the many roles of religion.

Certain rooms were distinguished by size, architecture, and decor. Reception halls, often easy to spot, played a very important role in domestic life, since wealthy house owners were obliged to receive guests often and treat them handsomely. Meals were a favorite way of discharging this obligation, and no noble house is without one or more dining rooms (triclinia). The design of the mosaic often makes this room easy to identify: the central space was usually decorated with a choice motif; the space along the wall where the diners' couches were placed was more simply decorated. The importance of the dining room was often emphasized by its size and three access bays; it frequently was the largest and most sumptuous of the house's reception areas. The House of the Train of Venus at Volubilis has a triclinium (Figure 96) with three bays that measures 25.6 by 32.2 feet, larger than the court of the peristyle; it is decorated with a complex mosaic representing the navigation of Venus. In the new House of the Hunt at Bulla Regia (Figure 94) the dining room is the largest and most luxuriously decorated room; its central panel depicts a hunting scene surrounded by a rich foliated scroll that twines around the forequarters of various animals.

Complex architectural designs could make a room particularly sumptuous. Vitruvius describes vast dining halls that included an interior colonnade, which he called an *oecus*. This device was used in Africa, as evidence of the remains reveals. In the House of Masks at Hadrumetum, the triclinium, nearly 2,500 square feet in size, is separated by a row of pillars from a gallery some 8 feet wide that leads through a colonnade into a garden. The House of Neptune at Acholla has a dining room of more than 1,000 square feet, whose couches were separated from a peripheral gallery by a colonnade.

The luxury of these rooms demonstrates the key role they played. The dinner ceremony, designed to display the host's wealth, was also an occasion to expound his philosophy and announce changes in his circle of friends or family. This is not the place to review information gleaned from well-known sources, most of which in any case concerns Italy or the eastern part of the Empire. The African sources tell us that in Africa as in Rome the triclinium was where the master of the house showed who and what he was.

The central propaganda theme was luxury. No attempt was made to conceal the equivalence of power and wealth, ostentatiously demonstrated in banquets. Let us follow the hero of Apuleius' *Metamorphoses:* ''I found a large number of guests there when I arrived, the flower of the city, as befits the house of so great a lady. Sumptuous tables glamed with thuya and ivory, couches were upholstered with gold fabrics, and the drinking cups were enormous, varied in their elegance but all equally precious. Some were of glass with studious reliefs, others flawless crystal, still others gleaming silver or sparkling gold. Amber and other stones were mirac-

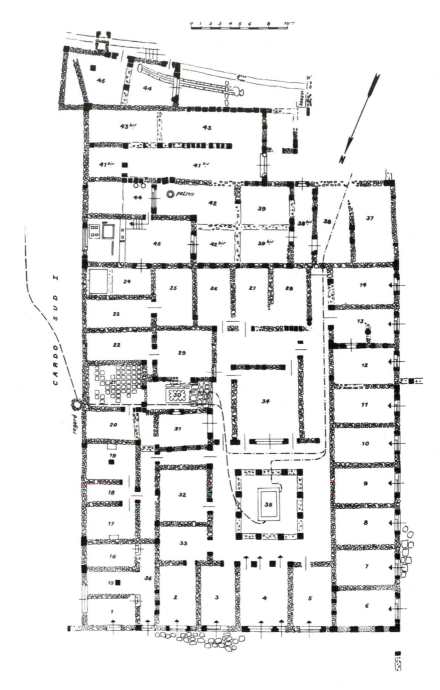

FIGURE 96 Volubilis, House of the Train of Venus *(Photo courtesy of Fototeca Unione, Rome, neg. no. 27398)*

ulously hollowed out for drinking. In short, one saw everything, even the impossible. Several carvers, wearing splendid robes, skillfully presented copious dishes. Curly-haired young boys wearing fine tunics continuously offered old wine in cups each of which bore a gem" (*Metamorphoses*, II, 19, from the French translation by P. Valette). None of this is surprising, and without dwelling on the luxury of the architecture, the decor, or the furniture, I want to stress the social significance of the food served. Wine of good quality (signified, as today, by age and origin) was essential at a true feast. The food, too, had significance. A host like Trimalchio organized an entire ritual around every plate, whose presentation was turned into a kind of spectacle. In Africa fish was the preeminent sign of a rich table. And it was costly indeed: the edict of Diocletian states that on the average fish cost more than three times as much as meat, and, for an earlier period, we have Apuleius' remark about "gourmands whose fortunes are being swallowed up by the fisherman" (*Apol.*, 32). The problem of supply did not arise in coastal cities, but it is remarkable that fish was eaten at all in the cities of the interior. The scarcity of fish is used by Apuleius in answering a charge that he practiced magic: "I was a long way inland, in the mountains of Getulia, where fish can be found, yes, thanks to Deucalion's flood" (*Apol.*, 41). Hence it is no accident that dining rooms and nearby corridors are often decorated with ocean scenes and representations of seafood. In the House of Venus at Mactar the decoration of the triclinium consists entirely of a catalogue of edible marine life, with over two hundred items initially: "the most important ancient work on marine fauna."[2] Marine life was not only decorative but reputedly prophylactic, capable of protecting a house against noxious influences. Beyond that, however, these maritime mosaics no doubt reminded viewers of luxurious meals past. Apuleius explains that, following the lead of the greatest names in Greek philosophy, he studied fish. He dissected and described various kinds and summarized and completed the work of his predecessors. He also coined Latin words to translate Greek terms. This scientific interest in classification and cataloguing is reflected in the mosaic at Mactar, where the various animals are represented so accurately that almost all have been positively identified by modern researchers. The illustrative plates accompanying Pliny's remarks on fish may have served as one source for this group of mosaicists. Was the culinary use of such scientific catalogues a vulgar perversion of philosophical speculation? No. Materialist and idealist interests coexisted in the noblest intellectual tradition. Apuleius himself reminds us that Ennius, a Hellenistic poet from southern Italy, wrote a poem celebrating seafood, in which he probably imitated earlier Greek poets. In this poem, for each fish he explains "where and how—fried or in sauce—it ought to be eaten to obtain the best taste" (*Apol.*, 39).

After this our attention turns naturally to the basins in the court of the peristyle—basins frequently decorated with marine motifs, a way of artificially bringing home the pleasures of the sea. This was not enough for some owners, however. Fish were raised in pools in a number of African houses. In the House of Castorius in Cuicul small amphorae are embedded into the masonry of the central basin, a device indicating the presence of fish. The same device occurs in the

House of Bacchus, also in Cuicul. The design of the tank in the House of Sertius in Timgad (Figure 91) is more complex. At the opposite end of the house from the main entrance on the *cardo maximus* a room opens onto the second peristyle through an antechamber with two columns. This may have been a triclinium. The court of the peristyle contains a basin consisting of two tanks, one on top of the other, with two holes to allow water to flow between them. Vessels, placed horizontally in the masonry walls of the basement, were designed as shelters in which the fish could spawn. These and many similar tanks found elsewhere were not just decorative ornaments but true fish hatcheries, which played an important economic role. In inland cities they enabled the host to offer his guests rare and highly prized fish dishes. These may have been but pale copies of the vast hatchery operations that occupied some Roman aristocrats to such a degree that Cicero called them *piscinarii,* or Tritons of the breeding tank. But the idea is the same, simply scaled down to suit local fortunes and conditions.

The dining room was more than just a place for the master of the house to display his wealth. It was used for more subtle—and significant—manifestations of domestic life. In Africa, as in the rest of the Roman world, women and even children had long attended banquets (see, for example, Augustine, *Confessions,* IX, 17, in which children are said to eat at their parents table). Changes in family habits were reflected in the order of meals, which was strictly governed, even in the afterlife, as is shown by a funerary mosaic depicting a couple observing the usual etiquette at a banquet in the other world. The old custom had been that only men reclined at table; women sat upright. But this custom had been abandoned by all but the most conservative. When Apuleius first describes Milo, known throughout the city for greed and base manners, he shows him lying on a low couch preparing to eat, with his wife seated at his feet and the table empty. The slim pickings and poor furniture might be interpreted in any number of ways, but the positions of husband and wife remove all doubt (*Metamorphoses,* I, 32).

The meal also brought together the entire *familia,* or household. Slaves were sometimes allowed to eat dinner leftovers (*Metamorphoses,* X, 14); on holidays they were allowed to recline while eating, just like their masters. Dinners marked social differences but also brought together heterogeneous groups. It is no accident that banquets became an important social occasion in Christian communities and, in particular, an opportunity to practice charity. In Africa these communal dinners, often taken at graveside in honor of the deceased, assumed such importance that the ecclesiastical authorities were forced to take steps to curtail them.

The triclinium was an essential room, the reception room par excellence as well as a setting for important family occasions. Here the devout noble received the itinerant priests of the Syrian goddess for a sacrificial meal (*Metamorphoses,* IX, 1). Here the marvelous donkey that eats the same dishes as humans is taken to show off its talents; the first thing his slave attendant teaches him is to lean on his "elbow" and recline at table (*Metamorphoses,* X, 16–17). Here the bonds that hold the private realm together are most overtly displayed: marital ties, family ties, household ties, and ties of friendship. All of these relations were clearly manifest

in mealtime ceremony. What is more, the master used the dinner stage to proclaim his conception of life. Space in the triclinium was coded space: the place where one sat signified rank, for the couches, and places on each couch, were hierarchically ordered, culminating in the master's seat on the right side of the central couch. To be *magister convivio* and preside over banquets was the role of the master (*Apol.*, 98). The guests were seated by a designated servant, the *nomenclator,* and the meal was served by specialized slaves, the *servi triclinarii,* each of whom was assigned a specific task. African artisans were careful to include these slaves in mosaics depicting banquet scenes.

Dinners were a visible affirmation of basic principles. Listen to the African Tertullian: "Our meal indicates the reason for its existence by its name, which is a word that signifies 'love' among the Greeks [*agape*] . . . Because it derives from a religious obligation, it is neither base nor immodest. We sit down at table [we do not recline] only after offering a prayer to God. We eat as much as hunger requires. We drink as much as sobriety allows . . . We converse in the manner of people who know that the Lord is listening . . . The meal ends as it began, in prayer. Then each person goes his own way . . . as though he had learned a lesson rather than eaten a meal" (*Apol.*, XXXIX, 16–19, from the French translation by J.-P. Waltzing). The same concern for propaganda through order is found two centuries later in Augustine: his friend Possidius reports that maxims engraved on the table are intended to elevate the conversation and that diners use silver utensils but earthenware dishes, not out of poverty but on principle.

These Christian attitudes derive without radical change from the dining art of earlier centuries. Even in pagan ideology the theme of temperance was developed in opposition to the association of social rank with sumptuous, not to say excessive, dining. When Erasmus in a later age praises "a table richer in literate conversation than in dining pleasure," he is merely repeating a favorite saying of the Romans, or at any rate of those Romans who thought of themselves as competent to pronounce on matters of the mind. Pliny the Younger, in praising the dinners given by the emperor Trajan, stresses the charm of the conversation and adds that the only diversions offered were music and comedies, as opposed to the dancers and courtesans so much in favor at African banquets. (A mosaic in Carthage shows them in action in the space delineated by the dinner tables.) When Apuleius seeks to discredit one of his detractors, he describes him as "a glutton, a shameless guzzler . . . a man who does not shrink from carousing at midday" (*Apol.*, 57). The accusation seems never to have grown stale. Another detractor is accused of having "devoured" an inheritance of three million sesterces, most of which ended up "in his stomach, frittered away on all kinds of revels," so that "all that is left of a fair fortune is a miserable scheming mind and an insatiable appetite" (*Apol.*, 75). Apuleius was too shrewd a man to have made such a charge unless it was likely to do some good.

The dining room, which played a key role in domestic socializing, was a theater with its own conventions, its own code governing relations of husband to wife and master to guests. Guests were shown how the master lived and learned

his opinions of the day's fashions. Every gesture, every dish, was of conscious significance. Reading how Juvenal or Martial, intellectuals always ready to engage in analysis and criticism, inform their guests in writing of the sophisticated, falsely modest menu of the dinner they are about to eat, with promises of properly moral, intellectual conversation, we see that there is no real difference between them and Trimalchio. For all these hosts the dinner is an occasion to teach, to preach a philosophy derived ultimately from the master's personal history. The dining room was all the more revealing because it was a dangerous place. As everyone knew, banquets often provided the occasion for the most audacious acts. This was the room where guests showed off, but it was also a room where certain types of behavior were proscribed. Martial promised his guests that on the day after one of his banquets they would not regret what they had seen or heard (X, 48). A citizen of Pompeii had maxims painted on the walls of his triclinium exhorting his guests to behave modestly and properly or risk being asked to leave. Augustine refused to serve wine to anyone who swore.

The atmosphere at Roman banquets ranged from the ascetic to the orgiastic. Augustine, in Book X of the *Confessions,* in the section dealing with the senses (X, 43–47), warns of the danger of taste: "For by eating and drinking we repair the daily decays of our body . . . But now the necessity is sweet unto me, against which sweetness I fight, that I be not taken captive; and carry on a daily war by fastings; often bringing my body into subjection . . . This hast Thou taught me, that I should set myself to take food as physic. But while I am passing from the discomfort of emptiness to the content of replenishing, in the very passage the snare of concupiscence besets me. For that passing is pleasure, nor is there any other way to pass thither, whither we needs must pass . . . Placed then amid these temptations, I strive daily against concupiscence in eating and drinking. For it is not of such nature that I can settle on cutting it off once and for all, and never touching it afterward, as I should of concubinage. The bridle of the throat then is to be held attempered between slackness and stiffness. And who is he, O Lord, who is not somewhat transported beyond the limits of necessity?"[3] For the sage, whether pagan or Christian, the act of eating is revealing precisely because it is both necessary and reprehensible. Recall that the only sin Augustine imputes to his mother is that of a somewhat immoderate, though quickly repressed, penchant for wine (*Confessions,* IX, 18). The social fact was inescapable: there was an art of eating, or, rather, a number of different ways of eating, none of which was innocent. And it was not, as in psychoanalysis, after the fact that people became aware of the real reasons for their actions. The moral dangers of the table were well known and feared or accepted. This awareness preceded the unconscious acts of daring or bold speaking committed in the heat of a banquet. Some people were known to be unable to control themselves, which only enhanced the danger. Worse still, there were people who made "disorderly" behavior at banquets a way of life.

Although the dining room was the most important room for receiving guests, it was not the only room used for that purpose. From what we now know, we can say with certainty that at least one other room was used primarily for meetings

with visitors: the exedra, generally smaller than the dining room but larger than other rooms and distinguished by a broad access corridor and fine decoration. Exedrae are often easy to identify. Opposite the dining room in the House of the New Hunt at Bulla Regia is an exedra that was originally attached to one of the porticoes of the peristyle by three bays. The same arrangement was used in the House of the Hunt, where the exedra is even larger than the triclinia (Figure 94). The exedra is the largest room of the House of the Peacock at Thysdrus, which gives some idea of the importance attached to it by the owner. In the House of Masks in the same city the exedra is accented by an apse. The noble house in Africa rarely lacked an exedra.

Since the triclinium usually was reserved for the main evening meal, the master of the house needed another room in which to perform his social duties. The exedra of African houses served many of the same functions as the *tablinium* in the traditional Italic house. It was primarily the master's office. In the House of Fonteius at Banasa the mosaic floor of this room bears his name: s. FONTE(ius). When the master needed to escape from the daily bustle of the house, it was to this room that he retired. This was where he dealt with business matters and received friends. Discussions and lectures took place here. It is no accident that the decor of the exedra often alludes to intellectual or cultural activities: mosaics represent the Muses in houses in Althiburos and Thysdrus, and theatrical masks and a portrait of a tragic poet have been found in the exedra of the House of Masks at Hadrumetum. Culture was important in the social life of the elite. One model was the *vir bonus dicendi peritus* (gentleman skilled at speaking), to repeat Apuleius' characterization (*Apol.*, 94). Conversational and epistolary skills revealed a man's talents and moral qualities. The written sources mention other rooms used for cultural purposes, but unfortunately we do not know how to identify them in the archaeological remains. Apuleius, for example, describes a library, a room that could be locked and that was guarded by a freedman (*Apol.*, 87).

When it came to meeting with clients, the exedra, which was often located near the center of the house and, all things considered, rather modest in size, might not have been adequate. Clientele relations, which structured society by making each person the dependent of a more powerful neighbor with whom he exchanged services, were of great importance in Italy, as is attested by abundant evidence. All signs are that relations with clients were equally important in Africa. Apuleius married in the countryside in order to evade the patron's duty to distribute sportulae on his wedding day (*Apol.*, 87). Augustine reports that Alypius, one of his students in Carthage, was in the habit of paying his respects regularly to a senator.

These morning ceremonies, concrete expressions of the dependence of client on patron, were represented in art. One of the most significant examples is surely the mosaic of the noble Iulius from a house in Carthage. Paul Veyne has reinterpreted this mosaic,[4] so I shall confine my remarks to points relevant to my subject. The villa occupies the center of the composition, which is framed by scenes of preparation for a hunt and includes symbolic components. According to traditional interpretation, the four corners contain scenes illustrating the four seasons:

winter (beating of the olive trees and duck hunting); summer (the grain harvest); spring (flowers); and autumn (the grape harvest and aquatic birds). But according to Veyne, the upper panel itself forms a coherent composition: the three standing figures are walking toward the woman in the center of the composition, bringing offerings. How can this spatial unity be reconciled with the temporal differentiation? By means of a symbolic interpretation. All the seasons are constantly bringing gifts. Similar symbolism occurs in the lower panel, which shows the noble couple ensconced in lush vegetation. He is seated with a stool under his foot, while she leans on her elbow next to a high-backed chair (*cathedra*), details indicating that the couple is actually inside the house. We are looking at an allegorical representation of the ceremonies in which dependents paid homage to their patron. What is symbolized is not simply clientele relations but economic dependence. There are the lord's coloni, peasants who were given a plot of land in exchange for a share of the produce. Here they are shown not paying rent per se but, according to Veyne's interpretation, bringing their masters the first fruits of the land, the forests, and the waters. (Corroboration of this religious dimension can be found in the fact that the mosaicist clearly indicates that the beating of the olive trees has only just begun, that the grain is still standing in the fields, and that the grapes are still on the vine.)

Examination of the *xenia*—representations of fruits, vegetables, and animals (familiar in Italic painting but a theme of African mosaic as well)—confirms Veyne's analysis. According to Vitruvius, such "still lifes" (which often contain not-so-still elements) depict the gifts that the master of the house bestows upon his guests. I have no reason to reject this interpretation, but it appears that in Africa (and it is unlikely that the phenomenon was purely local) these motifs carried a number of different meanings. The imagery often establishes a connection with the god Dionysus that transforms products of nature into symbols of fertility. This religious ideology is rooted, moreover, in a precise social context: the *xenia* are also, perhaps primarily, images of the first fruits offered to landlords by their coloni. Veyne's interpretation is bolstered by the floor of one of the bedrooms in the House of the Peacock at Thysdrus, whose four central tiles depict baskets filled with farm produce comparable to traditional *xenia*. These still lifes also symbolize the seasons, since each basket is filled with produce characteristic of one of the seasons. The message is the same as in the mosaic of Iulius, though here abstraction was preferred over allegorical social realism.

Such ceremonies, which occurred throughout the year, emphasized the power of the landlord, who alone was authorized to offer up to the gods the fruit of the community's labors. They also served as reminders of the rights of nobility. The colonate system frequently afforded the peasants a large measure of autonomy. Religion reasserted rights that the organization of labor tended to obscure or undermine. By according a leading role to the *dominus,* religion established his power beyond the reach of human controversy. In the mosaic of Iulius he is represented twice, once receiving visitors and once preparing to depart for the hunt. His wife also appears twice, and in a central role: receiving offerings. The peas-

ant is clearly showing the master a scroll containing either a petition or his accounts. The master's wife is not relegated to the second rank. Is her presence essentially symbolic, signifying that she, too, is a landlord? Or is it a realistic portrayal of her functions, suggesting that she actually participated in these ceremonies designed to exalt the power of the nobility? An answer would throw a good deal of light on the nature of aristocratic marriage in the Late Empire, but unfortunately none is at hand. Whatever the woman's actual role, the mosaic shows that she did have a place in the management of the family estates. In this connection it is perhaps worth mentioning Apuleius' description of his future wife, ''a businesslike woman [who verified] the accounts of farmers, ox-drivers, and lackeys'' (*Apol.*, 87).

Great landlords needed rooms in their residences both for the daily visits of their clients and for other, less routine ceremonies. The exedra and the vestibule, as we have seen, were used for these purposes. R. Rebuffat has noted that in Tingitane it is common to find houses with a large room entered through a narrow door from the peristyle at a point close to the vestibule (see, for example, the House of the Train of Venus, Figure 96). He suggests that this was a storeroom for *sportulae*, a hypothesis which would confirm my own hypothesis that the vestibule was used for the reception of clients.

Some houses contained a room specifically set aside for ceremonial purposes having to do with patron-client relations; Vitruvius calls it the private basilica. The private basilica in the House of the Hunt at Bulla Regia, with its apse and transept (Figure 94), was well suited for public appearances by the *dominus*. There can be little question about the interpretation of the basilica in this case. The basilica, with its independent entry, occupies the better part of the new lot; nothing less would have been suitable. It is not always so easy to identify private basilicas. It is reasonable to assume that the long room near the secondary entrance of House Number 3 in Bulla Regia is one. The presence of an apse, with sacred connotations that would have enhanced the master's image, is further evidence for this hypothesis. It is tempting to make a similar assumption about the large rectangular room in the House of Hermaphrodite at Timgad (Figure 97). Located near the main entrance, it communicates with the peristyle via the vast triclinium, separated from one of its two components by tripartite bays. What we have here may be a rather subtle architectural device, not without grandeur, for linking the peristyle with two different reception areas connoting two degrees of intimacy. Rather than cite other cases in which the interpretation of the architecture is open to doubt, let me cite a mosaic from Carthage that offers clear evidence of the presence of private basilicas in large houses. It depicts an ocean villa, one of whose parts is labeled ''*bassilica.*''

After the triclinium, few rooms are as readily identifiable as the bedrooms. They were among the more private parts of the house, and one might well apply to the noble African abode Corbin's description of the nineteenth-century bourgeois house, whose bedroom was a ''temple of private life, an intimate space deep in

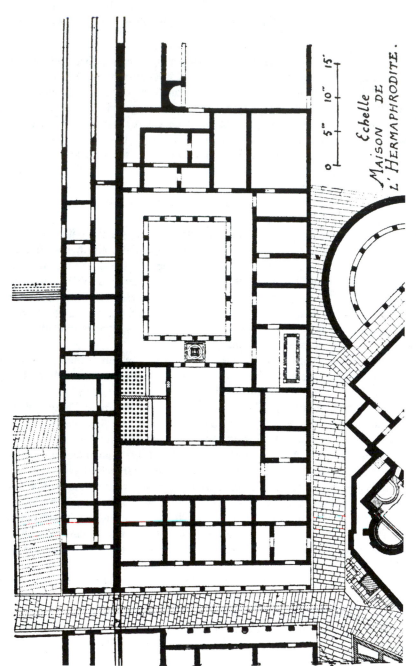

Echelle
MAISON DE
L'HERMAPHRODITE.

0 5" 10" 15'

FIGURE 97 Timgad, House of the Hermaphrodite; on the left: a row of shops; from left to right: entry vestibule, and large hall with adjoining room, probably a triclinium with dimensions of 36' x 25', with triple bays at either end (*Photo courtesy of Fototeca Unione, Rome, neg. no. 27505*)

the heart of the domestic sphere.'' The sexual connotations of the bedroom were as obvious in Roman times as in other periods. It was here that the prevailing morality was most shockingly transgressed—a place of adultery, incest, and unnatural intercourse (Apuleius, *Metamorphoses,* IX, 20–X, 3, 20–22); opening the bedroom to strangers was the symbol of debauchery (Apuleius, *Apol.,* 75). Saint Augustine's words reveal the profoundly intimate nature of the *cubiculum.* In describing intense emotions, Augustine several times in the *Confessions* uses metaphors based on elements of domestic architecture, in which the bedroom is the most secret and personal of all the rooms in the house: ''Then in this great contention of my inward dwelling, which I had strongly raised against my soul, in the chamber of my heart'' (cum anima mea in cubiculo nostro, corde meo; VIII, 19). Or this prayer to God: ''Speak Thou truly in my heart . . . and I will let them alone blowing upon the dust without, and raising it up into their own eyes: and myself will enter my chamber, and sing there a song of loves unto Thee; groaning with groanings unutterable in my wayfaring'' (XII, 23).

The opulence and complexity of domestic architecture were often on display in the bedroom, for the lover ''full of ardent hope'' (Apuleius, *Metamorphoses,* VIII, 11) was not the only outsider who found his way there. It was customary to receive travelers, relatives, and people sent on the recommendation of a friend, so every noble house required guest rooms. These are quite difficult to identify in the ruins, but the sources prove that they did exist (for example, Apuleius, *Metamorphoses,* I, 23).

This brings me to the question of private baths. All the cities of Roman Africa were equipped with public baths. They played an important part in everyday life, being used not only for bathing and related activities but also for physical exercise and intellectual activities. The public baths were a center of social life, if only by reason of their size, which made it possible to receive large numbers of users in rooms devoted to many different purposes. The pattern of use changed over time, and smaller neighborhood baths tended to be built as supplements to these vast edifices, possibly because the former were more convenient and accessible. There may also have been a change in customs, if we can believe the late Gallic author Sidonius Apollinaris, whose remarks appear to be applicable to Africa as well as to his native Gaul. He tells us that friends first gathered at a private home and then went to the baths, not to one of the large public baths but to a smaller establishment designed to respect each person's modesty (*Carmen,* XXIII, lines 495–499). The new attitude seems to reflect both the aristocratic need to stand apart from the crowd and a new, more modest attitude toward the human body.

These developments are relevant to understanding the proliferation of private baths in noble African homes. I feel justified in using the term ''proliferation'' because, although private baths had long been known, they seem to have become much more common in the late imperial period. Private baths were frequently added to existing houses or enlarged from smaller facilities, and eventually they became commonplace. Consider Bulla Regia: of the eight houses with peristyle

that have been fully excavated, four were equipped with small baths. The baths of the House of the Hunt were built in the fourth century, at the same time as the private basilica.

The use of private baths tended to make the wealthy more independent of communal life, on which their comfort had earlier depended, at least in part. This development went hand in hand with increasing formalization of the social hierarchy. Could the man who in the morning sat enthroned in his private apse to receive dependents in the afternoon join those same dependents in the public swimming pool, without clothes to indicate his rank? Private baths made it possible to maintain the necessary social distance.

Some African houses were equipped with latrines, and for the same reason. In the House of the Hunt at Bulla Regia these were built after the first private baths (Figure 94). They replaced the original *frigidarium,* which was moved farther south. Similar two-hole latrines have been found in other houses; like public latrines, they could be used by more than one person at a time. But the group of persons admitted was now quite limited. The latrines were something new; previously chamber pots had to be used when it was inconvenient to go outside. The change probably reflects a new modesty, a new attitude toward bodily functions, sounds, and odors. Latrines in the House of the Hunt were supplied with a water flush that emptied directly into the sewer in the neighboring street. These architectural developments give us at best a limited idea of a change in ruling-class habits that is parallel, it would seem, to what Corbin dubbed the ''deodorization'' of the nineteenth-century bourgeoisie. The new attitude toward the body was directly related to the way in which power was asserted; henceforth there was greater distance between rulers and ruled and increasing hierarchy in social relations. The strictly regulated ceremonies in the private basilicas and the proliferation of private baths and latrines had a common cause. Once public acts became private, domestic space played an increasingly important role in public life; and, within the house, rooms were assigned increasingly specific functions.

In conclusion, I want to say a few words concerning parts of the home about which little is known. We do not know what many of the rooms found in the remains of African houses were used for. The service rooms, particularly kitchens, are hard to identify, which proves that they housed relatively simple operations and depended on large staffs to serve such magnificent meals. The sources tell us a great deal about this. Apuleius says that one of the master's most important jobs is to command the *familia* (*Apol.,* 98). The mistress of the house never went out without an escort of several servants (*Metamorphoses,* II, 2). A well-bred lady would have been served by several *cubicularii* (X, 28), and her husband would have employed several chefs (X, 13). Add the pedagogue (X, 5), and you gain some idea of the size of the household staff. But we know next to nothing about where in the house such people lived. The most favored servants probably lived in the upper stories, now in ruins. Two brothers, slaves who worked as chefs, lived in a small room (*cellula*), but it was large enough to house an ass in addition to themselves (Apuleius, *Metamorphoses,* X, 13–16). More commonly, servants kept

their belongings in bags and slept on cots that could be moved as the occasion warranted. When Lucius, the hero of the *Metamorphoses,* is visiting a friend and needs to be alone in his room, the bed of the slave traveling with him is removed from the room and placed in another corner of the house (*Metamorphoses,* II, 15).

NOTES

1. Y. Thébert, "L'utilisation de l'eau dans la maison de la pêche à Bulla Regia," *Cahiers de Tunisie* 19 (1971): 11–17.

2. G. Picard, "La maison de Vénus," *Recherches archéologiques franco-tunisiennes à Mactar,* 1 (Rome 1977), p. 23.

3. This and other quotations from Augustine are from *The Confessions of Saint Augustine,* trans. E. B. Pusey (New York: Dutton, 1951).

4. P. Veyne, "Les cadeaux des colons à leur propriétaire," *Revue archéologique* (1981): 245–52.

Glossary

Achates Companion of Aeneas

Actium The battle in 31 B.C. off the coast of western Greece that left Augustus sole ruler of the empire

Adventus The arrival of a triumphal general or emperor in Rome

Aedile An official who organized games, religious festivals, and gladitorial and theatrical performances

Aeneas The hero of Virgil's epic *Aeneid* (26–19 B.C.), who fled Troy and founded Rome

Agora Marketplace; the social and civic center of a Greek city

Agrippa Close friend of Augustus; commander of his fleet in the civil war and later administrator in Rome

Ala **(plural** *Alae***)** Open recesses at the sides of the far end of the atrium in the Roman house.

Ambulacrum Corridor, walkway, avenue

Anchises The father of Aeneas; lover of Venus

Antony Rival of Augustus for control of the Roman world; consort of Cleopatra VII; defeated at the battle of Actium

Aphrodisias A city in Roman Turkey known for its sculptural workshops

Apuleius Wrote the novel *Metamorphoses* or *The Golden Ass;* born in north Africa and educated in Athens and Rome in the second century A.C.

Archon Basileus The high magistrate charged with the exchange of the *peplos* in the Panathenaic festival

Asia Minor Turkey

Attis The mortal lover of the goddess Cybele who castrated himself

Auctoritas Power, authority, leadership

Augur A priest who foretold the future by means of divination

Aureii (**sing.** *Aureus*) Roman gold coins

Barbarus Pater Savage father

Basilica An elongated rectangular building with a central nave and lateral aisles lit by a clerestory; in the Empire, the term stood for any hall with this plan or any large covered hall

Bosporus A kingdom on the Black Sea with chief cities on the western shores in the Crimea; known as the Cimmerian Bosporus

Bulla A rounded locket worn as an amulet

Calcei (**sing.** *Calceus*) The official Roman shoes worn with the toga

Camillus A youthful attendant in sacrifices

Campana Plaques Terracotta polychromed relief plaques that were used as architectural ornament

Canova (1757–1822) Neoclassical sculptor

Castitas Purity, chastity

Celts Peoples living in lands north of the Mediterranean, throughout western and eastern Europe and also in Asia Minor

Cithara Lyre

Clementia Mercy, clemency, compassion

Communis Opinio An accepted or generally held opinion

Concordia Concord, harmony, union

Constitutio The ceremony marking the establishment of the Ara Pacis on July 4, 13 B.C.

Corona Civica An oak wreath, awarded for saving a citizen's life

Crater Delicatus Bay of Naples

Cubiculum Bedroom

"Cur invidendis portibus et novo, sublime ritu moliar atrium"
 "Why should I construct a lofty hall in the latest style with enviable pillars" (Horace, *Odes* 3.1)

Dado The lower part of a wall treated decoratively with a plinth or molding

Dalmatia A Roman province on the east coast of the Adriatic

Denarii (**sing.** *Denarius*) Roman silver coins; each *denarius* was equal to four *sestertii*

Dextrarum Iunctio The gesture of the handclasp, often signifying union or concord through its evocation of the marriage bond

Dignitas Dignity, authority, distinction, rank

Dio Cassius (ca. A.D.155–235); Cassius Dio Cocceianus, who wrote a work of Roman history in 80 books

Dionysius of Halicarnassus Lived under Augustus, and wrote a history of early Rome

Domum Deductio The torchlit procession to a bride's new home

Duces (**sing.** *Dux*) Leaders, generals

Epigraphy The study of ancient inscriptions

Euphranor Greek sculptor of the fourth century B.C.

Euripus The canal in the Campus Martius built by Agrippa

Exedra A semicircular or rectangular recess

Fides Trust

Flammeum Bridal veil

Freedmen/Freedwomen Former slaves who were granted Roman citizenship

Furor Impius Unbridled rage

Gallia Belgica An area of Gaul that included Belgium, as well as territory between the Rhine, Mosel, and Seine rivers

Gaul or Gallia The territory corresponding with France, parts of Germany, S. Netherlands, Belgium, Luxembourg, W. Switzerland, and N. Italy

"geminorum mater amorum" "Mother of twin loves" (Ovid, *Fasti* 4.1)

Gens Family

Giallo Antico A type of marble streaked purplish-red

Gravitas Importance, dignity, influence

Herodotus Greek historian of the fifth century B.C.

Horace Poet of the Augustan period who wrote the public hymn, the Carmen Saeculare, for the Secular or Centennial Games of 17 B.C.

Insula A tenement or apartment house; also, a city block

Isis Goddess of Egyptian origins

Juvenal Satirical poet active in the early second century A.C.

Kline A bed or couch

Krater A vessel with a broad body and wide mouth in which wine was mixed with water

Kresilas Greek sculptor of the fifth century B.C.

Lacerna Mantle

Large Herculaneum Woman Statue type of a standing female figure with the mantle draped tightly around her

Lavinium The site in Italy where Aeneas landed and made his first sacrifice

Legatus The commander of a legion and the governor of an imperial province

Lex Law

Liberti/Libertini (**sing.** *Libertus/Libertinus*) Freedmen

Lictors Attendants and bodyguards of magistrates

Livia Wife of Augustus

Lucullus (117–56 B.C.); Wealthy Roman general and politician

Lugdunum Modern Lyons; capital city of a province in Gaul with a mint

Lusus Troiae Trojan games that consisted of military and equestrian exercises for boys

Macella (**sing.** *Macellum*) Markets

Magna Mater Cybele, an ancient Anatolian mother goddess, whose cult was brought to Rome in the third century B.C.

Marius General and consul of the first century B.C.

Martial Poet and satirist of the late first century A.C.

Megalography Painted frieze-like depictions of large figures representing grand historical or mythological subjects

Mithridates VI The king of Pontus in northern Asia Minor who was defeated by the Romans after a protracted war in the first century B.C.

Mos Maiorum (**plural** *Mores*) The ways of the ancestors; tradition

Mulier Nubit ''The woman marries'' or ''the woman gets married''

Municipium A self-governing community in Italy or in the provinces

Myron Greek sculptor of the fifth century B.C.

Necropolis Cemetery

Nefas Crime

Neo-Attic Reliefs Reliefs dating from the mid-first century B.C. to the early first century A.C. that imitate the styles of Greek art from the archaic period to the fourth century

Nike Goddess of victory

Nobilitas Fame, renown; noble birth

Nodus Knot

"Nullos his mallem ludos spectasse" "No spectacles would I have rather seen other than these" (Horace, *Sat.* 2.8.79)

Octavian The first emperor who then took the title Augustus (the title was used by all subsequent emperors)

Odeon A covered music hall

Oecus Dining room

Orbis Terrarum Earth, universe

Ordo Decurionum The rank of members of local town councils who had wealth and respectable backgrounds

Orthostat A vertical slab in the lower part of a masonry wall, or painted imitations of a slab

Ovid Poet of the Augustan period

Palla Mantle

Pallas The son of Evander who was slain in battle by Turnus (*Aeneid* 10)

Paludamentum A military or general's cloak

Panathenaic Festival Held in honor of Athena; the cavalcade and parts of the procession of Athenian citizens are depicted on the Parthenon frieze

Parthia A country roughly corresponding to Iran; its people were fierce enemies of Rome

Patera A flat dish used for offerings

Paterfamilias The head of the household

Pathos Emotion, suffering

Patronymic Derived from the name of a father or ancestor

Pax Augusta The Augustan peace

Peisistratos A tyrant in archaic Greece

Peplos A woolen garment worn by Greek women

Pergamon A city in Asia Minor that is an example of Hellenistic city planning with its terraces and elaborate acropolis

Pericles Athenian statesman, a leader in fifth century Athens

Phrygia A country in the central plateau and western flank of Asia Minor

Pietas A sense of duty, devotion, or responsibility (a virtue evoked by the *mos maiorum*)

Pinakes (**sing.** *Pinax*) A panel painting, frequently with wooden shutters

Pliny the Elder (A.D. 23/24–79); He wrote the *Naturalis Historia* in 37 books, a compendium of information on topics such as geography, botany, zoology, metals, and stones (including their use in medicine, art, and architecture)

Plutarch (before A.D. 50–after 120); Philosopher and biographer from Chaeronea in Greece; he wrote "parallel lives" of Greeks and Romans, among other works

Pompey (106–48 B.C.); Roman general who settled the east and was allied with Caesar and Crassus in the First Triumvirate in 60 B.C.

Pons Agrippae The bridge that Agrippa built across the Tiber

Pontus A country in northeastern Asia Minor on the south coast of the Black Sea

Potnia Theron Mistress of the animals; commonly an epithet of the goddess Diana-Artemis

Princeps Leader, emperor, "first citizen"

Princeps Iuventutis The title bestowed on Gaius and Lucius Caesar to honor them as leaders of youth (and of the youth associations)

Proconsular Imperium The power of a governor of a province

Propertius Poet of the Augustan period

Ptolemies The Macedonian (Hellenistic) kings of Egypt

Pudicus (-a, -um) Chaste, modest, virtuous

Punic War, Second (218–201 B.C.); One of three wars between Rome and Carthage, in which Hannibal invaded Italy

Rei Publicae Constituendae To be erected by the state

Res Gestae Augustus's account of his achievements

Revetment The facing applied to a wall

Ricinium A short mantle with fringe

"Romae, si vis habes, Pompeiis difficile est" "At Rome, (it can be done) if you have influence, at Pompeii it is difficult"

Salutatio Clients' morning calls to patrons' houses in hopes of obtaining gifts or favors

Sarmatia The area inhabited by the Sarmatians in southeastern Russia north of the Black Sea

Scaenae Frons The facade of a stage building in a Roman theater; backdrop of a theatrical stage

Sebasteion Imperial temple in eastern cities

Sella Castrensis A camp stool or magistrate's chair

Sepulchrum Grave, tomb

Sestertii (sing. *Sestertius*) Silver or brass coins used as a basic denomination in accounting; one *sestertius* was equal to one fourth of a *denarius*

Sibylline Books A collection of the utterances of the prophetic females known as sibyls

Sima The crowning molding of a cornice

Simulacra Gentium Representations of nations (peoples)

Stele (plural *Stela*) An upright slab of stone; a gravemarker

Strabo (64/3 B.C.–ca. A.D. 21); Historian and geographer from Pontus in Asia Minor

Sua Sponte Of itself, spontaneously

Suetonius Wrote *The Lives of the Twelve Caesars* and held several secretarial posts in the palace, the last under Hadrian in A.D. 121/2

Sulla The general who marched on Rome in 88 B.C. and became dictator in 81

Supplicatio Thanksgiving for victory; day of prayer

Syzygia A pair of columns surmounted by an entablature and a cornice

Tarquin Tarquinius Priscus, the fifth king of Rome; Tarquinius Superbus, the seventh king of Rome

Tertullian (ca. A.D. 160–240); The first Latin churchman and one of the founders of political and religious thought in the west

Thanatos Death personified

Tholos A circular pavilion

Thugga A city in northern Africa

Thymateria An incense stand

Tibullus Poet born between 55 and 48 B.C.

Toga Praetexta A toga bordered with purple

Togati Men wearing toga; Roman citizens

Toga Virilis The toga worn by young men to mark their rite of passage to manhood

"Tollite, o pueri, faces: "Boys, raise the wedding torches;
 Flammeum video venire, I see the bride (her veil) coming,
 Ite, concinite in modum" Go, sing like this" (Catullus, 61.114–116)

Torque A spiral, twisted neckband

Tribunicia Potestas The powers of a tribune of the people

Triclinium Dining room, reception room

Trimalchio The vulgar *nouveau riche* character in Petronius's *Satyricon* (written in the second half of the first century A.C.)

Tripod A cauldron or stool having three legs

Turnus Italian hero who fought the Trojans, slayed Pallas, and was finally killed by Aeneas (*Aeneid* 7–12)

Tusculum A resort near Frascati, southeast of Rome

Underground Basilica at Porta Maggiore, Rome A building of the first century A.C. decorated with stucco reliefs; its original function is unknown

Varro Scholar who lived from 116–27 B.C.; he wrote on the origins of Latin words and agricultural life, among other topics

Virgil (70–19 B.C.); Poet and author of the *Aeneid,* the mythical epic on the origins of Rome, as well as the *Georgics* and *Eclogues*

Virtus Valor, bravery, excellence

Vitruvius Roman architect and military engineer who wrote a treatise on architecture; active in the late Republican and early Augustan periods

Suggestions for Further Reading

ALFÖDY, GÉZA. *The Social History of Rome*. Translated by D. Braund and F. Pollock. Baltimore: The Johns Hopkins University Press, 1988.

ANDREAE, BERNARD. *The Art of Rome*. Translated by R.E. Wolf. New York: Harry N. Abrams, Inc., 1977.

BEARD, MARY, AND CRAWFORD, MICHAEL. *Rome in the Late Republic*. Ithaca, N.Y.: Cornell University Press, 1985.

BIANCHI-BANDINELLI, RANUCCIO. *Rome: The Center of Power, 500 B.C. to A.D. 200*. Translated by P. Green. New York: George Braziller Inc., 1970.

BOARDMAN, JOHN; GRIFFIN, JASPER; AND MURRAY, OSWYN, eds. *The Oxford History of the Roman World*. New York and Oxford: Oxford University Press, 1991.

BOATWRIGHT, MARY T. *Hadrian and the City of Rome*. Princeton, N.J.: Princeton University Press, 1987.

BRENDEL, OTTO J. *Prolegomena to the Study of Roman Art*. New Haven and London: Yale University Press, 1979.

BRILLIANT, RICHARD. *Visual Narratives: Storytelling in Etruscan and Roman Art*. Ithaca, N.Y. and London: Cornell University Press, 1984.

CANTARELLA, EVA. *Pandora's Daughters: The Role and Status of Women in Greek and Roman Antiquity.* Translated by M.B. Fant. Baltimore and London: The Johns Hopkins University Press, 1987.

D'AMBRA, EVE. *Private Lives, Imperial Virtues: The Frieze of the Forum Transitorium in Rome.* Princeton, N.J.: Princeton University Press, 1993.

GARNSEY, PETER, AND SALLER, RICHARD *The Roman Empire: Economy, Society, and Culture.* Berkeley and Los Angeles: University of California Press, 1987.

GAZDA, ELAINE K., ed. *Roman Art in the Private Sphere: New Perspectives on the Architecture and Decor of the Domus, Villa, and Insula.* Ann Arbor: The Univeristy of Michigan Press, 1991.

HANNESTAD, NEILS. *Roman Art and Imperial Policy.* Jutland Archaeological Society Publications 19, Aarhus University Press, 1986.

KAMPEN, NATALIE. *Image and Status: Roman Working Women in Ostia.* Berlin: Gbr. Mann Verlag, 1981.

KLEINER, DIANA E.E. *Roman Group Portraiture: The Funerary Reliefs of the Late Republic and Early Empire.* New York and London: Garland Publishing, Inc., 1977.

_____. *Roman Sculpture.* New Haven, Conn. and London: Yale University Press, 1992.

LING, ROGER. *Roman Painting.* Cambridge: Cambridge University Press, 1991.

MACDONALD, WILLIAM L. *The Architecture of the Roman Empire,* vol. II: *An Urban Appraisal.* New Haven, Conn. and London: Yale University Press, 1986.

POLLITT, JEROME J. *The Art of Rome, c. 753 B.C.–A.D. 337: Sources and Documents.* Englewood Cliffs, N.J., 1966; rpt. Cambridge: Cambridge University Press, 1983.

RAMAGE, NANCY H., AND RAMAGE, ANDREW. *Roman Art, Romulus to Constantine.* Englewood Cliffs, N.J.: Prentice Hall, 1991.

RICHLIN, AMY, ED. *Pornography and Representation in Greece and Rome.* New York and Oxford: Oxford University Press, 1992.

STAMBAUGH, JOHN E. *The Ancient Roman City.* Baltimore and London: The Johns Hopkins University Press, 1988.

STRONG, DONALD. *Roman Art.* Revised and annotated by R. Ling. Harmondsworth: Penguin, 1988.

ZANKER, PAUL. *The Power of Images in the Age of Augustus.* Translated by A. Shapiro. Ann Arbor: The University of Michigan Press, 1988.